A Garland Series

OUTSTANDING
DISSERTATIONS
IN THE

FINE
ARTS

The Sculpture of
Vincenzo Danti:
A Study in the Influence of
Michelangelo and the Ideals
of the Maniera

John David Summers

Garland Publishing, Inc., New York and London

1979

All volumes in this series are printed
on acid-free, 250-year-life paper.

Library of Congress Cataloging in Publication Data

Summers, John David.
 The sculpture of Vincenzo Danti.

 (Outstanding dissertations in the fine arts)
 Originally presented as the author's thesis, Yale
University, 1969.
 Bibliography: p.
 1. Danti, Vincenzo, 1530-1576. 2. Buonarroti,
Michel Angelo, 1475-1564--Influence. 3. Mannerism (Art)
--Influence. I. Title. II. Series.
NB623.D35S9 1979 730'.92'4 77-94718
ISBN 0-8240-3252-7

Printed in the United States of America

PREFACE TO THE GARLAND EDITION

This dissertation should be read as the middle of some-
thing, not as the end. When faced with the prospect of pub-
lishing it as it stands, I was at first reluctant to do so.
If I were to write it now, I would certainly do it differently,
and no doubt would manage to avoid some of the premature or
hopeful readings of the facts that are to be found here. Trained
eyes will recognize at once an accurate record of hasty com-
pletion and presentation. Circumstances demanded that it be
proofread in the length of time of a train ride from Bryn Mawr
to New Haven. And, as a most distinguished scholar of Renais-
sance sculpture once told me of his own work, I am not sure of
anything in it. Since I finished the thesis I have changed my
mind on several issues. Readers should consult two articles
("The Sculptural Program of the Cappella di San Luca in the San-
tissima Annunziata," Mitteilungen des Kunsthistorischen Instituts
in Florenz, 14, 1969, p. 67-90; and "The Chronology of Vincenzo
Danti's first Works in Florence," Ibid., 16, 1972, p. 185-98)
or come and see me. I simply repent of the section on the icono-
graphy of Danti's bronze reliefs. All this notwithstanding,
Vincenzo Danti occupied my days for many years, and I can only
hope that this cluttered latterday monument will serve his
memory, as it marks a considerable portion of my own life. To
those scholars who consider the same questions I did, I have
decided to offer the whole weight of my apprehensions and mis-
apprehensions, in the sincere hope that my labor will have eased

theirs, that correction of my errors will lead to clear and
proper solutions, and that finally they will make more (or less)
of it all than I did.

The Institute for Advanced Study

Princeton

January 25, 1979

THE SCULPTURE OF VINCENZO DANTI

A STUDY IN THE INFLUENCE OF MICHELANGELO
AND THE IDEALS OF THE MANIERA

by

J. David Summers

1969

A Dissertation Submitted to the Faculty
of the Graduate School of Yale University
in Candidacy for the Degree
of Doctor of Philosophy

TABLE OF CONTENTS

ACKNOWLEDGEMENTS

The resuscitation of Vincenzo Danti has been
assisted by many people who have taken time from their own
affairs to consider the airy, impractical problems of
gathering and evaluating the traces left by this corres-
pondingly airy and scholarly man. I am first of all grateful
to Yale University and the Samuel H. Kress foundation who
supported my researches both at Yale and abroad. First
in order of acknowledgment are also the numerous members
of the staffs of libraries in Florence and Perugia, es-
pecially those of the Biblioteca Nazionale, the Biblioteca
Moreniana, the Biblioteca Marucelliana in Florence, and
the Biblioteca Augusta in Perugia. I wish expressly to
thank P. Giuseppe Palumbo of the Biblioteca Comunale
in Assisi.

I owe an especial debt to the staff of the
Archivio di Stato in Florence and to Dottore Roberto
Abbondanza of the Archivio di Stato in Perugia whose
intimate knowledge of his efficiently and cheerfully run
archive contributed greatly to this study. Dr. Abbondanza
assisted in the transcription of many of the Perugian
documents. Perugia calls to mind another friendship and
more debts. Mr. John Grundman of Stanford University
stirred himself many times from what he considered to be

the much more important problems of economic history to
measure a statue which I had neglected to measure myself.
He was responsible for the completion of many of the
photographs of Danti's works in Perugia, and to Mr. Grundman
is owing that exemplary scholarly deduction found below in
which the length of the sixteenth-century Perugian foot
is established beyond any doubt. I am similarly grateful
to my friend and colleague Philip E. Foster of Yale
University whose knowledge of the Florentine archives was
freely set at my disposal, and whose help in practical
matters was always forthcoming.

I wish particularly to thank Dr. Catherine
Wilkinson of Yale University. Her sound scholarly
judgment, nimble critical wit and ready knowledge are
quite simply a part of the fabric of this study.

Finally I wish to thank two of the great scholars
of Renaissance sculpture, Professor Charles Seymour Jr. of
Yale University and Dr. Ulrich Middeldorf of the Kunst-
historisches Institut in Florence. To Dr. Middeldorf I
am grateful for sharing his knowledge, seemingly as
boundless as it is generously offered, in many conversations.
To Professor Seymour this whole enterprise owes its
beginning and much of the worth that it might have at its
end.

LIST OF ILLUSTRATIONS

INTRODUCTION

Vincenzo Danti is best known not as a sculptor but as the author of the _Trattato delle perfette proporzioni_, published in Florence in 1567, dedicated to Duke Cosimo I de'Medici. Danti began his treatise by swearing fealty to the _maniera_ of Michelangelo, vowing to imitate the works of his master with all possible energy. Danti's treatise has been the glass through which his sculpture has been examined, and most critics have taken his vow to imitate the works of Michelangelo at face value. His discipleship has thus served him badly, and Danti has most often been regarded as a mere reflection of his master. With the exception of a few studies, most attention has been given to Danti's sculpture by scholars bent on the illustration of reconstructions of the Tomb of Julius II or the Medici Chapel. This is instructive to a point, but it has had the unfortunate side effect of obscuring the nature of the work of an artist of considerable merit, and of making invisible the traces of the processes of creation, at once cooly conscious and inscrutable, which record the spiritual involution of Danti's age. Michelangelo is still the great monolithic support of the modern myth of the artist. Vincenzo Danti has had the misfortune to play the role of his conventional counterpart, the servile

imitator. Danti's debt to Michelangelo was significant, but no more so than that of his contemporaries, and the purposes to which he turned Michelangelo's forms are clearly illustrative of the central problems and attitudes of artists of the mid-Cinquecento.

On its own, out of the shadow of Michelangelo, Danti's sculpture has been highly regarded. For all his reservations about the stylistic creed to which Danti subscribed, Cicognara thought Danti one of the best sculptors of the sixteenth century.[1] Reymond considered him one of the most gifted artists of the time, whose just fame was denied him by a short life.[2] Julius von Schlosser considered Danti the most interesting artistic personality among Michelangelo's followers.[3] Maclagan found Danti "a quite unusually interesting artist, who learned from Michelangelo without succumbing to him", and saw in the Onore che vince l'Inganno (fig. 28) "a sculpture more modern in feeling than any other works of the period," referring to its tense purification of volume and masterful exploitation of the energies of the shaft of marble from which it was carved.[4] Kenneth Clark admiringly called the Onore "one of the finest compressions of energy in sculpture."[5] The definition of the figures in Danti's Moses and the Brazen Serpent (fig. 20) has been compared to Rodin and it is true that although such bronze relief has sources in the sixteenth century, it has no real precedents.[6] In his best works, Danti was one of the

most accomplished sculptors of the Cinquecento, and the principles of his style are of more than simply historical interest.

In any sense of the word, Danti was a Mannerist. He plumbed the expressive surfaces of Rosso and Pontormo in his <u>Brazen Serpent</u> relief, rivalled Giulio Romano in his statue of Julius III, equalled Bronzino in the linear refinement of the <u>Onore</u>, and drew freely on the inventions of Michelangelo. Like the works of artists to whom he can be compared, Danti's sculpture was rapidly forgotten after his death in 1576 and there are only faint echos of it in the works of later artists. His name was kept alive not by continued admiration for his work, which gradually became confounded with the works of Giovanni Bologna and Baccio Bandinelli, but by the simple repetition of the biographies of Giorgio Vasari and Raffaello Borghini. In the eighteenth century Lione Pascoli added some new material to these biographies.[7] Finally early in the nineteenth century, a certain interest in the <u>Trattato delle perfette proporzioni</u> was kindled by Count Cicognara, who praised it as one of the finest essays in the literature of art. He sketched its contents in his <u>Storia della Scultura</u>, and at his suggestion a new edition of the treatise was prepared and published in Perugia in 1830 by G. B. Vermiglioli.[8] Cicognara also provided the first critical evaluation of Danti's sculpture. He had not reassembled Danti's works and

speaks of only two pieces of sculpture. He had seen
the statue of Julius III by candlelight while it was in
hiding from the revolutionary troups in 1814, and judging
from the engraving of the bronze which he published, it
must have been well hidden indeed. He made the mistake of
identifying Vasari's description of the Onore che vince
l'Inganno with Giovanni Bologna's Florence Triumphant over
Pisa. Despite these handicaps, Cicognara concluded that
Danti had been an artist of genius born into a bad age,
and that as he accumulated the habits of his contemporaries
he had grown ever more distant from the precocious bril-
liance of his first statue of Julius III. Cicognara's
account of Danti's activity--trailing clouds of glory at
the outset and dim with mannerism at the end, if not well
grounded visually, still provides a basis for the under-
standing of Danti's sculpture. Throughout his career he
moved between the demands of a strongly individual artistic
personality and the cold, disciplined study of visual
elements as such. Only at the end of his relatively
short career--Danti was forty-six when he died--did he
unite the discipline gained in his middle years with the
technical and imaginative freedom of his first commissions.

Vincenzo Danti was one of the few artists in the
history of art whose theoretical ability and practical
ability were comparable. He was a learned artist, the
friend of the cognoscenti of Florence of the time; he

seems earnestly to have pursued the ideal of the universal
artist, and devoted himself to poetry and biography as
well as sculpture, painting, and architecture. His life
could hardly have been quieter, and he seems to have had
little desire to create a myth around his own name.
Danti's work is difficult to approach, and his writings
even more so.

No theme occurs more frequently in Vasari's
biographies than that of the importance of fate in deter-
mining whether or not one achieves the immortality of fame.
Danti's life was stalked by misfortune, ending in early
death. Part of the fate of an artist took the immediate
form of the patron for whom he worked. Danti served a
willful tyrant whose favor he never really won. It is an
insensitive reader of Cellini's Autobiography who does not
see beneath the mask of sword play and courtly word play
the despair of an artist of genius who, through the whim
of his patron, and the accident of his dislike, has been
robbed of the chance to earn through his works the eternal
fame after which he and the other men of his age hungered.
Fate handled Vincenzo Danti even more capriciously, and
he did not win the renown of which his contemporaries
thought him deserving.

The purpose of this study is to reassemble Danti's
oeuvre, and thus to provide the concrete basis for the
further consideration of his achievement. Clarification of

his historical position is a necessary condition of a
detailed examination of his Trattato. Such clarification
had been begun by Julius von Schlosser, Walter Bombe,
and Adolfo Venturi.[9] Most recently, Herbert Keutner
has offered a hypothetical reconstruction of Danti's
late style.[10] The list of Danti's works is by no means
settled and in some cases is downright controversial. He
remains a personality who cannot be reached by simple
examination of his writings on the one hand or of his
sculpture on the other. This study, drawing on new material
and combining the full range of Danti's activity, is pri-
marily an attempt to explicate the principles of his
sculpture. Danti will emerge from the study a different
artist than he was when it began. He was much more firmly
rooted in the maniera than in the manner of Michelangelo.
His work presents a problem of great interest, the relation-
ships of the formal ideals of the maniera--an art of
graphic refinement, non-empathetic and non-spatial,
texturally and visually various--to art in three dimensions.
And in this light his search in the 1560's after the
philosopher's stone, the secret of the manner of Michelan-
gelo, becomes a more heroic quest than it might otherwise
seem. If he were simply a pale reflection of the artist
whom he so admired, then his struggle to define the rules
of Michelangelo's art would be doomed to failure. But if
he set out in search of an ideal, starting from premises
wholly different from those he sought to understand, then

it is not the same, and the interaction between Danti's
inclinations, training and the pull of the ideal of
Michelangelo might be righ and complex, as indeed it
was.

Notes to Introduction:

1
L. Cicognara, Storia della Scultura dal suo
risorgimento in Italia fino al secolo di Canova, Prato,
1824, V, 239

2
M. Reymond, La Sculpture Florentine, Le XVIe
Siècle et les Successeurs de l'ecole Florentine,Florence,
1900, p. 173-175

3
J. von Schlosser, "Aus der Bildnerwerkstatt der
Renaissance; Eine Bronze des Vincenzo Danti," Jahrbuch
des Kunsthistorischen Sammlungen in Wien, XXXI, 1913,
p. 73-86

4
E. Maclagan, Italian Sculpture of the Renaissance,
Cambridge, 1935, p. 232-234

5
K. Clark, The Nude, A Study in Ideal Form, Garden
City, 1956, p. 282

6
J. Pope-Hennessy, "Italian Bronze Statuettes,
II," Burlington Magazine, CV, 1963, p. 64

7
See Chapter I, note 11

[8] See Appendix V

[9] J. von Schlosser, "Aus der Bildnerwerstatt,"
p. 73; W. Bombe in Thieme-Becker, <u>Kunster-Lexikon</u>, VIII,
p. 384-5; A. Venturi, <u>Storia dell'arte Italiana</u>, X, 2,
Milan, 1935, p. 507-529

[10] H. Keutner, "The Palazzo Pitti <u>Venus</u> and Other
Works by Vincenzo Danti," <u>Burlington Magazine</u>, C, 1958,
p. 427-431

CHAPTER I

THE FIRST YEARS IN PERUGIA AND ROME

"Signor Michelangelo", gli risposi,
"Madre natura produsse uomini
ed animali fatti tutti con la
stessa arte e proporzione, e
pur ben differenti gli uni
dagli altri. Così troverete
per i modi di dipingere, che
quasi tutti i grandi maestri
hanno ciascuno una maniera l'
una dall'altra differente, e
questi modi possono tutti esser
buoni, e degni, d'essere lodati.
Così a Roma Polidoro pittore,
Messer Perino, Giulio da Mantova
. . .il dipingere vostro non
può paragonarsi ad alcun altro."
 -----Francesco de Hollanda

CHAPTER I

THE FIRST YEARS IN PERUGIA AND ROME

Family and Education:

Because of the skill with which he imitated the poetry
of Dante, Piervincenzo Rinaldi, Vincenzo Danti's grandfather,
came to be called by his name, which he, his family, and his
descendants bore.[1] Piervincenzo was a goldsmith and his bio-
graphers have described him as an architect, although no
buildings have been linked with his name. He was well-versed
in mathematics, constructed an astrolabe and translated the De
Sphaera Mundi, a 13th century elementary geometry by Giovanni
di Sacrobosco, into Italian.[2] His brother, the fabled military
architect Giovanni Battista Danti, earned the name Dedalo with
a three hundred foot flight over Perugia during the wedding
celebration of one of the Baglione in 1503.[3] The shadowy
artistic activity of these two brothers and their dabbling
interest in scientific and mathematical matters set the pattern
for the lives of their descendants. Piervincenzo Danti
had a daughter, Teodora, and a son, Giulio. Teodora was
a painter, a saintly spinster who is said to have worked
in the manner of Perugino and to have written poetry and
a treatise on painting. Neither paintings, poems, nor
treatise survive.[4] The son, Giulio, continued the family
trade of goldsmith, in which he worked steadily and comfort-
ably. As an artist he was uninspired and retardataire, sat-
isfying the slack demands of a provincial market.[5] He too

is reported to have been an architect, and is variously connected with Baldassare Peruzzi and Antonio da Sangallo, although nothing can be attributed to him with complete certainty. He is also credited with two treatises, one on the ornaments of architecture, another on the flooding of the Tiber. Both of these are lost.[6]

Giulio Danti had three sons, Vincenzo, Pellegrino and Girolamo.[7] The youngest of them, Girolamo, born in 1547, was trained as a goldsmith but was active as a painter, working in an exaggeratedly mannered and ineptly drawn style that compares unfavorably with the frescoes of Giorgio Vasari.[8] In the oldest sons the aspirations of the family came to fruition. Pellegrino--who assumed the name Ignazio when he took Dominican orders in 1555--was one of the most renowned mathematicians of his time and at his death was the bishop of Alatri.[9] Vincenzo Danti became Perugia's only important sculptor.

Vincenzo Danti was born in Perugia in April, 1530.[10] His two earliest biographers agree in stating that he was trained as a goldsmith by his father.[11] Lione Pascoli, Danti's eighteenth-century biographer, wrote instead that he was sent to study grammar and rhetoric. There can be no question that Danti was trained as a goldsmith since he was enrolled in the guild at the age of eighteen;[12] but training in Perugia would have meant more than simply learning a trade. Interest in art, literature and mathematics is the one continuous thread in the fanciful history of Danti's forebears

and Ignazio Danti is said to have been instructed in geo-
metry and drawing by Teodora Danti, and she may also have
contributed to the education of Vincenzo, who was six years
older. However this may have been, Pascoli continued that
Vincenzo's studies prospered and that he was sent "in età
si puo dir puerile" to Rome.[13] This could simply be a
reasonable reconstruction of Danti's artistic education. At
the same time a pilgrimage to the Rome of Michelangelo was
common enough for young artists around 1550, and it is
possible that in writing his biography Pascoli has access
to sources not available to other writers. In any case his
account agrees with the earliest surviving record of Danti's
activity outside Perugia.[14]

Late in the summer of 1557 Giulio Danti's shop in
Perugia was robbed. In August he wrote a letter to Panfilio
Marchesi, a Brescian goldsmith working in Rome, asking him
to keep an eye peeled for the stolen items. ". . . io tengo
tal fede in voi per essere con voi li miei figlioli quanto
tengo a un mio fratello proprio. . .De Vincenzio no ve ne
so dire altro che si è andato a Firenze. . . "[15] From this
it may be concluded that Giulio's sons had stayed with
Marchesi and that he especially had reason to know Vincenzo.
Panfilio Marchesi maintained a shop in Rome from 1543 to
1571.[16] Thus Vincenzo Danti could have been in his shop at
any time from around 1545, when he was fifteen years old, to
1553, when he undertook the commission for the statue of
Julius III. It seems unlikely that Danti was in Rome for

any length of time after the commission since his movements
after 1553 can be more or less completely followed and there
would not have been time for an extended stay in Rome. The
silence of the records in Perugia after Danti's matriculation
in the college of goldsmiths in 1548 is more significant
than the silence before his matriculation since as a master
his name could be expected to begin to appear in contracts.
Since no such evidence has come to light, and since Danti's
superior talent would have insured a demand for his work in
Perugia, it may be surmised that he was outside the city.
This would agree with Pascoli's statement that Danti was
recalled to Perugia from Rome by the Priors of the Perugian
guilds to execute the statue of Julius III.[17] Thus, what
little is known of Danti's circumstances in Perugia tallies
with the supposition that he was in Rome, probably between
1548 and 1553. More important, it agrees with the visual
evidence. The statue of Julius III (fig. 3) is unmistakably
the work of an artist whose primary experience was that of
a goldsmith. At the same time, the stylistic currency of
many of its elements indicates that Danti was more aware of
events in Rome than a training in Perugia would have made
likely, and the easy skill of the pope's reliefs suggests
a wider capability than a goldsmiths.[18]

Rome: Danti and the Circle of Michelangelo:

Danti's earliest biographies make no mention of any
connection between him and Michelangelo, nor do they say that

he spent any time in Rome. Giorgio Vasari was employed
by Julius III immediately after his elevation to the papacy
in 1550, the same year that he published the first edition
of his Vite. Vasari watched the Roman artistic situation
in which Danti would have found himself with the care not
only of an historian but also of a man whose fortunes depended
upon it. He was a close friend of Michelangelo and knew all
the major artists personally. Possibly as a young goldsmith,
or as one young artist among many, Danti simply escaped
Vasari's notice. In any case, when Danti's life was published
in 1568, in the second edition of the Vite, eighteen years
had passed since both he and Vasari were in Rome, and in the
meantime Danti had completed a series of works in Florence
which would have surpassed any of his Roman juvenilia.
Danti's life appears among the short, sometimes sketchy,
biographies of the Accademici del disegno, and he is charac-
terized as a foreign artist whose genius had flowered under
the protection of Duke Cosimo de'Medici. Vasari was con-
sequently most interested in those of Danti's works which
were most conspicuous and accessible, the major ducal com-
missions in Florence.

Danti's second biography, in Raffaello Borghini's
Il Riposo of 1584, contains precise information about his
late years in Perugia--probably provided by Ignazio Danti--
but, following Vasari, also makes no mention of Michelangelo
or his circle. And when stylistic dependence upon Michelangelo
was the rule neither Vasari nor Borghini took notice of it.

Since there is a lack of biographical evidence, Danti's
activities in Rome cannot be precisely determined. Still,
a brief consideration of the artistic climate in Rome around
1550, together with what circumstantial and visual evidence
can be adduced, will contribute to an understanding of the
foundations of Danti's concerns as an artist and later as
an author. In lieu of an account of Danti's own first years
in Rome, Bellori's version of the early education of Federigo
Barocci provides something of the flavor and probably some-
thing of the fact of Danti's experience. There is some
justification for connecting the two artists. Barocci came
from Urbino, Danti from Perugia, and both sprang from similar
artistic and semi-scientific backgrounds. Their careers
crossed in 1567 when Barocci painted the Deposition for
Danti's Altar of San Bernardino in the Duomo in Perugia.[20]
This may or may not mean that the two men knew one another
in Rome, but as we shall see, Barocci encountered many of
the artists to whom Danti must have been drawn, and it is
instructive to see how these encounters took place.

At the age of twenty, in 1548, fired by the example
of Raphael (as Bellori tells it), Barocci went to Rome where
he was introduced to Cardinal Giulio della Rovere. "He
drew the works of Raphael with other youths who gathered
there. . . drawing in the loggia de'Chigi there happened by
Giovanni da Udine, returned to Rome, who, loving those who
studied his own master, corrected the drawings and spurred

the youths on with his sound instruction. . . drawing an-
other day in the company of Taddeo Zuccaro a facade of Polidoro,
Michelangelo passed by on his way to the palace, riding a
mule as was his custom, and while the other youths ran to
meet him, and show their drawings, Federigo hung back, and
did not go foward. So that Taddeo took his tablet from his
hand and gave it to Michelangelo, who studied the drawings
carefully, finding among them his own Moses, imitated with
diligence. Michelangelo praised him, and wished to meet him,
encouraging him to pursue the studies he had begun. Afterwards
Federigo returned to Urbino. . . "[21]

 The subsequent course of Danti's career makes it
evident that it was Michelangelo who impressed him most
deeply and indeliby. Danti wrote in his treatise that he
had passed twenty-two years of his life before he was inspired
by the "knowledge and greatness" of Michelangelo to devote
himself to the arts of design.[22] It is not clear whether
Danti claimed to have been inspired by Michelangelo or simply
by his example. Whichever the case may have been, since
Danti was born in 1530, his conversion would have occurred
in 1552, and therefore probably in Rome. However deep this
influence may have been, Danti, like Barocci, must have studied
several manners, and there is a germ of truth in Lione Pascoli's
story that Vincenzo Danti, the disciple of Michelangelo,
advised his younger brother Girolamo to perfect his manner
by studying the works of Raphael.[23]

 Lione Pascoli, writing in the eighteenth century, was

the first of Danti's biographers to suggest a specific
relationship of Danti to the circle of Michelangelo. He
wrote that Danti studied anatomy with Michelangelo and
Daniele da Volterra.[24] This statement raises interesting
questions and casts new light on a number of disparate facts.
That Danti was skilled in anatomy by the time his Trattato
delle perfette proporzioni was published in 1567 is evident
both from the nature of the projected treatise and Danti's
boast--no doubt much exaggerated--that he had dissected eighty
cadavers in its preparation.[25] It was also precisely in
the years around 1550 that, as Condivi relates, Michelangelo
was intensely concerned with anatomy.[26] His friendship
with the anatomist Realdo Colombo is attested by Condivi
and, independently of Condivi, it is known that Colombo's
De re anatomica--which was intended to supersede Vesalius--
was being written in close association with Michelangelo
and that artists were employed in its illustration as early
as 1548.[27] The years around 1550 were also the period in
his life when Michelangelo was most seriously concerned with
theory, or at least wished to appear so. At the same time
Condivi described Michelangelo's study of anatomy he outlined
a treatise Michelangelo planned to write "che tratti di tutte
le maniere de' moti umani e apparenze, e dell'ossa, con una
ingegnosa teorica, per lungo uso da lui ritrovata."[28] That
the envisioned treatise was to have been principally con-
cerned with human anatomy is evident not only from this
description but also from the fact that Michelangelo conferred

with Realdo Colombo about it, and revealed part of his
theory to Condivi over a cadaver supplied him by Colombo.[29]
Leaving the comparison of Danti's Trattato and the treatise
Michelangelo failed to write aside for the moment, it is
sufficient to say that there must have been many of Michelangelo's
theoretical notions in the air when Danti was in Rome, and
these ideas centered around human anatomy.

Michelangelo's avowed interest in systematically
setting forth the principles of his art coincided with a
maximum conceptual severity in his own style. The figures
in the Pauline Chapel frescoes, finished in 1550, are
repeated variations on a similarly conceived figure, massive
and twisting on a serpentine core. The final project for
the tomb of Julius II in San Pietro in Vincoli shows
Michelangelo abandoning the sculptural wall areas and multiple
tensions of the Laurenziana and the Medici Chapel in favor
of large dry surfaces and the straightfoward inversion of
large brackets. Michelangelo was by no means alone in his
desire for conceptual clarity, and the academic drift of
his thought was paralleled in the preparation of the ground
for academies of art, to the idea of which Vincenzo Danti
was to be devoted throughout his life. During the late
1540's Girolamo Muziano, later the founder of the Accademia
di San Luca, came to Rome. He formed a manner reliant upon
the style of Sebastiano del Piombo, whose sober and yet
relatively approachable assimilation of the style of
Michelangelo exerted a particularly strong attraction during

these years of the definition of Counterreformation taste.

Pascoli linked Danti not only with Michelangelo but also with Daniele da Volterra. Daniele worked with Perino del Vaga in the 1540's, and his general stylistic predicament, midway between the decorative refinement of the late school of Raphael and the plasticity of the manner of Michelangelo constituted a demand for synthesis which many artists must have felt. After the death of Perino in 1547 Daniele continued to work at large papal decorative commissions, and was one of the most skillful stuccatori of his time. Daniele had become increasingly independent of Perino, and increasing proximity to Michelangelo seems to have reinforced a strong inclination toward sculpture. This is evident not only in the sculpture which became a larger and larger part of his work, but also in the increased plasticity of his painting. However complex his transformation of the influence, as he became closer personally to Michelangelo, he began to investigate more deeply the leaden virtual masses and severe spatial location of figures and elements in Michelangelo's late drawings and paintings.[31]

Danti must have grappled with the problem of the synthesis and clarification of seemingly contradictory styles just as other artists had to do. Michelangelo's own late manner permitted the eidetic coldness of the Leah of the tomb of Julius II on the one hand, and, starting from the same formal principles, the dusky visionary intensity of the Pauline Chapel frescoes on the other. The

concomitant of a sometimes numbing formalism was a
powerful spiritualization of form. Marco Pino da Siena,
a pupil of Domenico Beccafumi, came to Rome immediately
after the unveiling of Michelangelo's Last Judgment in 1543,
and worked under both Perino del Vaga and Daniele da
Volterra. In his painting Marco Pino explored the somber
world of the spirit opened up by Michelangelo's late frescoes.
But such a work as Pino's Resurrection in the Oratorio del
Gonfalone in Rome is not simply a reflection of Michelangelo,
and Marco Pino did not forsake his earlier experience. Rather
in the wake of Michelangelo's frescoes he effected a complex
amalgamation of stylistic elements, as dependent as much
upon a pervasive memory of Raphael's Transfiguration as
upon the Pauline Chapel. He achieved an unstable unity of
the sculptural volumes of Daniele, the linear sublimation
of Perino del Vaga, and the tilted ground plane that locks
each figure in place in the Pauline Chapel frescoes. He
combined Michelangelo's color with the drawing of the Roman
maniera uniting the whole composition in a visually salient
rhomboidal structure. His figures are animated by the linea
serpentinata. According to Lomazzo, it was Marco Pino to
whom Michelangelo dictated the famous doctrine of the linea
serpentinata, and if this account is true, it was probably
during the 1550's that the lesson took place. Whether this
doctrine was actually codified by Michelangelo or simply
gathered from the examination of his works is to a large extent
beside the point, and its academic application by Marco Pino

is of greater importance for an understanding of artistic currents around the late Michelangelo.[32]

Rome at mid-century attracted many artists who figured prominently in the later history of central Italian art. Beside Marco Pino, Pellegrino Tibaldi and Pierino da Vinci were there, as well as older artists such as Vasari, Salviati, and, briefly, Bronzino. The Flemings Giovanni Bologna and Giovanni Stradano, both of whom were to exert powerful influences on art in Florence in the decades following, experienced and contributed to the complex developments in Rome. The style of Michelangelo was a fact with which all of these artists had to deal, and this style underwent many transformations. Not only was it tinctured with other styles, it was miniaturized, and the themes which had been titanic in intention became the stock in trade of goldsmiths and small scale copyists. Chief among the practitioners of this mode was Giulio Clovio, whose miniatures were highly prized throughout the century.[33] A page from the Farnese Hours (fig. 80)need only be compared to Danti's sportello relief of 1561 (fig. 27) to see that Danti was fully conversant in the piccola maniera. The crystallization of monumental forms in images of intimate scale took place in the late conceptions of Michelangelo himself and was consequently encouraged in the work of artists around him. Marcello Venusti painted his miniature copy of the Last Judgment in 1549, and in the 1550's Michelangelo supplied Venusti with meticulously finished drawings which were

transferred into paintings. Under the circumstances these
little panels must have been regarded as major utterances.[34]

Michelangelo's works had long served as a kind of
sala dei gessi, but in Rome around 1550 this study began to
have more explicit visual consequences, and the number of
artists quoting Michelangelo in their finished works increased.
Such imitation was not even condoned by the arch mannerist
Giorgio Vasari, who seems to have been perfectly aware of
the risks involved in drawing from works of art to the ex-
clusion of nature, as his biography of Battista Franco makes
clear. If Vasari's account of its reception is accurate,
Franco's Allegory of Montemurlo (fig. 81) was criticized
because of its direct references to paintings and drawings
by Michelangelo. The painting would not have been at all
extraordinary around 1550. Direct copies of Michelangelo
are rare in the works of such painters as Pontormo or even
Vasari. Usually entire paintings were copied or if figural
motifs were taken, they were alluded to rather than quoted,
and carefully veiled in the painter's own manner. Battista
Franco had no such scruples. Vasari called the Allegory of
Montemurlo a mixture of poetry and fantasy. Michelangelo's
figures became elements in a visual centone.[35]

Vasari describes Battista Franco as an artist obsessed
with study after the works of other artists to the point of
the ruination of his own manner. However accurate the
description may be his drawings are instructive models of
the proto-academic transformation of Michelangelo's style

and, on a simple visual level, of its practical fusion with
other styles.[36] In a drawing such as Franco's study for a
<u>Flagellation</u> in the Metropolitan Museum, (fig. 82)memory
of Michelangelo's form is evident, but sculptural value has
evaporated in Franco's hesitant contour and waxen, middle
value shading. This drawing stands very near the first work
that can be attributed to Vincenzo Danti.[37]

<u>Works Associable with the Roman Period:</u>

 The terracotta relief now in the Musée Jacquemart-
André in Paris is probably Danti's earliest surviving work.[58]
(fig. 1) It bears an old attribution to Pierino da Vinci
but certain qualities more firmly suggest Danti. The abrupt
transition from low to high relief is typical of Danti and
was well defined in his Julius III reliefs. (fig. 16) The
small figures on the architecture in the background directly
anticipate his bronze reliefs of the following decade. The
insistence on foreshortening, as in the leg of the figure
on the left, is also characteristic of Danti. This foreshort-
ening derives from Michelangelo and, although it was an
element in Michelandelo's work from the beginning, was
obsessively explored in the Pauline Chapel frescoes. It was
mirrored in the painting of Michelangelo's disciples, modified
by refinement of contour and deprived of its implications of
mass. Such a drawing as the study for a <u>Decollation of the</u>
<u>Baptist</u> by Marco Pino (fig. 83) stands in the same relation-

ship to Michelangelo's late drawings and frescoes as does
Danti's relief.

Danti's debt to Battista Franco's drawings is plain.
The two figures of Christ are virtually the same, especially
the torsoes, and even the simple column behind the figures
is shared. Danti has flattened his figure by minimizing its
spatial complexity and, in the manner of Marco Pino's drawing,
subjected the whole to a large uniting contour. The function
of this contour is not only to unify the movement of the
figure, but to establish a rhythm which includes the flagellants
on either side. If Danti knew Battista Franco's entire
Flagellation composition, he used only the figure of Christ,
and returned to the often-repeated pattern established by
Michelangelo's Flagellation composition for Sebastiano del
Piombo of 1516.[39] The visual saliency of the compositional
arcs in Danti's Flagellation is matched only by Michelangelo's
own studies in the movements of simple three-figured groups.[40]
(fig. 84)

The composition of the movements of figures based on
single continuous curves evident in Michelangelo's drawings
and Danti's relief is found both in painting and sculpture.
Giulio Mazzoni used the device in his shield bearers in the
courtyard of the Palazzo Spada in Rome.[41] (fig. 85) These
stucchi, if lighter and more graceful than Danti's figures
in the flagellation, conform to the same type. In Rome stucco
decoration had assumed major importance in such programs as the
Palazzo Spada and the Villa Giulia,[42] and the qualities of

stucco relief, midway between painting and sculpture would necessarily have been the object of a proportionate increase in sculptors' concern. Danti must have been drawn at once to the sketchy, "unfinished" antique stucco relief abounding in Roman ruins, and must also have quickly seen its possibilities for his own purposes. He applied the method directly to the reliefs of his statue of Julius III, and expanded it to the textures of the large curved surfaces of the statue. It received its highest expression in his work in the Brazen Serpent relief of 1559 (fig. 21). Daniele da Volterra, the foremost follower of Michelangelo, was also the foremost stuccatore in Rome at mid-century. As much as to the school of Michelangelo, however, the interest in antique stucchi also points to the tradition of Raphael, and Danti was surely aware of the finest reinterpretations of this kind of antique decoration, Giovanni da Udine's decorations of the Loggia di Raffaello (fig. 86).[43]

It would seem reasonable to place Danti's next relief, a Cleansing of the Temple which survives only in a cast (fig. 2) in the years around 1552-3--about the time of the commission for the statue of Julius III--while Danti was still under the spell of Roman patterns.[44] It is a much more complex relief than the Flagellation, and is sufficiently individual to allow it to be attributed with greater certainty.

The composition of Danti's Cleansing of the Temple derives from Michelangelo's drawings for the theme of the 1550's (fig. 87).[45] The two foreground figures and the figure of Christ are taken more or less literally from these

drawings. Behind the figure on the right is a Hercules figure, which reappears in Danti's <u>Moses</u> <u>and</u> <u>the</u> <u>Brazen</u> <u>Serpent</u>.[46] Behind Christ to the left is a female figure carrying a vase which in type, contour, and modelling might have been taken from Pierino da Vinci's <u>Cosimo</u> <u>I</u> <u>as</u> <u>patron</u> <u>of</u> <u>Pisa</u> now in the Vatican (fig. 88).[47] The definition of the figures of Danti's relief within broad arcs links it with the earlier <u>Flagellation</u>,although in the <u>Cleansing</u> <u>of</u> <u>the</u> <u>Temple</u> the linear stylization has reached a higher level. Once again, a conspicuous characteristic of the relief is severe foreshortening, and differences from the relief style of Pierino da Vinci are clear. By comparison Pierino brought each of his forms completely to the surface, creating a frieze of figures, all in profile, set against an abstract and undefined space.[48] The relief surface, which Danti began to develop as space by foreshortening, was given a schematic, zig-zag structure, alternating from low to high relief, and from near to far. The low relief of the background may still be compared to Pierino's low relief, and Danti had only begun to explore the range of nuance which marked his later reliefs. But the insistence on the ambiguity between relief surface and virtual space which reached its peak in the <u>Moses</u> <u>and</u> <u>the</u> <u>Brazen</u> <u>Serpent</u> was clearly defined as a sculptural problem.

The old attribution of Danti's <u>Flagellation</u> relief to Pierino da Vinci and the lingering traces of Pierino's manner in his <u>Cleansing</u> <u>of</u> <u>the</u> <u>Temple</u> are not without

significance, and indicate more than the simple similarity between two artists' styles. Pierino da Vinci was of the same generation as Danti, and after a precociously successful career in the shop of Niccolò Tribolo in Florence, he went to Rome in 1548. Vasari minimizes the importance of this trip, saying that the greatest lesson Pierino learned was that there was more in Rome than he could learn. Far from leaving the young artist untouched, however, the experience made a profound impression upon him, and it is the watershed in the short development of his style. It was not simply exposure to Michelangelo's sculpture which affected him. He had always had some of the greatest examples of Michelangelo's sculpture at hand in Florence from which to study, and the feathery modelling of his early works is an extreme refinement of Michelangelo's modelling. But Pierino's hulking Samson and the Philistine (fig. 89) carved after his return from Rome is a more zealous and sculpturally more ambitious effort than his early works. It is a technical study of Michelangelo's style.

It was a commonplace among sixteenth-century sculptors to acknowledge Michelangelo as their model and master, but Vincenzo Danti and Pierino da Vinci were the only two sculptors who undertook the systematic study of his manner. Both were in Rome during the same years. It is possible that the two young sculptors knew one another, although it is more important that they were similarly impressed by the same ambient. According to Vasari, Pierino

based his <u>Samson</u> <u>and</u> <u>the</u> <u>Philistine</u> on drawings he had seen
on the same theme by Michelangelo and used Michelangelo's
method of carving the block.[49] The derivation of Pierino's
relief from drawings of Michelangelo has been noted, and a
similar argument can be made for Danti's reliefs such as
the Washington <u>Deposition</u> (fig. 18) or, as we have just seen,
the Paris <u>Flagellation</u>, which is contemporary with Pierino's
reliefs and more exactly comparable to them.[50]

The most important sculptor in Rome at the middle
of the sixteenth century was Guglielmo della Porta. His
association with Perino del Vaga, begun in Genoa was con-
tinued in Rome under the approving eye of Michelangelo, who
saw to the advancement of his career in the Farnese court.
In the years around 1550, della Porta was engaged in the
gigantic bronze and marble tomb of Paul III, the dispute
over which resulted in a parting of the ways with Michel-
angelo.[51] The bronze portrait for the tomb was cast in 1552
(fig. 90).[52] Although it was probably the general inspir-
ation for Danti's bronze Julius III (fig. 3), if it did
not serve as the basis of Danti's conception, Della Porta's
carefully described drapery, carefully drawn contours and
uniform surfaces, varied by restricted, finely chased
detail, seem to have made no impression upon Danti at all.
In decorative details, however, there is a close relation-
ship between the two papal statues, so close in fact that
Danti's familiarity with them seems unquestionable.[53]

Danti's period in Rome visibly involved him in a current mingling many stylistic strains, particularly the academic study of Michelangelo and the late phase of the school of Raphael. The two reliefs which can be related to this period suggest that he was most aware of the former, but not untouched by the latter. It is not possible to tell how long Danti was connected with artistic activity in Rome or for how long. Still, his presence in the circle of Michelangelo and Daniele, however peripheral, would have placed him in an artistic environment that not only accounts for his early work, but makes sense as a foundation for his later artistic and literary activity.

Danti drew indifferently from painting and sculpture, and this practical equivalence of the two arts was to mark the character of his sculpture throughout his career. In this fusion Danti exemplified a general tendency. During these years in Rome, as well as in Florence, the _paragone_ between sculpture and painting once again became a serious concern. In Florence, where the question had already been quietly urged by the painting of Bronzino, the most conspicuous results were theoretical. The discussion culminated in Benedetto Varchi's _inchiesta_, published as part of his _Della Maggioranza delle Arti_ in 1550.[54] Speaking philosophically Varchi found no distinction between the two arts, since they had the same end. In Rome a similar conclusion was reached, but on a more practical level. The _paragone_ had a parallel in an extremely fluid relationship between the two arts.[55]

For a time their borders blurred. The question of the
relationship of real and fictive form must always have
arisen for any thoughtful follower of Michelangelo after
the Sistine Ceiling. Daniele da Volterra explored clearly
defined volume in both painting and sculpture. Perhaps
such a background helps to explain why, from beginning to
end, Danti's sculpture is essentially linear and volumetric.
In his marble works mass is smoothed away in generalized
forms defined by strong, abstracted contours. In his bronze
reliefs mass dissolves in light or is just indicated by line.
The foundations of this ambivalent sculpture were laid in
Rome.

Pascoli's statement that Danti studied anatomy with
Michelangelo and Daniele da Volterra, if not demonstratable,
has a considerable evidential value. This will have impor-
tant implications for any discussion of Danti's Trattato.
Michelangelo's own theoretical concerns of the period and
their echoes in his followers fed the beginnings of the
attempt to universalize style. This effort fertilized the
growth of adademies and Danti's treatise, in which he sought
to provide a basis for the arts of design in the style of
Michelangelo, was its first systematic statement.

The Monument to Pope Julius III:

For its part in the Guerra del Sale of 1540 the city
of Perugia was stripped of its powers of self government.
In spite of all its pleadings the city was partially laid
waste and rebuilt as a papal fortress by Paul III. Antonio
da Sangallo the Younger's Rocca Paolina rose over the
rubble of the old houses of Perugia's infamous ruling
family, the Baglione.[56] Ten years later, in 1550, Julius
III del Monte assumed the papacy. In the nepotistic scramble
following his election Fulvio della Corgna, cardinal of
Perugia, the son of the Pope's sister, Francia del Monte,
interceded on behalf of the city. On February 28, 1553 Perugia's
rights were partially restored.[57] The papal brief was
delivered to the Priors of the city by Cardinal della Corgna
on March 11. Immediately the Priors began to consider a
bronze statue of their benefactor, and 1000 scudi were
allotted for it. The resolution to construct the monument
was voted upon and unanimously approved for the fourth and
last time on May 7. Three days later the contract was given
to the goldsmith Giulio Danti and his son Vincenzo.[58]

How Danti came to be given the commission is not
clear. Giulio Danti had no experience with large scale
sculpture and in any case no very impressive monument could
be expected from him. Vincenzo was only twenty three years
old. Although the names of both the father and the son
appear in the contract, Giulio Danti had no visible role in

the statue as it was executed and he probably did no more than act as a legal standin for Vincenzo. The statue is signed by Vincenzo.

The impulse to erect the monument to Julius III seems to have come from Rome, and the commemoration was not simply the spontaneous result of enthusiastic gratitude. The city of Perugia could ill afford 1000 scudi.[59] The Priors never had such an amount of money on deposit for the project, and borrowed money from Ascanio della Corgna, the Cardinal's brother and captain of the Pope's guard,to bring it to completion. It is possible that the monument was understood as an appropriate sign of gratitude before the privileges were restored. It would also have continued a Perugian tradition. After Paul II quelled the civil strife of the city, the Perugians commissioned a bronze statue in his honor from Bartolommeo Bellano in 1466.[60] This was set in a nichehigh on the wall of the Duomo, facing the main square, a short distance from the place Danti's statue was to occupy. The statue of Julius III was only generally defined in the contract as a seated portrait between two griffins.[61] This simply specified that Danti should follow a standard formular for papal monuments and that the Pope should be placed on a throne doubly emblazoned with the traditional symbol of Perugia.[62]

The fortunes of the papal city of Perugia and the della Corgna family were made and unmade in Rome, and probably Vincenzo Danti's were made there was well. If

Pascoli is correct in saying that Danti was in Rome and
was recalled to Perugia to undertake the commission, it
is possible that he had taken the opportunity while in
Rome to present himself to Cardinal della Corgna, who was
largely responsible for the commission.[63] There are also
payments in 1551 and 1552 to Panfilio Marchesi, Danti's
master in Rome, from Fabiano del Monte, the legitimized
nephew of the Pope and last hope of the del Monte.[64]
Perhaps this contact provided the occasion for Danti to
come to the attention of the papal family. He might thus
have had recommendations from men of influence both in
Rome and Perugia. The role of impartial third party to
appraise the completed statue was left to Cardinal della
Corgna and the legate of Umbria, Cardinal Giulio Feltrio
della Rovere.[65]

 For an artist with no major works to his credit
the statue of Julius III was an impressive commission
(fig. 3). Its early progress is matter of factly recorded
in payments through the following year. At the end of June
1554 Vincenzo Danti travelled to Rome "ad quam destinatus
fuit ex causa statuae Iulii tertii construendae".[66] When
Danti went to Rome the casting of the figure was nearly a
year in the future and most probably its modelling had just
begun in earnest. The documents do not reveal Danti's reasons
for going to Rome. Perhaps he needed advice before modelling
the portrait of the notoriously ugly Julius III or the series[67]
of reliefs which encrust the figure; and a decision might

have been necessary as to what the official personality
of the Pope was to be. Julius III finally appeared with
the keys of the Church, symbolic of Apostolic succession.[68]

Perhaps the most important question raised by Danti's
statue is its possible relationship to Michelangelo's bronze
statue of Julius II. Julius III had taken his name in honor
of Julius II, who had first elevated a member of the del
Monte family to cardinal;[69] and it is reasonable to expect
that Danti's statue was intended to recall Michelangelo's
lost bronze of the Pope's great namesake. The precedent
would have interested Danti no less than Julius III.
Michelangelo's statue was placed on the facade of San
Petronio in Bologna in 1508 and hauled down and destroyed
at the end of 1511.[70] The scant visual evidence that survives
permits us to do little more than relate the statue to the
general tradition of papal monuments.[71] Since the statue
of Julius II was destroyed forty years before Vasari and
Condivi wrote, neither writer had seen it; nor did they have
a very precise knowledge of it when they described it. If
Danti was aware of Michelangelo's design for the Julius II
it remains a question how he knew it when men who were
Michelangelo's close friends and biographers did not. Danti
may nevertheless have known such designs, even though the
conception of his figure is different enough from anything
that might be expected from Michelangelo to exclude the
possibility that it is more than a free and general reference

to the earlier figure. The Julius II was the immediate
ancestor of the prophets of the Sistine Ceiling.[72] Vasari
describes an image of a conqueror, his gesture so fierce
that it might have been taken as easily for a curse as a
benediction.[73] Michelangelo's bronze was also an arrogantly
permanent memorial to a temporary state of affairs and it
was as impetuously destroyed as it had been erected. Danti's
intention would have been altogether different. Julius III
had restored the rights of Perugia, countermanding the Pope
who had subjugated it. Danti's bronze pope would then have
been conciliatory, as indeed he appears, and not symbolic
of the worldly dominion of the Church.

It has been suggested that a drawing attributed to
Bandinelli--identified as a study for his tomb of Clement
VII in Santa Maria sopra Minerva--derives from a drawing or
model for Michelangelo's Julius II (fig. 91).[74] The posture
of the figure is unusually animated and its gesture corres-
ponds to Vasari's description. The Pope holds a book in his
left hand. Both Vasari and Condivi wrote that Julius II
originally held a book, then a sword.[75] They did not know
early Cinquecento accounts of the figure which describe the
statue as holding keys, as Danti's pope does. Such an image
as the drawing, a pope brandishing a book like Moses with
the tables of the law is without example in papal portraiture.
At first it seems to have little to do with Danti's placid,
elaborately ornamented figure. Beneath the drapery of the
Julius II, however, it can be seen that his left foot is

thrust foward, his right drawn back, although rather less
dramatically than in the drawing. Danti completely
avoided torsion in the body of his statue and calmed its
gesture. If this adjustment is made then the two popes
become more similar. The double fold of the cope over the
arms of the figure, the drapery laid across the lap, ending
in thick heaps is much the same in both. The general corres-
pondence between the two is close and it is possible that
they have a common source. The evidence supports the iden-
tification of the drawing as a reflection of Michelangelo's
lost bronze. In that case Danti turned his model to more
peaceful ends and at the same time made a double obeisance
to Michelangelo and Julius II.

Although Danti may have wished the resemblance of his
bronze pope to Michelangelo's Julius II (and therefore his
own resemblance to Michelangelo) to be recognized in the
composition, there could hardly be less of Michelangelo in
the execution of the details of his statue. Rather the free
undulation of the drapery recalls the papal portraits by
Giulio Romano in the Sala di Costantino (fig. 92) Danti
controlled the sculpturally difficult movement of this
drapery by subjecting it to the basic conical structure of
the statue, forming a loose upward spiral (fig. 3). The
great arm of the pope stiffly extended from the fictile
mass of his body and drapery recalls another precedent in
painting, the foreshortened arms in Daniele da Volterra's
Deposition in Sta. Trinità dei Monti.

Danti's statue of Julius III is a masterpiece of
bronzecasting. It is a figure of almost endless complexity,
and it was successfully cast on the first try. When Danti
went to Rome in 1554 he must have sought, in addition to
programmatic directions, practical advice for the prepar-
ation of his model and the risky task of casting that lay
before him. The most likely place in Rome for Danti to have
gone for such guidance was the shop of Guglielmo della Porta.
Della Porta had completed his bronze figure for the tomb
of Paul III in the previous year, and was beginning the
second of the marble allegories when Danti arrived in Rome.
Della Porta might well have taken some responsibility for
the success of a monument important to the papal court.

Despite the difference in conception between the
two popes, the many reliefs decking the robes of Julius III
are close in style to those on the cope of Guglielmo della
Porta's Paul III. Della Porta's reliefs were probably
Danti's immediate model, even though he departs from their
proportions in figures reaching an extreme of mannered elong-
ation which beggars Parmagianino himself (fig. 13). The
restrained combination of the whole range of low, medium
and high relief is much the same in the work of both artists.
Both favor the same slender-wristed female figures and incised
drapery placed fold over fold and pressed against the surface
(figs. 15 and 93). In the relief of the right shoulder
of Paul III the drapery of the female figure hooks in a
distinctive fashion at the bottom. This mannerism appears

repeatedly in the reliefs of Julius III (figs. 15 and 94).
That it was borrowed is suggested by the fact that it only
appears in these reliefs; by the end of the decade it had
disappeared.[76]

The reliefs with which Danti decorated his statue
of Julius III thus connect him with one of the foremost
sculptors of the sixteenth century, and thus once again
with Perino del Vaga and the Roman *maniera*, to whose
aesthetic ideals the drawing of the reliefs shows him to
have been very susceptible. The oval cartouche framing
a crowded space with an architectural background which
Danti used in the small reliefs goes back to Perino (fig.
14). Drawings of a similar format (fig. 95) have been
identified as one of the scenes for a pluvial which Perino
designed for Paul III.[77] These or similar drawings would
have been familiar to Guglielmo della Porta, and they are
not many steps removed from the pattern for Danti's reliefs.

Danti's three earliest works, of which the statue
of Julius III is the culmination, show him sensitive to
several manners, irresolute in his devotion to any one
of them, and capable in all of them. It is perhaps most
important to emphasize in Danti's first major work that
his habits are not those of a follower of Michelangelo,
but of an artist of the *maniera*. The small free-standing
bronzes on the sides of the throne of Julius III (figs. 10
and 11) already are in full possession of the decorative
suavity of Danti's Leda and the Swan and look foward to

the sublimation of the Studiolo _Venus_ at the end of his
career. The Julius III is a record of habits, memories
and tests of skill which are not entirely fused. At the
same time it stands apart from its recognizable sources and
is the first statement of Danti's own inclinations.

The concentrated complexity of Danti's Julius III
is without parallel in Renaissance figural sculpture.
Monumental scale is combined with equally emphasized
decorative detail, and the surface which continually
divides and subdivides betrays a goldsmith's sensibilities.
Danti did not altogether resolve the resulting sculptural
problem and despite its size, the statue is of an uncertain
scale. At the same time this antinomy of large form and
decoration sets the stage for the first appearance of an
important component of Danti's style, his concealment of
meaningful elements. This sometimes occurs on an obvious
level. For example, one of the female figures in the car-
touches at the sides of the papal throne (fig. 11) is un-
accountably hidden by a large fold of drapery. More subtle
is the veiling of the symbolic meaning of the many reliefs
encrusting the pope's robes. At least eight are partially
visible, not including the main relief which characteristically
adorns the pope's back (fig. 12). The reliefs appear here
and there as the pope's pluvial folds and reverses around
him. Not only does this imply reliefs which cannot be
seen, but it denies the identity of visual and thematic

sequence, and there is a consequent loss of clarity. It must be assumed--or discovered--that the reliefs form a meaningful series.

Not only is the manifest content obscured, but the decorative elements are similarly suspended in ambiguity. The griffins, emblematic of Perugia, and specified in the contract, are there as the arms of the throne, but it takes a moment to find the one beneath the pope's left hand (fig. 5). These griffins, which quickly dissolve in the endless decorative interplay of the throne, reemerge as great, convincingly grasping claws which grip the statue's base at either front corner. On the breast of each griffin is the head of a laughing faun, holding the end of two swags in his mouth (fig. 8). Beneath each faun is a winged caryatid which emerges from the matrix of decorative energy with a dull, imprisoned sentience (fig. 7). Beneath the pope's keys (fig. 8) a small bronze bird alights to tweak the nose of the helplessly laughing faun, like one of the bronze creatures in Ghiberti's second doors, now carrying a note of irony and ambiguity.

Danti's concealment is still more general and fundamental. He avoided empathetic mass in favor of volumes whose husklike surfaces are defined by slowly moving gradations of value. These surfaces provide a foundation for the play of his chief visual means, light and line. It was Danti's greatest realization as a sculptor that these elements are free to become anything. He made

this absolute possibility visible, since the indefinite
unity of these elements is what is seen first, and is
always the condition of seeing the parts which compose it.
Sorting the elements, recognizing them and relating them is
a task which follows the initially engaging sense of profusion.
At first all the parts seem unique, but there are really
only a small number of different forms. The right side of
the throne (figs. 4 and 6) is largely composed of wings.
The wings of the griffin are overturned in the wings of
the Victory below. Her cartouche touches the wing of the
caryatid, which curls into volutes at the bottom. This
transformation of natural to decorative form is echoed
in the great spiral above the caryatid which loses itself
in the rectilinear framing. Such linking and combination
is the play of an imagination limited to the visualization
of natural and decorative form. Danti's Julius III is
more than a portrait; it is a display of wit, carried along
on a surface of visual energy by the chance logic of resem-
blance, the decorative logic of permutation and poetic fancy.

Other Early Works in Perugia:

The most important link between Rome and Perugia was
Cardinal della Corgna. He had won the favor of the Pope,
probably suggested the erection of the monument, and employed
one of the papal architects, Vignola, for the design of his
family's chapel in San Francesco al Prato in Perugia. Vignola
began his rise to prominence under Julius III and during the

years of his papacy was employed with Giorgio Vasari
and Bartolommeo Ammannati at the Villa Giulia. His
association with Danti's project amounts to papal interest.

Both Julius III and the pope that followed him,
Marcellus II, died before the statue was cast. Julius
III died March 23, 1555, and the statue was cast late in
the afternoon of May 8.[78] Vignola came to Perugia about
three weeks later. He had two reasons for making the
journey. The first was to appraise the value of Danti's
statue for Cardinal della Corgna, and the second was to
supply the designs for the Cardinal's family chapel. On
May 24 a contract was notarized between Ascanio della Corgna
and the muratore Giovanni di Domenico for the execution of
the San Francesco chapel which was to be built "according
to the design that maestro Giacomo Barozzi called Vignola
will give him."[79] Since Vignola had not yet presented the
design at the time of the contract, and so probably was
not in Perugia before the end of May, he could not have
assisted in the casting of the Julius III.[80]

Part of Vignola's project for the della Corgna
Chapel belonged to Danti. The contract specified that
two figures were not to be executed by the muratore.
Two years later Giulio Danti accepted payment in his son's
name for "quarundarum figurarum" completed in the chapel by
Vincenzo. The chapel is destroyed, and little evidence
remains of what Danti did there. It is possible that his
figures were marble reliefs.[81] In any case, Cardinal della

Corgna, Vignola and Danti were associated in Perugia, if
not in Rome, in the planning of the chapel. Vignola had
reported the success of the statue of Julius III to the
Cardinal in Rome by the third week óf June. From the same
letter in which his report is mentioned, it can be seen that
Danti himself returned to Rome after the casting of the
statue.[82]

The statue of Julius III was finibhed and in place
by December 1555 and its value, 550 scudi, was agreed upon
between the Priors and the artists. The Priors could not
pay the price which had been set, and gave the Danti instead
a bottega which could be redeemed later for the amount owed
them. The account was finally settled three years later,in
1559.[83]

As was customary, one of the conditions of the Julius
III contract was that the artists work without interruption.
Nevertheless,at a time when he must have been most occupied
with the modelling of the statue, in April, 1554, Danti
entered into another lesser agreement, also with the Priors,
for a gilt silver bowl to be finished by May of the follow-
ing year. Apparently Danti observed the letter of both
contracts, since his father executed the bowl and it was
finished on time. Giulio Danti accepted payment for it
in his own name in May, 1555.[84]

Aside from the statue of Julius III, there are two
major works from the years before Danti left Perugia for
Florence. The della Corgna Chapel in San Francesco was

one of them. The other is the monument to the jurist
Guglielmo Pontano in the church of San Domenico (fig. 17).
Pontano died in 1555, and Danti must have modelled his
effigy immediately after the casting of the Julius III.[85]
The clay figure, originally painted white to simulate marble,.
could have been completed in a relatively short time. It
is a much more assured sculpture than the Julius III. Pontano's
delicately modelled and individualized portrait differs
markedly from the official papal portrait. The resolution
of the drapery into large swelling areas crossed by heavily
breaking folds and the tendency of the folds to organize
concentrically are shared with the bronze. In contrast
to the pope, the reclining figure is severely simple, and
belies much less a goldsmith's concern for decorative
detail. The alternation between complication and simpli-
fication shown by the two figures is characteristic of Danti's
early sculpture; the bronze sportello relief (fig. 27) of
1561 need only be compared to the marble Onore che vince
l'Inganno (fig. 28) of the same year.

The monument to Julius III was a stroke of great good
fortune for Danti, the more so because the extremely difficult
problem of casting which he had set himself was masterfully
accomplished. Large bronzes were not so common that Danti's
project would have failed to attract the interest of other
artists, all of whom kept themselves well informed of one
another's doings. It would also not have failed to reach
the ears of prospective patrons. The statue of Julius III

thus began a career which could not have been pursued in Perugia; such a commission would not have come Danti's way again in his lifetime had he remained in his native city.

Pascoli wrote that when Danti had completed the Julius III he wished to return to Rome to rejoin his friends there.[86] But late in the spring of 1557 he left Perugia for Florence "to do some things for the Duke."[87] He was still in Perugia on March 29, 1557 when he, together with the painter Ottaviano Ciburri, appraised some decorative frescoes by Giulio Caprali in the house of one of the Baglione.[88] Danti had probably remained in Perugia to complete the work in the della Corgna Chapel. When his father accepted payment for the sculpture in his name on May 18, 1557, Danti must have been in Florence.[89]

Notes to Chapter I:

[1]
L. Pascoli, <u>Le Vite de' Pittori</u>, <u>Scultori ed
Architetti Perugini</u>, Perugia, 1730, p. 24. The early
sources for the Danti family have been collected and
summarized by W. Bombe in Thieme-Becker, <u>Kunstler-Lexikon</u>,
Leipzig, 1913, VIII, p. 380-7.

[2]
Published by Ignazio Danti in 1571. <u>La Sfera
di Messer G. Sacrobosco tradotta emendata & distinta in
capitoli da P. V. Dante de Rinaldi con molte. . .anno-
tazione del medesimo, rivista da Frate E. Danti</u>, Florence,
1571

[3]
C. Crispolti, <u>Perugia Augusta</u>, Perugia, 1648,
p. 168-9; A. Oldoini, <u>Atheneum Augustum</u>, Perugia, 1678,
p. 360-1; L. Pascoli, <u>Vite Perugini</u>, p. 56-7. Pascoli
refers to Giovanni Battista Danti as the brother of Pier-
vincenzo Rinaldi. His hubristic feat is the topic of an
article by P. Pizzoni, "Il volo attribuito a Gio. Battista
Danti," <u>Bolletino della Deputazione di Storia Patria per
l'Umbria</u>, XLII, 1945, p. 209-225.

[4]
On Teodora Danti see A. Oldoini, <u>Atheneum Augustum</u>,
p. 313-4, where she is characterized principally as the
teacher of Ignazio Danti. Pascoli's account of Teodora

Danti (<u>Vite</u> <u>Perugini</u>, p. 75-9) is probably more fanciful
anecdote than fact. See also W. Bombe, Thieme-Becker,
VIII, p. 385.

[5]
On Giulio Danti see A. Oldoini, <u>Atheneum</u> <u>Augustum</u>,
p. 198; C. Crispolti, <u>Perugia</u> <u>Augusta</u>, p. 360; L.
Pascoli, <u>Vite</u> <u>Perugini</u>,p. 81-2; W. Bombe, Thieme-Becker,
VIII, p. 381-3. As an example of Giulio Danti's crafts-
manship as a goldsmith see F. Ansano, <u>Visso</u> <u>e</u> <u>le</u> <u>sue</u> <u>Valle</u>,
Visso (?), 1964, p. 116. Ignazio Danti (<u>Le</u> <u>Due</u> <u>Regole</u>
<u>della</u> <u>Prospettiva</u> <u>Pratica</u> <u>di</u> <u>Jacopo</u> <u>Barozzi</u> <u>da</u> <u>Vignola</u>,
Rome, 1583, p. 82) is consistently followed in giving
his father a part in Galeazzo Alessi's church of Santa Maria
degli Angeli near Assisi. There is a documentary basis for
his design of the Palazzo Bindangoli (now the Istituto
Universitario S. Paolo) in Assisi.

[6]
According to Pascoli, the manuscripts were left to
Ignazio Danti (<u>Vite</u> <u>Perugini</u>, p. 77)

[7]
Giulio Danti's wife was Biancafiore degli Alberti
(L. Pascoli, <u>Vite</u> <u>Perugini</u>, p. 82; A. Mariotti, <u>Lettere</u>
<u>Pittoriche</u> <u>Perugine</u>, Perugia, 1788, p. 118, n1) M. A.
Maltempi, <u>Trattato</u>. . . <u>diviso</u> <u>in</u> <u>quattro</u> <u>libri</u>, Orvieto,
1585, p. 104, names a Giulio Danti who married a certain
Donna Camilla di Gio. Giacomo who had three previous husbands
and subsequently took a fifth. G. Baglione, <u>Le</u> <u>Vite</u> <u>de'</u>

<u>Pittori</u>. . .,Rome, 1635, p. 56 confuses Giulio's sons and adds a fourth. According to Baglione, Ignazio had a brother, Antonio, who painted with him in Rome, died prematurely and was honored with a bust by Valerio Cioli. Girolamo worked with Ignazio in the Vatican. Both Vincenzo and Girolamo died prematurely. The bust by Valerio Cioli is of Vincenzo and there is no reason to believe that Antonio Danti ever existed.

8
 On Girolamo Danti see L. Pascoli, <u>Vite</u> <u>Perugini</u>, p. 155-7; and W. Bombe in Thieme-Becker, <u>Kunster</u> <u>Lexikon</u>, VIII, p. 381. Pascoli relates that Girolamo was trained as a painter by Vincenzo. Girolamo is found in the records of the Accademia del Disegno in Florence in 1571-2 (D. E. Colnaghi, <u>A</u> <u>Dictionary</u> <u>of</u> <u>Florentine</u> <u>Painters</u> <u>from</u> <u>the</u> <u>13th</u> <u>to</u> <u>the</u> <u>17th</u> <u>Centuries</u>, London, 1928, p. 86.) An example of his work may be seen in the wall frescoes of the sacristy of the church of San Pietro in Perugia. See O. Gurrieri, <u>La</u> <u>Basilica</u> <u>di</u> <u>San</u> <u>Pietro</u> <u>in</u> <u>Perugia</u>, Perugia, 1954, pp. 28, 35.

9
 Ignazio Danti (1536-86) worked in Florence during almost the same years that Vincenzo was there, and has a biography in the second edition of Vasari's <u>Vite</u>.(Vasari-Milanesi, VII, p. 633-6) The various early sources have been collected by O. Pollak, Thieme-Becker, <u>Kunster</u>-Lexikon, VIII, p. 380. The most thorough studies of Ignazio Danti are I. del Badia, "Egnazio Danti Cosmografo, Astronomo e

Matematico e le sue opere in Firenze," <u>Rassegna Nazionale</u>,
VI, p. 621-31; VII, p. 434-74, Florence, 1881; also published separately under the same title, Florence, 1882; P.
Vincenzo Marchesi, <u>Memorie degli Artisti Domenicani</u>, Florence,
1854, p. 175-97; and V. Palmesi, "Ignazio Danti," <u>Bolletino
di Storia Patria per l'Umbria</u>, V, 1899, p. 81-125. Palmesi
and del Badia give bibliographies of Ignazio Danti's publications. A manuscript treatise on military architecture
"Sopra le fortesse e loro situazioni" was first published by
G. Baccini, "Un'Opera inedita del P. Ignatio Danti da
Perugia," <u>Archivio Storico per le Marche e per l'Umbria</u>,
IV, p. 82-112. Documents relating to his maps in the
Guardaroba in the Palazzo Vecchio in Florence are to be found
in H. W. Frey, <u>Literarische Nachlass</u>, Munich, 1940, III,
and A. Lorenzoni, <u>Carteggio Artistico inedito di D. Vincenzo Borghini</u>, Florence, 1912, Appendice quarta. The
traditional attribution of the church of Santa Croce in
Boscomarengo has been supported by W. Lotz and J. Ackerman,
"Vignoliana," <u>Essays in Memory of Karl Lehman</u>, New York,
1964, p. 23, n54; and his edition of Vignola's <u>Due Regole</u>
has been most recently discussed by T. K. Kitao, "Prejudice
in Perspective: a study of Vignola's perspective treatise,"
<u>Art Bulletin</u>, XLIV, 1962, p. 173-94.

10
 I have not found documentary substantiation of
Danti's birth date. L. Pascoli provides the most precise
date, April 22, 1530 (<u>Vite Perugini</u>, p. 137). The last lines

of the inscription on Danti's tomb in San Domenico in
Perugia.(see Appendix , no. for complete inscription)
reads "VIXIT. ANN. XLVI. MI. DIES VIII. OBIIT. MDLXXVI.
KAL . JVNII. " Danti died May 26, 1576 (see below note 12),
and if the inscription is correct, would have been born
April 18, 1530. This inscription apparently served as the
basis for the approximate date of April, 1530 given by
G. B. Vermiglioli in Biografia degli Scrittori Perugini,
Perugia, 1829, I, p. 372. Rather than choose one of these
dates it seems best to follow Vermiglioli's lead and await
documentary verification.

11
 Danti's principal biographers through the
eighteenth century are G. Vasari, Vasari-Milanesi, VII,
p. 630-33; R. Borghini, Il Riposo, Florence, 1584, p.
519-24; C. Crispolti, Perugia Augusta, Perugia, 1648,
p. 372; A. Oldoini, Atheneum Augustum, Perugia, 1678,
p. 329; L. Pascoli, Vite. . . Moderni, Rome, 1630, I,
p. 289-94; and Vite Perugini, Rome, 1732, p. 137-143.
Before Pascoli, only the two Florentine biographers attemp-
ted to deal with Danti's earliest years. Both Vasari and
Borghini wrote that Danti set his hand to goldsmithing at
an early age and did not mention his leaving Perugia until
coming to Florence. Danti's nineteenth-century biographer,
G. B. Vermiglioli (Biografia degli Scrittori Perugini,
Perugia, 1829,I p.372-5) added nothing essentially new in
his useful compilation of the earlier writers and the archival

information scattered in A. Mariotti, Lettere Pittoriche Perugine, Perugia, 1788.

[12]
PBA. cod. 976, f. 27r. "Vincentius Julii Pervincentii receptus die 28 Januarii 1548/ obiit magno bonorum moerore die 26 mai 1576." Published in "Statuto e matricola dell'arte degli orefici di Perugia", ed. F. Santi, Bolletini della Deputazione di Storia Patria per l'Umbria, L, 1953, p. 170.

[13]
L. Pascoli, Vite Perugini, p. 137-8. In his briefer account in the Vite Moderni,(I, p. 289) Pascoli wrote that Danti "Andò giovinetto in Roma, vi stette qualche tempo. . . "

[14]
Pascoli adds important material to Danti's earlier biographies. Pascoli may have had access to Ignazio Danti's papers, some of which were in Perugia at the end of the sixteenth century and were one of the minor sources for Cesare Ripa's Iconologia. The invention for "Equità"-- which is also an explanation of one of the figure's in Vincenzo Danti's Testata group (Cat. no. XV)--"fu fatta dal Reverendissimo Padre Ignazio Vescovo di Alatri e Matematico già di Gregorio XIII. essendosi cosi ritrovata tralle sue scritture." (ed. Perugia, 1765, II, p. 344; it appears in all earlier editions) It is known that Ignazio Danti had Vincenzo Danti's papers.(R. Borghini, Il Riposo, 1584, p.

522-23) Pascoli, who is the only early writer to mention
an autobiography by Vincenzo Danti may have been the only
writer who consulted it.

[15]
A. Bertolotti, Artisti Lombardi a Roma nei Secoli
XV, XVI e XVII, Ricerche e Studi negli archivi romani,
Mantua, 1884, p. 309-10. The letter is dated August 5,
1557. Danti is linked with Rome on the basis of this letter
by W. Bombe (Thieme-Becker, VIII, p. 385) followed by
J. Pope-Hennessy, Italian High Renaissance and Baroque
Sculpture, III, p. 77.

[16]
C. Bulgari, Argentieri Gemmari e Orafi d'Italia,
Parte Prima, Roma, Rome, 1966, II, p. 88.

[17]
L. Pascoli, Vite Perugini, p. 138; Vite Moderni,
p. 289.

[18]
The recent assertion by J. Pope-Hennessy, Italian
High Renaissance and Baroque Sculpture, I, p. 3, that
Danti had casts of Michelangelo's works from which to study
during his early years in Perugia is, as far as I know,
incorrect. It is probably a confusion with the casts of
the Medici Chapel figures (Cat. XXVIIa) made by Ignazio
and Vincenzo Danti which were brought to Perugia around the
time of the foundation of the Accademia del Disegno in 1573

[19] Vincenzo Danti, _Trattato_ _delle_ _Perfette_ _Proporzioni_, ed. Barocchi, p. 211. Vasari-Milanesi, VII, p. 630: "Attese costui, essendo giovinetto, all'orefice, e fece in quella professione cose da non credere. E poi datosi a fare di getto, gli bastò l'animo, di venti anni, gettare di bronzo la statue di papa Giulio III. . ." The vagueness of this account cannot be denied. The error--Danti was twenty five when he cast the statue--may be due to its inscription, ". . . adhuc puber faciebat", which Vasari could have read himself in Perugia and which has stirred a quiet debate ever since. R. Borghini, _Il_ _Risposo_, p. 529-30. "Vincentio di Giulio Danti si mise da giovanetto all'arte dell'orefice, faccendo in quella cose maravigliose; non lasciando intanto di studiare nel disegno: & al fine si diede tutto al gittar figure di bronzo."

[20] See Chapter IV below:

[21] P. Bellori, _Le_ _Vite_ _de'_ _Pittori_, _Scultori_ _ed_ _Architetti_ _Moderni_, Rome, 1728, p. 100-1.

[22] Vincenzo Danti, _Trattato_, ed. Barochi, p. 211, ". . avendo già passato ventidue anni e quasi il fiore della mia prima giovanezza quando, mediamente la cognizione e grandezza si tant'uomo (Michelangelo) ad attendere a quest' arte et all'imitazione di lui mi disposi. . . " In her note

to this statement (p. 496) P. Barocchi suggests that Danti
was referring to his trip to Rome of 1554, after he had
undertaken the statue of Julius III, which would have given
him the opportunity to see the works of Michelangelo. Danti
would have been twenty-two in 1552, however, and this date
is in agreement with other evidence.

23
L. Pascoli, Vite Perugini, p. 155.

24
L. Pascoli, Vite Moderni, I, p. 289. "Andò
giovinetto in Roma, vi stette qualche tempo, operò sempre
sotto la direzione del Buonarotti, e del Ricciarelli." In
the Vite Perugini, p. 138, Pascoli wrote that Danti went to
Rome while young: "e si diede a conoscere a Michelangelo
Buonarruoti, ed a Daniel di Volterra, da' quali ebbe dotti
insegnamenti, e gli fu fatta studiare anche la notomia fin-
chè il Magistrato de'dieci lo richiamò in patria a gettare
la statua di Giulio III."

25
V. Danti, Trattato, ed. Barocchi, p. 268-9
Of the next fourteen books of the treatise--only the first
book was published--seven were to have dealt with anatomy,
and two with the movement of the whole body. Anatomy was
the core of Danti's method in the Trattato, in preparation
for which he claimed to have dissected no fewer than eighty
three cadavers. (Trattato, p. 209)

26
A. Condivi, *Vita di Michelangelo Buonarroti*,
ed. C. Frey, Berlin, 1887, p. 192-4.

27
Realdo Colombo wrote a letter to his patron, Cosimo
I de'Medici on April 17, 1548, seeking premission to stay
in Rome in order to be near Michelangelo, have access to
cadavers, "et essere sopra a pittori." See *Giornale Storico
degli Archivi Toscani*, III, 1859, p. 71-2. Colombo's *De
Re Anatomica, Libri XV* was finally published in Venice in
1559, without illustrations.

28
Condivi, *Vita*, p. 192.

29
Condivi, *Vita*, p. 194.

30
On the state of painting in Rome at mid-century see
H. Voss, *Die Malerei der Spätrenaissance in Rom und Florenz*,
Berlin, 1920, I, p. 110-148; and F. Zeri, *Pittura e
Controriforma: l'Arte sensa tempo di Scipione da Gaeta*,
n. p. , 1957; The ambient in Rome around 1550 is also
discussed by G. Briganti, *Il Manierismo e Pellegrino
Tibaldi*, Rome, 1945. See also M. L.. Perer, "l'ambiente
attorno a Michelangelo," *Acme*, III, 1950, 1, p. 106-14;
and M. Rosci, "Manierismo e accademismo nel pensiero del
Cinquecento," *Acme*, IX, 1956, 1, p. 78. On Girolamo Muziano:
Ugo da Como, *Girolamo Muziano*, 1528-1592, Bergamo, 1930;

and A. Venturi, Storia, IX, 7, p. 428-61; his relationship
to the Accademia di San Luca is discussed by N. Pevsner,
Academies of Art Past and Present, Cambridge, 1940, p. 57-9.
The attention of Daniele da Volterra to Sebastiano del Piombo
is noted by M. Hirst, "Daniele da Volterra and the Orsini
Chapel--I. The Chronology and the Altarpiece", Burlington
Magazine, CIX, 1967, p. 533-61.

[31]
 On the late school of Perino del Vaga, including
Daniele, see B. F. Davidson ed., Gabinetto disegni e
stampe degli Uffizi, Mostra di Disegni di Pierino del Vaga
e la sua cerchia, Florence, 1966. The recent monograph of
S. H. Levie (Der Maler Daniele da Volterra, Cologne, 1962)
should be used in conjunction with the more recent studies
of M. Hirst ("Daniele da Volterra and the Orsini Chapel",
Burlington Magazine); B. Davidson "Daniele da Volterra and
the Orsini Chapel--II," Burlington Magazine, CIX, 1967,
p. 553-61; and F. Sricchia Santoro, "Daniele da Volterra,"
Paragone, CXIII, 1967, p. 3-34. The study of W. Stechow,
"Daniele da Volterra als Bildhauer," Jahrbuch der preuszischen
Kunstsammlungen, XLIX, 1928, p.82-92 has not been superseded.
On Daniele's work in the Vatican see N. W. Canady, "The
Decoration of the Stanza della Cleopatra", Essays in the
History of Art presented to Rudolf Wittkower, London, 1967,
p. 110-118, with bibliography.

[32]
 The textual basis for the "linea serpentinata" is

provided by G. P. Lomazzo, <u>Trattato</u> <u>della</u> <u>Pittura</u>, <u>Scultura</u>,
<u>ed</u> <u>Architettura</u>, Rome, 1844, I, p. 33-34. For a fuller
discussion of the <u>linea</u> <u>serpentinata</u> see Chapter V below.
A solid foundation for the further study of Marco Pino da
Siena has been given by E. Borea, "Grazia e furia in Marco
Pino," <u>Paragone</u>, CLI, 1962, p. 24-52.

[33]
W. Smith, "Giulio Clovio and the 'maniera di
figure piccole'", <u>Art</u> <u>Bulletin</u>, XLVI, 1964, p. 395-401.

[34]
On Marcello Venusti see J. Wilde, "Cartonetti
by Michelangelo", <u>Burlington</u> <u>Magazine</u>, CI, 1959, p. 370-81.

[35]
Vasari-Milanesi, VI, p. 571-97. Battista Franco's
career has been reviewed in some detail by W. R. Rearick,
"Battista Franco and the Grimani Chapel," <u>Saggi</u> <u>e</u> <u>Memorie</u>
<u>di</u> <u>storia</u> <u>dell'arte</u>, II, Venice, 1959, p. 105-39. A
monograph on Franco promised by Miss Rearick has not
appeared. A painter of considerable historical importance,
Franco has only recently received attention. Vasari des-
cribes his allegory of the Battle of Montemurlo (August
2, 1537) in the following terms: ". . . con bella invenzione
fece Battista una storia della battaglia seguita, mescolata
di poesia a suo capriccio; che fù molto lodata, ancor in
essa si riconoscessino nel fatto d'arme e far dei prigioni
molte cose state tolte di peso dall'opere e disegni del
Buonarrota. . . " The painting is now in the Pitti Palace
in Florence.

36 The nature of Battista Franco's _Libro di
Contrafazioni_ in the Biblioteca Reale in Turin is difficult
to establish. It is unpublished and has not been carefully
studied. In Thieme-Becker, _Kunstler_ _Lexikon_, XIIᵢ, p.362
it is described as drawings after Michelangelo, Raphael, and
the antique, assembled in Rome around 1550. Rearick, "Grimani
Chapel," p. 108, n5, describes it as a collection of early
drawings after the antique. On the classicizing transformation
of Michelangelo's style see F. Antal, "Observations on
Girolamo da Carpi", _Art_ _Bulletin_, XXX, 1948, p. 94-102.
Girolamo da Carpi, near Battista Franco, was also in Rome
at mid-century.

37 J. Bean and F. Stampfle, _Drawings_ _from_ _New
York_ _Collections_, _I_, _The_ _Italian_ _Renaissance_, exhib. cat.
no. 78, listed as a standing male nude, possibly a _St.
Sebastian_ or a _Flagellation_. The drawing is a study for an
engraving of the _Flagellation_ and is a companion to a
drawing at Windsor Castle. See A. E. Popham and J. Wilde,
Italian _Drawings_ _at_ _Windsor_ _Castle_, London, 1949, no. 329.
The engraving is listed by A. Bartsch, _Le_ _Peintre_ _graveur_,
Vienna, 1803-21, XVI, p. 122, 10, as signed by Battista
Franco. No date is given. H. Tietze, _Titian_, _the_ _Paintings
and_ _Drawings_, London, 1950, fig. 319 follows Bartsche in
tracing the composition of Franco's engraving to Titian.
Popham and Wilde convincingly refute this allegation, arguing

from Franco's manifest authorship of the Windsor drawing
and from its fresh mintedness. Tietze reproduces an en-
graving after Franco's engraving by Martino Rota, dated
1568. Bartsch notes in his description of Franco's engraving
that the head of Christ is turned to the left in the print,
which of course would have reversed the drawing in which
Christ faces to the right. The original direction of the
composition in the drawing would have been restored by Rota's
copy. Therefore, assuming that Danti would not have gone
to the trouble to reverse the figure from Franco's engraving
himself (and since Rota's engraving is too late to be con-
sidered as the immediate source of the relief) Danti must
have known Franco's drawing or drawings like it rather than
the engraving for which it was made. The relief is in fact
much closer in feeling to a drawing than to an engraving.

[38]
Cat. I

[39]
A full critical discussion of these drawings is
given by J. Wilde, Italian Drawings in the Department of
Prints and Drawings in the British Museum, Michelangelo and
his Studio, London, 1953, p. 27-9

[40]
These drawings are published and discussed by
P. Barocchi, Michelangelo e la sua scuola, i disegni di
Casa Buonarroti e degli Uffizi, Florence, 1962, tav. CLXXXIX-
CXCIV.

41
Of the Palazzo Spada, one of the chief programs of
the period, little is known and there is no basis for par-
celling out its decoration beyond its present general
attribution to Giulio Mazzoni. Discussion of the date and
architect of the Palazzo Spada and bibliography are pro-
vided by J. Wasserman, "Palazzo Spada," Art Bulletin,
XLIII, 1961, p. 58-63. P. Dreyer, "Giulio Mazzoni as
a Draughtsman," Master Drawings, VI, 1968, p. 21-4 argues
that Wasserman's date for the decorations is too late since
there are del Monte monticule among them. Dreyer also
supposes that all work in the palace was done by Giulio
Mazzoni.

42
The programs of stucco decoration in Rome at the
middle of the century have only begun to be studied and
will probably never be carefully photographed. The Villa
Giulia has been comparatively well studied beginning with
P. Giordano, "Ricerche intorno alla villa di Papa Giulio,"
L'Arte, X, 1907, p. 133-8; J. A. Gere, "The Decoration
of the Villa Giulia," Burlington Magazine, CVII, 1965, p.
199-206; and P. Hoffmann, "Scultori e stuccatori a villa
Giulia. Inediti di Federico Brandani," Commentari,
Gennaio-Marzo, 1967, p. 48-66. A stuccatore named
Girolamo Denti--called Dante Parentino, Dante parentini
fiorentino, Dante fiorentino pittore and Danti scultori
in the documents--active in Rome in the early 1560's, should

not be mistaken for Vincenzo Danti. On Denti see A.

Bertolotti, Artisti Lombardi a Roma, p. 19; J. Ackerman,

Il Cortile del Belvedere, Vatican City, 1954, p. 90-2; and

W. Friedlander, Das Kasino Pius des Vierten, Leipzig,

1912, p. 132.

[43] Giovanni da Udine's stucchi in the Loggia di

Raffaelo are discussed and photographs of them are pro-

vided by N. Dacos, "Il Trastullo di Raffaello," Paragone,

CCIX, 1968, p. 2-29.

[44] Cat. II.

[45] The dating of these drawings to the decade of the

1550's is generally accepted. See J. Wilde, Michelangelo

and his Studio, London, 1953, p. 118; C. de Tolnay, Michel-

angelo, V, p. 77-8; L. Dussler, Die Handzeichnungen des

Michelangelo, Berlin, 1959, p. 105-6. Danti's composition

also distinctly recalls the small painted relief beneath the

statue of Apollo in Raphael's School of Athens.

[46] This popular figure, which is apparently related

to one of Michelangelo's best known drawings, now in the

Casa Buonarroti, was first identified with a figure of

Hercules from a Labors of Hercules sarcophagus of the Lateran

type by J. Wilde, "Eine Studie Michelangelos nach der

Antike," Mitteilungen des Kunsthistorisches Instituts in

Florenz, IV-V, 1932-40, p. 41-64. P. Barocchi, Michelangelo e la sua scuola, p. 12-3 has discounted this identification-- despite the fact that the arms and legs of the figure in the drawing end where they disappear into the marble of an example of the type of sarcophagus in the Villa Ludovisi, which has its on its opposite end a figure similar to the David--in favor or the idea that it is a study from a model, connected with the Cascina Cartoon.

[47]
J. Pope-Hennessy, Italian High Renaissance Sculpture, III, p. 61, discusses this relief in some detail. See also H. Utz, "Pierini da Vinci e Stoldo Lorenzi," Paragone, CCXI, 1967, p. 47-69.

[48]
The source of this space seems clearly to be Roman fresco, a taste paralleling Danti's for antique stucco.

[49]
Vasari-Milanesi, VI, p.128.

[50]
J. Wilde, "An illustration of the Ugolino Episode by Pierini da Vinci," Journal of the Warburg and Courtauld Institutes, XIII, 1951, p. 125-7. The most recent con- sideration of Pierini da Vinci is H. Utz, "Pierino da Vinci," Paragone.

[51]
Vasari-Barocchi, I, p. 88.

52
The large programs of bronze relief which Guglielmo
della Porta envisoned came only to the slightest realization,
and only a few pieces associated with records of them have
come to light. See M. Gibellino-Krascenninikowa, Guglielmo
della Porta, scultore del Papa Paolo III Farnese, Rome, 1944,
for a general treatment of della Porta; more specifically
see U. Middeldorf, "Two Wax reliefs by Guglielmo della
Porta," Art Bulletin,XVII, 1935, p. 90-7; and W. Gramberg,
"Die Hamburger Bronzebüste Paul III Farnese von Guglielmo
della Porta," Festschrift für Erich Meyer zum 60 Geburtstage,
Hamburg, 1959, p. 160-72. Gramberg has also more recently
treated the Ovid plaquettes, "Guglielmo della Porta, Coppe
Fiammingo und Antonio Gentili da Faenza," Jahrbuch der
Hamburger Kunstsammlungen, V, 1960, p. 31-52; and pub-
lished the only record of many of della Porta's conceptions,
Die Dusseldorfer Skizzenbucher des Guglielmo della Porta,
Berlin, 1964. For the fine Desposition relief in the
University of Michigan Museum of Art see Renaissance bronzes
in American Collections, exhib. Smith College, Northampton,
Mass., 1964, no. 24. For bibliography and a brief history
of Guglielmo della Porta's tomb of Paul III see J. Pope-
Hennessy, Italian High Renaissance Sculpture, III, 3, p. 97-8.
A monograph with detailed photographs of the monument has
been published by E. Steinmann, Das Grabmal Pauls III in
St. Peter in Rom, Rome, 1912. A. Venturi, Storia, X, 3,
524-555, also published details of the subsidiary reliefs of
the tomb.

[53] A detailed comparison of the two monuments is given below pp. 29-30

[54] Published by P. Barocchi, Trattati d'arte del Cinquecento, Bari, 1960, I, p. 59-82. The date 1550 for the publication rather than the usual 1549 is in keeping with a correction made by E. H. Ramsden, The Letters of Michelangelo, Stanford, 1963, II, p. 276. On Daniele da Volterra, Bronzino, Giovanni della Casa, the paragone and its relationship to sculptural developments in Florence see J. Holderbaum, "A Bronze by Giovanni Bologna and a Painting by Bronzino," Burlington Magazine, XCVIII, 1956, p. 439-45. The influence of sculpture upon painting in the school of Michelangelo is discussed by S. J. Freedburg, "Observations on the Painting of the Maniera," Art Bulletin, XLVII, 1965, p. 190.

[55] Salviati's momentary involvement in this trend has been recently discussed by M. Hirst, "Salviati's Two Apostles in the Oratorio of S. Giovanni Decollato," Studies in Renaissance and Baroque Art presented to Anthony Blunt, New York, 1967, p. 34-36.

[56] L. von Pastor, History of the Popes, London, 1924, XI, p. 331-2.

[57] See Cat. no. III below. For the history of Perugia

see L. Bonazzi, Storia di Perugia dalle origini al 1860,
Perugia, 1875 and W. Heywood, A History of Perugia,
Cambridge, 1910.

[58] See Appendix I, Document I.

[59] Perugia had been weakened by endless years of
civil strife, and the Guerra del Sale had arisen from the
refusal of the city to pay a papal salt tax. Under heavy
pressure from Rome the Perugians agreed to the payment of
an annual tax of 500 scudi in 1537. (Pastor, History of
the Popes, XI, p. 328,n2) thus 1000 scudi was a very
considerable expenditure.

[60] See Catalogue III, "history".

[61] See Appendix I, Document I.

[62] The type which Danti followed was established by
Pollaiuolo's tomb of Innocent VIII. See L. D. Ettlinger,
"Pollaiuolo's Tomb of Sixtus IV," Journal of the Warburg and
Courtauld Institutes, XVI, 1953, p. 239. The precedents
for Danti's statue in Perugia, Bellano's Paul II of 1467 and
Simone Mosca's Paul III on the Rocca Paolina, c. 1547, are
discussed in Cat. no. III, "history."

[63] L. Pascoli, Vite Perugini, p. 138. ". . .il Magistrato

de'dieci (the Priors of the Guilds) lo richiamò in patria
a gettare in bronzo la statua di Giulio III."

64
 C. G. Bulgari, _Argentieri Gemmari e Orafi d'Italia_,
Parte Prima, Roma, Rome, 1966, II, p. 88. The payments date
February 20, 1551 and September 5, 1552. The payments, from
the _tesoriere pontificio_, are for items of jewelry.

65
 Catalogue III, Document I.

66
 Catalogue III, "history".

67
 Pastor, _History of the Popes_, XIII, p. 48-9.
Danti's portrait of Julius III, who was not often portrayed,
is very similar to the medal of Giovanni Antonio de'Rossi
of 1555. See G. F. Hill and G. Pollard, _Complete
Catalogue of the Samuel H. Kress Collection: Renaissance
Medals_, London, 1967, no. 369a.

68
 The iconographic personality of Julius III has not
been carefully investigated. As a cardinal he presided at
the opening of the Council of Trent in 1545. During his
papacy Christendom weathered the Turkish threat from without,
discord within, and saw the brief restoration of Catholicism
in England in 1554. During the first years Julius III seemed
intent on a policy of reform. (Pastor, _History of the Popes_,
XIII) He is better known, however, for his secular interests

which are symbolized in the Villa Giulia. See J. Coolidge, "The Villa Giulia," Art Bulletin, XXV, 1943, p.177-225. The theme of the relief on the cappuccio of Danti's statue is the Triumph of the Church over Heresy with Four Fathers of the Church, identified by W. Bombe, Thieme-Becker, VIII, p. 385. The heretics are labeled. A legible cast of this relief is illustrated by U. Tarchi, L'Arte del Rinascimento nell'Umbria e nella Sabina, n. p., 1954, tav. CCCXXIV. The small reliefs seem to deal with the sacraments, with Peace and Victory in the cartouches at the sides of the throne. More thorough analysis waits the cleaning of the statue. The only detailed studies of programs finished under Julius III are N. W. Canady, "The Decoration of the Stanza della Cleopatra," Essays in the History of Art Presented to Rudolf Wittkower, London, 1967, p. 110-118 and S. Beguin, "A Lost Fresco of Niccolo dell'Abbate at Bologna in Honor of Julius III," Journal of the Warburg and Courtauld Institutes, XVIII, 1955, p. 114-22. The political significance of the reliefs adorning Guglielmo della Porta's portraits of the previous pope, Paul III, has been studied by W. Gramberg, "Die Hamburger Bronzebüste." No tomb was built for Julius III, although a plan for a tomb pendant to that of della Porta's Paul III is described by Vasari. (Vasari-Barocchi, I, p. 88) It seems never to have been more than an idea in which Michelangelo and Vasari shared. Vasari attributes the collapse of the project--of which Danti must have known, and to which he probably aspired--to the contrariness of Guglielmo della Porta.

[69] Pastor, <u>History</u> <u>of</u> <u>the</u> <u>Popes</u>, XIII, p. 42.

[70] The sources and visual evidence for the <u>Julius II</u> are considered by C. de Tolnay, <u>Michelangelo</u>, I, p. 219-223. See also P. Barocchi, <u>Vita di Michelangelo</u>, II, p. 389-395, for a full critical discussion of the sources. Most recently Nanni di Baccio Bigio's figure of Clement VII done in completion of Bandinelli's tomb in S. Maria sopra Minerva after 1540, has been advanced as a derivation of Michelangelo's <u>Julius II</u>. See R. Wittkower, "Nanni di Baccio Bigio and Michelangelo," <u>Festschrift Ulrich Middeldorf</u>, Berlin, 1968, p. 249. General similarities to Danti's figure suggest that both belong to an identifiable tradition of papal images descending from Michelangelo's statue.

[71] A drawing of the facade of San Petronio before the destruction of the statue has been published by N. Hesse, "Eine Bild-dokument zu Michelangelos 'Julius II' in Bologna," <u>Mitteilungen des Kunsthistorischen Instituts in Florenz</u>, XII, 1966, p. 355-8.

[72] W. Hager, <u>Die Ehrenstatuen der Päpste</u>, Leipzig, 1929, p. 44-5 has noted the similarity in posture of Danti's figure to the prophets of the Sistine Ceiling, and compares the drapery specifically to that of the prophet Joel. Hager does not insist on the comparison, and the influence--if it can be isolated at all--is general and not specific.

[73] Vasari-Milanesi, VII, p.170-171

[74] C. de Tolnay, _Michelangelo_, I, fig. 247.

[75] Vasari-Barocchi, I, p. 34-5. A Condivi, _Vita di Michelangelo Buonarroti_, Florence, 1746, p. 22-3. Vasari's 1568 version derives from Condivi. Neither actually describes the appearance of the statue beyond its fierce gesture.

[76] The decorative details are similar in several respects. Compare, for example, the faun's heads and volutes from the tomb of Paul III (ill. Venturi, _Storia_, X, 3, fig. 448 ; A. E. Brinckmann, _Barock Skulptur_, I, Berlin, 1917, p. 101, fig. 90) to similar details of Danti's _Julius III_ (figs. 6 and 8). The putti on the scroll above the heads on the tomb of Paul III distinctly suggest the putti that both Giovanni Bologna and Danti were doing as fountain figures in the early 1560's. See Cat. X and Chapter III below.

[77] B. F. Davidson, _Perino del Vaga e la sua cerchia_, exhib. cat., _Gabinetto dei Disegni e Stampe degli Uffizi_, Florence, 1966, no. 51. P. Pouncy and J. A. Gere, _Raphael and his Circle_, London, 1962, no. 172, discuss the seven known drawings related to the Uffizi drawing, and cast doubts upon the identification with the designs mentioned by

Vasari. The relationship of Guglielmo della Porta--whose own drawings reach heights of distortion comparable to Danti's reliefs--to Perino del Vaga is discussed by Hager, Die Dusseldorfer Skizzenbucher.

78
Catalogue III, "history"

79
Catalogue

80
Vignola was an experienced bronzecaster from his days at Fontainebleau, when he assisted Primaticcio in casting bronze copies of classical sculpture for Francis I. M. Walcher Casotti, Il Vignola, Trieste, 1960, I, p. 29. This is recorded by Ignazio Danti in his biographical intro-duction to Le due regole della prospettiva di M. Iacopo Barozzi da Vignola, Rome, 1583.

81
Catalogue XXVII

82
Catalogue III, document II

83
Catalogue III, "history".

84
Catalogue LIII . Giulio Danti's execution of this contract adds further evidence ot the argument that his part in the preparation of the model for the Julius III was minimal.

85 Catalogue IV.

86 Pascoli, _Vite Perugini_, p. 137

87 A Bertolotti, _Artisti Lombardi_ _a_ _Roma_, p. 309-10.
This is mentioned in Giulio Danti's letter of August 5, 1557.
"De Vincenzio ne ve ne so dire altro che si è andato a
Firenze a fare certe cose per il duca e penso che stia sano
et de molte volte mentre è stato qui avemo ragionato de li
casi vostri in questi. . .

88 W. Bombe in Thieme-Becker, VIII, p. 385. See
ASP. Archivio Notarile, no. Guerriero di Matteo Guerrieri,
1551-1589, ff. 196v-197r. ". . . Vincentium Julii Dantis
et Optavianum Polidori Ciburrae pictores perusinos. . .ad
iudicandum picturam per ipsum Julium factam in domibus dicti
Baleoni. . ."

89 Catalogue XXVII

CHAPTER II

THE FIRST WORKS IN FLORENCE
THE BRONZE RELIEFS FOR COSIMO I

I moved from where I stood, to scan this limning
More close at hand, and saw another story
Behind the back of Michael whitely gleaming
-----Dante

THE FIRST WORKS IN FLORENCE
THE BRONZE RELIEFS FOR COSIMO I

Introduction:

When Vincenzo Danti arrived in Florence in 1557
the city was firmly under Medici rule and, following the
wars with Siena, was returning to stability under a despot
whose confidence had been greatly magnified by his recent
victories. The last traces of republicanism had been ruth-
lessly stamped out, and the absolute rule of Cosimo I de'
Medici was never again to be seriously challenged. Money
which had been diverted to the wars for many years had begun
to nourish the arts which more than ever before were turned
to dynastic glorification of Cosimo I and the embellishment
of his newly expanded duchy. The extent of Cosimo's con-
trol can be appreciated in the fact that in his sixteen
years in Florence all Danti's works were directly or in-
directly patronized by the Duke. Some were quick to see
the possibilities of this centralization, and by 1557, Giorgio
Vasari had already consolidated his control of painting
in the city. His own typographically productive genius
and the large efficient shop he had established were equal
to any scheme that Duke might devise.

Nothing similar had taken place in sculpture.
Baccio Bandinelli was the leading sculptor in Florence, as
he had always been under the Medici. He was old, however,

and died within three years of Danti's arrival. The heir
apparent to the ducal favor enjoyed by Bandinelli was
Bartolommeo Ammannati, a more versatile artist who was
closely associated with Vasari and was, when Danti arrived,
engaged in large projects both in marble and bronze.[1] But
there was the promise of more sculpture to be done than could
be handled by the sculptors then in Florence. Aside from
Bandinelli and Ammannati, Benvenuto Cellini had done no
major work since the _Perseus_. Niccolò Tribolo, an import-
ant figure in the artistic activity of the early reign of
Cosimo I, and most notably responsible for beginning the
program of the villa at Castello, had died in 1550. His
project remained incomplete, and the vacancy left by his
death had not been satisfactorily filled. These oppor-
tunities attracted other artists than Danti. Daniele da
Volterra came to Florence to stay for several months at
the same time as Danti, and may well have come with him.[2]
About a year before Giovanni Bologna, almost exactly Danti's
age, had stopped in Florence on his return from Rome to
Flanders and never left again.[3]

In short, the circumstances were perfect for a
young sculptor who had already proven his ability in
casting a large and important bronze. Probably Danti had
more than his success to recommend him and was most likely
brought to the attention of the Duke by the Perugian Sforza
Almeni, Cosimo's _camerlengo_ and close advisor. Almeni, who
had done a similar favor for Vasari four years earlier, seems

to have had a special interest in the arts, and continued
to watch over Danti's career in the years that followed.

Danti's first commission in Florence was a bronze
group of Hercules and Antaeus. According to Vasari, it was
to have topped Tribolo's fountain of Hercules at Castello,
Cosimo's favorite villa.[4] Although this is a natural
assumption, since the fountain was being completed at that
time, an earlier source, a note to a sonnet of 1559 written
to Danti by his friend Tomoteo Bottonio,mentions only that
the group was a Hercules and Antaeus and that it was com-
missioned by Duke Cosimo, but does not say where it was to
have gone.[5] The only relevant documents are to be found
in the fabbriche of the Palazzo Vecchio. One of these,
dating June 1558, is the record of a payment for iron wire
"per armare la figura dunò anteo."[6] Similar documents of
October, 1558 record payment for wire "per armare la
figura per sala di bronzo."[7] At the same time there are
no payments to Danti in the fabbriche for Castello,[8]
Whatever its destination, the wax model of Danti's group,
which Vasari described as "bellissimo" must have been ready
to cast by the fall of 1558, since the wire of the documents
would probably have been used for the external armature.
Unfortunately this shadowy commission was a failure. The
group was miscast three times.[9] Danti had missed his chance
and the fountain at Castello was completed in the following
year by Bartolommeo Ammannati. There is no trace of what
Danti's group might have looked like. Ammannati made use

of the model devised by Tribolo, based on the traditional
Florentine composition invented by Pollaiuolo.[10]

The failure of Danti's first Florentine commission
was a serious reversal. It compromised his reputation as
a bronze caster and wiped out the lead which he had in the
essential matter of courting the Duke's favor. What might
have been the second step in a glorious career turned out
to be a disaster which Danti was many years in overcoming.
Vasari used the story of the bronze Hercules and Antaeus to
show how, stalked by misfortune, Danti had triumphed by
turning his hand to marble and successfully completing
the Onore group. For all Vasari's moralizing version is
generally correct, in that Danti did overcome the reversal
of fortune, it is not a clear reflection of the historical
facts, since Danti's finest reliefs were created between
the Hercules and the Onore. After his initial failure
in bronze, Danti modelled and cast the relief of Moses
and the Brazen Serpent which, according to Bottonio, was not
only the vindication of his powers as a sculptor, but a
proper triumph of a Christian over a pagan theme. Judging
from the sonnet which Danti wrote in reply to Bottonio,
he was not consoled by the conceit.[11]

Moses and the Brazen Serpent:

Danti's <u>Moses</u> <u>and</u> <u>the</u> <u>Brazen</u> <u>Serpent</u> must have been
begun early in 1559 since it was commissioned after the
failure of the <u>Hercules</u> <u>and</u> <u>Antaeus</u> and was finished by
November of that year. [12] (fig. 20) The relief was com-
missioned by Cosimo I, but since it went immediately into
the hands of the Duke's chamberlain, Sforza Almeni, its
original destination was probably no longer available by
the time it was completed. [13] The <u>Brazen</u> <u>Serpent</u> was made
together with two marble reliefs, only one of which, a
<u>Flagellation</u> (fig. 26) has survived. The other, a <u>Resurrec-</u>
<u>tion</u>, which went into the Medici guardaroba right after it
was made, has since dropped out of sight. [14] That these
marble reliefs were related to the bronze seems likely
since they were done at the same time and form an icono-
graphic unit with the <u>Brazen</u> <u>Serpent</u>. The small flanking
scenes of the <u>Flagellation</u> and the <u>Resurrection</u>--the marbles
were less than half the height of the bronze--would have
complemented the Brazen Serpent which is a prefiguration
of the crucifixion of Christ. [15] The shape of the bronze
panel, and its association with the marble reliefs suggest
that the <u>Brazen</u> <u>Serpent</u> was to have been the central panel
of an altar antependium, possibly for the Chapel of Leo
X in the Palazzo Vecchio. [16]

The surviving marble relief is considerably less
appealing than the bronze, and its pneumatic forms, tight

detail and pencilled perspective space are in marked contrast to the <u>Brazen</u> <u>Serpent</u> relief. Still, the insistence upon contour and the generalized modelling look directly toward Danti's portrait of Carlo de'Medici of 1565 (fig. 39) and the smooth compression of the torso of the figure on the right promises the figure of <u>Onore</u> of 1561 (fig. 28). The large curving forms recall the early <u>Cleansing</u> <u>of</u> <u>the</u> <u>Temple</u> (fig. 2). The <u>Flagellation</u> also exhibits the typical qualities of foreshortening evident in the Perugia relief and the earlier <u>Flagellation</u>, but combines the forms of the Roman school of Michelangelo with the brutal simplicity and density of Bandinelli's reliefs for the choir of the Duomo in Florence, which seem to have made a deep impression on Danti during his first years in Florence.

Reasonably enough, it was not the marble reliefs but the <u>Brazen</u> <u>Serpent</u> which earned Danti the praise of his contemporaries.[17] Bronze was the medium in which he was most sure and experienced, and it was upon the bronze that he lavished his utmost care and attention. As it was cast the panel is extremely thin and there are numerous holes around the figures. It was perhaps the thinness of the cast, as well as an understandable reluctance to repeat his recent failure, which lead Danti to the precaution of casting the relief in two parts and joining it at the center.[18]

The <u>Brazen</u> <u>Serpent</u> relief was the first major work which Danti completed in Florence, and it was the first of two reliefs made for Cosimo I between 1559 and 1561. Traces

of Danti's training as a goldsmith, so evident in the
details of the statue of Julius III, linger in the Brazen
Serpent and the sportello relief which followed it. Other
than what can be gathered from these two reliefs there is
no indication that Danti pursued his first trade in Florence
until 1567 when he was paid for a silver figure of St.
Andrew.[19] Nevertheless, work on a small, decorative scale
may well have occupied Danti between his more conspicuous
commissions, and the prevalent taste for the miniaturization
of monumental themes exemplified in such works as the
Farnese Casket and the Ovid plaquettes of Guglielmo della
Porta underlies both of the reliefs for Cosimo I.

About five years passed between the modelling of the
reliefs for the statue of Julius III and the Brazen Serpent.
There is no surviving documented work from this period, and
the task of even conjecturally charting Danti's development
during these years is made almost impossible by his native
facility, which allowed him to master quickly any new styles
that he might have encountered. No simple or consistent
development should be looked for, not only because, as Danti
gained experience, one style could snuff out the one previous
to it, but also because, as his early works show, Danti
could move quite happily from manner to manner and back
again. The Deposition relief in Washington (fig. 18) must
belong to the period sometime after Danti's arrival in
Florence.[20] The relationship to the Julius III reliefs is

evident (figs. 16, 19) but the new concern with surface
construction and plastic definition suggests the strong
impact of study in Florence. The relief marked a new
concern with deep psychological expression, generally re-
flecting the painting of the Florentine High Renaissance
and early Mannerism. This in turn necessitated a re-
evaluation of the implications and possibilities of his
earlier relief style.

If it was in fact intended as an antependium, the
Brazen Serpent relief would have been prescribed as a long
rectangle and would have been a difficult problem. Danti
sought to unite the horizontal movement of the interlacing
figures of the front plane--an organization finally based
on battle sarcophagi--with a depth created by an astonish-
ing display of schiacciato relief which, at the same time
that it afforded an illusion of distance also afforded,
with its faceted surfaces, a pictorial unity to the whole
relief. Danti carried the free, sketched execution which
he had explored in parts of the Julius III to a new height
and in so doing achieved a ductile surface altogether diff-
erent from the severely chased surfaces which both Giovanni
Bologna and Cellini favored in their reliefs.

Danti worked in a refined linear style from the
first. His line could be simply decorative, as it often
was in the Julius III, but it also had the potential of
sublimating the sculptural masses which it bounded. Perhaps
study of Donatello's San Lorenzo pulpit reliefs was the

catalyst for Danti's visionary transformation of the
maniera vocabulary in his Brazen Serpent relief. Donatello's
uncanny creation of light through the organization of
unremitting linear disturbance, the radiance hovering over
spatial and textural definition of the forms, knitting them
to the surface and the progression of the drama, must have
made a deep impression upon Danti. He would have discovered
in these reliefs possibilities of the treatment of bronze
surface which he had only casually and unexpressively in-
vestigated in his pre-Florentine reliefs. Nevertheless,
it is evident that Danti translated Donatello's relief
into contemporary means of expression, and the historical
gulf which separates the two artists was not bridged. In
Donatello's pulpits Danti would have found the precedent of
a technically kindred but much deeper spirit, and the
vindication of the extraordinary freedom of his own relief.[21]

If a sculptor in bronze must choose either to exploit
the malleability of the original wax or to work the surface
toward the intransigence of the final bronze, then Danti
made the former choice and Donatello the latter. Both
artists carved forms in wax, and both depended upon line to
define the slight differences in surface which comprise the
mass of their forms in low relief (figs. 21 and 96). The
constant drypoint quality of Donatello's line is the simple
means by which he achieved his control of light. Danti's
line is comparatively fluid and soft and describes more
spatial forms. Perhaps then Danti learned less from

Donatello's bronze reliefs and more from his schiacciato
marble reliefs such as the Or San Michele St. George and
the Dragon. Danti's drawing is extremely various, sensitive
to the subtle yieldings and resistances in the wax itself,
which in some places was dug away, or cut away, or added
and them cut away again (fig. 24). The neutral areas are
all enlivened by the retention and control of accidental
surfaces. The relief still bears Danti's fingerprints, and
the record of its creation was kept, both before and after
casting.

It has been said in the discussion of Danti's
period in Rome that he may well have had experience in the
technique of stucco. A precedent to which such experience
might have led Danti, and to which the tastes of his gener-
ation would surely have disposed him, was antique stucco,
which in many cases exhibited a freedom unknown in Renaissance
relief. (fig. 97) This free style had been re-mastered
by Giovanni da Udine in the Loggia di Raffaello in the
Vatican.[22] Vasari's frescoes in the Chapel of Leo X show
a marked proclivity for the summary light-play of the Roman
"impressionist" frescoes corresponding to these stucchi, and
seem to point to a decorative, "non-classical" influence from
antiquity which may have touched both Vasari and Danti at
the same time, perhaps in collaboration on the same program.[23]

Contact with the painting of early Florentine
Mannerism might have facilitated Danti's transformation of

his relief style. Pontormo died the year that Danti came
to Florence, and his frescoes in San Lorenzo, done up to
his death, were the most powerful continuation of the
style of his generation into the Florence of the *maniera*.
Danti seems to have looked less attentively at these evening
blooms of eccentric genius, however, than at such exper-
imentations with the structure and identity of painted
surface as Rosso Fiorentino's Santa Maria Nuova altarpiece.
The kneeling female figure, seen from behind (fig. 22) to
the left of the pole in the Brazen Serpent relief seems
very likely to have been taken from a similar figure in
Rosso's Marriage of the Virgin in San Lorenzo.

There is also the question of the influence of
Michelangelo's relief. It has been said that Florentine
relief sculpture of the Cinquecento was largely determined
by the fact that Michelangelo did very little relief and
that what he did was not readily available.[24] Nevertheless
Danti must have known at least some of them. His debt to
Michelangelo's early contrafazione of Donatello, the
Madonna of the Stairs, has been pointed out;[25] and he could
have known both the Pitti and Taddei tondi, the unfinished-
ness of which seems largely explainable as an exploration
of visual texture from which Danti might easily have learned
a lesson.[26] It is also possible that he was aware of the
Battle of the Lapiths and Centaurs when the Brazen Serpent
was modelled.[27] If Danti knew Michelangelo's designs for
the reliefs of the bronze canopy for Santa Maria delgi Angeli

in Rome cast by Jacopo del Duca--and some of his figures, such as the two directly below the Brazen Serpent are similar to figures in the <u>Resurrection</u> and <u>Deposition</u> panels--he borrowed only motifs and did not pattern his relief on the spacelessness and compression of masses of Michelangelo's example.[28]

Michelangelo's <u>Brazen Serpent</u> pendentive (fig. 98), one of the last of the Sistine Ceiling frescoes to be painted, is usually singled out as the source for the composition of Danti's relief.[29] There is only a general relationship. If an immediate source for Danti's relief is to be found in the work of Michelangelo at all, it is closer to his later studies on the theme which have been related to the Medici Chapel.[30] Michelangelo's pendentive established the pictorial definition of the theme as a crowded, writhing profusion of human forms, but his <u>Brazen Serpent</u> was virtually forgotten in the only important example of a work of art on the theme in Florence at the time Danti executed his reliefs, Bronzino's cool, statuesque rendition in the Chapel of Eleanora of Toledo in the Palazzo Vecchio. Danti followed both leads when he took up the problem, but for the most part he drew on a completely different pictorial tradition in solving it. The planar interlacing of Danti's forms has almost nothing to do with the spatial continuity of Michelangelo's spiraling figures. It is much nearer such paintings as Giulio Romano's <u>Battle of Constantine and Maxentius</u> in the Sala di Costantino in the Vatican.

The spatial clarity of the weft of figures in Danti's relief, in which all the limbs can be accounted for, suggests a source such as the Vatican paintings or Michelangelo's Battle of the Lapiths and Centaurs rather than direct contact with the senseless packing of the Roman battle sarcophagi which were the final source of all three works. Danti shared the taste which lay behind Vasari's statement that antique sarcophagi were the proper models for relief sculpture, but at the same time he saw the advantage of using the modern version of the style.[31]

The running figure seen from the back on the right hand side of the Brazen Serpent panel (fig. 23) presents a problem which exemplifies the complexity of Danti's position and the consequent difficult in precisely establishing his sources. The closest parallel to Danti's figure is a running soldier in Giulio Romano's Battle of Constantine and Maxentius. This figure, with its far shoulder turned into the plane and its oddly doughy arm seems certainly to have been one of Danti's models. The running soldier derives from a figure which commonly appeared in Amazon sarcophagi, and it is not certain whether Danti was inspired by the antique or by a "restoration" of it. Even his sixteenth-century source is not obvious. As Gombrich has pointed out, reversal of a figure was a frequent means of disguising an artistic debt, or to put it more neutrally, of permitting recognition of a form while avoiding repetition.[32] If Danti's figure is reversed then it comes very near one of

Michelangelo's best-known drawings (fig. 100).[33] This
is supposedly a study done in connection with the Cascina
cartoon, itself a frequently tapped source of motifs for
later painters, and in its turn considerably in the debt
of Roman sarcophagi. Michelangelo's drawing has been
connected with an antique prototype, a sarcophagus of the
Lateran type showing the Labors of Hercules. Danti's
familiarity with Giulio Romano's fresco seems likely, and
his awareness of Michelangelo should probably also be assumed.
His direct study of antique sculpture, despite his taste for
figures with antique sources, is questionable, and he seems
to have preferred to fuse or overlay modern figures of
ancient ancestry.

For all the various kinds and degrees of assimilation,
the Brazen Serpent is a work of great originality, and on
its own terms the relief is an incisive essay in the re-
lationship of form, idea, and material. But the acute
aesthetic awareness, the involved critical reflection
evident in every part of the relief sets it at at distance,
and even flickering surfaces and the shifting forms they
comprise are elements in a whole as cold and studied as a
Bronzino portrait. Danti's active surfaces are not primarily
expressive. They run a gamut between the heightening of
accidental suggestions of form in the wax and almost free
standing relief. Because some forms are barely realized,
all forms are called into question. The flamelike figure
of Moses is no more substantial than the figures around him,

and he takes his authority from the formal saliency of a
plumb vertical axis (fig. 20).[34]

It is the tension between the insubstantiality of
the forms and the compositional, iconographic, and historical
necessities animating and uniting them that gives the Brazen
Serpent its power. The relief is a sustained reflection on
the meaning of the realization of form. By Danti's time
the bozzetto had become the concrete means by which the
conception of a sculpture was formed, and had become an
integral part and extension of the three-dimensional imag-
ination.[35] The bozzetto allowed almost immediate realizia-
tion of the artist's concetto, and could be regarded as a
kind of symbol of the passivity of matter; it was thus
also a symbol of the activity of the artist's imagination.
That unfinishedness--that is, a record of the coming to be
of some form, and a mark of the process through which its
state was changed from indifferent matter to an image--was
a positive aesthetic catagory is evident in the sculpture
of the followers of Michelangelo, including Danti, in
works which there is no reason to believe could not have
been "finished". Danti thought of creation in two ways.
One was the combination of parts of natural forms, the
grottesche, which was immensely popular on a practical
level, and the enthusiasm for which was never spent on a
theoretical level. The other kind of creation was achieved
through the recapitulation of the process by which nature gave

form to the absolute formless, matter. Danti's forms are a meditation on this second creation. They have been plucked from the wax with a concentrated nonchalance that more than sprezzatura, is a kind of ironic disdain. As his hand moved from figure to figure, Danti gave tremulous form to one and held full existence from another; like nature, the creative force which his own activity parallels, he could as easily dissolve the forms as make them (fig. 25).[36]

The same ambivalence that governs the definition of the forms of the relief governs the meanings they carry. In Michelangelo's Brazen Serpent pendentive Moses himself is absent, and only the brazen serpent stands silhouetted against the bright sky behind. In Danti's relief his position and gesture establish the most firmly fixed point in the swarm of other figures. Behind him, his presence marked by a cleft cap, is Aaron (fig. 22). Moses and the pole are the only uninterrupted vertical forms in the relief. The other figures group themselves along large compositional X's and arcs, rising in waves from either side to the pole in the center. The right hand side of the pole is the precise center of the relief.

The two vertical elements, Moses and the pole behind him, stand in a clearly spatial relationship to one another. That is, unlike the other figures, they firmly denote positions in space. In the rest of the relief, the two dimensional arcs which govern the groups in the background can only be understood as intelligible depth with

some difficulty--notice, for example, that the figures form
a fairly regular ring around the brazen serpent. Despite
the fact that the pole does not diminish with respect to
the figure of Moses (which would facilitate the reading
of the space) the points are established, and like two
columns, the forms initiate a progression into depth to
the left. Following this clue, if a line is drawn from the
foot of Moses through the approximate base of the pole around
which the serpent is coiled, the resulting orthogonal leads,
at the deepest point in the virtual space, to a tree at
the bottom of a small valley (fig. 20). Running from
this tree in the direction of Moses and the Brazen Serpent,
looking back over their shoulders, are two small figures.
These are Adam and Eve. Their identities are indicated
not only by the tree but also by the barely sketched angel
to the left who with a menacing gesture seals the gates of
Eden.

 That Danti's use of this device was fully intentional
can hardly be doubted since the orthogonal links the two
most important clusters of meaning in the relief. This
sort of concealment of meaning in clear spatial structure
had precdents in Renaissance painting. Fra Angelico used
a precisely similar scheme in his Cortona Annunciation,
and later examples of Piero della Francesca's Urbino
Flagellation or Raphael's Fire in the Borgo might also be
mentioned.[37] Most comparable to Danti's virtual conceal-
ment of the Expulsion is an engraving of Virgil in the

Basket by Lucas van Leyden (fig. 101). In the foreground
a miscellaneous crowd points and gestures toward the back-
ground where, just to the right of the vanishing point, the
theme can be made out. Danti used a similar device not
simply to play a trick with the convention of one point
perspective, or to comment upon its representational
peculiarities, but to effect a schematic time structure and
to link the two major symbolic events in his relief.

The sixteenth century took evident delight in the
theme of the Brazen Serpent and repeatedly invoked and explor-
ed its symbolism. In the north it was an important and
consistent symbol of the Reformation and appeared in such
significant contexts as the border decoration of the Luther
Bible.[38] In Italy it served as a theme for three of the
greatest painters of the century, Michelangelo, Bronzino,
and Tintoretto. The Brazen Serpent was in many ways a
theme perfectly suited to the tastes of the century. It
was heavily laden with meaning and demanded a broad variety
of form and expression in its visualization which, no doubt
happily for them, provided artists with an opportunity to
give their wits free rein on a dramatic and potentially
morbid subject. It was precisely the complexity and emotion-
al magnitude of the theme which limited its representation
in sculpture.[39] In order to treat it in the prescribed
format, it was necessary for Danti to exercise considerable
ingenuity. He chose to unite the symbolic and dramatic
multivalence of the theme, and his Brazen Serpent is more

than an elaborate composition or a vivid recasting of the brief biblical text. It is a structure of metaphors, references, and parallels which fuses two dimensional, three dimensional amd emblematic organization of meaning.

Once the basic elements have been recognized, the iconographic complexities of Danti's relief can be quickly dealt with, not because they are few or simple, but because an entire book of emblems, published in 1588 by Principio Fabricio, was dedicated to the theme of the serpent and related creatures, real and fanciful. This greatly facilitates the analysis of the relief. The book is a commentary on the arms of Pope Gregory XIII, the principal element of which was a dragon. One of Fabricio's recurring concetti is the Brazen Serpent, which in two hundred and thirty one different emblems is run through what must be nearly every possible variation.[40]

The episode of the Brazen Serpent occurs in Numbers 21:8. The people of Israel, wandering in the wilderness, began to curse God. In retribution a rain of poisonous serpents was sent, and many of the Israelites died. Moses interceded and was instructed by God to make a serpent of bronze, and place it on a pole. This he did, and everyone who looked upon it was saved. Afterwards Moses' serpent had a mixed history. It came to idolized; incense was burned to it, and for this reason it was destroyed by King Hezekiah (2 Kings 18:4).[41] In the Gospel of John (3:14) the Brazen Serpent became the prefiguration of the crucifixion

of Christ, through the logic of a literary parallel that
must have been an especial delight to the sixteenth-century
reader. "And as Moses lifted up the serpent in the Wilder-
ness, even so must the son of God be lifted up." In the
following verse the Brazen Serpent becomes an analogical
promise of salvation. "That whosoever believeth in him
shall not perish, but have eternal life. For God so loved
the world that he gave his only begotten son, that whoso-
ever believeth in him shall not perish, but have ever-
lasting life." The Brazen Serpent is thus a symbol of
redemption behind whose antetypical interpretation stands
the authority of Christ himself.

Danti began his symbolic narrative in the deep
space at the left with the aftermath of the Fall, the ex-
pulsion from the Garden of Eden. The parallel between the
serpent on the pole and the snake in the tree of knowledge
of good and evil had been drawn before. St. Augustine
for example had noted the paradoxical similarity of the
elements implicated in both man's fall and his redemption.
When Fabricio cited this it assumed the tabular form so
dear to the Cinquecento imagination.[42]

	Per
Lignum	
Mulierem	
Serpentum	
	i. per
Pomum	
Evam	
Demonem	
	Homo perierat
	Idem per

```
Lignum
Mulierem
Serpentum
                    i.  per
Crucem
Mariam
Christum
            redemptus est
```

In Fabricio's illustration (fig. 153) Adam and Eve, along
with the tempter in the tree, are shown beside the Brazen
Serpent. Augustine's words are illustrated only if the
viewer supplies the knowledge that Christ and the Brazen
Serpent are equivalent. The same is true of Danti's
relief. The Brazen Serpent was a promise of redemption.
Christ was its fulfillment.

The serpent in the relief is coiled around a short
armed cross. Danti alluded again to Christ in the two figures
to the left of Moses, and old man kneeling and above him
a woman who holds a child up to the Brazen Serpent. These
are also Adam and Eve, and the compositional reference is
to Christ rescuing the first parents from Limbo. Danti's
relief once again corresponds to a pattern later followed
by Fabricio (fig. 102). In the foreground of the engraving
Christ draws Adam from Limbo. Midway back in the landscape
stands the Brazen Serpent. In the far space, following the
same diagonal progression, the Fall is shown.[43]

The spatial progression and the idea of redemption
lead through the theme of Limbo to the most general idea
governing Danti's relief, one of the prevalent notions of
triumph to which Danti seems particularly to have been

drawn--the theme of Truth revealed by Time. As Panofsky
has pointed out, [44] a tapestry on a cartoon by Angelo
Bronzino showing Innocence rescued by Justice, uses the
traditional composition for Christ rescuing souls from
Hell, and combines it with the theme of Truth unveiled
by Time, which was frequently represented in this way. [45]

 Danti's relief follows the organization of Michelangelo's
Brazen Serpent pendentive to the extent that the serpent on
the pole divides each of them roughly in half. On the
right side of Danti's relief all is confusion. On the left
side--which includes Adam and Eve--the Brazen Serpent has
done its work and the people, except for a few beyond
saving, offer thanks. Moses faces the confusion. In the
right hand corner, at the hub of a swirl of forms, an old
man sits, pulling a serpent from his breast; above him to
the left is a youth seen from the side; and to the right
is an infant. This is probably a reference to Laocoon and
his sons who like the Israelites, were set upon by serpents
for defying the will of the gods. The same comparison was
made by Fabricio. [46] Such a reference opens the possibility
that the right hand side of the relief is meant to refer to
antiquity, and therefore to the theologically troublesome
status of the classical world, which existed outside the
possibility of redemption. Following this suggestion, the
fact that many of the figures on this side derive from
classical themes assumes a new meaning. The large over-
turned figure above the Laocoon is similiar to Phaeton figures,

a sarcophagus motif which served as the basis for a series
of drawings by Michelangelo (fig. 103).[47]

Continuing the pattern, the two figures above, one
on the other's shoulders, might then become Aeneas and
Anchises.[48] The running figure seen from the back would
make equal sense as either Hercules or a more anonymous
figure from an Amazonatomachy. All the major figures on
the right hand side of the relief, in short, derive in
one way or another from classical examples. The reference
to Michelangelo's Battle of the Lapiths and Centaurs
(described as the battle of Hercules and the Centaurs by
Vasari)[49] is more indirect but still consistent. The
temptation to conclude that this right side represents the
classical world and the left side the world of the old
dispensation is checked only by the ambiguity of the
figure on the far right. It is probably a direct quotation
of Michelangelo's Haman from the pendentive opposite the
Brazen Serpent on the Sistine Ceiling, although
it may as easily be a reference to the Orestes figures to
which Michelangelo's Haman has been compared.[50]

Danti created an overlay of contexts in which Moses
could also be Plato (fig. 104) or even St. John the Baptist
(fig. 105).[51] The borrowing of form and fusion of formal
resemblances is the product of a fairly widespread habit of
Cinquecento thought, invention based upon the metaphorical
transference of meaning and the synthesis of similar images,
all of which retain their identities. The object of such

a work is to raise the mystery of the equality of identity
and correspondence inherent in the metaphor, a mystery to
which the poetry and poetics of the sixteenth century were
tirelessly devoted. Behind the often repeated idea of the
preeminence of metaphor--which had a long developed history
in Christian thought--also lay the unimpeacheable authority
of Aristotle. ". . . by far the most important thing to
master is metaphor. This is the one thing that cannot be
learnt from anyone else, and it is the mark of great natural
ability, for the ability to use metaphor well implies a
perception of resemblances."[52] The coincidence of several
meanings in one form must have seemed as marvelous as
Augustine's imponderable seeming parallel of God's instru-
ments of sin and redemption. It is understandable in these
circumstances that form should become generic, and therefore
indefinite, since it could contain a number of identities,
all the same by virtue of correspondence, their sameness
symbolized by a single form. Individual form was a means
by which meanings could be brought together, composition a
means by which they could be arranged, space another dimension
of complexity. Forms gathered and contained a variety of
meaning and in so doing became generic rather than ideal.
It would be a mistake to see Danti's quotations as the simple
uncreative identity of ideas with already established forms.
On the contrary, if Danti had invented new forms, rather
than organizing old ones, the recognition of accumulated
and implied meanings which is the necessary condition of

his conceptual organization would not have been possible.

The Sportello Relief for Cosimo I:

Danti's sportello, now in the Museo Nazionale in
Florence, was cast to serve as the door for the safe in
which Duke Cosimo de'Medici kept valuable papers in his
quarters in the Palazzo Vecchio (fig. 27). It was paid
for at the same time as the Brazen Serpent relief, although
it was executed later.[53] The two reliefs are quite different,
no doubt owing largely to the purposes for which they were
intended, and the sportello makes use of a decorative
vocabulary which is understandably lacking in the Brazen
Serpent. Even assuming the greater rigor of the format,
the careful, relatively close finishing of the sportello
relief seems to point toward 1561, when Danti first began
serious work in marble, rather than to 1559 when the Brazen
Serpent was finished.

The sportello is most comparable to another bronze
door, that of the sacristy in San Marco in Venice by
Jacopo Sansovino.[54] It is not likely that Danti had ever
seen Sansovino's sportello, although of course he may have
known of it. There is little stylistic relationship between
the two, and the general arrangement--a large panel sur-
rounded by four cartouches--was a standard decorative-
emblematic scheme, and was used in works of all sizes, from
title pages of books to tapestries and ceiling decorations.[55]

Scale was not a primary concern to the artist of
the mid-Cinquecento, and Giovanni Bologna, for example,
lavished equal care on a small bronze or a large marble
version of the same composition. Like many great works
of art of the period, Danti's sportello is small in scale.
Even so, as much thought has gone into it as any church
facade. So consciously ordered is Danti's relief, in fact,
that a modern viewer might be tempted to dismiss its most
important characteristics as inessential. To do so would
be to fail to see the relief at all. Danti was about
something else, and the strange, tangled poetry of his
sportello for Cosimo I is one of the most lucid and in-
structive documents of the maniera.

As in the Brazen Serpent relief, the surface is kept
alive by incessant variation and formal profusion. This
animation of the surface is more literal in the sportello,
where human forms are almost everywhere. Other natural
forms are excluded and every hint of space is denied. The
negative areas created by the obsessively hard framework
are filled with human figures, merging with decoration,
which in turn is half transformed into monstrous visages.
The corners of both the upper and lower sections of the
relief are taken up with Knorpelwerk masks.[56] Beneath the
shields at the lower corners, for example, volutes form the
cheeks, and a row of rings the mouth and chin of a sleeping fe-
line countenance with wings fastened to its head by a band across
its forehead. Such a combination creates an ambiguity as to

what things really are, felt in the whole relief, the sense
of which emerges only after some perusal. Forms can be
found everywhere, sometimes still half submerged in the
possibility of partial realization. The central panel
contains no fewer than sixteen figures, not including the
infants creeping around behind the river god. Some of these
figures are no more than irregularities in the surface of
the bronze which Danti fixed with a contour and defined as
human images. Their genesis remains clear.

The two extremes in Danti's relief are rigid
schema and forms verging on disintegration in the areas
defined by it. Still, the fragmented activity of the skin
of the relief in these areas is rather uniform in character.
The many highlights are similar in size and shape, and the
anatomical surfaces are one much like another. All this is
organized by Danti's drawing and selective chasing. On
examination the systems of symmetry, reversal, repetition,
rotation, and other formal devices become clear, and the
importance of the emblematic framework becomes more evident.
The rapid, relentless movement of the intersecting rectangles
and cartouches not only complements the surface activity,
but also controls it, creating a rigid hierarchy of areas.
Both movement and definition would originally have been
strengthened by gilding.

The relief has the appearance of being more rational
geometrically than it is. The forms are all unique and
aesthetically determined, without the generality of basic

geometric figures. The central panel, which at first seems
square, is actually a vertical rectangle, corresponding to
the larger, more nearly square rectangle into which it is
locked by the four cartouches at the sides. These cartouches,
which also appear regular, are of different sizes, those
at the sides being longer than those at the top and bottom.
The latter pair reflect the proportions of the shape of the
lower part of the panel, which is very nearly composed of
two tangential circles connected top and bottom.

Typically of Danti, there are abrupt changes from
low to high relief. The virtual mass of the low relief,
continuing the actual volume of the high relief is accomplished
by incised contours around slight modulations in the bronze
surface, creating generalized anatomical structures of
great apparent density. The resulting forms are ponderously
weighty, and at the same time appear to float because of their
general ovoid configuration, which concentrates mass at the
center of the body and minimizes their support. Most of
the figures have almost no feet at all.

Danti's principal means is the manipulation of
light. It is never allowed to pass freely over a broad
area, but is constantly drawn into rectilinear highlights,
as if the tense surface were cut and peeling, like strap-
work. The relationship of light and articulating form to
surface has a precise parallel in Vasari's contemporary
wall surfaces of the Uffizi. The slivering and constant
disturbance of the surface which Danti used in the <u>Brazen</u>

Serpent relief as the means for an unparalleled exercise
in aerial perspective in bronze is here used in strict
relationship to the surface, setting every plane of light
immediately before the impenetrable bronze background.

There are pronounced juxtapositions of scale. The
smaller size of the ignudi with shields in the corners of
the main rectangle can be explained by their being subsidiary
decorative figures. Even these differ in size, however.
The figures at the bottom corners--which are considerably
smaller--are cramped at right angles to the framing; those
at the top are allowed to stretch out along the oblique
axes. While the lower figures shrink into their ill-defined
and waxy surroundings, those at the top are carefully chased
and defined. In the lower section of the relief, where con-
sistent scale might be expected to follow thematic unity,
the figure of Peace is small in comparison to the titanic
slaves bound at her sides. This constant shifting of scale
denies any empathetic value which the figures might have
in themselves, and they are pushed toward symbol, and toward
positions in Danti's essentially emblematic order.

Before considering the meaning of Danti's relief, a
few of his formal habits should be pointed out, since they
are intimately connected with the organization of the meaning.
Not only has he given his relief an extremely sturdy skeleton,
but he has insisted on every axis created by it. This is
particularly true of the main panel, where horizontal, ver-
tical, and diagonal axes are strongly emphasized by the

elements of its frame. It is less true of the secondary
lower section of the relief, where the horizontal axis
is somewhat circumlocuitously stated by the contrast between
the protrusion of the legs of the figure of Peace and the
low relief midsections of the doubled up prisoners on either
side of her. The central vertical axis, shared by the rest
of the relief, locates the figure of Peace and is much stronger.
Danti made use of other purely formal relationships, for
instance, the reversal of the reclining figures--based on
Ghiberti's Adam and Eve from the east doors of the Baptistry--
in the horizontal cartouches. The number of obtuse angles
serving as the basis for figures or parts of figures is
extraordinary, and in fact only the lower part of the relief
escaped the formula. This might become monotonous, but it
does not, and it is instructive to see why not. Danti's
forms differ only slightly. The arm of the emperor, the
arm of the old man to the left, and of the nude youth at
the right are all similar. The arms of the two side figures
are reversals of one another, and the general shape is in-
verted in the leg of the river god below, which in turn is
a reversal of the leg of the right hand figure, and so on.
It is clear that Danti's primary concern is not forms but
their relationships, and since the emphasis is upon relation-
ships, and visual interest is not a function of variety among
individual forms, the forms themselves can be much alike.

That Danti was a conscious master of this game,
halfway between logic and decoration, can be deduced from

the ignudi at the corners. There are only two different
sets of figures, one above and one below. Again Danti
has created visual variety by playing the rules of his
schema, this time with paradigmatic purity. The pair of
figures in the lower right hand corner, if moved to the
left through ninety degrees, produces the lower left hand
pair. This can also be done with the ignudi at the top.
What appears to be slight variation of generally similar
figures, then, becomes a system of combinations whose rules
are at once apparent and which, most significantly, are
made possible by the general schema. It is important to
bear this in mind, because Danti treats meaning in the
same way, as we shall see. Discrete terms are used in
quasi-logical structures, and poetic reverberations of a
stated theme are as strictly controlled as the formal
variations of the figures just discussed.[57]

The theme of Danti's relief has so far eluded
detection. Gaetano Milanesi observed that the central
figure in the main panel was a Roman emperor, and Walter
Bombe suggested that the scene represented was Trajan
buring the tax rolls.[58] However, this hypothesis accounts
neither for the figures in the central scene nor for the
allegorical figures surrounding it. Milanesi was correct
in identifying the principal figure as a Roman ruler, but
as we shall see shortly, the ruler is not Trajan but
Augustus and, as might be expected from its original loca-
tion in his quarters, the relief is an elaborate glorification

of Cosimo I de'Medici.

A clue to the interpretation of the scene is pro-
vided by a fresco in the Biblioteca Vaticana, which has
been attributed to both Paris Nogari and to Giovanni
Baglione.[59] It was painted around 1589. The fresco
(fig. 106) is an illustration of Tarquinius Superbus buying
the three sybilline books. The king is shown seated before
a fire in which several books blaze and into which several
more seem soon to be thrown by one of the women at the right.
At the left, together with a soldier, stands a scoffing
swain in contemporary dress, presumably to show the former
attitude of Tarquinius, whose scepticism has resulted in
the irremediable loss of the books of prophecy. The king
himself is shown at the moment of decision, just responding
to the expostulations of the worried augur at his side.

In Danti's relief the emperor--generally similar
to Tarquinius but with a baton in one hand and a small
volume in the other-- is surrounded by ten men, some of
them so sketchily modelled as to be almost invisible, plus
four soldiers and a river god. There are no sibyls in the
central scene. Also, the figure in the right foreground,
about to drop an armload to books in the flames is a male
nude and not the prophetess of the fresco. The sibylline
books are evidently still the theme since most of the
same actors are present, but the episode is the burning
of the spurious books of prophecy, and the ruler therefore
not Tarquinius but Augustus. The ten men surrounding him

are the Decemviri, the keepers of the sibylline books.
The relevant text, from Suetonius' Lives of the Caesars,
is the following: "After he finally assumed the office
of pontifex maximus. . . he collected whatever prophetic
writings of Greek and Latin origin were in circulation
anonymously or under the names of authors of little
repute, and burned more than two thousand of them, re-
taining only the Sibylline books and making a choice even
among those; and he deposited them in two gilded cases
under the pedestal of the Palatine Apollo."[60]

In order to understand the rest of the relief it
is necessary to make clear at the beginning that Danti's
organization is emblematic rather than narrative. Appear-
ances are determined by associational value, by their
relationship to the governing concetto, and not by the
exigencies of illustrating any particular episode. Accord-
ingly, Danti selected elements from Suetonius' life of
Augustus as need required.

The explanation of the soldiers and the river god
provides a clearer illustration of Danti's procedure, and
leads to the heart of the concetto. After the battle of
Actium, Augustus made a province of Egypt and, in order to
make the land more productive, set his soldiers to work
improving the canals of the Nile.[61] This perhaps excuses
the presence of the soldiers, who are otherwise unexplain-
ably martial in the generally scholarly company. As for
the river god, Danti has encouraged a generic reading by

placing the cornucopia on his far side, nearly out of
sight.[62] With Romulus and Remus at his back, the figure
is evidently an allegory of the Tiber, and not only locates
the action, but refers to the capitol of the dominion of
Augustus. It would be consistent with the interpretation
of the soldiers if, as they might, the children were also
intended to suggest the Nile. Carrying this sort of associa-
tion further, the two children could suggest the city of
Siena whose ancient symbol, like Rome's, was the she-wolf
and twins. The river might also suggest the Arno, and there-
fore Florence. The four possible interpretations of the
river god, then, as referring to Florence, Rome, Siena,
and Egypt permit the following parallels: Florence to
Augustan Rome, and the recently conquered republic of Siena
to the province of Egypt. Then, of course, Cosimo I de'
Medici would have been compared to the Emperor Augustus.

This parallel was frequently and much more directly
made. Without going outside the quarters of Cosimo I, for
which the sportello was made, one could have found a fresco
of the battle of Actium. The fresco no longer survives,
but the program does, and Vincenzo Borghini, who drew it
up, informs us that it was intended to refer to Cosimo's
victory at Montemurlo.[63] Likening Cosimo I to Augustus
seems to have been a standard courtly ploy, and it was carried
to considerable lengths. Cosimo's favored device was the
capricorn, the astrological sign under which he was born.
It was also the sign under which Augustus was born.[64] When

Ruscelli commented on this device in his _Imprese Illustri_,
he extended the coincidence, asserting that the battles
of Actium and Montemurlo had occurred on the same day,
and that the two leaders had been exactly the same age.[65]

The parallel between Cosimo I and Augustus was more
than a literary device, however, and was one of the standard
forms taken by Medici apologetics. The sibylline prophecy
that the Parthians could only be conquered by a king, which
nearly lead to the crowning of Julius Caesar but because of
its threat to the republic resulted instead in his assassin-
ation, was finally fulfilled by Augustus.[66] The similarity
between this and the circumstances leading to Cosimo's rise
to power following the assassination of Alessandro de'Medici,
the first Duke of Florence, and the defeat of his republican
enemies, was too exact to be overlooked. The soldiers
among the scholars in the relief are no doubt intended to
signify that Cosimo had beaten his swords into plowshares,
and like Augustus in Egypt, had turned his military power
to peaceful ends, to the rebuilding of a city which he had
mercilessly crushed. This is clearly the import of the
lower register of the relief. The figure of _Peace_, similar
to Salviati's _Allegory of Peace_ in the Palazzo Vecchio, seated
on a throne displaying scenes of reconciliation, is a ref-
erence to Augustan peace and the reconciliation of Florence
and Siena.[67] But the presence of the soldiers is also a
justification of an absolutist state. In a book entitled
Il Ritratto del vero governo del principe dall'essempio vivo

del Gran Cosimo de'Medici, published in 1552, Cosimo is described as having been chosen monarch by Divine Providence, and a kind of paragone is staged between arms and letters.[68] Arguing against the accusation that arms destroy the golden age, Rosello concludes that "in both peace and war arms are more worthy than letters. . . both work to the end of conserving the public good, but arms contribute to it as an emperor, and letters as a counselor."[69] If Cosimo's realm was small, and his power borrowed, this was more than compensated for by the excesses of such justification.

The Emperor Augustus was considered to be the son of Apollo.[70] It will be remembered that he placed the sibylline books in the temple of the Palatine Apollo, which he had built.[71] Augustus had also enlarged the temple of Apollo at Actium after his victory there. That Cosimo I also identified himself with Apollo has been pointed out, but the central connection with Augustus has not. Around 1559, about two years before Danti's relief was cast, a medal of Cosimo I was struck by Domenico Poggini. On the reverse is Apollo, with a lyre and an empty quiver, placing a crown on a capricorn, victorious over the python.[72] In Danti's relief the stage is set for the appearance of Apollo by the theme of the sibylline books and the consequent reference to the sibyls, the priestesses of Apollo.[73] The potential is made actual by the two figures in the vertical cartouches at either side of the central panel. The figure

to the right is Minerva, with a serpent symbolizing
prudence, and a book symbolizing her dominion over the
arts and sciences. Opposite her, on the left is Diana, who
appears to be holding a long-handled amphora. This probably
refers to Diana under the form of the Egyptian goddess Isis,
following Cartari.[74]

Assuming that Augustus is Apollo, the level of mean-
ing has shifted from historical parallel to allegory. How
then are the figures of Minerva and Diana to be related to
the central scene? Minerva appears as the personification
of prudence and patroness of the sciences, and thus re-
flects a common interpretation of Apollo. Diana is his
sister. Since she is the moon, he is the sun, as well as
the patron god of the arts, as we are reminded by the
presence of Minerva. However flattering this may have
been to Cosimo I, the three divinities can be united on
yet another level which introduces another facet of Cosimo's
allegorical personality. Apollo, Diana, and Minerva appear
together in the story of the dispute between Apollo and
Hercules for the tripod. Hercules, as the story is re-
counted by Cartari, had gone to the oracle--the priestess
of Apollo--and when she refused to answer him to his sat-
isfaction, made off with the tripod.[75] This was an affront
to Apollo. A major confrontation was averted by Minerva,
who cooled the wrath of Hercules. Apollo was calmed by
his mother and sister, Latona and Diana,"una Dea vergine &
piacevole."[76] Danti has reduced the story to its emblematic

essentials: Diana is present as the companion of Hercules. Latona, an ill defined character, has been ommitted. Her absence is minor, however, in comparison to the absence of Hercules. This puzzling absence can be explained if the central figure of the relief is both Apollo and Hercules. The structure thus becomes one of paired oppositions. The opposition intended is probably nature-civilization, as Diana-Apollo, which is repeated in the opposition Hercules-Minerva. Thus one term of each pair overlaps visually and Augustus is defined as Hercules and Apollo by his position midway between Minerva and Diana. Danti has thus established an ingenius set of shifting oppositions, and indeed the pleasure of seeing the relief, for someone who knew his ancient history and Cartari well, must have consisted largely in watching the artful manipulation of the strict rules Danti had set himself. The elements play through a series of permutations comparable to the formal permutations of the small figures at the corners of the panel described previously. Since Diana and Minerva counteract the opposing elements in the emperor, they become opposites. And since they are opposites, they represent the original forces they counteracted. That is, Diana becomes Hercules and Minerva becomes Apollo. The concetto comes to rest when the two goddesses have become straightfoward allegories of the warring aspects of the imperial nature.[77]

The tripod was a sign of honor, esteem, heroic virtue and truth.[78] The struggle was between a god and a hero.

We have already seen that Cosimo was allegorized as Apollo.
He also had a medal struck in which he appeared as Hercules,
and in so doing preempted a traditional Florentine symbol
as well as a time-honored symbol of imperial power.[79] The
struggle of primordial forces united in the person of the
ruler was a standard form of allegorization. The restraint
of vicious wrath was an especially common theme. Since the
ruler could always relax his restraint and unleash his
wrath he was to be feared. Fury was the essence of the
ruler, which was tempered by reason and law, just as arms
were the emperor and letters, the councilor. As Meller has
demonstrated, Cellini's well-known bust of Cosimo I in
the Bargello shows the Duke with the skins of two lions,
one small and one large. This is a reference to Hercules.
The lions represent fury and wrath, the idea being that
Hercules, having overcome both, donned their skins, and
that he bore the lion's image to symbolize the defiance of
vice by leonine ferocity.[80] Four years after the sportello
relief Danti himself made use of a similar formula for his
marble group of Equity and Rigor on the testata of the
Uffizi. Rigor, "uomo rigido, e spaventevole" represented
the fierce inevitability of the law; Equity was its more
reasonable side, discretion and mercy. The two were united
in Cosimo I, who as a matter of fact was the law and who
at least allegorically was both rigorous and just.[81]

Danti's image of Cosimo I, for all its ingenuity,
is not an appealing one. Cosimo is shown as absolute ruler,

patron, and censor, as indeed he was. The reference to
Apollo is afforded a final dimension by the structure of
Danti's relief. Cosimo-Apollo is seated at the intersection
of the axes. He may thus be seen as seated on the omphalos,
the center of the world. Cartari writes of Apollo that he
sits at the center of the Muses, that he is the sun and
source of light.[82] Thus in an emblematic identification
of cosmic and political order frequently made in the
Cinquecento, Cosimo becomes the source of light and power,
his <u>virtu</u> penetrating the world like the rays of the sun.
This image of hierarchy and rigid order is as emblematic
of the end of the Renaissance as Vitruvian man was of its
apex. Form is now inflexible and at the same time particular,
unlike the earlier ideal of the square and the circle. The
transcendent democracy of Vitruvian man, providing the
measure of perfection, has given way to political helio-
centrism. The human form remains, meaningful in a world
abstract but no longer ideal. The great Renaissance image
of order remains in related form and essentially lost
meaning.

Notes to Chapter II:

1
Ammannati was at work on a large wall fountain for
the Salone dei Cinquecento which was never realized and is
now scattered, in all its various parts, in the Boboli
Gardens and in Museo Nazionale. The fountain was re-
constructed by F. Kriegbaum, "Ein verschollenes Brunnen-
werk des Bartolommeo Ammannati," Mitteilungen des Kunst-
historischen Instituts in Florenz, III, 1919-32, p. 71-103.

2
Danti left Perugia between May and August, 1557.
(see Chapter I, note 87) The date of Daniele's stay in
Florence is anchored by the date of the burial of his
garzone Orazio Piatesi of whom Daniele carved a bust now
in San Gaetano in Florence. This was on July 14, 1557.
See W. Stechow, "Daniele da Volterra als Bildhauer,"
Jahrbuch der Preuszischen Kunstsammlungen, XLIX, 1928, p.
85. Vasari (Vasari-Milanesi, VII, p. 63) wrote that
"quando a principio venne da Roma a Fiorenza. . .non fu
sì tosto arrivato a Fiorenza che si morì."

3
On the early years of Giovanni Bologna's career in
Florence see W. Gramberg, Giovanni Bologna: eine Untersuch-
ung über die Werke seiner Wanderjahre, bis 1567, Libau, 1936.

4
Vasari-Milanesi, VII, p. 631.

[5] Catalogue VI, "Date".

[6] ASF. Mediceo, _Fabbriche_, 1556-58, f. 140r, June 1558.

[7] ASF. Mediceo, _Fabbriche_, "Copia di lustre e conti del Palaco Ducale," 1558-1560, f. 132r.

[8] Payments for materials to Bartolommeo Ammannati begin December 20, 1559 and end February 17, 1560. See B. H. Wiles, _The Fountains of the Florentine Sculptors and their Followers from Donatello to Bernini_, Cambridge, 1933, p. 24n.

[9] Danti seems to have made the final model too thin ". . . ma fatta la forma addosso al detto modello" Vasari-Milanesi, VII, p. 631. See also Catalogue VI, "Date."

[10] The history of the fountain is most recently recounted by J. Pope-Hennessy, _High Renaissance Sculpture_, III, p. 59-60.

[11] Bottonio's sonnet is dated November 15, 1599. Both his sonnet and Danti's are published by J. von Schlosser, "Aus der Bildnerwerkstatt", p. 73 The sonnets are the same in manuscript, PBA, man. G. 73. The introduction to Bottonio's sonnet is in Cat. VI, "date".

Se la profana Erculea imago, e l'forte

Valor, ch'Anteo si fieramente strinse

Non secondo il desio la mano effinte

E gran sudor n'ando in poch'ore, e corte;

Colpa vostra non fu; ma bella sorte

Di voi, ch'il fuoco ogni sua fiamma estinse

E'l liquido metallo allor ristrinse

Per non formar di favolosa morte

Or poi ch' al sagro, e al ver, l'arte, e l'ingegno

Volgete, e a più bell'opre, il puro e bianco

Marmo, e l'eneo liquor v'alza alle stelle.

Sequite dunque si onorato, e degno

Pensier, di che invidiar vi potranno anco

Zeusi, Fidia, Miron, Timante, Apelle.

For Danti's reply see Appendix

12
 Catalogue VI, "Date".

13
 Catalogue VI, Document I

14
 Catalogue VII

15
 Timoteo Bottonio (see Catalogue no. VI) wrote that
Danti did two marble reliefs at the same time as the bronze
relief. Had the antependium been assembled, the sequence
would have been left to right, <u>Flagellation</u>, Crucifixion,

Resurrection, assuming that the Brazen Serpent was equi-
valent to the crucified Christ. The Resurrection is a
common companion theme to the Brazen Serpent. A Brazen
Serpent surrounded by a complete passion cycle, including
a Flagellation, is the theme of a late sixteenth-century
North Italian plaque published by G. Mariacher, Argenti
Italiani, Milan, 1965, tav. 17. For the iconography of
Danti's relief see below pp. 79-88

16
Catalogue VI, "Discussion".

17
Vasari describes Danti as the equal of any artist
in Florence in low relief: ". . .in questa maniera di
sculture per avventura non inferiore a qualunque altro."
Vasari-Milanesi, VII, p. 631.

18
Catalogue VI, "Discussion".

19
Catalogue

20
Catalogue V.

21
Donatello's horizontal movement of Christ through
Limbo culminating in the Resurrection in the San Lorenzo
pulpits parallels the construction of the left side of
Danti's relief, which culminates in Adam and Eve and refers
to Limbo. On Donatello's influence in the Cinquecento, see

I. Lavin, "Observations on Medievalism in Early Cinquecento Style," Gazette des Beaux Arts, L, 1957, pp. 113-8; U. Middeldorf, "An erroneous Donatello Attribution," Burlington Magazine, LIV, 1929, p. 184-88; and "A Bandinelli Relief," Burlington Magazine, LVII, 1930, p. 65-71; and M. G. Ciardi Dupré, "Alcuni aspetti della tarda attività grafica del Bandinelli," Antichità Viva, V, no. 1, 1966, p. 22-31. Bandinelli's concern with Donatello is placed in the context of his academic classicism by L. Marcucci, "Disegni del Bandinelli per la Strage degli Innocenti," Rivista d'Arte, XXIX, 1954, p. 97-114.

22
 Chapter I, n. 43 above.

23
 P. Barocchi, Vasari Pittore, Milan, 1964, p. 136.

24
 J. Pope-Hennessy, High Renaissance Sculpture, I, p. 64.

25
 C. Eisler, "The Madonna of the Steps. Problems of Date and Style," Stil und Überlieferung in der Kunst des Abendlandes. Akten des 21. Internationalen Konresses für Kunstgeschichte, Berlin, 1967, II, p. 115-120. Eisler (p. 116) directly relates the Santa Croce Madonna and the Prato Madonna to the Madonna of the Steps, and after arguing that Danti cannot have forged the relief because no forger could have the gall to imitate his own forgeries, concludes

"All in all the revival of the relief style of the <u>Madonna</u> <u>of</u> <u>the</u> <u>Steps</u> in other works by Danti, not shown here, and its figures in the round in the Carlo de'Medici tomb and Baroncelli Chapel may perhaps best be taken as the relief's certificate of authenticity by emulation." It is not apparent to me what the other reliefs mentioned might be, and, as we shall see, Danti's relationship to Michelangelo is much more complex than Eisler would represent it. The point that Danti may have known Michelangelo's relief, and that Danti worked in earlier styles is well taken, although there is no reason to conclude from this that the <u>Madonna</u> <u>of</u> <u>the</u> <u>Stairs</u> had an importance in Danti's style as major as that proposed by Eisler.

26
 R. Lightbrown, "Michelangelo's Great Tondo: Its Origins and Setting", <u>Apollo</u>, LXXXIX, 1969, p. 22-31. The Pitti Tondo was in the possession of Fra Miniato Pitti, a close friend of Ignazio Danti and Vasari (Lightbrown, n. 17). A word should be said here about "unfinishedness." The question of Michelangelo's intentions aside for the moment, it is clear from later events that the numerous <u>abozzato</u> figures which Michelangelo left were a problem with which his followers felt the need to grapple. It is not necessarily true that had there been world enough and time the Taddei Tondo would resemble Rustici's <u>Madonna</u> <u>and</u> <u>Child</u> <u>with</u> <u>St.</u> <u>John</u> as Lightbrown argues. Even Rustici felt obliged to transform the background of his relief into its present

stippled stylization in imitation of Michelangelo's infinitely
more various and effective textures. This suggests that
Rustici (whose relief is the statement closest to Michelan-
gelo's) recognized the surfaces as intentional, and the
"unfinishedness" as in some degree desirable.

27
The figure pressing into the plane to the right
of Moses may be a reversal of a similar figure in Michel-
angelo's relief. Since the figure is of a common type, however,
this is difficult to demonstrate conclusively.

28
These reliefs are published in Venturi, Storia,
X, 2, p. 161-177, esp. fig. 152; see also C. de Tolnay,
"Minor Works", in The Complete Works of Michelangelo, II,
London, 1966, p. 500-1 with bibliography.

29
J..Pope-Hennessey, Italian High Renaissance Sculpture,
I, p. 69.

30
Recorded in a drawing in the Ashmolean Museum. See
K. T. Parker, Catalogue of the Collection of Drawings in
the Ashmolean Museum, the Italian Schools, Oxford, 1956,
no. 318. If Parker is correct in his estimation of the
magnitude of the composition for which the drawings were
intended, it would have been a major precedent for Danti's
relief, at some distance, in conception as well as in time,
from the Sistine pendentive. Related drawings (not copies)

in Dusseldorf are reproduced by L. Dussler, _Die Zeichnungen_
des Michelangelo, Berlin, 1959, no. 393 and 394. Dussler
relates the drawings to a Roman follower of Michelangelo.
These drawings, which emphasize the interlacing of forms
rather than spiral movement, are nearest Danti's relief.

31
 Vasari-Milanesi, I, p. 156. Donatello and antiquity
are the two models mentioned; see also L. S. Maclehose,
Vasari on Technique, New York, 1960, p. 155.

32
 E. H. Gombrich, "The Style _all'antica_: Imitation
and Assimilation," in _Norm and Form_, London, 1966, p. 124.

33
 Chapter I, note 46.

34
 Danti's reservation of a privileged formal situation
(the only strict vertical which is allowed visibly to govern
the attitude of the figure) is an instance of a kind of
compositional procedure which was common in sixteenth century
Italian art and awaits further descriptive definition. It
was used, for example, in Bronzino's _Crossing of the Red_
Sea in the Chapel of Eleonora of Toledo. There a man
facing left stands on the vertical axis dividing the pic-
ture, and Moses' gesture to the left, which is dramatically
central, is the strongest of the two or three horizontals.
This kind of organization should be added to the antique
sarcophagus based formalism described by C. H. Smyth,

"Mannerism and Maniera," <u>Studies in Western Art</u>. <u>Acts of</u> <u>the Twentieth International Congress of the History of Art</u>. II. <u>The Renaissance and Mannerism</u>, Princeton, 1963, p. 174-199.

[35] Irving Lavin, "Bozzetti and Modelli: Notes on Sculptural procedure from the Early Renaissance through Bernini," <u>Stil und Überlieferung in der Kunst des Absendlandes</u>. <u>Akten des 21 Internationalen Kongresses für Kunstgeschichte</u>, Berlin, 1967, III, p. 93-103. The role of the <u>bozzetto</u> is succinctly stated by Cellini (<u>I Trattati dell' oreficieria e della scultura</u>, ed. L. de-Mauri, Milan, 1927, p. 271-2) ". . . dicono, che volendo fare un'opera di scultura, alli scultori essere di necessità il farla prima in disegno. . . rispondono gli scultori, che quando e' voglion fare, pigliano, per esprimere il loro concetti, terra o cera, e con quella più facilmente e con più brevità si purgano della difficultà della vedute sopradette."

[36] J. Bialostocki, "The Renaissance Concept of Nature and Antiquity," <u>Studies in Western Art</u>, <u>Acts of the Twentieth International Congress of the History of Art</u>, Princeton, 1963, II, p. 19-30. The grotesque was a pure form of art. Of many such statements see Sir Philip Sidney;s "An Apology for Poetry," c. 1583, in Gregory Smith, <u>Elizabethan Critical Essays</u>, London, 1964, I, p. 155-6. "There is no Arte delivered to mankinde that hath not the works of Nature for

his principall object, without which they could not consist.
. . .Only the poet, disdayning to be tied to such subjection,
lifted up with the vigor of his owne invention, dooth growe
in effect another nature, in making things either better
than Nature bringeth forth, or quite a newe, formes such
as never were in Nature, as the Heroes, Demigods, Cyclops,
Chimeras, Furies, and such like: so as he goeth hand in
hand with Nature, not enclosed within the narrow warrant of
her gifts, but freely ranging only within the Zodiack of his
owne wit." Danti's own treatise, consistent with Bialostocki's
characterization of Cinquecento theory as concerned with
natura naturans, is a constant play between the implementation
of the intentions of the artist and the activities of Nature.

[37] The relationship of dramatic space and time to
perspective construction is discussed by K. Badt, "Raphael's
'Incendio del Borgo'", Journal of the Warburg and Courtauld
Institutes, XXI, 1959, p. 35-59.

[38] A fairly detailed visual and exegetical history
of the theme of the Brazen Serpent is provided by Usala
Diehl and Ruth Matthaes, "Ehrne Schlange," Reallexikon
zur Deutschen Kunstgeschichte, IV, p. 818-37; and a host
of representations of the subject is listed by A. Pigler,
Barockthemen, Budapest, 1956, I, p. 104-6. On the Brazen
Serpent and the Reformation see D. L. Ehresmann, "The
Brazen Serpent, a Reformation motif in the works of Lucas

Cranach the Elder and his Workshop," Marsyas, XIII, 1966-7, p. 32-47. Also C. Dodgson, "Holbein's Early Illustrations to the Old Testament," Burlington Magazine, LV, 1929, p. 176-181.

[39] The alabaster relief for the trascoro of the Valencia Cathedral (1418-25) by Giuliano Fiorentino, a follower of Ghiberti (R. Krautheimer, Ghiberti, Princeton, 1956, p. 118, n10) is to my knowledge the only treatment of the theme not in bronze in fifteenth and sixteenth-century sculpture. The relief is illustrated by A. L. Mayer, "Giuliano Fiorentino," Bolletino d'Arte, VII, 1922-3, p. 343; in bronze, the theme was treated by Bartolommeo Bellano, San Antonio, Padua after 1480. Late in the sixteenth century, around 1590, a Brazen Serpent was cast by Antonio Calcagni for the bronze doors of the Basilica at Loreto. (Venturi, Storia, X, 2, p. 731). The most important interpretation of the theme in Renaissance sculpture is the small polychrome wood relief on the archbishop's throne in the Cathedral of Toledo by Alonso Berruguete, carved sometime after 1529. Although Berruguete's composition is more concentrated and intense than Danti's, it is closest of all to Danti's Brazen Serpent, perhaps owing to common involvement in the formal language of early Florentine Mannerism.

[40] P. Fabrici, Delle Alluszioni, Imprese, et Emblemi

sopra la vita, opere, et attioni di Gregorio XIII Pontefice
massimo Libri VI. Nei quali sotto l'allegoria del Drago,
Arme del detto Pontefice, si descrive anco la vera forma
d'un Principe Christiano, & altre cose. . . Rome, 1588. Many
parts of the book are dated 1582.

41
Presenting itself as a survivor of Hezekiah's zeal
is a bronze serpent in S. Ambrogio in Milan. With a sure
eastern provenance prior to its appearance in Milan in 1001,
it was first rejected as a copy of Moses' original in 1675.
It has also been associated with Aesculepius. See M. di
Giovanni, "Il Serpente di bronzo della Basilica di S. Ambrogio,"
Arte Lombarda, XI, 1966, p. 3-5.

42
Fabricio's table is a schematic digest of
Augustine's Sermon CCXCIV. Cap. X (J. P. Migne, Patro-
logia Latina, XXXVIII, 1341-8); P. Fabrici, Delle
Allusioni, p. 212. The Brazen Serpent was also juxtaposed
to the Crucifixion in facing pages of Giulio Clovio's
Farnese Hours. See W. Smith, "Giulio Clovio and the
'maniera di figure piccole'", Art Bulletin, XLVI, 1964,
p. 395-401. The parallel was also made in the trascoro
reliefs of Giuliano Fiorentino. See note 39 above; and
was also one of the parallels in the Biblia Pauperum; see
A. N. Didron, Christian Iconography, London, 1886, p.
419 compared to the Crucifixion.

43
P. Fabrici, Delle Allusioni, p. 148. The rain
of serpents was coupled with Christ in Limbo in two paintings
of 1544 mentioned by Vasari by Francesco del Prato, a gold-
smith who chased Bandinelli's bronzes and was a follower of
Salviati. (Vasari-Milanesi, VII, p. 44)

44
E, Panofsky, Studies in Iconology, p. 84.

45
F. Saxl, "Veritas Filia Temporis," Philosophy and
History, Essays presented to Ernst Cassirer, Oxford, 1936,
p. 204.

46
P. Fabricio, Delle Allusioni, p. 76-7.

47
On this series of drawings see J. Wilde,
Michelangelo and his Studio, p. 91-3. The source was
apparently a sarcophagus now in the Uffizi. Michelangelo's
drawings served as a model for plaquettes by Giovanni
Bernardi, and must have been well known in the Cinquecento.
J. Pope-Hennessy, Renaissance Bronzes from the Samuel H.
Kress Collection, London, 1965, no. 32. The figure was
a fairly common one, and was utilized in a similar con-
junction with four horses in a plaquette by Moderno, iden-
tified by Pope-Hennessy as representing the death of Hippolytus.
(Renaissance Bronzes, no. 160.)

[48]
In which case it would probably relate to Raphael's much admired Aeneas and Anchises group in the _Incendio del Borgo_ which, although reversed, Danti's group closely resembles. See Vasari-Milanesi, VII, p. 359.

[49]
Vasari-Milanesi, VII, p. 143

[50]
C. de Tolnay, _Michelangelo_, II, p. 182
The hypothesis that borrowed forms brought their meanings with them, and were consciously used this way in some Cinquecento programs has been advanced by N. W. Canady, "The Decoration of the Stanza della Cleopatra," _Essays in the History of Art presented to Rudolf Wittkower_, London, 1967, p. 110-118.

[51]
Comparison of Moses to ancient sages and philosophers was a standard element of traditional Christian syncretistic thought, as early as Clement of Alexandria. See J. Seznec, _The Survival of the Pagan Gods_, New York, 1940, p. 15. Specifically on the parallel between Moses and Plato see Marsilio Ficino, _Concordia Mosis et Platonis_, _Marsili Ficini opera_, Basel, 1561, I. Ficino held that all philosphical and religious knowledge was derived from the Hebraic revelation. See D. P. Walker, "Orpheus the Theologian and Renaissance Platonists," _Journal of the Warburg and Courtauld Institutes_, XVI, 1953, p. 737. Allusion

to St. John the Baptist would have linked the relief to the city of Florence, of which he was the patron saint, and to the iconography of the Chapel of Leo X for which the relief was probably intended. To suggest what is likely, that Moses is also intended to be Aesculepius, and therefore probably to allude to Cosimo I himself rather than simply his papal ancestors would be to wander too far into Medici iconography.

[52]
Poetics, xxii, 17.

[53]
Catalogue VIII, "Date."

[54]
Sansovino's sportello was begun in 1546, finished in 1563 and set in place in 1572. Venice is mentioned in connection with the metal for the statue of Julius III in the documents of 1554; see Catalogue III, "History."

[55]
Vasari repeatedly used the format in his Palazzo Vecchio frescoes. It was linked with the visual organization of meaning by Raphael, see E. Wind, "The Four Elements in Raphael's Stanza della Segnatura," Journal of the Warburg and Courtauld Institutes, II, 1938-9, p. 75-9. A fine representative of such organization is the frontispiece of the System Planetae designed by Gerard de Jode and Martin de Vos, 1581, illustrated by A. Chastel, The Crisis of the Renaissance 1520-1600, Geneva, 1968, p. 42. Here compositional-

diagrammatic relationships define a parallel between the four elements and the four humors, the seven ages and the seven planets.

56

The treatment of the corners and general format of the relief should be compared to the frame of a portrait of Giovanni de'Medici by Bronzino. The frame is perhaps attributable to Bronzino's own design. See D. Heikamp, "Agnolo Bronzinos Kinderbildnisse aus dem Jahre 1551," Mitteilungen des Kunsthistorischen Instituts in Florenz, VII, p. 133-8, fig. 61.

57

Danti's is an example of a prevalent kind of treatment of form in Renaissance art which awaits descriptive elucidation. A quick canvass of Renaissance decorative arts and furniture produced only one tapestry, on a cartoon by Bacchiacca (1553) which had similarly treated corners, and these contained the four winds (M. Viale Ferrero, Arazzi Italiani, Milan, 1961, tav. 41). The subjection of forms to two- and three-dimensional diagrammatic logic was already employed by Pollaiuolo in his Martyrdom of St. Sebastian (National Gallery, London; see E. H. Gombrich, Norm and Form, London, 1966, p. 95-6, pl. 143) and in the central figures of his Nude Men Fighting. The principle here is not symmetry but spatial reversal; the figures are moved through 180° with respect to the viewer. This rotation of the figure made painting sculpture by creating a kind of

intelligible circumambulation (J. Holderbaum, "A Bronze by Giovanni Bologna and a Painting by Bronzino," _Burlington Magazine_, XCVIII, 1956, p. 439-45; C. Seymour Jr., _Sculpture in Italy 1400-1500_, Harmondsworth, 1966, p. 184) and at the same time established what must have been a delightful sort of intelligible _varietà_. The spatial elaboration of such relationships reached the height of literal formal counterpoint in Raphael's _Three Virtues_ in the Stanza della Segnatura. The same principles were rather cold-bloodedly applied by Pontormo (H. S. Merritt, "The Legend of St. Achatius: Bacchiacca, Perino, Pontormo," _Art Bulletin_, XLV, 1963, p. 262, where the figures in the upper right corner of Pontormo's _Martyrdom of the Ten Thousand_ are described as "rather dully organized in trochaic pentameter. . . .almost an academy of Michelangelesque nudes. . .") That five crucified bodies would have been difficult to vary significantly among themselves has, this unappreciative description notwithstanding, become the opportunity to treat them as units in a higher order. As if Pontormo had not made the point that the nudes have been subjected to a spatial pentameter, he precisely punctuated the sequence of crucified bodies with five heads.

The specific source of Danti's figures is probably the archetypes from which all such figures came: those of the Sistine Ceiling. There the bronze nudes over the ancestors of Christ and the _putti_-_telamone_ flanking the prophets and sibyls are governed by inflexible bilateral symmetry.

By the middle of the sixteenth century, symmetry as
the basis of decoration and the idea of rotation (possible
in two or three dimensions) had merged to produce such figures
as those in a drawing for a cofana attributed to Francesco
Salviati (M. Tinti, Il Mobilio Fiorentino, Milan-Rome,
1928, pl. LXXIII). The pairs of nudes appear to be simple
transpositions of a pattern, but were made by moving one
group through 180°, so that what is seen on the left is the
back of the group on the right. A combination of mirror
symmetry and spatial rotation was applied by Giulio Clovio
to the row of putti at the bottom of a drawing for the
Adoration of the Magi in Windsor Castle. See A. E. Popham
and J. Wilde, The Italian Drawings of the XV and XVI
Centuries in the Collection of His Majesty the King at
Windsor Castle, London, 1949, no. 241. These examples
could be multiplied; such devices--which could hardly be
more conscious--create maximum variety within a system of
maximum order, and create a tincture of clarity and ambiguity
of identity which seems to have delighted the sixteenth-
century eye and mind.

[58]
Vasari-Milanesi, VII, p. 632, n1; and W. Bombe,
Thieme-Becker, XIII, p. 386.

[59]
For the attribution of the painting to Giovanni
Baglione, see C. Guglielmi, "Intorno all'opera pittorica
di Giovanni Baglione," Bolletino d'Arte, XXXIX, 1954,

p. 311-26, fig. 3; and independently J. Hess "Some Notes on Paintings in the Vatican Library," Kunstgeschichtliche Studien, Rome, 1967, p. 163-79, fig. 15.

60
This and following references are to the Loeb Classical Library edition, Suetonius, with an English translation by J. C. Rolfe, London-New York, 1914-35, Augustus XXXI, p. 171.

61
Cosimo's own concern with water works is well known, and a significant part in the planning and execution of his projects was played by Ignazio Danti. See I. del Badia, "Egnazio Danti Cosmografo, Astronomo e Matematico e le sue opere in Firenze," Rassegna Nazionale, VI, 1881, p. 621-31; VII, 1881, p. 434-74; also published separately under the same title, Florence, 1882.

62
The figure of the River God has been connected without supporting argument with Michelangelo's uncarved Medici Chapel River Gods by A. Gottschewski, "Ein Original Tonmodell Michelangelos," Munchner Jahrbuch der bildenden Kunst, I, 1906, p. 63.

63
A. del Vita, Lo Zibaldone di Giorgio Vasari, Arezzo, 1938, p. 14. "Quanto poi alli due archj lati farej in uno lo esercito di Marcontonio quando assetato si partj poi quasi che fuggendo: dove potete fare parte de soldati che portjno

acqua nelle celate nelle rotelle et in altrj vasi, alle
qualj moltj assetatj corrino a bere; et parte che fuggendo
marcin verso il monte perseguitati da quelli di Augusto: che
sarà a proposito del levar campo che fece piero strozj per
la fame e per la sete et vi aggiungerej questo motto. . ."

64
 And under which Florence was founded. N. Rubenstein,
"Vasari's painting of the "Foundation of Florence' in the
Palazzo Vecchio," Essays in the History of Architecture
presented to Rudolf Wittkower, London, 1967, p. 64-73,
esp. p. 67.

65
 G. Ruscelli, Le Imprese Illustri, Venice, 1580,
p. 133-4. "Et ricorda il Giovio per cosa notabile, che
in questo giorno primo d'Agosto, nel qual' Ottaviano ebbe
sì rara vittoria contra Marc'Antonio al Promontorio Attico,
il Duca Cosimo ebbe quella gloriosa vittoria contra i suoi
nemici a Monte murlo. Al che si deve aggiungere la con-
formità quasi dell' età, & di esser cio avenuto nel principio
del principato così dell'uno, come dell'altro."

66
 Suetonius, Julius LXXIX and Augustus XXI.

67
 For Salviati's fresco see A. Venturi, Storia, IX,
6, fig. 86; and J. Shearman, "Maniera as an aesthetic ideal,"
Studies in Western Art, p. 200-21, pl. LI; and Mannerism,
Baltimore, 1967, fig. 89.

68
L. P. Rosello, Il Ritratto del vero governo del
principe dall' esempio vivo del Gran Cosimo de'Medici, Venice,
1552, p. 10. Cosimo I was reluctantly party to book burning
at papal instigation in 1559 after the first Index of pro-
hibited books was issued. See L. Berti, Il Principe dello
Studiolo, Florence, 1967, p. 272.

69
Ibid., p. 70r and v.

70
Suetonius, Augustus, XCIV.

71
Ibid., XXIX.

72
Cosimo's identity as Apollo is discussed by U.
Middeldorf, "Forgotten work by Domenico Poggini," Burlington
Magazine, LIII, 1928, p. 9-17. The source for Domentáo
Poggini's marble Apollo-Cosimo now in the Boboli Gardens
in Florence is the so-called "Augsburg Mercury." See E.
Panofsky, "Albrecht Dürer and Classical Antiquity," Meaning
in the Visual Arts, Garden City, 1955, p. 236-85, figs.
73 and 74.

73
It is tempting to identify the reclining figures
in the horizontal cartouches as sibyls, although it is
difficult to do so convincingly since both figures seem to
be accepting tribute. The vertical axis of the relief inter-
sects four figures; the figure at the top holds a branch, as

does the figure at the bottom, and Augustus is crowned with
laurel (on laurel, sacred to Apollo, see Ruscelli, Imprese,
p. 494) If laurel is what the three figures have in common,
and the supposition that the reclining figures are sibyls is
correct, then the top sibyl would be the Cumaean, and
(occupying a position appropriate for an impresa) she would
allude to a standard piece of Medici iconography, the en-
counter of Aeneas and the Cumaean sibyl (Virgil, Aeneid,
VI, 143, Loeb Classical Library ed., I, p. 516-17) from
which arose the motto VNO AVVLSO NON DEFICIT ALTER which,
as J. Sparrow has recently suggested, was both a personal
and dynastic symbol of Cosimo I. See J. Sparrow, "Pontormo's
Cosimo il Vecchio," Journal of the Warburg and Courtauld
Institutes, XXXVII, 1967, p. 163-175. The origin of the
motto is recounted by Ruscelli, Imprese, p. 135.

[74]
These two figures may be seen simply as the
virtues of Temperance and Prudence. For the description
of Diana as Isis see V. Cartari, Imagini delli dei de gl'
antichi, 1647 ed., Facs. Graz, 1963, p. 70. On Cartari's
close relationship to mid-Cinquecento iconographic schemes,
see J. Seznec, The Survival of the Pagan Gods, New York,
1953, p. 283-306.

[75]
Cartari, Imagini, p. 185.

[76]
Ibid., p. 56.

77
The identity of Hercules and Apollo operates on
a structure similar to that operant in the <u>Brazen</u> <u>Serpent</u>
antependium:

<div align="center">

Flagellation Crucifixion Resurrection

<u>Brazen</u> <u>Serpent</u>

-----------------direction of narrative------>

</div>

The position in the narrative schema doubles the identity
of the central scene, enforcing a duality inherent in the
theme itself. In the <u>sportello</u>, the model would be:

In both cases the double identity is enforced by the visual
structure of meaning, and such formal qualities as equidis-
tance and equivalence in size and position are made of pri-
mary importance in the determination of the meaning of the
relief. As an example of such fusion of structure and elements
of meaning in poetry, Donne's Hero and Leander couplet
may be offered (J. T. Shawcross, <u>The</u> <u>Complete</u> <u>Poetry</u> <u>of</u>
<u>John</u> <u>Donne</u>, Garden City, 1967, no. 83).

 Both rob'd of aire, we both lye in one ground,

 Both whom one fire had burnt, one water drowned.

Each phrase contains a reference to one of the four elements,
giving the poem on one level an emblematic and cosmic basis,
and providing a fundamental intelligible clarity within which
the specific conceits resound.

[78] Cartari, _Imagini_, p. 185.

[79] On the Hercules seal and the tradition of Hercules representations in Florence see N. Rubenstein, "Vasari's Painting of the 'Foundation of Florence' in the Palazzo Vecchio," p. 67, n47 with bibliography.

[80] P. Meller, "Physiognomical Theory in Renaissance Heroic Portraits," _Studies in Western Art_, II, p. 67-9.

[81] See Chapter III, p.

[82] Cartari, _Imagini_, p. 28.

CHAPTER III

THE FLORENTINE MARBLE COMMISSIONS

Solo è dell'arte le linee
che cercandano un corpo, le
quali sono in superficie; onde,
non è dell'arte l'essere di
rilievo, ma della natura.
-----Bronzino

CHAPTER III

THE FLORENTINE MARBLE COMMISSIONS

The Competition for the Fountain of Neptune:

Danti's bronze reliefs would have won him no more
than a position as a goldsmith in the Medici court. The
failure of the Hercules and Antaeus group surely gave
Cosimo I pause before granting another large bronze com-
mission to Danti, especially when he had a sculptor of
proven dependability and versatility in Bartolommeo
Ammannati. To make matters worse, Danti's contemporary
and chief rival for the Duke's favor, Giovanni Bologna, had
successfully cast his Bacchus for Lattantio Cortesi shortly
after Danti's conspicuous failure.[1] Danti was also hand-
icapped by lack of experience in carving marble. This
excluded him from consideration for most commissions, and
in order for Danti to win a place on the roster of court
artists it was necessary that he display his ability to carve.

The first opportunity to present itself was a
grand one, the competition for the Fountain of Neptune
in the Piazza della Signoria. The colossal marble Neptune
which was to be the central figure of the fountain was to
join the series of Giganti begun by Michelangelo's David
and--at least in intention--continued by Baccio Bandinelli's
Hercules and Caecus. Danti was one of four sculptors to

make a model for the fountain in Florence. There was
no hope of his gaining the commission and, as Vasari
wrote, Danti competed not to win the stone but only in
order to show "l'animosità e l'ingegno suo."[2]

Two years before the competition, in 1558, Baccio
Bandinelli paid a deposit on an unusually large block of
marble at Carrara. In 1559 the owner of the block demand-
ed full payment, and Bandinelli persuaded the Duke to buy
the marble for a fountain which the two of them had been
planning for the Piazza della Signoria since 1550. There
had never been any question that the commission was to be
Bandinelli's; but when Cellini and Ammannati heard of the
affair they entreated Cosimo to allow them to present models
also. Thinking that competition might goad Bandinelli on
to greater achievement, the Duke agreed. News of the
competition enraged Bandinelli, who instead of devising
a better fountain to meet the challenge, rode to Carrara
where he cut the clock down to the shape of his model and,
as Vasari wrote and Cellini protested, spoiled it. This
deed was one of Bandinelli's last, and he died early in
February, 1560.

Ammannati was then the most likely to receive the
block since he was the most experienced sculptor. Ammannati
had also taken the precautionary measure of enlisting the
support of Michelangelo; this was merely insurance, however,
since as a friend and collaborator of Vasari, he was solidly
in the Duke's good graces. The models which were prepared

were full scale. Ammannati and Cellini were allowed to
partition off bays of the Loggia dei Lanzi in which to
work.

Meanwhile the competition expanded. Giovanni
Bologna, under the auspicious patronage of Prince Francesco,
began a model in the convent of Santa Croce, and Vincenzo
Danti set to work on a model in the house of Alessandro
d'Ottaviano de'Medici. The Duke subsidized the models of
Ammannati, Cellini, and Giovanni Bologna. Payments for
materials cover the period from March to June 1560.[3]
There are no payments for Danti's model, and he must have
financed it himself or with the aid of a generous patron
interested solely in the advancement of his career.

The models had been completed, and the contest de-
cided in favor of Ammannati--as expected--by October 14,
1560 when Leone Leoni reported the outcome in a letter to
Michelangelo in Rome. Leoni seems to have viewed the
whole affair with some scorn, but except for his exaggeratedly
unfavorable estimation of Cellini's clay fountain (there
was no affection lost between them) his account is accur-
ate and agrees with Vasari. The models of the two youngest
sculptors were never considered. Giovanni Bologna's model
was praised, but he had no experience in marble, and his
project was criticized for the expense it would have in-
volved. The Duke did not even inspect his model. Danti
must have fared little better. Leoni wrote that he had

done well "for one so young", but that he had no voice in court.[4]

No certain trace remains of any of the models for the Fountain of Neptune, and a chance never arose for Danti to design another fountain that might provide a notion of the appearance of his project. A drawing in the Dubini collection (fig. 144) seems, however, more likely to record a study for Danti's model than for Giovanni Bologna's Fountain of Neptune in Bologna with which it has been connected.[5] The main figure in the drawing bears a striking resemblance to Danti's Onore of 1561, (fig. 28)[6] and to the drawings with which it is related. The designs from which the Onore developed were without a lower figure, and in his fountain design Danti solved the problem that he later solved with the figure of Deceit by placing the knee of his Neptune upon a dolphin. Danti was eliminated from the competition for the Fountain of Neptune because he could not carve marble. No more reasonable response can be imagined than for him to have demonstrated his ability to carve the very figure he had proposed. Perhaps for this reason, as Vasari wrote, he carved the Onore quickly. In any case, the ploy seems to have worked, for the skill that Danti displayed in carving the Onore, as Vasari also observed, changed Danti's fortunes.[7]

The statue that Danti carved for the Duke's Chamberlain must have reached the attention of the Duke himself and after his initial failure, Danti's career began again. His first work in marble was his best and is, in fact, one of the finest

sculptures of the sixteenth century. In the years that
followed, Danti struggled to reconcile the ideals of the
maniera and sculpture in three dimensions, continually
haunted by the example of Michelangelo. Only in 1569 did the
opportunity arise for him to work in his favored material,
bronze, at a monumental scale.

L'Onore che vince l'Inganno:

As cults grew up around the name of Michelangelo in
Florence and Rome the decisive factor in the character of
the two schools seems to have been the presence of Michel-
angelo himself. However heavy the artistic traffic may have
been between Florence and Rome, and however speedily Michel-
angelo's works may have been reproduced and circulated in
drawings and prints, Roman art around 1550--almost exclusively
painting--was determined by the works which Michelangelo had
done there after 1534. In the works of such artists as Daniele
da Volterra and Marco Pino it was the Last Judgment and later
frescoes which told most heavily. These works were much less
important in Florence, where early works--mostly sculpture--
became a kind of museum and underwent a slow metamorphosis
uninterrupted by radical reinterpretation and more prey to the
disturbance of other influences. The works of Michelangelo thus
became the distant initial impulse for the mature styles of many
Florentine artists who acknowledged Michelangelo as their
master. Angelo Bronzino, for example, must have studied
Michelangelo's Holy Family with great care. But by the time
he had formed his mature style, Michelangelo's work had become

a distant if necessary precedent, and what Bronzino learned
had undergone a basic change. An aspect of the whole range
of Michelangelo's creation had been fixed upon and defined,
tempered by the influence of other artists, another sensi-
bility and new demands of patronage.

It was in such a situation that Danti began his work
in marble. He did not return to the works of Michelangelo
and attempt to recreate them, rather he drew upon the style
as it had been defined by over two decades of change in the
hands of óther artists. He did not mime Michelangelo's
technique of carving marble, and used the toothed chisel
chiefly to vary textures. Once again, painting played a
decisive part in determining the direction of Danti's
sculpture. The late paintings of Daniele da Volterra stand
nearest Danti's L'Onore che vince l'Inganno (figs. 28 and
99). Daniele's explorations of the boundaries of sculp-
ture and painting were not unique, and if Danti did not know
them he could have found a similar development close at hand
in Florence. The ideal surfaces bounding abstract volumes
in white light are much like the marble surfaces of the
figures in Bonzino's paintings of the 1540's, from which
Danti drew both details and a general conception of volume
and surface in light. (figs. 28 and 107)

Danti seems also to have been attracted from the
beginning of his years in Florence to the sculpture of
Benvenuto Cellini, and his Onore shares facial type and
degree of languid refinement with such a figure as Cellini's

Narcissus. (fig. 108) More important, however, was Danti's
appreciation of the sculpture of Baccio Bandinelli, which
presented a conscious alternative to Michelangelo's style
in Florence, and the considerable importance of which has
not been fully evaluated.[8] Danti's debt to the late marble
reliefs of Bandinelli is plain. In his Flagellation relief
of 1559, he studiously imitated Bandinelli's Santissima
Annunziata Pietà (fig. 109) when he carved the head of
Christ. (fig. 26) Danti seems especially to have been
struck by Bandinelli's juxtaposition of intricate, homo-
geneously textured detail--such as hair and drapery--to
severely generalized anatomical surface. Danti juxtaposed
the taut body surfaces and the carefully drilled and polished
hair which Vasari so admired.[9] This contrast is an impor-
tant aspect of both Bandinelli's Pietà and of the Duomo choir
reliefs, which may have served as the inspiration for the
ropy hair of the lower figure of Deceit. (figs. 32 and 110)
The maenad figure from Bandinelli's relief on the monument
to Giovanni delle Bande Nere of 1540 (fig. 111) makes it
evident how clear and how literal, Danti's debt to
Bandinelli remained.

The formal limitations inherent in traditional
triumph themes, like the limitations of the sonnet or
the distich, were a continual spur to invention in Cinque-
cento sculpture. David and Goliath, Judith and Holofernes,
and Hercules and Antaeus all received major sculptural inter-
pretations by Florentine sculptors in the Quattrocento, and

while he worked in Florence Michelangelo gave a powerful
new impetus to the old themes. Although he came near
completing only one such group of victor and vanquished--
the so-called Victory for the tomb of Julius II, which was
carved in Florence and remained there--Michelangelo planned
several others and his conceptions continued to fuel the
imaginations of Tuscan sculptors. Perhaps more than any-
thing else, the formula of one figure over another carved
from one block of marble was identified with the style of
Michelangelo, and four such groups stood on his catafalque
in 1564 together with allegories of the four arts of which
he was master.[10]

Bartolommeo Ammannati's Nari monument Victory
(fig. 112) and Pierino da Vinci's Samson and the Philistine[11]
(fig. 89) drew directly upon Michelangelo's inventions.
Giovanni Bologna's Florence Triumphant over Pisa was con-
ceived as a pendant to Michelangelo's Victory.[12] Vincenzo
Danti's Onore group has been placed among the sculptures
which derive directly from Michelangelo, and has been iden-
tified as a reflection of Michelangelo's intended counter-
part of the Victory for the 1532 project of the Tomb of
Julius II.[13] This possibility cannot be denied. It is
difficult, however, to separate the arguments for such a
hypothesis from the simple fact of the contemporary repu-
tation of the Victory, which was one of the most admired
sculptures in the Cinquecento, and whose widespread influence

has made it a paradigm of sixteenth-century sculpture in modern criticism. Whatever the case, the hypothesis should not be allowed to obscure the independence of Danti's group, its differences from Michelangelo's works, and its characteristic methods of invention and procedure.

The main figure of the group, the Onore, clearly owes its compositional basis to Michelangelo. As realized it most probably combines features of several works--the Victory, the Bearded Slave and the Hercules and Caecus modelli, for example--and is not a pure translation of a model by Michelangelo. Closest to the Onore is a drawing in the Louvre which has been attributed to Danti, and identified as a study for the figure. (fig. 113) More recently, the drawing has been assigned to Michelangelo himself. Another drawing in the Casa Buonarroti suggests that a modello of this figure must have existed, since a precisely similar figure is shown from three points of view.[14]

Both of these drawings have in common the lack of a lower figure, although such a figure is implied. Some clue may be afforded by a related drawing on the Victory theme attributed to Battista Franco. (fig. 114)[15] The lower part of the figure is a reversal of the Louvre drawing. The second figure is only sketched, but it can at least be said that it was to have been horizontal, as the vanquished figure is in Michelangelo's Victory and other similar groups planned for the various projects of the tomb of Julius II,

such as that reflected in Ammannati's <u>Victory</u>. Danti's
group is completely vertical, in opposition to the cross-
axiality of these groups. It should also be pointed out
that the proportions of Danti's figures are decidedly out
of tune with Michelangelo's <u>Victory</u> and with the drawings
that have been connected with it. The relatively stocky
proportions of the <u>Onore</u> are much more reminiscent of
Bandinelli (once again of the reliefs for the Duomo choir)
and suggest that Danti took Michelangelo's precedent only
as a compositional theme.[16]

The verticality of Danti's group may have arisen
from the limitations of his block, which are strongly felt
in the <u>Onore</u> group. However it came about, this alteration
had an important result. Unlike Michelangelo's <u>Victory</u>,
Danti's group cannot be satisfactorily understood from
the front, since the lower figure is almost incomprehensible
from this point of view and it is only from the sides that
it assumes any specific character at all. (figs. 29. 31)
This suggests that in devising the second figure Danti de-
parted from the pattern which governed the <u>Onore</u>.

The lower figure of <u>Deceit</u> was probably takem from
Francesco Salviati's <u>Allegory of Peace</u> in the Sala de' Udienza
in the Palazzo Vecchio, (fig. 115) a composition
which probably served as the pattern for Danti's own <u>Allegory</u>
<u>of Peace</u> in the lower register of the <u>sportello</u> relief.[17]
Even if Danti only took his theme from the general formula
of such a bound crouching figure, he must have profited from

Salviati's example, and the correspondence in pose and
detail between the two figures is quite precise. The
captive has not only been expanded into three dimensions,
he has been turned on his back. This at once permitted
close adherence to the shaft of marble and disguised a
known figure through spatial manipulation. The point of the
disguise once again is to surprise by recognition and to
evoke upon recognition--at least generally--the meanings
which the figure bears.

This diagrammatic spatial play controls the con-
ception of the whole group, since, for all their different
ancestry, the figures of Honor and Deceit are essentially
reversals of one another. That is to say, the group was
made by reversing, inverting and interlocking one figure.
The equivalence in mass of the two torsoes creates a certain
empathetic ambiguity between upper and lower. Both figures
have their right leg extended, their left bent and their
right arms crooked behind them. The principal difference
is in the left arms, both of which clutch Deceit's beard.
Deceit then becomes a kind of monstrous reflection of Honor
with which, since it is his own reflection, Honor is in-
evitably entangled. As in the sportello relief, Danti
used pure formal means to create a puzzle at the bottom of
which lay a paradox of identity and the paradoxical unity
of opposites.[18]

The forms of Danti's figures pass smoothly from full
round to relief, paralleling transitions from finished to

unfinished. Some parts, such as the right hand of Deceit, appear to have been cut directly on the surface of the original block. (fig. 33) These "unfinished" parts are worked with a toothed chisel, the texture of which is used as a delicate variation of the surface. As was the case with many mid-Cinquecento marbles, the entire surface of the Onore group was worked with the precision of a small bronze, and there can be no question about its complete realization. Such decorative, rather precious utilization of "unfinished" areas was typical of Danti's marble from the beginning of his career to the end.

The degree of evidence of the textures of carving in Danti's work is about the same as that of the Times of Day in the Medici Chapèl. At times, as in the Onore, Danti's use of texture recalls the pictorial refinement of such Quattrocento examples as Desiderio da Settignano's St. Jerome relief in Washington. A small putto carved for Sforza Almeni's villa at Fiesole shortly after the Onore offers a more Michelangelesque example (fig. 34). Here the hands and feet are barely indicated in the remaining chunks of stone.[19]

The compression of the forms in the generalized surfaces of the Onore was a characteristic of Danti's style in marble and bronze, full round and relief. The bulging volumes of the Onore, all the more tense because of the disappearance of detail in the skin of the figure, are altogether a function of surface. Danti's creation of mass

is almost totally virtual, and is understandable apart from the actual mass of the stone. The figures of the sportello relief were given mass by outlining conventional surface modulations in oval contours. The shape focused the density at the center of the body. Danti's Onore has a similar structure, the apparent mass of the figure coinciding with the point of maximum tension in the arc governing the left side of the figure and uniting the group. (fig. 28)

Danti's graphic creation of mass can perhaps be clarified by comparison with Michelangelo's Brutus. (fig. 116) Here each form isolated by light moves through a complete range of values from darkest to light. This is true not only of individual modulations, but also of the sculpture as a whole. The slow, uniform movement of light over the surfaces of the stone implies central mass points which govern each of the movements of surface, just as the gradual shading of a round shape implies its sphericity, and the ideal concentration of mass at its center. The modulations thus become a system of contiguous masses finally organized by the configuration of the whole. The resulting surface definition of mass is linked to the texture and hence to the actual massive substance of the marble by the rough-- but once again uniform--treatment of the surface.

In contrast, Danti never allowed his form to rest in shadow. The scale of values of the Onore is extremely high, passing into deep shadows only in details, at the

extremities, and at the contours; the statue was thus
made to seem unusually bright. The result was a tense,
lustrous surface, reinforced by finishing, which ends
suddenly in crisply drawn contours. Marble is much
more evident as white crystalline stone than as dense mass,
just as Bronzino achieved his imitations of marble sculpture
in painting through concentration on visual and tactile
qualities (whiteness, coolness, hardness) and not by creat-
ing the two dimensional equivalent of dense volume, as
Michelangelo did in his painting.

The legs of the _Onore_ are related to the torso by
similarity of surface and not by organic junction. The
similarity of surfaces contributes to the equivalence of
all linear features. The line which demarks the junction of
the left leg and torso is equivalent in force to the con-
tours. This results in the isolation of the forms, creating
the possibility of the group's being what it is, a highly
artificial composition of similar parts, the relationships
among which are based upon the unique adjustment of axes
possessed by the parts themselves. The group itself is
without an axis. It is a unique agreement of axial forms,
controlled by the block and such uniting formal devices
as the governing arcs. Once the unity provided by the
block was abandoned, that is, once one of the basic prin-
ciples of Michelangelo's sculpture was forgotten, the same
principles that animate Danti's group were developed in
the mature sculpture of Giovanni Bologna.

The resolution of complex physical movement into an arc on one side of the body, a common device which was used by Danti in his earliest reliefs, was again utilized. In the Onore group this arc plays powerfully against the vertical thrust of the upper figure's gesture and the vertical and horizontal structure of the block itself. Danti formed a close, essentially rectilinear space within which the unifying arc attained a maximum intensity. Danti used other graphic devices within the strictures of the shaft of marble which he carefully maintained, exploited, and perhaps even exaggerated. The figures are locked together by the strong vertical gaze of the Onore, reinforced by the strong vertical thrust of his arm. Around the elements of the composition, Danti threaded a band which passes around and around the figures, at once heightening the compression across the surfaces, adding tension to the voids, and inextricably tangling the two figures. The relationship of the continual movement of this band to the sculptural core is much the same as the spiraling drapery around the figure of Julius III. In the Onore, it was more consciously used as a witty elaboration on the theme of the band, which Michelangelo used in his Slaves for the Tomb of Julius II.

Danti addressed himself seriously to the theoretical problem of a statue satisfactory from many points of view. The group displays itself to best advantage when the figure of Onore is seen head on; then the arc of the body is entirely

visible and the upper figure gains its full force from the
tension across the shape of the block, retained in the
square base of the group. (fig. 28) From a position
directly behind Deceit the composition loses tone somewhat
although a new arc, this time on the right hand side, begins
to take shape, formed by the continuation of the arms of the
two figures. (figs. 29, 30) This arc also governs the
right side views of the group.

Danti's approach to the problem of multiple points
of view is an extension of the thinking that lay behind de-
fenses of painting in the paragone dispute, the argument
that a painter could equal sculpture by painting the same
figure from both sides. This was an oddly recurrent
Florentine notion, which appeared in close conjunction with
paragone discussions in the two sided paintings of Daniele
da Volterra and Angelo Bronzino.[20] The same idea was merely
multiplied to arrive at Cellini's injunction that a statue
should be able to be seen from eight sides.[20] Views are
thought of as discrete and fixed, and the ideal is to satis-
fy a series of stationary points of view rather than a spec-
tator in movement. For all the composition of Danti's group
is adjusted to separate viewpoints, it is essentially an
elaboration of the original block, a prismatic series of
reliefs, different both from Michelangelo's linea serpentin-
ata--in the form it took in the Victory--which destroys large
relief planes by continuity of movement, and Giovanni Bologna's
complete abandonment of the relief conception for counterpoised

axial forms in severely conceptual space.

Danti's L'Onore che vince l'Inganno consists of
two large figures, a nude youth with a roughly carved skin
at his back who has pinioned an equally nude old man in a
kind of Phrygian cap.[22] Both figures clutch the old man's
beard. On the base of the statue, behind the lower figure,
a mask is carved in low relief, and beside it, near the
foot of the youth, a snake with the head of a woman is shown
dead. (fig. 33) The theme is Honour Triumphant over
Falsehood, which has just been unmasked. The small snaky
creature who symbolizes Deceit here symbolizes Deceit over-
come. The specific concetto which controls the treatment
of the theme is Deceit caught in its own snare, the band in
which the two figures are entangled.[23]

The Onore group was carved for Sforza Almeni, the
chamberlain of Duke Cosimo. Like Danti, Almeni was a
Perugian. He enjoyed--and profited from--the close confi-
dence of the Duke until 1566 when Cosimo, for reasons of
intrigue that have remained shrouded, killed him with his
own hands.[24] There are few traces left of Sforza Almeni,
and it is difficult to say why he might have commissioned
the Onore group from Danti. But he seems to have taken a
special interest in the arts and in Danti's career as a
sculptor. The Brazen Serpent relief was consigned to him
in 1559 and he continued to patronize Danti in the years
after 1561.[25] It seems likely that Sforza Almeni and
Danti were part of a literary circle which included

Benedetto Varchi, a close friend of Danti, and the leading
man of letters in Florence.[26] The Palazzo Almeni in the
Via dei Servi, in the courtyard of which the Onore group
originally stood, was given to Almeni in 1545.[27] It was
Sforza Almeni who introduced Giorgio Vasari to Cosimo I
in 1553 and in return Vasari decorated the facade of his
palace with the lavish care that repayment of this consid-
erable favor demanded. The frescoes that Vasari designed
for the facade of the Palazzo Almeni scarcely outlasted
the man for whom they were painted, and had been destroyed
by exposure to the elements when Vasari wrote the second
edition of his Vite in 1568. No trace of them remains.
Vasari's descriptions of the facade survive, however, and
the program which he planned is of considerable interest
since it formed a context of meaning for Danti's group.[28]

Vasari divided the facade into seven vertical bands
flanking each of the six windows. These vertical bands were
divided by four horizontal registers. In the lowest register
were the seven liberal arts; in the second, the seven virtues;
the third consisted of scenes showing the seven ages of man,
beneath which were subsidiary scenes with allegories typifying
each age; the seven planets occupied the last register. The
stress thus fell upon the coincidence of the traditionally
mystical number seven, dictated by architectural circumstances.
The elements in the resulting order assumed meaning from
their positions; everything in each horizontal register
was of the same kind. Reading vertically accomplished an

ascent from the arts, through the virtues and human time
to celestial time. It is significant that the closest
precedent for Vasari's scheme in Florence was Andrea da
Firenze's Spanish Chapel in Santa Maria Novella, with its
virtues, theological sciences, liberal arts and examplars
arranged in sevens. Vasari had taken the same schema and
turned it to secular purposes. He thus combined tabular
arrangement of meaningful elements with monumental scale,
establishing a structure prior to meaning in which simple
relationships of upper and lower were significant in them-
selves; and he applied this schema with a rigor that surpassed
the scholastic program.[29]

Danti's L'Onore che vince l'Inganno stands in a
tradition of psychomachic triumph themes with a long history
in Christian iconography.[30] The generic significance of these
groups was virtue triumphant over vice, simply paralleling
the formal relationship of superior and inferior. In Danti's
group the composition has been separated from religious or
civic context and turned to private, at most courtly, pur-
poses. The result is an imbalance between form and content,
and the dialectical opposition made explicit in formal sit-
uation is stronger than the dialectical opposition of the
concepts symbolized. Few clues were given as to the signif-
icance of the group, and what were are visually secondary.
The forms resist equation with content and insist to be
read on a most inclusive level of meaning. There is, just
as in Vasari's scholastic facade, a tension between formal

organization as meaning and manifest content.

It is difficult to say in such a case whether we
are dealing simply with a _tour de force_ exercise within the
limitations of a difficult sculptural problem (as Giovanni
Bologna's _Rape of the Sabines_ is usually discussed) or
whether such groups as the _Onore che vince l'Inganno_ were
not carefully defined on a generic level, thus providing
an occasion for poetry on a theme. Benedetto Varchi's dis-
tich on the group would not have been written before Danti
began the _Onore_, but after he had finished it. Danti himself
could have defined his own terse conceit after the figures
were carved by sketching the attributes in relief on the
base. Since we are outside the rules for proper response
to this consummately aristocratic art, we see only the forms,
deprived of the power to kindle thought they had in themselves,
and we find it silent.

The formally privileged central position of Vasari's
facade for the Palazzo Almeni was occupied by Youth (_gioventù_).
Above was the planet Venus, whose personification was shown
embracing Cupid. Youth was shown as a young man holding
books and musical instruments, while others behind him
engaged in various dalliances. As this might lead one to
expect, Youth, like Adolescence before it, was shown with
warring properties, knowledge and fraud (_cognizione_ and
fraude), meaning that it was the particular task of Youth
to avoid the pitfalls of deception and stay on the path of
Truth. Beneath was the virtue of Temperance, holding a

bridle; the art below Temperance was Rhetoric.[31]

The central position of Gioventù on the facade parallels Danti's own characterization of youth as the standard of beauty for the other ages of man. It is more than simply one inter pares, it is the age when human beauty "shines forth most clearly".[32] Danti argued that the other ages (of which he said there were five) possess beauty and perfect proportion to the extent that they partake of youth. The human body is most beautiful during youth because it is anatomically most perfect and therefore most functional. The low keyed but careful anatomy of the Onore, which Vasari praised, might serve as an illustration of Danti's chapter.[33]

Danti's figure of Onore is certainly a youth, and it is described in a sonnet by Timoteo Bottonio as "giovenile."[34] Thus in reference to Vasari's facade the groups might be seen as the victory of Youth as well as Honor, over Deceit. The group might be autobiographical in intention and refer to Danti's own defeat of ill fortune, as Vasari described.[35] But such explantions do not exhaust the potentiality for meaning of the two marble forms. If Honor is also Youth, then it might be the triumph of Youth over Age, since the contrast of the ages of the contestants is so marked. And since Danti equated Youth and Beauty, it might also be the victory of Beauty over Ugliness, and again, in terms of Danti's treatise, of order over disorder, emblematic of the living contrariety which Danti saw at the heart of things.[36]

Further Work in Florence and Perugia:

Danti was associated with Sforza Almeni until at
least 1563, and the two men are frequently encountered
together in the letters of Vasari and Vincenzo Borghini.[37]
Sforza Almeni seems to have been especially close to Borghini,
and the access to the attention of the court which this con-
tact afforded Danti was very likely an important factor in
the machinations preceding the ducal commissions which he
received in the next few years.[38] While these commissions
were still in the works, Danti continued to work for Sforza
Almeni. According to Vasari, Danti "made many ornaments
in the gardens and around certain fountains" at Almeni's
villa at Fiesole.[39] Vasari's description gives no indica-
tion of the nature or extent of these decorations, and
perhaps he had never seen them. No sculpture remains at
the villa--now the Villa Rondinelli--except one marble
putto, broken and badly weathered, but still visibly of
the high quality and careful workmanship of the Onore.
(fig. 34) This lone survivor, now perched atop a pillar,
may have belonged to a group such as Giovanni Bologna's
Fountain of the Fishing Boys, formerly in the Casino Mediceo,
and it is very close in pose to one of the putti from this
fountain now in the Museo Nazionale.[40] The modest Michel-
angelesque framing applied to the windows and door of the
Villa may also be attributable to Danti's designs. (fig.151)

The Leda and the Swan in the Victoria and Albert
Museum (fig. 35) also belongs to this period of Danti's
activity, and may have been one of the fountain figures
for Sforza Almeni's gardens.[41] The group has been called
Danti's last work in sculpture in recent criticism on the
basis of a reconstruction of his development which places
him firmly under the influence of Michelangelo during his
first years in Florence; this influence is supposed to have
been entirely eclipsed by that of the sculpture of Giovanni
Bologna and the aesthetic ideal of the maniera by 1570.[42]
But in one of his most Michelangelesque works, the Onore,
Danti recast his source in the stylistic mould of Bronzino
and Bandinelli; and it is difficult to imagine a more ex-
aggerated sensitivity to the ideals of the maniera than
Danti displayed at the beginning of his career in the Julius
III reliefs. (figs. 12-16) This exuberance was sobered
by Michelangelo's influence in the sportello relief of 1561,
but here also the sublimation of form that Danti had learned
in Rome is still evident and essential.

The attribution of the Leda and the Swan to Danti
was first advanced on the strength of a comparison of the
figure of Leda to the figures of the sportello relief, and
the resemblance of the Temperance, on the left, is convinc-
ingly exact.[43] (figs. 35, 27) The comparison of the head
of Leda to one of the female heads from the statue of
Julius III (fig. 9) leaves little doubt as to Danti's
authorship, and at the same time suggests an early date, since

the facial type--which gave way by degrees to an orthodox classical type, fused with the ubiquitous _teste divine_-- appears only in this early work.

The _Leda_ _and_ _the_ _Swan_ has a generally late appearance, and exceeds the usual attenuation of the _maniera_ formula in the direction of eighteenth-century neo-classical pretti- ness. But it occupies an advanced position in a Florentine development and not in Danti's personal development. Such gracefulness was an identifiable strain in Florentine sculp- ture, with a solid foundation in the work of Bandinelli and Cellini, by 1560.[44] At the same time Danti carved the _Leda_ _and_ _the_ _Swan_, Giovanni Bologna was engaged in the series of less airy female figures typified by the Petraia _Florence_. Elaborate formal poising (which is the rigidly controlled basis of Danti's _Onore_ composition) was one of the paths explored in Florentine sculpture from 1540 on, the initial impulse coming once again from the sculpture of Bandinelli. (fig. 117) It served as the compositional principle behind Vincenzo de'Rossi's _Theseus_ _and_ _Helen_, and it was an essential factor in the formation of Giovanni Bologna's style. That such a composition was not beyond Danti's reach from the beginning of his career (and that he would therefore have been susceptible to this aspect of Florentine style) is apparent in his victory figures on the monument of _Julius_ _III_. (figs. 10,11)

The composition-for-its-own-sake accompanied a surprisingly prim departure from Michelangelo's frankly

venereal treatment of the same theme. The impression of
antique sculpture upon Danti's group has been noted, and
to this should be added the strong influence of Ammannati
and Venetian classicism.[45] Perhaps most important is the
dependence upon small bronzes such as those on the base
of Cellini's _Perseus_ or Bandinelli's _Leda_ and _Cleopatra_
in the Museo Nazionale.[46] The ideal of the bronze sta-
tuette might well be said to have governed the group, which
is of an intimate scale, slightly under life size. The
alabaster surfaces are a direct evocation of small scale
preciousness. The stylized incompleteness--also evident
in the _Onore_ and the _putto_ at Fiesole--is certainly in-
tentional.

While Danti was laying the foundations of his style
and his reputation as a sculptor in Florence, he continued
to work in Perugia, responding to the less splendid demands
of the poorer city. Most of his commissions involved arch-
itecture in some form or another rather than sculpture, and
none of them was either large or conspicuous. Still, the
work must have required supervision, and Danti spent con-
siderable time in Perugia, where he held the office of Prior
in 1559.[47] In the same year he supplied the design for
the altar of San Bernardino in the Duomo in Perugia, for
which he later modelled stucco figures.[48] In 1561, he com-
pleted two years' repairs of the perennially troublesome
Fontana Maggiore, which had gone dry again in 1558 following
a brief but hopefilled interruption in over a century's

waterlessness.[49] This was accomplished to the great de-

light of the people of Perugia and the feat was not quickly

forgotten. Before its memory faded it had incidentally

fostered the idea, which has maintained itself in subsequent

biographies, that Danti was an engineer of genius.[50]

Danti's first ducal commission in marble, the

Monument to Carlo de'Medici in the Duomo at Prato, was

probably begun shortly after the completion of the Onore

group for Sforza Almeni. The project is first mentioned in

a letter from Cosimo I to Giorgio Vasari dated May 1, 1562.[51]

Danti is not named in the letter, but the commission must

have been given to him by that date or shortly thereafter,

since by the end of the same month marble for the group was

on its way.[52] The monument was substantially finished, as

Vasari reported to Cosimo I, by April, 1564.[53] It is poss-

ible that Vasari exaggerated his report of its completion

so that Danti would be clearly available for his next major

commission, the ducal arms on the Testata of the Uffizi.[54]

First mention of Danti's connection with the Uffizi occurs

in March, 1563.[55] His part in the project was arranged

through Vasari, by whom he was specifically mentioned as

the sculptor of the Testata figures nearly a year later,

in February, 1564.[56] After considerable delay, during which

Vasari displayed his full genius for browbeating and wheedling,

the marble for the figures arrived in Florence in May, 1564.[57]

By the second week of June Danti had fixed the contract

with the Proveditore of the Uffizi, and shortly thereafter

began what was to prove the most exasperating job of his
career.[58]

Meanwhile other opportunities came and passed. When
the great column from the baths of Caracalla--now in the
Piazza Santa Trinità in Florence--was presented to Cosimo
I in 1560 by Pius IV, the idea occurred to Cosimo, as it
often did, that the column should be raised as a monument
to his victory at Montemurlo. A statue was planned to sur-
mount the column, and by May, 1563 several sculptors had
prepared models, Danti among them. He had excused himself
from the project a few months later.[59] The competition
evaporated, and nothing was done with the column until 1565
when a terracotta statue of <u>Justice</u> by Bartolommeo Ammannati
was placed atop it as part of the decorations for the wedding
of Giovanna of Austria and Francesco I de'Medici.[60] In the
following year, 1564, there were also persistent references
to four pieces of marble which were shipped to Vincenzo
Danti, described as being "for four heads".[61] These were
probably for restorations of classical sculpture. These
pieces had arrived in Florence by April 22, 1564.[62] Only
one restoration can presently be associated with Danti with
any degree of assurance, and this was not carved until around
1570, six years after the marble was sent.[63]

The Monument to Carlo de'Medici:

The Monument to Carlo de'Medici in the Duomo at
Prato is so poorly lighted that Vasari, who judging from his

letters, superintended the project, apologised for it in
his biography of Danti. (fig. 36) He wrote that it was
not possible to see the monument to best advantage, as
indeed it is not.[64] The portrait of Carlo de'Medici
(fig. 39), by far the most distinguished part of the en-
semble, is particularly invisible. Despite these problems,
the group is of importance because it is the first step in
an important stylistic departure in Danti's sculpture. Also,
Danti is no doubt responsible for the entire design, and it
is thus one of the few architectural efforts that can be
attributed to him.[65] For the portal itself Danti compounded
elements from the Medici Chapel and the large triglyph brackets
which Michelangelo favored in his late architectural decor-
ation. The application of these elements and the thin
division of the surfaces of the stone reveal an architectural
vocabulary akin to but drier than those of Vasari and
Ammannati.[66] The lack of vertical continuity and the scanty
articulation of the upper part leave the whole composition
oddly unresolved. (fig. 36)

 After the _Onore_, the sculpture of the Prato group
is a surprising performance. It is uneven in conception and
quality of execution. The Virgin is ungainly and unartic-
ulated, and the bunching of drapery calls to mind Baccio
Bandinelli and his shop at their worst.[67] (fig. 37) The
generalized surfaces of the _Onore_, whose sensitive gradation
and variation Danti had learned from Bandinelli's late reliefs,
lost their variety and changed simply to strongly cylindrical

volumes. There is little difference between the legs of the putti and the candelabra they hold. (fig. 38) Around the cylindrical forms of the Madonna, Danti placed parallel rings of drapery, even more severely precise than he had done when he used a similar device in the statue of Julius III (fig. 4). It is difficult to make any sense of the patterns of the larger folds at all, unless they are read together with the volumes that underly them. Massive, abstract drapery such as that at the lower left side of the Virgin, which simplifies and unites the contour of the figure , became more and more pronounced in Danti's sculpture in the years that followed.

In the putti, Danti introduced a certain torsion, but it is stiff and clear in its function, linking the plane of the sarcophagus with that of the Virgin and Child. They also effect a transition between the major horizontal and vertical elements of the composition, like the scrolls of a church facade.

The precedents for Danti's figures are not far to find. That he knew Michelangelo's Bruges Madonna in some form or another seems unquestionable.[68] The left side of his Madonna is a free copy of the left side of Michelangelo's. (figs. 37, 118) A more immediate source, however, and the source which governed the conception of Danti's statue, was not Michelangelo's Madonna but the more highly mannered treatment of the theme in Parmaginino's Vision of St. Jerome.[69] (fig. 119) The sublimation of the forms at the head, feet,

and hands of Parmagianino's exquisitely immobile Madonna seems clearly to have been Danti's objective in electing his elongated proportions. The volumetri severity of the Prato <u>Madonna</u> was the paradoxical result of a heightened concern on Danti's part for the aesthetic ideals of the <u>maniera</u>, now accademically applied. His attempt to translate Paramianino's Michelangelo-derived vision of the Madonna was a questionable success. In a small marble relief in the Museo Archeologico in Milan (fig. 42) he approached the same problem.[70] He returned to the pattern of one of the reliefs for the statue of Julius III (fig. 16) and, with a stylized <u>non finito</u> technique, translated his former sketch in wax into an arid essay in <u>maniera</u> formulae. Danti had no more than raised the need for the synthesis of graphic symbolism and three dimensional volume which marked his last sculpture.

Danti's <u>Madonna</u> is really a large relief sculpture, and perhaps she had an earlier source, consistent in its overall proportions with Parmagianino's courtly Madonna. The parallel of Danti's figure to the Virgin of Nanni di Banco's <u>Assumption of the Virgin</u> (fig. 120)on the Porta della Mandorla of the Duomo in posture, axiality, articulation and gesture are too precise to be fortuitous.[71] This would mean that when he conceived the figure, Danti made a direct accommodation with the manner of an early Quattrocento sculptor.

Either Parmagianino's painting or Nanni di Banco's relief could have answered the need for the high placement of the <u>Madonna</u> <u>and</u> <u>Child</u>. Probaly a certain amount of her

pronounced frontality, as well as her vertical distortion
(seated,she is seven heads tall) was intended to reinforce
one point of view. She looks down, as does the Christ child
and the two putti. Their gazes would engage the viewer at
a point at which the portrait relief could be seen and the
inscriptions read. The group was thus probably intended
to be seen at close range, thus at a steep angle. From a
lower vantage point the figures are considerably more unified.[72]
(fig. 36)

The portrait of Carlo de'Medici is the finest of Danti's
few marble reliefs. (fig. 39) A portrait in one of the
frescoes in the choir of the Duomo, the Funeral of St.
Stephen, commissioned by Carlo de'Medici from Fra Filippo
Lippi a century earlier, served as Danti's model.[73] Since
Danti's hand was unchecked by a living subject, the relief
is a kind of dictionary of his traits and habits as a sculp-
tor. The dead pan expression, relieved only by a small frown;
almond shaped eyes, slightly heavy lidded, the same top and
bottom; the straight nose with small nostrils; the thin
mouth and square notched ears made up a formula which Danti
had used since the monument to Julius III, and continued to
use until just before he left Florence.

At the same time Danti made a conscious attempt to
retain the Quattrocento qualities of the portrait, and seems
to have even adapted his method of relief to the problem. The
drawing of the portrait is extremely subtle, and the relief

itself is uniformly low, rising from the surface only at the shoulder, the nose, and in a few wisps of hair. Danti combined delicacy of drawing and simple spatial clarity and achieved a reasonable approximation of a Quattrocento relief portrait. The use of drapery as a graphic means of clarifying the shallow space of the relief, the thin, highly charged contour, and taut simplification of planes might be compared to such a relief as Mino da Fiesole's portrait of Alfonso of Aragon in the Louvre. (fig. 121) Just as he had ready access to Filippo Lippi's portrait in the choir when he carved his own portrait of Carlo de'Medici, Danti could have easily referred to Mino's reliefs on the pulpit in the nave of the Duomo.

The Venus with two Amorini:

The Venus now in the Casa Buonarroti, which has been attributed to Michelangelo and to nearly all of his followers, finally came to rest in Danti's late style when it was identified with a larger than life size Venus said by Raffaello Borghini to have been at one time in the Palazzo Baroncelli.[74] This identification is almost certainly not correct, and the figure to which Borghini referred is lost. Danti's part in the Casa Buonarroti Venus probably dates around 1565, rather than after 1568, which absence from Vasari and presence in Borghini would imply.

The Venus is problematic on sight because it was quite obviously intended to be something else.

(fig. 40) The uncomfortable conformity of the _putto_ to
the shaft of drapery beneath the left hand seems clearly
to brand him an afterthought, and the closest composi-
tional parallel to the figure is not a Venus but Fabiano
Toti's _Eve_ in the Duomo at Orivieto.[75] The Casa Buonarroti
Venus seems best accounted for by a history as complex as
as its attributions have been various. It is probably
not the work of one artist. Danti's participation seems
beyond question; the head, with its long tapering nose
and ears and sheeplike expression, is quite comparable
to the Prato _Madonna_.(figs. 37 and 41) The flat, sliding,
square-toed feet, pointed to as one of Danti's hallmarks,
were also well defined by the time Danti carved the Prato
Madonna. The ears are precisely those of the Uffizi _Equity_.
(fig. 41 and 46) The characteristic cutting away of one
of the left fingers of the _Venus_ also appears in the Santa
Croce _Madonna_ of 1566-67. (figs. 40 and 59)

The correspondence of the _Venus_ to a female figure
shown in Michelangelo's shop in Fanti's _Trionfo della
Fortuna_ of 1527 (fig. 122) suggests that Michelangelo
might have been responsible for the invention of the
figure, because of the early date and because Michelangelo
is shown at work on a large reclining figure. This further
suggests a connection with the Medici Chapel.[76] This
connection is reinforced by the dimensions of the _Venus_,
which coincide precisely with those of the allegories which
were to have flanked the _Capitani_.[77] This in turn links

the Venus with that twilit period in the history of the
Medici Chapel described by Vasari when, in 1533, Michel-
angelo parcelled out the sculpture remaining to be done
to other sculptors, Raffaello da Montelupo, Giovanangelo
Montorsoli and Niccolò Tribolo.[78] Raffaele da Montelupo
and Montorsoli carved the figures of St. Cosmos and St.
Damian. Tribolo was to have made two nude female statues
to be placed on either side of Giuliano de'Medici. Accord-
ing to Vasari, he made a clay model of Earth.[79] Vasari
also states that Michelangelo himself made models from
which the figures were to have been done.[80] Since the
allegories reached the stage of execution in marble, they
must have been fully realized compositions. Studies by
Michelangelo after the antique type of the Cnidian Aphrodite
have been connected with the Medici Chapel.[81] It would
be surprising if these inventions were not well known and
if they did not have echoes in Florentine sculpture;
Danti's own Studiolo Venus is probably a direct descendant.[82]

 Tribolo actually began to carve the statue of Earth.
His work does not seem to have gotten very far, however,
before Clement VII died and Tribolo himself became too
sick to work.[83] Nevertheless Vasari described the statue
begun by Tribolo and in the seventeenth century there were
two statues of women "abbozzato da Michelangelo" which had
been taken from San Lorenzo in the Uffizi.[84] One of these
was destroyed by fire in the eighteenth century, but one
was not.[85] Since, then, the Venus is stylistically related

to the proposed Medici Chapel allegories, and since her dimensions coincide with their probable dimensions, and since Danti obviously accommodated the figure to its present role as a _Venus_ with some difficulty, it seems best to identify the _Venus with two Amorini_ with Tribolo's figure, which might have been left just freed from its block. This might explain the compositional irresolution of the figure as well as Danti's undeniable role in the carving.

If this argument is correct, the Casa Buonarroti _Venus_ slips easily into a part of Danti's artistic activity which has recently been examined, and which shows him to have been involved, as many of the artists of the Studiolo were, in the practical consequences of a rapidly deepening historical sense. Vasari's _Vite_ were written in the face of the paradoxical coexistence of a variety of distinct individual styles and what was considered to be the perfection of the techniques of representation. The development which Vasari traced, premised upon the notion of progress, ended in multiplicity rather than unity, as it should have according to any theory of imitation. Art and nature clearly parted ways. The separation of art and nature ultimately drove art and art theory to the alternative of realism on the one hand and academic idealism on the other. Danti's _Trattato delle perfette proporzioni_ was one of the first treatises to address itself to the problem of the coexistence of different _maniere_ by attempting to provide a universal basis for the style of Michelangelo.

As the Casa Buonarroti <u>Venus</u> suggests, Danti was also
aware of the consequences of the definition of style on
a more concrete level. With various degrees of success
he practised different styles. There was some precedent
for this. Collaboration among artists entailed a certain
amount of stylistic accomodation; more directly related
was the example of Michelangelo's <u>contrafazione</u> of Donatello
in the <u>Madonna of the Stairs</u>, or Tribolo's (and others')
Querciesque reliefs for the facade of San Petronio in
Bologna. There was also the constant problem of the restor-
ation and imitation of antiques.[86] It has already been
suggested that Danti made a conscious effort to simulate
the sculpture of Nanni di Banco (Jacopo della Quercia to
him) and Mino da Fiesole in his Prato <u>Madonna</u>.[87] The
<u>Monument to the Beato Giovanni da Salerno</u> in Sta. Maria
Novella of 1571 is openly archaizing; (fig. 70) and it
was Danti who was called upon to complete Andrea Sansovino's
<u>Baptism of Christ</u> over the east doors of the Baptistry.[88]
Danti's completion of Sansovino's figure of Christ is an
instructive example. (fig. 123) The sculpture was prob-
ably fairly well advanced when Danti took it over; but
the head of Christ is a clear illustration of how skillfully
Danti could adapt his own stylistic habits to the work of
another artist without seriously changing them. The head
of Christ is quite typical of Danti's style and at the
same time is an appropriate completiton of what must have
been substantially Sansovino's work. The Casa Buonarroti

Venus is best explained as an attempt on Danti's part to make a fairly nondescript piece of sculpture decoratively useful by "finishing" it as it had been begun, in the manner of Michelangelo.[89]

Equity and Rigor:

The marble for the two reclining figures of Equity and Rigor, to be placed on the testata of the Uffizi, had arrived in Florence by May 13, 1564, while the Prato Madonna was still in the final stages.[90] The Duke approved the terms of the commission by June 9 and Danti began work.[91] Vasari noted the speed with which Danti completed the Onore, and he seems to have worked quickly as a rule.[92] The two figures and the coat of arms beneath them were finished before the agreed upon eighteen months had passed, by September 11, 1566.[93] The figures were probably set in place shortly thereafter.[94] Only two figures were included in the first phase of the program because of the piecemeal financing of the project.[95] Although it was probably always planned, and began to be discussed immediately after the completion of the two allegories, no provision was made for the third statue of Cosimo I in the agreement, and the group remained headless for some seven years before a sat- isfactory figure by Danti's hand, the Cosimo I in the Museo Nazionale (fig. 75) was added.[96] This stood in place for only a little over a decade; it was removed in

in 1584 and replaced by Giovanni Bologna's figure which
now tops the group.[97]

The figures of Equity and Rigor appear small, high
upon the testata of the Uffizi, which is a context of
difficult scale. (fig. 43) If the group had been com-
pleted as first planned, with the large seated figure of
Cosimo I above them, the allegories would have appeared
even smaller.[98] (fig. 44) Danti made no more attempt
to deal with human scale in planning the ensemble than
Vasari made in designing the building which it decorates.
The scale which he chose can be explained by the emblematic
intention of the group, which was essentially a coat of
arms. Unambiguous statement of rank was of first impor-
tance, and Equity and Rigor need only have put in legible
and pleasing appearances. The two allegories were treated
altogether decoratively; they are of no definable scale,
and despite their size, might be two figures on a saltcellar.
The statue of Cosimo I on the other hand approaches the col-
ossal scale of the three marble giganti in the Piazza della
Signoria a few hundred feet away. The group which Danti
first envisioned (fig. 44) would have commanded the Piazza
degli Uffizi as the present group does not.

Danti mimicked the Medici Chapel in the pyramidal
arrangement of reclining figures and seated portrait above.
But the sculptures embody alternative, hierarchical trans-
formations of their respective sources, corresponding to
their levels. The mannered elegance of the two allegories

would have been in harsh contrast to the formal severity
of the ideal portrait above them. Gravity was reserved to
the image of Cosimo I. The Minervan propriety of the alle-
gory of Equity in Domenico Poggini's foundation medal for
the Uffizi of 1561 (which records the iconographic germ of
Danti's group) was forgotten in Danti's more complicated
formulation and replaced by the sleek nakedness of his
Equity and Rigor.[99]

The Uffizi was the heart of Medici administration
and a concrete symbol of Cosimo's I centralization of
political and economic power. Poggini's medal indicates
that the iconographic theme of any major decoration of the
Uffizi had been set from the beginning. The medal shows
the long narrow Piazza degl'Uffizi, looking from the
Arno to the Piazza della Signoria. (fig. 124) Equity,
who signifies the just rule of Cosimo I, stands in the fore-
ground, facing the Arno, beneath the position Danti's group
now occupies. Whether to make more work for himself or
simply out of force of habit, Danti split the idea of Equity
and provided her a dialectical partner in the allegory of
Rigor. These two extremes of justice--inevitable force and
discretion--were to have been symbolically united in the
statue of Cosimo I.

The conceit which animates Danti triadic diagram
of the perfect ruler is partly saved. When Cesare Ripa
compiled his Iconologia, he had access to Ignazio Danti's
papers, among which was an explanation of the figure of

Equity.[100] She is shown (fig. 45) with an architect's rule,
a lead measure mentioned by Aristotle, used on the island
of Lesbos.[101] The idea is that the lead rule, being flexible,
accomodates itself to what it measures without forcing com-
pliance with the measure.[102] This was to be compared to
Aristotle's definition of equity as "justice that goes
beyond the letter of the law."[103] It is not possible to see
what Rigor holds in his hand, but he represents the strict
interpretation and execution of the law.[104] (fig. 47) The
duality of measure and law is doubtless a reference to
Cosimo I as statesman-architect, a central theme in Medici
iconography.[105]

In Raffaello Borghini's Il Risposo, written nearly
twenty years after the completion of Danti's two figures,
the interlocutors of the dialogue censured him for faulty
invention. The distant allusion was lost on them, and they
complained that Danti had ambiguously identified the figures
by their attributes, and worse than that, hidden what clues
there were. Before resuming their stroll through Florence,
they decided that Danti had either left his invention in
the marble, or else had simply wished to represent a man
and a woman and nothing more.[106] This judgment arose partly
from a demand formed by the prescriptions of the Council
of Trent, chief among which was iconographic clarity; but
it is also a fair evaluation of the arid excesses which
Danti had reached in the construction of his concetto. The
criticism is an indication of the historical fragility of

his intention, which had become entirely invisible in
only twenty years. It also reflects the end of a phase
of Danti's career. In the following years he for the
most part abandoned the attempt to visibly interweave
levels of meaning as he had done in his early Florentine
reliefs. The strained and heartless concetto of the testata
group was the last of its kind, and in the following years
Danti turned to a radically formal art, beginning with a
severe Michelangelo-based monumentality, and ending in the
pure stylistic refinement of the maniera.

The First Statue of Cosimo I:

A month after the completion of Equity and Rigor,
the proveditore of the Uffizi wrote to Prince Francesco
inquiring about the statue which was to crown the testata
group, the portrait of Cosimo I.[107] No agreement concerning
such a statue existed, and none was to be made until several
years later; but Danti, apparently acting on the strength
of Vasari's assurances that the Duke had approved the idea,
had begun a model, ordered the marble, and was pressing for
the settlement of the financial arrangements that would
make serious work possible. Francesco took a dim view of
the project from the beginning and replied that they would
worry about the sculpture when the time came, and for the
present worry about paying for the building.

The proveditore, who were consistently sympathetic to
Danti's case, then took the tack of telling the prince that

since the block of marble for the figure had already been
mostly paid for, it would be cheaper to pay the balance
than to lose the money already spent; and they added the
argument that, the question of the statue aside, the stone
should be bought in anticipation of the eventual need for
it, so that it would not be sold to someone else. These
down-to-earth considerations carried the day, and on December
24, 1566 the Prince sent word that Danti should be paid
the appraisal (which he considered exorbitant) for the
Equity and Rigor and the coat of arms which he had executed,
and permission was given to have the stone for the third
figure brought to Florence.[108]

Whether Francesco's lack of enthusiasm or simple
bureaucratic and practical matters got in the way, the
stone was not brought. Danti, as Vasari was also in the
habit of doing, met the situation by going around Francesco
to Cosimo himself. The requisite bit of flattery was the
dedication of his Trattato delle perfette Proporzioni,
which closes with the suggestion that if the Duke ever
stoop to read the treatise, the knowledge gained might
enable His Excellency to judge whether or not the precepts
set forth in it had been realized in some part in Danti's
statues. This dedication was dated April 21, 1567; four
days later a letter was sent by Tommaso de'Medici in the
name of the Duke to Matteo Inghirami, proveditore of the
quarries at Pietrasanta to block out the figure. Since the
stone was to be blocked out it must already have been quarried,

as the earlier letters of the proveditore of the Uffizi also
imply.[109]

Danti had returned to Florence from Pietrasanta
by May 3, and left almost at once for the quarries at
Seravezza.[110] Danti was something of a mineralogist and
was instrumental in opening the quarries of colored marbles
which so delighted Cosimo I and his heirs and became the
brick and mortar of late Medici taste. An important
reason for his trips to the quarries was gathering marble
for "un pavimento a una stanza d'ottangoli di marmi misti,"
a project especially dear to the Duke.[111]

It is not clear from the sources what became of the
piece of marble that Danti had blocked out at Pietrasanta.
The next ducal command in Danti's behalf, six months later,
urged that his stone be quarried with all possible diligence
and haste.[112] All that prevents the conclusion that this
is simply a reiteration of the earlier command--and that
this command had not been obeyed--is the fact that the
stone mentioned in the first letter was already quarried,
if not "sbozzato." The existence of the two statues is
explainable only if the two stones are different, and the
first stone from Pietrasanta had been brought from the
quarries to Florence immediately after Danti's trip to
Pietrasanta. He would then have had about six months
to work on it before it was judged uncompletable and a new
stone was ordered.

The request for a new piece of marble had been complied with by June 8, 1568 when Matteo Inghirami wrote that the marble needed by Vincenzo Danti for the figure he was to do for the Magistrati was among the first stones quarried at Altissimo.[113] The stone for the new statue was in Danti's shop by 1570.[114] The dimensions of the stone which Inghirami described, five braccia by two by two, are clearly for a standing figure; the height of the stone (5 braccia, c. 110 inches) compares exactly with the height of the figure in the Museo Nazionale (110 ¼ inches).[115]

If all this is correct it tallies with Vasari's report that Danti was expecting "at any moment" marble for a seated statue of the Duke "much larger than life size."[116] It would also mean that the documentary evidence after 1568 refers to the figure in the Museo Nazionale. It was this figure which was not yet begun in September 1570 when an appraisal of Danti's progress was made.[117] If the judgment of the four sculptors--Giovanni Bologna, Vincenzo de' Rossi, Battista Lorenzi and Francesco da Sangallo--was sound, and Danti, could not, as they said, have completed the statue in less than eighteen months, and could not have begun it until he finished his Baptistry group (set in place in June, 1571), then Danti would not have finished the Cosimo I in the Museo Nazionale until early 1573, or just before he left Florence. The Boboli Gardens figure

would then have been blocked out at Pietrasanta and worked
on in Florence for about half a year before it was abandoned.
It was then taken from Danti's shop in San Piero Scheraggio
to the villa at Pratolino in 1577, where it was forced into
the role of a fountain by sculptors in the shop of Giovanni
118
Bologna.

The Cosimo I in the Boboli Gardens is based upon
the Capitani in the New Sacristy, just as the Equity and
Rigor above which it was to have been placed reflect the
Times of Day (fig. 48) The head of the figure is a
striking prefiguration of nineteenth-century neo-classical
heads, combining Bronzino's penchant for the Greek manner
in classical models and the example of the personal classi-
cism of Michelangelo's Rachel and Leah on the tomb of Julius
II (fig. 49) Its artifical composition of heavy, discrete
parts recalls Bandinelli's statue of Cosimo's father,
Giovanni delle Bande Nere, in the Piazza San Lorenzo. The
unstable diamond configuration concentrates the weight at
the center of the seated figure, as Danti also did in the
Augustus of the sportello relief (fig. 27) Adjustment was
made to the considerable height at which the figure was meant
to stand. It tilts a few degrees forward on its base. The
large head and torso (which contribute importantly to its
heavy, wooden appearance at eye level), as well as the care-
ful poising of the parts--anticipating the Baptistry group
of 1569-70--only assemble when the figure is seen from
directly below (figs. 50 and 64). This unique formal

adjustment of individually axial elements--an extension
of the formal principles underlying the Onore, but applied,
probably under the influence of Giovanni Bologna, without
regard to the block of marble--linked with an extremely
low vantage point is reminiscent of Bronzino's St. Michael
in the Chapel of Eleonora of Toledo in the Palazzo Vecchio
(figs. 50 and 107)

The composition of the seated Cosimo I is at once
accomplished and ugly, and it is not difficult to see why
the statue was abandoned, even if there were a flaw in the
stone to further excuse it. The right arm is grafted to
the figure--perhaps in an attempt to make a larger scale
statue out of a narrow block--and must always have appeared
as clumsy as it appears now.

The fatal flaws of the statue were only accentuated
in the later modifications. The dragon-gargoyle upon which
Cosimo now sits was an ad hoc monstrosity added when the
figure was made to do as a fountain. Probably Cosimo I
was originally shown triumphant over Deceit, upon whose
whittled torso his left foot rests, the remnant of whose
claw is still hooked over the front of the statue's base,
and whose snaky tail he holds in his hand. The lower
part of the figure seems nearest a finished surface; but
since Danti only worked on it for a short time, the whole
figure lacks final finishing and detailing, and many of
the surfaces are unresolved.

The Santa Croce Madonna and Child:

When Danti carved the Onore che vince l'Inganno,
he worked Michelangelo's compositional precedent like a
model in his mind, smoothing and refining it until, while
remaining visible and essential, it was made to serve his
own more elegant purpose. The Prato Madonna is much more
severe in kind if not in degree of abstraction from its
models. In it a vocabulary appears for the first time to
which Danti turned repeatedly in his marble sculpture of
the next few years, combining forms of columnar volume,
drapery moving in slow swells over the surfaces and graphic
devices of unconditioned purity. This relatively severe
direction in Danti's sculpture seems to have arisen prin-
cipally from the systematic study and imitation of Michel-
angelo's works, probably in connection with the writing of
the first book of the Trattato. Danti had established
an alternative manner. It was not simply a development
in his style, since he continued to oscillate between this
abstract monumentality and the maniera preciousness of the
Onore and the Leda and Swan. After the Prato Madonna he
turned to the slinky decorative unity of Equity and Rigor,
tenuous reworkings of the Medici Chapel Times of Day.
(fig. 43) In the portrait of Cosimo I, which was to
have completed the two reclining figures, Danti drew once
again on the Medici Chapel, but this time he returned to
an abstract, monumental style, exaggerating the classical

coldness and formalism of the <u>Capitani</u>.

Just before the <u>Cosimo</u> <u>I</u> was begun, Danti finished
the large <u>Madonna</u> <u>and</u> <u>Child</u> now in Santa Croce.[119] (fig.
53) It stood complete in Danti's shop in Santa Maria
degli Angeli when Vasari wrote his biography of Danti,
perhaps in May of 1567.[120] The figure was thus finished
at almost exactly the same time as the <u>Trattato</u> was pub-
lished.[121] Why the statue was made is not clear. Vasari
described it with approval, but said only that it was in
Danti's shop. When Borghini wrote, it was in the Archbishop's
Palace.[122] The statue must have been there for only a short
period since it appears in no later descriptions. It is
possible that it was taken to the Archbishop's palace after
Danti had left Florence and, since Vasari did not mention
its purpose, that it was carved without a commission.

Like most of Danti's sculpture, the Santa Croce
<u>Madonna</u> <u>and</u> <u>Child</u> reveals little about itself. The mood
is one of unapproachable distance. The marble is treated
with the archaizing harshness of the <u>Beato</u> <u>Giovanni</u> <u>da</u>
<u>Salerno</u> (fig. 70) in Santa Maria Novella which Danti
carved three years later to replace a Trecento tomb des-
troyed by Vasari.[123] The swelling drapery surfaces defy
variation, and the marble was worked like chalk (figs. 58
and 56). One of the fingers of the Virgin was simply cut
away (fig. 59) Light is more important than it had been
in Danti's other marble sculpture. The drapery is cut in
sweeping, artificial vertical channels. The forms are

defined strongly and separately, and when light plays
over the statue (figs. 55 and 57), it takes on a kind
of visual and psychological activity which it lacks when
evenly lighted. The wonder is that the mass of the marble
is so completely spent in the conceptually pure vertical
movement of strong light and shadow. All of these move-
ments are equal, and since the undercutting is so uncommon-
ly deep, the boundary of the figure is without strong de-
finition. The great cumbrous woman becomes a fascicle of
light and dark; she drifts, passively, sustained by the
same visual energy in which the Christ child stands as
in a trance.

The image is partly courtly, but Danti's Virgin
belongs to the family of ethereal, flamelike women who,
like those in Pontormo's Carmignano Visitation or Jacques
Bellange's Three Marys at the Tomb, touch the point at which
an ideal of elegance and the dream of pure spirit grow
indistinguishable. Michelangelo's Medici Madonna, which is
usually pointed to as the source for Danti's Madonna, par-
takes of the same spirit. Danti also looked to earlier
art than Michelangelo's, as he seems to have been in the
practice of doing by this time; and the relationship of
his Madonna to Albertinelli's Visitation is too close to
be overlooked. That Albertinelli and Fra Bartolommeo an-
ticipated the taste of the Counterreformation has been
pointed out.¹²⁴ Danti takes up their classical gravity,

pushed past dignity to severity. All this leads back
to the ideal which lay behind the Santa Croce Madonna and
Child, the ideal of the Roman school of Michelangelo
around 1550.

Danti's group is constructed around a simple vertical
axis to either side of which the elements gather with an
equivalence that approached bilateral symmetry. These
elements work with respect to the core-axis emphasized by
the principal folds of drapery which, beginning with a
sharp bend at the bottom center, describe a slow, slightly
spatial S-curve ending in an angle--the reversal of the
angle with which it began--of the Virgin's slightly inclined
head. (figs. 53 and 54) This is the same device that
Michelangelo used in his Leah for the tomb of Julius II.
(fig. 125) The two figures of Rachel and Leah were the
lineal ancestors of Danti's Madonna. The linear unity in
two dimensions and delineation of volume in three; and the
mass abstracted from anatomical form, varied by unaccountably
changing drapery surfaces (especially comparable in the knees
of Danti's Madonna and Michelangelo's Rachel) were the
qualities which Danti fixed upon and strove to imitate.

The formal severity of Michelangelo's Rachel and
Leah yielded, in combination with the developed forms of
the Roman maniera, a canon very similar to that behind
Danti's Madonna. It was probably from this transformation
in the school and not directly from Michelangelo's own
sculpture that impetus for Danti's conception came. The most

precise parallel to Danti's <u>Madonna</u> is the central figure
in a study for a <u>Martydom</u> <u>of</u> <u>St</u>. <u>Catherine</u> by a Roman
follower of Michelangelo near Daniele da Volterra. (fig. 126)[125]
In addition to the similarity of the two figures the visual
saliency of the compositional schema should also be noted
in the drawing. The specific kind of formulation--which
on the basis of such late sculpture as the <u>Rachel</u> and
<u>Leah</u> may well have had a basis in Michelangelo's own utter-
ances and procedures--probably also spawned the tradition
of the <u>linea serpentinata</u>, supposedly disclosed by Michel-
angelo to Marco Pino.[126] Part of the doctrine of the
<u>linea serpentinata</u>,as it was recorded by Lomazzo, reads
like a description of Danti's <u>Madonna</u> and deserves to be
quoted at length:

> The most grace (grazia) and elegance (leggiad-
> ria) that a figure may possess is that it appear
> to move itself (che mostri di muoversi), which
> appearance of movement painters call the <u>furia</u>
> of the figure. And in order to represent this
> movement, there is no form more suitable than
> that of a flame, which according to Aristotle
> and all the philosophers is the most active ele-
> ment; and the form of the flame is most apt to
> movement of all forms, because it has a cone and
> sharp point, with which it seems to wish to rend
> the air, and rise to its own sphere. So that
> when the figure has this form it will be most
> beautiful. This may be put into practice in
> two ways; one is that the trunk of the pyramid--
> this is, the widest part--be located in the
> widest part, like a flame; then one ought to
> show fullness and breath in the legs and draperies
> at the bottom of the figure; and above one should
> sharpen the figure in the manner of a pyramid,
> showing one shoulder, and making the other recede
> and foreshorten so that the body is twisted, and
> one shoulder is hidden, and the other stands out
> and is revealed. . . the shape of a flame. . .

> Michelangelo called serpentinata, that
> reproduces the curviness of a moving snake,
> that is the very form of the upright letter
> "S". . .
> 127

The _linea_ _serpentinata_ is usually taken to mean

a spiral, and illustrated by such works as Michelangelo's
128
Victory or Giovanni Bologna's _Rape of the Sabines_.

This is no doubt correct, but Danti understood it as essen-

tially a two dimensional device, the S-curve described by

Lomazzo, coupled with the torsion of the figure around the

axis governing the rise of the curve, as in Michelangelo's

Leah. There is nothing in Lomazzo's account to contradict

this understanding; and in the _Rachel_ and _Leah_, Danti chose

the most compressed, restrained late results of Michelangelo's

long concern with the problem of movement in sculpture.

The object of the _linea_ _serpentinata_ was to endow

the figure with an apparent potentiality for movement.

Movement, of course, was one of the central problems of

Danti's treatise, not necessarily because all human move-

ments are unique or complicated beyond complete visual

comprehension--problems which bothered him verylittle--

but because self-movement was the distinguishing capability

of the higher forms of life, man and the animals.

> in addition to their structure being made
> up of more parts, different among themselves,
> it (the structure) also has self-movement
> (il muoversi). This movement of many parts of
> one body increases the difficulty and art re-
> quired, because it is necessary not only to
> compose the parts of a sensitive or intellec-
> tual animal well so that they correspond to the

> whole, but also to give the parts movement
> and attitude as they are called for. . .
> 129

The linea serpentinata was a principle of unity around
which the parts of the body could be organized, and the
chief constituent of the symbolism of movement.

Danti was concerned with syntactical formal
relationships, similar in kind to the visual syntax operant
in his sportello relief, where specific meaning was de-
termined by position in a diagrammatic system, half-apparent
on inspection in the strict ordering of the elements, but
fully discoverable only after close examination. This pro-
vides the key to the basic idea of Danti's Trattato delle
perfette proporzioni: the idea of order. What Danti meant
by this term is not easy to discern in the text itself,
and Danti was hard-pressed to define a concept which as
one of the shibboleths of Renaissance discussion of the
arts was seldom closely examined in its own right. [130]
Danti's meaning can be clarified by the example of arch-
itectural order. [131] An order is a set system of defined
parts in a fixed relationship to one another, considered
independently of individual application or instance, and
therefore without regard to quantity. [132] Danti saw a
similar necessity of disposition of elements in the struc-
ture of the natural world and the cosmos (making possible
a diagrammatic visualization which isometric space excluded),
and believed that it existed in the human figure, and was
discoverable through the study of anatomy. [133]

Danti expressly repudiated quantitative proportion, and with it went the postulate that, insofar as it is measurable, the human body is all of a kind. Rather the human body for Danti was a relationship of parts, each definable by its use.[134] The principles of unity, then, which he intended by the term "order" were the higher principles which governed the disposition of the parts of the body. He was concerned with the human image on the level of organization. In contrast to the tradition of proportion, which attempted to be both normative and descriptive, Danti's was a highly abstract concern, split away from appearance and directed even at the level of description (anatomy) to the generic rather than the particular. The transparent formalism of the Santa Croce _Madonna_ is a study of such an "order."

An obvious and crucial element in order is bilateral symmetry, a pure formal relationship, non-quantitative, and a primary basis for the organization of the human body. Significantly enough, Danti discusses bilateral symmetry in the chapter of his treatise on grace.

> I should not neglect to say that in many of her works Nature has been pleased to create symmetry (la parità e conformità) which, it must be said, is useful, convenient, and multiplies beauty. Through this union of similar beauties, symmetry strengthens and increases the perfection of the beauty that consists in the individual members. Still, this symmetry is unable to attain its end if it has not in itself three parts, or three qualities, those of position, of form, and of quantity. But of this I will speak at length in the book on the use of the parts.

That the mystery of mirror symmetry in nature occupied
Michelangelo, and that he considered it essential to the
understanding not only of architecture, but also of the
human body, and that this understanding was grounded in
the structure of the human anatomy, is clear from his
well-known letter to an unknown prelate.[136] The defin-
ition and reverberation of Michelangelo's thought about
his art in the last years of his life have not been clearly
charted. It is only known that he had such thoughts which,
if they were not elaborated by Michelangelo himself, were
expanded by his followers. It might be suggested, however,
that the idea of order lay at the heart of the "ingegnosa
teorica" which Michelangelo explained to Condivi and about
which Condivi planned some day to write.[137]

Danti's Santa Croce _Madonna_ was a serious investi-
gation of Michelangelo's sculpture, based partly, as Danti
says in his treatise, on examination of the sculpture itself
with an eye to the discovery of the rules governing it and
partly on a tradition of precepts which had originated
around Michelangelo; these Danti might have come to know
either in Rome or in Florence. The sculpture throws a
certain amount of light on Danti's highly theoretical and
completely unillustrated treatise, and may be taken as a
practical essay complementary to the _Trattato_. It is the
clearest example of the academic transformation of Michel-
angelo's style which Danti sought.

Notes to Chapter III:

[1]
The date 1559 for the Bacchus, now in the Borgo
San Jacopo in Florence, was first advanced by F.
Kriegbaum, "Der Meister des 'Centauro' am Ponte Vecchio,"
Jahrbuch der Preuszichen Kunstsammlungen, XLIX, 1928, p.
135-40; and is accepted by J. Pope-Hennessy, High Renaissance Sculpture, III, p. 80.

[2]
Vasari-Milanesi, VI, p. 188. The history of the
competition is recounted in detail, with bibliography, by
J. Pope-Hennessy, High Renaissance Sculpture, III, p. 73-
75; and B. Wiles. The Fountains of the Florentine Sculptors,
Cambridge, 1933, p. 117-119.

[3]
Wiles, Fountains, p. 119.

[4]
E. Plon, Benvenuto Cellini, Orfèvre, Médailleur,
Sculpteur, Paris, 1883, p. 236n. prints Leoni's letter.
". . . Il Perugino ha fatto assai per giovine; ma non ha voce
in capitolo." Leoni is described by Cellini as "my great
enemy", which perhaps accounts for Leoni's belittling report
on Cellini's model. See The Life of Benvenuto Cellini written
by himself, ed. J. Pope-Hennessy, New York, 1949, p. 235.

[5]
Published by E. Dhanens, Jean Boulogne: Giovanni

Bologna Fiammingo, Brussels, 1956, fig. 25 .

6
See Chapter III below p. 137

7
Vasari-Milanesi, VII, p. 631.

8
Baccio Bandinelli; a prolific sculptor and
draughtsman, whose roundly hated life is perhaps better
recorded than any other sculptor of the Cinquecento besides
Michelangelo, has not had a systematic study devoted to
him. See J. Pope-Hennessy, Italian High Renaissance
Sculpture, III, p. 62-69; A. Venturi, Storia, X, 2,
p. 187-239; and more recently M. G. Ciardi Duprè,
"Alcuni aspetti della tarda attività grafica del Bandinelli,"
Antichità Viva, V, 1966, p. 22-31; "Per la cronologia dei
disegni di Baccio Bandinelli fino al 1540," Commentari,
XVII, 1966, p. 15-38; D. Heikamp. "In margine alla vita
di Baccio Bandinelli del Vasari," Paragone, 191 , 1966,
p. 51-62; and "Baccio Bandinelli nel Duomo di Firenze,"
Paragone, 175, 1964, p. 32-42. C. H. Smyth found precedent
for the early independent style of Bronzino in the sculp-
ture of Bandinelli ("The Earliest works of Bronzino," Art
Bulletin, XXXI, 1949, p. 202-3); D. Heikamp, "Baccio
Bandinelli nel Duomo," found precedent for Bandinelli's
late reliefs in the painting of Bronzino.

9
Vasari-Milanesi, VII, p. 631. "onde alla testa di

quell'Onore, che è bella, fece i capelli ricci, tan ben
traforato, che paiono naturale e propri, mostrando oltre
ciò di benissimo intendere gl'ignudi." Benvenuto Cellini's
reaction to the failure of Danti's Hercules and Antaeus is
recorded in a poem fragment published by A. Mabellini,
Delle Rime di Benvenuto Cellini, Florence, 1892, p. 307.

> Hercol sospese Anteo; poi 'l gittò via
> Perchè il ladron rubava vacche et buoi
> Molto più bravo è questo, or, che è fra noi
> Chè à tre volte ambeduoi gittati via.
>
> Sforzzommi quel da l'alta impresa mia
> Tirarmi indietro et a lui rimase i buoi,
> Le vacche al Bandinello et i servi suoi
> Prese un Granchio il Grifone e 'l gittò via.

The irony of the first verse is clear: Hercules
lifts up Anteus, then throws him away/ Because the thief
stole cattle and oxen/ Much braver is this one, now among
us/ Because he has cast both of them away three times.
The meaning of the second verse is less clear: That (one)
dissuaded me to withdraw from my own high task and leave
to him (Danti) the oxen, Leave the cows to Bandinelli and
his lackeys; the griffin (the Perugian) took a crab and
threw it away. Reference to Bandinelli may be a clue
to Danti's first contacts in Florence and may explain where
Danti learned to carve marble and why his debt to Bandinelli's
Duomo choir reliefs is so outstanding. The references to
cattle may be to the animals carved for the grotto at
Castello. The work of Bandinelli and his pupil Giovanni
Fancelli in the Boboli Gardens must have been well-known
and would have been little admired by Cellini. "Il Granchio"

might be a similar reference but primarily it refers to
Danti's blunder,"a prendere un granchio" being to make
a mistake.

14
The drawing was given to Danti by C. de Tolnay,
Michelangelo, IV, fig. 271; and it was taken away from
him and given to Michelangelo himself by C. de Tolnay, "Sur
des vénus desinées par Michel-Ange a propos d'un dessin
oublié du Musée du Louvre," Gazette des Beaux Arts, LXIX,
1967, p. 193-200; without dismissing his earlier attri-
bution. A drawing in the Casa Buonarroti (Barocchi,
Michelangelo e la sua scuola, no. 182, attrib. to Antonio
Mini), although badly overdrawn, shows a similar figure from
three sides--182 recto is the most legible--and from this
it may be inferred that a modello of a similar figure existed.
The resemblance of the Louvre drawing to certain of Michel-
angelo's Resurrection drawings (J. Wilde, Michelangelo and
his Studio, 1953, no. 53) should be noted. The composition
that Danti was referring to was a popular one.

15
Barocchi, Michelangelo e la sua scuola, no. 200.
The similarity of the left hand of the figure in this
drawing should be compared to the right hand of Danti's
Onore.

10
See below, Chapter IV, p.

[11] Ammannati's _Victory_ has been connected with the 1505 project for the Tomb of Julius II by C. de Tolnay, _Michelangelo_, IV, p. 92. On Pierino da Vinci's _Samson and the Philistine_ see Vasari-Milanesi, VI, p. 128 and J. Pope-Hennessy, _Italian High Renaissance Sculpture_, III, p. 61-62.

[12] Vasari-Milanesi, VII, p. 630; ". . .una statua di braccia cinque d'una Vittoria con un prigione, che va nella sala grande dirimpetto a un'altra di mano di Michelangelo. . ."

[13] C. De Tolnay, _Michelangelo_, IV, p. 110, ("probably an echo of the pendant") followed by J. Pope-Hennessy, _Italian High Renaissance Sculpture_, III, p. 24. An alternative is offered by J. Wilde, _Michelangelo's Victory_, London, 1954, p. 18 who links Michelangelo's projected figure with a _bozzetto_ in the Casa Buonarroti which is usually associated with Michelangelo's _Samson and the Philistine_ or _Hercules and Caecus_ invention. A copy of this _bozzetto_ is to be found in the Victoria and Albert Museum, and a full discussion of the problem of its identity is given by J. Pope-Hennessy, _Catalogue of the Italian Sculpture in the Victoria and Albert Museum_, London, 1964, no. 445.

[16] Michelangelo's _Slaves_ were in Florence and were

studied. "Nel medesimo modo si debbono cavare con la scarpello le figure de' marmi; prima scoprendo le parti più rilevate, e di mano in mano le più basse" il quale modo si vede osservato da Michelangnolo ne sopradetti prigioni, i quale Sua Eccellenza vuole che servino per esempio de' suoi Accademici." (Vasari-Milanesi, VII, p. 273)

17
See Chapter II, note 67.

18
On this kind of composition see Chapter II, note 57. Other examples in sculpture which might be adduced are Vincenzo de'Rossi's Hercules and Diomedes in the Salone dei Cinquecento of the Palazzo Vecchio, in which one figure is simply inverted, and Bernini's Aeneas and Anchises in the Borghese, where a figure is repeated vertically and reversed.

19
See Catalogue X.

20
With the significant exception of Giorgione (Vasari-Milanesi, I, p. 101 and IV, p. 98). On these paintings see J. Holderbaum, "A Bronze by Giovanni Bologna and a Painting by Bronzino," Burlington Magazine, XCVIII, 1956, p. 439-45.

21
P. Barocchi, Trattati, I, p. 80. "Dico che l'arte

della scultura infra tutte l'arte che s'interviene disegno
è maggiore sette volte, perchè una statua di scultura de'
avere otto vedute e conviene che le sieno tutte di egual
bontà." In his Sopra la differenza nata tra gli scultori
e i pittori circa il luogo destro stato dato alla pittura
nelle essequie del Gran Michelangnòlo Buonarroti (I Trattati
dell'oreficieria e della scultura, ed. L. de-Mauri, Milan,
1927, p. 270) Cellini states that sculpture must be able
to be seen from "a hundred or more" points of view.

22
Dr. Ulrich Middeldorf has suggested to me that
the lower figure might represent Aristotle, the Stagirite,
and thus refer to the dispute between Benedetto Varchi
and Castelvetro.

23
As set forth in a sonnet by Timoteo Bottonio;
see Catalogue IX, "Discussion" for the sonnet, dated
Florence, 1561.

24
L. Berti, Il Principe dello Studiolo, Florence,
1968, p. 280, accepts the story that Sforza Almeni had
divulged Cosimo's love for Eleonora degli Albizi to
Prince Francesco. He was murdered in the Palazzo Vecchio
on May 22.

25
See below pp. 150-155

26

Danti occupied the cell in the Monastery in
Santa Maria degli Angeli which Benedetto Varchi left
vacant at his death. The two men exchanged sonnets (Appendix
VII) and Varchi composed a distich on the Onore che vince
l'Inganno. PBA. I. 105 Epistola di Benedetto Varchi.

VINCENTIUS DANTIUS

Catenata invidia indotta

exsculpsit honorem

Dantius; una ut sint, an duo

signa roges

"With Ignorant envy chained, Danti has sculptured Honor so
that you ask whether they are one statue or two."

27

ASF. Misc. Medicea 514, no. 21. "Donazione di
Beni, e Pensione Annuo fatto dal Serenissimo Gran Duca Cosimo
e dal Serenissimo Gran Duca Francesco." A Messer Sforza
Almeni Cameriere l'Anno 1545 gli donò una Casa nella via
de'Servi, fu di Vincenzio Taddei, Stimata ducati m/2. "
On the Palazzo Almeni see L. Biadi, Notizie sulle Antiche
Fabbriche di Firenze non terminate, Florence, 1824, p. 240.
And G. B. Ristori, "Di una casa in Via dei Servi, e di
alcuni avvenimenti che vi si riferiscono (il Palazzo Almeni)",
Arte e Storia, terza serie, Florence, January, 1906, no. 1-2,
p. 38-40. The second of these articles deals mostly with
the circumstances of Almeni's death. On the facade decoration
by Cristofano Gherardi and Giorgio Vasari see note 28 below.

28
On the facade of the Palazzo Almeni see Vasari's
original description in a letter of October 21, 1553 (Frey,
Nachlass, I, p. 373-379) and his slightly variant des-
cription in the life of Christofano Gherardi (Vasari-Milanesi,
VI, p. 228-237) and H. Werner-Schmidt, "Vasari's Fassade-
malerei am Palazzo Almeni," Miscellanea Biblioteca Hertzianae,
zu Ehren von Leo Bruhns, Franz Graf Wolff Metternich, Ludwig
Schudt, Munich, 1961, p. 271-74. G. and C. Thiem,
Toskanische Fasaden Dekoration in Sgraffito und Fresko, 14
bis 17 Jahrhundert, Munich, 1964, p. 131; J. Rouchette,
La Renaissance que nous a Léguée Vasari, Paris, 1959, p.
26-32; and S. Chew, The Pilgrimage of Life, New Haven,
1962, p. 163-65.

29
On the Spanish Chapel see M. Meiss, Painting in
Florence and Siena after the Black Death, New York, 1964,
p. 94-104. Vasari's favorable impressions of the Spanish
Chapel are in Vasari-Milanesi, I, p. 551-2. A poem by
Alfonso de'Pazzi, cited by L. Berti, Il Principe dello
Studiolo, p. 268, satirizes the didactic structure and
encyclopedic content of Vasari's facade. ". . .E così li
Aretini--pittori e accademici hanno cura--d'insegnar le scienza
con la mura."

30
A. Katzenellenbogen, Allegories of the Virtues
and Vices in Medieval Art, New York, 1964.

31
S. Chew, The Pilgrimage of Life, New Haven, 1962,
p. 163-5.

32
Danti, Trattato, p. 227-8.

33
It should be remembered that Danti boasted of
having dissected eighty corpses in the preparation of his
treatise. (Danti, Trattato, p. 211) However true this may
be, when Vasari speaks of the Onore as "mostrando. . .di
benissimo intendere gli'ignudi," (Vasari-Milanesi, VII, p.
631), he should be taken seriously. There is no record of
Danti's activity as an anatomist in Florence of which I
know, although Ignazio Danti, speaking of "Vesalius,
Valverde et Vincenzo Danti" (Le Due regole della prospettiva
di M. Iacopo Barozzi da Vignola, Rome, 1583, p. 3) speaks
of annotations made at dissections in Florence. Cosimo I
was an enthusiastic patron of Vesalius.

34
See Catalogue IX, "Discussion".

35
Vasari-Milanesi, VII, p. 631. "Voltossi dunque,
per non sottoporre le fatiche al volere della fortuna, a
lavorare di marmo: condusse in poco tempo di un pezzo solo
di marmo due figure, cioè l'Onore che had sotto l'Inganno,
con tanta diligenza, che parve non avesse mai fatto altro
che maneggiare i scarpelli ed il mazzuolo. . ."

36
Danti, *Trattato*, p. 216, "negli elementi poi piacque al grande Dio che, oltre all'ordinatissima loro composizione, vi potesse ancor aver luogo il disordine, per lo quale nelle cose elementari esso potesse cagionarsi."

37
Frey, *Nachlass*, III, p. 49, April 24, 1563. ". . . Messer Vincentio Danti scultor perugino in casa Messer Sforza." See also *Nachlass*, I, p. 757, May 22, 1563.

38
Ibid.

39
Vasari-Milanesi, VII, p. 631.

40
See Catalogue no. X.

41
See Catalogue XI.

42
H. Keutner, "The Palazzo Pitti Venus and other Works by Vincenzo Danti," *Burlington Magazine*, C, 1958, p. 427-431.

43
See Catalogue XI, "Discussion."

44
Leda and the Swan was a popular theme in Florentine sculpture which has had a poor rate of survival. Ammannati,

Vincenzo de' Rossi, Cellini, and Daniele da Valterra had all treated the theme in sculpture by 1560. See Catalogue XI, "Discussion."

45
The closely repeated decorative pattern of the drapery distinctly recalls Ammannati as does the hard, linear design of the shell, the softness of the surface, and the large thighs which are similar to the Nari monument _Victory_. The direct classical influence pointed to by Keutner (_Burlington_ _Magazine_) seems to me to be minimal. Danti's _Leda_ is several removes from its closest classical prototype (See Catalogue XI) and is understandable in terms of contemporary models.

46
This dependence was pointed out by Keutner (_Burlington_ _Magazine_).

47
Danti maintained close ties with his native city during his years in Florence; and W. BOmbe, Thieme-Becker, VIII, p. 384 wrote that he was elected a Prior for the second quarter of 1559, and castellan for the first semester of 1564. Bombe also wrote that Danti rebuilt the staircase of the Palazzo del Capitano during the same years that he repaired the fountain. This is also described by R. Borghini, _Il_ _Riposo_, p. 521-22. Since Bombe did not give documentary evidence for this statement, and follows it with the statement that Danti submitted his design for

the church of the Escorial during the same years, there is
no reason to suppose that this was not done after 1573, when
Danti was city architect of Perugia, as Borghini implies.
(See Chapter VI, note 9) Danti's design for the church
of the Escorial was presented in 1572. For the document
describing the restoration of the Fontana Maggiore see
G. B. Vermiglioli, Dell'Acquedotto e della Fontana Maggiore
di Perugia, Perugia, 1827, p. 60-1. For its hydraulic
history see A. Mariotti, Lettere Perugine, p. 29. The
fountain ran out of water in 1458; in 1554 and effort was
made to repair it; and in 1558 it was without water. After
Danti's repairs it went dry again in 1670. In October 1565,
Danti was also recorded in Perugia. (Thieme-Becker, VIII,
p. 384).

48
 Catalogue XXIX.

49
 G. B. Vermiglioli, Dell'Aquedotto e della
Fontana Maggiore di Perugia, p. 16, n82-84.

50
 Danti's reputation as an engineer began with R.
Borghini's biography (Il Riposo , p. 521-22). See also
G. B. Vermiglioli, Dell'Aquedotto e della Fontana Maggiore,
p. 16, n82-84.

51
 Frey, Nachlass, I, p. 43; the project was men-
tioned earlier as a possibility (Frey, Nachlass, I, p. 629-30)

in August and September 1561.

52
Frey, Nachlass, III, p. 6, May 29, 1562. The
marble is not identified as for the monument, but since
it had arrived in Pisa already, it cannot have been the
marble for his next commission, the Uffizi group, which
soon begins to dominate discussion.

53
A. del Vita, Lo Zibaldone di Giorgio Vasari,
p. 248, April 18, 1564.

54
The Prato group is dated 1566 by inscription. This
is problematical since the inscription had been chosen by
March 13, 1564 (Frey, Nachlass, II, p. 50). The group
must have been largely complete by this time.

55
Frey, Nachlass, III, p. 43, March 13, 1563,
letter of Giorgio Vasari to Giovanni Caccini, the Proveditore
of Pisa. ". . . il Sasso di Vincentio Perugino lo mandj, che
sarà servitio a me particulare. . . " The purpose of the
stone is not mentioned, but Vasari, as architect of the
Uffizi, is evidently referring to that program.

56
Frey, Nachlass, III, p. 70, February 16, 1564.

57
For the wheedling and browbeating see Frey, Nachlass,
III, p. 77-78, April 22, 1564; the stone had arrived by May

13. Frey, Nachlass, III, p. 81.

58 Frey, Nachlass, III, p. 200, June 7, 1564.

59 The column is mentioned May 1, 1562; A. del
Vita, Inventari, p. 46. Danti had disclosed his scheme
for the column to V. Borghini by May 22, 1563. (Frey, Nachlass,
I, p. 757). On the plans for a statue, perhaps of Cosimo
I, see Frey, Nachlass, II, p. 9-12. Danti had opted out
by September 26, 1563 (Frey, Nachlass, II, p. 5). Frey
notes that the letter probably refers to the Fountain of
Neptune competition, but this is incorrect since this took
place three years earlier.

60 P. Ginori Conti, L'Apparato per le Nozze di
Francesco de' Medici e di Giovanna d'Austria, Florence, 1936,
p. 22.

61 Frey, Nachlass, III, p. 79, March 4, 1564. The
letter is from Francesco Moschino to Giovanni Caccini. "Lapporta-
tore di questa vi consegnera dui pezzi di marmo, di due carrate
el'pezzo, (for the Prato putti?) e quattro pezzi per 4 teste,
che sono una carrata, quali sono di messer Vincentio Danti
Scultore. . ."

62 Frey, Nachlass, III, p. 77-78.

63
See Catalogue XXV.

64
Vasari-Milanesi, VII, p. 632.

65
Vasari-Milanesi, VII, p. 632. ". . .di ordine del
quale (Signore) fece la porta della Sagrestia della Pieve
di Prato, e sopra essa una cassa di marmo con una Nostra
Donna alta tre braccia e mezzo, col figliuolo ignudo app-
resso, e due puttini, che mettono in mezzo la testa di
bassorilievo di Messer Carlo de'Medici.

66
The design bears a general resemblance to a drawing
in the Casa Buonarroti (Barocchi, I Disegni, no. 258, tav.
CCCLVI) which has been attributed to Danti.

67
See Bandinelli's figure of God the Father in the
Chiostro Grande of Santa Croce, or a similar figure banished
to the Boboli Gardens.

68
The problem of the influence of the Bruges Madonna
is discussed by E. F. Bange, "Spuren von Michelangelos
Brügger Madonna in Deutschland, Frankreich und den Neder-
landen," Mitteilungen des Kunsthistorischen Institutes in
Florenz, ,1940-41, p. 109-114. The monument to Carlo
de'Medici is listed by C. de Tolnay as a "copy" of the
Bruges Madonna (Michelangelo, I, p. 159). This is a

problem since neither Condivi nor Vasari knew the statue
which had been sent to Bruges in 1506. Vasari omitted it
in 1550; Condivi described it as bronze in 1553, followed
by Vasari in his second edition, adding that it was a tondo.

[69] S. J. Freedberg, Parmagianino, his Works in
Painting, Cambridge, 1950, p. 71, cites the Bruges Madonna
as Parmagianino's immediate source and concludes that he
must have known it through a drawing, since it was not
engraved until 1527.

[70] Catalogue XIV

[71] The Porta della Mandorla was much admired by
Vasari, who attributed it to Jacopo della Quercia. (See
H. W. Janson, "Nanni di Banco's Assumption of the Virgin
on the Porta della Mandorla," Acts of the Twentieth Inter-
national Congress of the History of Art, Princeton, 1963,
II, p. 98-107.) Danti might well have meant to refer by
this resemblance--and this would be perfectly consistent
with his method of invention--to St. Thomas receiving the
sacro cingolo. This was the theme of Nanni's Assumption,
and the cingolo was Prato's prize relic. Donatello's pulpit
on the facade of the Duomo is the pergamo del Sacro Cingolo,
and inside a cycle of paintings by Agnolo Gaddi illustrates
the legend of the Holy Girdle. Thus Danti would have had

iconographic reaon for referring to Nanni's relief in addition
to attempting to re-do a Quattrocento sculpture, as he did
in the relief below. As usual, Danti's formal and icono-
graphic blending resulted in ambiguity as to his intention
in later writers. Apparently because of the strong presence
of the two candelabra-bearing putti, the Madonna has been
consistently, and no doubt incorrectly, identified as a
Charity figure, first by A. Baldanzi, Descrizione della
Cattedrale di Prato, Prato, 1846, p. 104-5; followed by
Vasari-Milanesi, VII, p. 632, n2; and G. Marchini, Il Duomo
di Prato, n. p. , 1957, p. 68-69 .

72
 The question of such an application of the "seste
dell'occhio" to the problem of the high placement of
sculpture is discussed by E. Rosenthal, "Michelangelo's
Moses dal di sotto in sù," Art Bulletin, XLVI, 1964, p.
544-50.

73
 On Carlo de'Medici, the natural son of Cosimo
Vecchio and provost of Prato from 1460 to 1492, see C. Guasti,
Bibliografia Pratese, Prato, 1844, p. 126n; and Frey,
Nachlass, I, p. 630.

74
 H. Keutner, "The Palazzo Pitti Venus and other
Works by Vincenzo Danti," Burlington Magazine, C, 1958, p.
427-431. See Catalogue XIII for other attributions.

[75] This statue has not been published.

[76] C. de Tolnay, "La Venere con due Amorini già a Pitti ora in Casa Buonarroti," Commentari, XV, 1966, p. 324-332.

[77] M. Weinberger, Michelangelo the Sculptor, New York, 1968, p. 350.

[78] Vasari-Barochi, III, p. 1130-1137 . On the figures which were to have completed the chapel see Frey, Nachlass, I, p. 739, "Dove il Tribolo el Monte Lupo el Frate feciono alcune statue."

[79] Ibid.

[80] Ibid., 1128-30.

[81] Catalogue XIX.

[82] See Chapter V below p.

[83] Vasari-Barochi, III, p. 1128-30.

[84] See Catalogue XIX.

[85] Ibid.

86
On Danti's restoration see Catalogue XXV. The problem of interpretation in restoration is discussed by M. Neusser, "Die Antiken ergänzungen der Florentiner Manieristen", Wiener Jahrbuch für Kunstgeschichte, VI, 1929, p. 27.

87
See above p. 158-160

88
Catalogue XXIX.

89
Catalogue XIII.

90
Frey, Nachlass, III, p. 81.

91
Ibid., p. 200

92
Vasari-Milanesi, VII, p. 632.

93
Frey, Nachlass, III, p. 200.

94
H. Keutner, "Über die Enstehung und die Formen des Standbildes im Cinquecento," Münchner Jahrbuch der Bildenden Kunst, III, Folge, VII, 1956, p. 148 discusses the chronology of the figures in detail.

95
On the history of the Uffizi project see U. Dorini,

"come sorse la fabbrica degli Uffizi," Rèvista Storica degli archivi toscani, V, 1933, p. 1-40. Francesco I, then regent, was largely responsible for the project, and was not as free-spending as his father had been.

[96] See Chapter V below p. 305-307

[97] See E. Dhanens, Jean Boulogne, p. 231-32 for a brief discussion, and later sources pertaining to Giovanni Bologna's figure.

[98] The first figure which was to have completed the group was only begun. The so-called Perseus, now in the Boboli Gardens (Catalogue XVI) is no doubt identical with the seated figure larger than life size which was described by Vasari. (Vasari-Milanesi, VII, p. 632)

[99] See G. F. Hill, G. Pollard, Complete Catalogue of the Samuel H. Kress Collection. Renaissance Medals, London, 1967, no. 341.

[100] C. Ripa, Iconologia, in all editions, sub voce "Equità" Del Reverendissimo Padre Fra Ignazio. Donna con un regolo Lesbio di piombo in mano; perchè i Lesbi fabbricavano di pietre a bugne, e le spianavano solo di sopra, e di sotto, e per essere questo regolo di piombo, si piega secondo la bassezza delle pietre; ma però non esce mai dal dritto:

così l'Equità si piega, e inchina all'imperfezione umana
ma però non esce mai dal diritto della giustizia. Questa
figura fu fatta dal Reverendissimo Padre Ignazio Vescovo
di Alatri, e Matematico già di Gregorio XIII. essendosi così
ritrovata tralle sue scritture." Since Ignazio Danti had
Vincenzo Danti's papers after his death, either one or
both of them might have been responsible for the invention.
See Appendix IV below.

101
 Bocchi-Cinelli, Le Bellezze, p. 99"...
perochè tale fu il suo (Cosimo I) governo, ed il suo
valoroso avviso, che dicidendo le cause di ragione, con grave
senno tutta via temperò sempre il rigore delle leggi con
la discrezione, e con l'equità. È notabile questa, ma
per quello avviso, che trattato dal miglior filosofo, co-
tanto è da' letterati ricordato. Egli si usava nell' isola
di Lesbo nel misurare à braccia gli intagli di architettura
una regola di piombo: perchè piegandosi sopra luoghi, ove
era il lavoro intagliato, distesa poscia, come era nel
vero, si conosceva il nemero delle braccia senza errore,
e quello che dare à gli artefici si dovea. A questa Regola
Lesbia agguaglia il Filosofo l'Equità; ed in questa figura,
quantunque non sia di piombo, ma di marmo, tuttavia, perchè
significhi la discrezione, è state ottimamente effigiata."
A. M. Salvini, Discorsi Accademici, Bologna, 1821, I,
p. 114 repeats the attribution of this metaphor to Aristotle.
I have not located it in Aristotle's writings.

102
Salvini, Discorsi, I, p. 114.

103
Rhetoric, I, XIII, 10-13.

104
Rigor is probably holding a rod or part of a
rod. See Ripa, Iconologia, sub voce "Rigore. . .Uomo rigido,
e spaventevole, essendo il rigore sempre dispiacevole, e
risoluto ad indur timore negli animi additi. . . Onde la
verga di ferro si pone per l'asprezza del castigo, o di fatti,
o di parole. . ." Ripa does not say whether this invention
came from Ignazio Danti's papers. The nicety of a rod of
iron and a rule of lead would have been much to Danti's
taste, and fully in the spirit of the enterprise.

The relationship of Equity to Rigor was not Danti's
alone; see the Vocabulario dell'Accademia della Crusca,
sub voce "Equità" from the Statuti d'arte di Por Santa
Maria (Arte della Seta) in which a cluster of ideas appears
which is identical with Danti's and perhaps explains the
small figure of Deceit beneath the seated portrait of
Cosimo I which was to have completed the group. (Catalogue
XVI) "Quanto discordà dalle legge divine ed umane, ed è
contrario all'equità naturale la fraude e l'inganno. . .
tanto si debbe con le nuove leggi et ordini provedere rigoros-
amente contro quelli che l'usono. . ."

105
Studied in detail by K. Langedijk, De Portretten
van de Medici tot omstreeks 1600, Diss., Amsterdam, 1968,

p. 105-121. The reference to Lesbos also carries a
connotation of which Danti's lapidary interests must have
made him aware; Lesbos as Pliny recounts, boasted a highly
prized bluish marble, a part of the concetto probably
intended to match the pietra serena of the Uffizi itself.
(Pliny, Natural History, XXXVI, V, p. 44)

106
 R. Borghini, Il Riposo, p. 65-66.

107
 Frey, Nachlass, III, p. 201.

108
 Frey, Nachlass, III, p. 202.

109
 V. Danti, Trattato, p. 210; Frey, Nachlass, III,p. 202.

110
 G. Gaye, Carteggio, III, p. 246. Danti got
marble for Giovanni Bologna's Florence group as well as
colored marbles for the Duke. The following year, Danti
wrote two long-winded letters to Francesco I from the
quarries at Seravezza (Gaye, Carteggio, III, p. 251-154
and 254-256) reporting on the progress in mining the marbles.
These letters are also published by C. da Prato, Firenze
ai Demidoff e S. Donato, Florence, 1886, p. 284-288, "Cenni
storici sulle cave dei marmi di Seravezza, ecc." Danti
also found (Pascoli, Vite Moderni, I, p. 290-1) "non lungi
dal castello di Lacugnano una copiosa cava di marmo giallo
mischio simile all'antico, e ne furono ritrovate altre d'

altri colori belli, e rari, interzati con ischerzi di
varie vene mirabilmente dalla natura. . ." For Francesco's
reply to Danti see Gaye, Carteggio, III, p. 257. Danti's
archaeological bent also found expression during these
years. The late Etruscan bronze, the Arringatore was
brought to Florence in 1567. This has always been con-
sidered a joint enterprise of Giulio, Ignazio, and Vincenzo
Danti. See T. Dohm, "L'arringatore, capolavoro del museo
archaeologico di Firenze," Bolletino d'Arte, XLIX, 1954,
p. 97-117 with bibliography. It seems that the responsibil-
ity for bringing the statue to Florence was largely Ignazio's.
See ASF. Carteggio Artisti. Cod. I, Ins. no 22, an un-
signed letter dated 1573 explaining the miserable circum-
stances of the contadino Costanzo di Camillo da Pisa who
had found "la statua di metallo, che l'anno 1567 del mese
di settembre fu portata in Firenze fu da Frat' Egnatio
comprata in Perugia. . ."

111
 G. Gaye, Carteggio, III, p. 246-8.

112
 Frey, Nachlass, III, p. 143.

113
 G. Gaye, Carteggio, III, p. 250-1; also Frey,
Nachlass, III, p. 144.

114
 Frey, Nachlass, III, p. 203-4.

115
 "un pezzo di 5 br. grosso 2 e largo 2, che nescie

la fiura, che debbe face Vincenzo Danti per e magistrati",
G. Gaye, Carteggio, III, p. 250-1.

116
Vasari-Milanesi, VII, p. 632. The difference
in size between the blocks of marble used for the two
statues of Cosimo I is slight. In the seated figure,
Danti created a figure of grander scale by making him seated
and grafting his right arm to the block.

117
Frey, Nachlass, III, p. 204, "viddono il
modello della statua grande et referirno, che attese le
altre cose fatte dal Perugino et l'esser giovane et per-
sona nobile et destra al andare sempre migliorando, che a
guiditio loro il prezzo di detta statue grande habbi a essere
senza computarsi il marmo ne altro la somma di fiorini 500,
et forse di molto maggiore secondo l'eccellentia et bellezza
di che la riuscissi, et questo dissono non per via o modo
di stima, ma per via et modo di parere, allegando che, non
sendo fatta la statua, non possano veramente stimarla, et
quanto al tempo che in fra 18 mesi el' harebbe haver data
finita."

118
G. Gaye, Carteggio, III, p. 402, Niccolo Gaddi
to Cavalier Serguidi, November 23, 1577: "io vedessi a che
termine era la figura di mischio verde per Impratolino, che
fa Gianbologna. . .harebbela tirata, secondo che dice, molto
più innanzi, se non havessi tenuto gli huomini a lavorare

sopra la figura a sedere che fece Vincentio Perugino, la
quale e a bonissimo termine." See Catalogue XVI.

119
Catalogue XVIII

120
Vasari-Milanesi, VII, p. 632. Danti was expect-
ing marble for the statue of Cosimo I as described by Vasari,
around May, 1567.

121
Danti dated the dedication in Florence, April 21,
1567. See note 109 above.

122
R. Borghini, Il Riposo, p. 521.

123
Catalogue XXIII

124
F. Zeri, Pittura e Controriforma: L'arte senza
tempo di Scipione da Gaeta, n. p.,1957, p. 28.

125
L. Dussler, Die Zeichnungen, no. 689.

126
Marco Pino wrote a treatise, now lost, described
as "Architettura di Marco da Siena pittore et architetto,
M. S. in un grande volume 1560"; it was known to Lomazzo
and mentioned in his Idea of 1590. See E. Borea, "Grazia
e Furia in Marco Pino," Paragone, 151, 1962, p. 47, n11.
Since Lomazzo is the source for the linea serpentinata

(Trattato di Pittura, Scultura ed Architettura, Rome,
1844, I, p. 33-35) there is no reason to doubt that it
was recorded by Marco Pino as Lomazzo stated. (Trattato,
p. 33) If the idea did in any way originate with Michel-
angelo, then Marco Pino would probably have gotten it in
the early '50's. Borea's analysis of Marco Pino's Resur-
rection, painted around 1550, implies that he was aware of
the doctrine and applies it. It can probably be assumed that
it was a fairly widespread piece of Michelangelo lore.

127
 G. P. Lomazzo, Trattato, I, p. 33-34.

128
 For an exemplary discussion of the linea serpen-
tinata as a category of Mannerist art see J. Shearman,
Mannerism, Baltimore, 1967, p. 81-91.

129
 Danti, Trattato, p. 254. Danti was more
concerned with change (such as aging) than with motion; both
cases of alteration are considered in Chapter XI of his
treatise.

130
 Danti's discussion of order is found in Chapter
I of his treatise ("Che l'ordine è un mezzo a conseguire la
perfetta proporzione dei composti nelle tre manifatture, divine,
naturali et umane", p. 215-220). He distinguished it from
proportion in Chapter X ("Che la proporzione nasce e depende
dall'ordine, e la differenza che è tra loro", p. 233-4)

131
On the history of the word 'order' as applied to architecture and its relationship to ornament, see A. Coomaraswamy, "Ornament," _Art Bulletin_, XXI, 1939, p. 375-382.

132
Danti defines order as follows: ". . .l'ordine solamente divide et accompagna le cose che vanno o prima o poi, o quelle veramente che sono o più o meno, come s'è detto, sanza guardare se quello che ha da essere o prima o poi, o più o meno, contenga o non contenga la sua debita quantità, cioè se la cosa che ha da essere più dell'altra, in quanta qualtità le sia superiore; o vero se, quando una ha da essere prima dell'altra, quanta distanza ha da convenirsi tra loro. E così l'ordine intendo che non arrivi a questi termini, per non confondere, ma che a essi sì bene entri in luogo suo la proporzione." (_Trattato_, p. 233)

133
Danti, _Trattato_, Chap. IX, p. 231, "Che il vero mezzo di pervenire alla cognizione delle perfette proporzioni delle membra degli animali è propriamente l'uso della notomia." See also Chap. III, p. 221: "Che, come nelle cose naturali la più perfetta e più dificile composizione è il composto dell'uomo, così nell'artifiziali la figura di esso uomo è parimente di tutte l'altre più perfetta e più difficile."

[134] Danti's "functional conception of proportions" is commented upon by R. Klein and H. Zerner, Sources and Documents: Italian Art 1500-1600, Englewood Cliffs, 1966, p. 100-105; and is directly related to Michelangelo by K. Tolnai, "Die Handzeichnungen Michelangelos im Codex Vaticanus," Repertorium für Kunstwissenschaft, LVIII, 1929, p. 157-205.

[135] Danti, Trattato, p. 230. Danti's term for 'symmetry' was not simmetria, which meant what we understand by 'proportion', but parità e conformità; for a similar useage see D. Barbaro, I Dieci Libri dell'Architettura, Venice, 1555, 1629 ed., p. 27. And Vasari-Milanesi, I, p. 146: ". . .la facciata vuole avere decoro e maestà, ed essere compartita come la faccia dell'uomo. . .le finestre, per gli occhi, una di qua e l'altra di là, servando sempre parità. . ." Bilateral symmetry was of course always a foundation of architectural practice although it was seldom applied as a conscious principle of design until the mid-sixteenth century. See R. Wittkower, Architectural Principles in the Age of Humanism, New York, 1965, p. 70. The usages adduced here make it clear how little the properties of symmetry itself had been thought about, and how generally it was still defined when Danti wrote. At the same time, it is evident that bilateral symmetry is in large part the basis for the comparison between architectural and human structure.

136
As Michelangelo's only utterance on architecture, and one of the few opinions on art in his own hand, this letter has received considerable attention. See J. Ackerman, The Architecture of Michelangelo, New York, 1961, I, p. 1-10, with bibliography. If the argument advanced here is correct, Ackerman's conclusion that in foresaking descriptive (i. e. mathematical) proportions Michelangelo shifted from "an objective to a subjective approach to reality" must be overstated. E. H. Ramsden, The Letters of Michelangelo, Stanford, 1963, II, p. 290-2, dates the letter around 1550-51, and tentatively identifies the prelate as then Cardinal Marcello Cervini, later Pope Marcellus II; he also summarizes the argument for the older identification of Cardinal Ridolfo Pio da Carpi, with its later date of 1560-61. Ramsden's characterization of the letter as "Vitruvian" is misleading.

137
A. Condivi, Vita, ed. C. Frey, Berlin, 1887, p. 194. ". . .egli con grande amore minutissimamente m'ha ogni cosa aperto. . .Michelangelo molte cose rare e recondite mi mostrò, forse non mai più intese, le quali io tutte notai; et un giorno spero col'aiuto di qualche huomo dotto dar fuore à comodità et utile di tutti quelli che alla pittura ò scultura voglion dare opera." Ascanio Candivi (c. 1525-1574) is a shadowy figure about whom little is known aside from the fact of the authorship of his biography of Michelangelo. Condivi was from Ripatransone in the Marches, and

is called Ascanio da Ripa by Vasari (Vasari-Milanesi, VII,
p. 273-4). One wonders if he is not the Ascanio da Ripa
named among the new members of the Accademia Fiorentina of
September 26, 1565. (Florence, Biblioteca Marucelliana,
"Annali dell'Accademia degli Umidi poi Fiorentina", cod.
B III 54, f. 15r.) This was the same day that Danti and
Alessandro Allori were accepted. If so, Danti could have
had at least what Condivi understood of Michelangelo's
doctrine at first hand in writing his <u>Trattato</u>.

CHAPTER IV

TEMPORARY SCULPTURE

L'arte adunque del disegno
merita di essere nobile tenuta;
l'opere sue sono fatte a ornamento
et a perpetua memoria di fatti
illustri degli uomini eccellenti,
e non per necessità; la quale
necessità suole in gran parte
la nobilità diminuire.
-----Vincenzo Danti

CHAPTER IV

TEMPORARY SCULPTURE

Introduction:

Like many artists of the sixteenth century, a good
part of Vincenzo Danti's labor was spent on temporary works.
Despite the fact that only traces of them have survived, the
great festivals of the Cinquecento, creating a few hours'
or days' magnificence, demanded a scope and completeness
of conception which work in more durable materials—especial-
ly bronze and marble—made impracticable. Like the bozzetto
or the titanic creative wish expressed in Michelangelo's
sonnets, the festival was an affirmation of the ability of
the human mind to transform the world at will, and made
real a splendid, fantastic order of an inclusiveness which
nothing but the visual arts in unison could effect. Danti's
thought and artistic practice were deeply rooted in such
modes of thought, and examination of his temporary sculp-
ture and painting affords insight into his work as part
of larger systems of order, outside of which neither the
meaning nor the quality of much Cinquecento art is under-
standable.

The techniques employed in these decorations differed
little from those used in extensive palatial programs.
When Giorgio Vasari decorated the Palazzo Vecchio for Cosimo
I, he superintended large numbers of painters working with

varying degrees of success in a common style, who covered
walls and ceilings with epic political histories and myth-
ological cycles in very short order. Stucco decoration had
reached a high stage of development by midcentury which
permitted a rate of sculptural production comparable to
that of painting.

Programs of temporary decorations provided artists
with opportunities to realize works on a large scale necess-
itated close collaboration. Both of these factors are
important in Danti's artistic development. Danti worked at
two major projects of ephemeral decoration: the exequies
of Michelangelo in 1564 and the marriage of Giovanna of
Austria and Francesco I in 1565. Both the altar of San
Bernardino in the Duomo in Perugia, for which Danti modelled
figures in 1567, and the Cappella di San Luca in Santissima
Annunziata, to which he contributed a figure in 1571, made
use of techniques of temporary decorations and will be con-
sidered in this chapter.

The Funeral of Michelangelo: Danti and the Academies:

The regimentation of artistic talent which the large
decorative programs of the Cinquecento necessitated merged
with and contributed to the formation of a parallel hist-
orical development, the academy of art. Giorgio Vasari,
whose organizational genius had made both the decorative
schemes of the Palazzo Vecchio and the idea of an academy

of the arts of design under the patronage of Duke Cosimo
into realities, later pointed with particular pride to
the academy's collective accomplishments, and always
thought of it as a body rather than as a group of men whose
individual efforts were strengthened by association.[1]
While the Accademia del Disegno was still in the works,
Vasari concocted the notion of parcelling out to its members
the unfinished work in the Medici Chapel.[2] That Michelangelo
made no reply to this proposal is probably no adequate
indication of the scorn with which he greeted it, and no
more was heard of the plan. A few months later Michelangelo
was dead, and the first group effort of the kind which
Vasari envisioned was not the completion of Michelangelo's
chapel, but the decorations for his exequies. Its second
was the construction of his tomb.

Michelangelo died in Rome February 18, 1564, thirty
years after he had left Florence for the last time. He
had steadfastly refused to return to Florence under the rule
of Cosimo de'Medici, despite frequent entreaties, and
although he kept a paternal eye on artistic events in his
native city, he never saw it again after his departure.
The works which he left in Florence rapidly became canon-
ical, and in his lifetime his name achieved the stature of
the city's other great expatriate son, Dante.[3] The Accademia
delle Arti del Disegno was founded in Florence under the
patronage of Cosimo I and the symbolic headship of Michel-
angelo in Februrary, 1563, almost exactly a year before

Michelangelo's death.[4] Michelangelo's body arrived in
Florence March 1, 1564; the new academy, whose leaders had
immediately seen the propaganda potential of an elaborate
funeral celebration, and whose members stood in unquestion-
able awe of the man, had already begun to plan the con-
struction of the catafalque and the decoration for the church
of San Lorenzo, in which the exequies for its "capo e
maestro" were to be celebrated on July 14.[5]

The funeral was at once the apotheosis of Michelangelo
and the baptism of the modern academy of art. However
inconsiderable the actual accomplishments of the Accademia
del Disegno may have been, the facade which Vasari and the
other organizers presented to the world in the funeral of
Michelangelo proved to be one of the most successful pro-
motions in history. Aggrandizement was a habit of sixteenth-
century thought, and Vasari was a master, especially on
the subject of the blessings of the patronage of Cosimo I.
In the second edition of his _Vite_, published four years
later in 1568, Vasari recounted the funeral in detail, and
its fame and the fame of the Accademia del Disegno consequent-
ly spread.[6] The commemoration of Michelangelo's death was
thus made to give an important initial impulse to the for-
mation and iconographic configuration of academies of art.[7]

Vincenzo Danti was as devoted to the ideal of the
academy as any artist of his time. He was among the
sculptors listed by Vasari who were to complete the Medici

Chapel, and was a member of the Accademia del Disegno almost from its beginning. In May, 1564, two months before Michelangelo's funeral and in the midst of the preparations for it, Danti was chosen <u>console</u> of the Accademia.[8] This was the highest office, shared by three men at once, directly under the <u>Luogotenente</u> (at the time Vincenzo Borghini) appointed by the Duke. The Accademia del Disegno was a fugitive company, and its members fell to bickering immediately after its foundation. Danti seems to have avoided these quarrels, and consistently worked in the interests of the Accademia. He frequently held high office, took part in almost every committee, straightened out the books of the organization, when they became snarled, and wrote a treatise intended for the use of its members.[9] When he left Florence and returned to Perugia in 1573, Danti helped found another academy there. To a large degree, the adulation of Michelangelo which the treatise voiced, which has always been attributed to Danti person- ally, was nothing more than the public position of the Accademia del Disegno.

In September 1565 Danti also became a member of the Accademia Fiorentina.[10] This was an important membership since it insures Danti's acquaintance at first hand with Florentine literary and critical activity. His connection with the Accademia Fiorentina was probably more than casual. He was the friend of Benedetto Varchi, the most distinguished man of letters in Florence. Varchi wrote the distich on

Danti's <u>Onore</u> <u>che</u> <u>vince</u> <u>l'Inganno</u> in 1561, and they
exchanged "spiritual sonnets" according to the practice
of the time.[11] Since the completion of a work of art was
customarily the occasion for a blizzard of conceits from
artists and <u>letterati</u> there is nothing unusual in these
exchanges, and they need indicate no extraordinary friend-
ship. But Vasari wrote that the two men were close friends.[12]
Danti carved a relief portrait of Varchi--now lost--after
his death in 1565, which was nearly complete when Vasari
wrote Danti's biography.[13] Danti also occupied Varchi's cell
in Santa Maria degli Angeli after his death, and lived and
maintained his shop in the monastery during the remainder
of his years in Florence.[14] Varchi, who read the oration
at the funeral of Michelangelo, was the foremost theoretical
exponent of Michelangelo's art and poetry. His <u>inchiesta</u>
of 1548 is one of the major documents in the history of
Cinquecento art literature, as is his exegesis of Michel-
angelo's sonnet <u>Non</u> <u>ha</u> <u>l'ottimo</u> <u>artista</u> <u>alcun'concetto</u>,
published with it in 1550.[15] Varchi's friendship may well
account for the character of Danti's early works in Florence,
and was an essential factor in determining the eventual content
of Danti's <u>Trattato</u> <u>delle</u> <u>Perfette</u> <u>Proporzioni</u>.[16]

Rather than lessening the contentiousness of the
members of the Accademia del Disegno, the funeral of
Michelangelo only intensified it. Cellini launched into
a furious polemic over the position of the allegory of
sculpture on the catafalque, arguing that the art had been

slighted in favor of painting; Ammannati's uncooperative attitude earned the wrath of the two chief organizers, Vasari and Vincenzo Borghini; Francesco da San Gallo did not attend the exequies; and with his usual aloofness Giovanni Bologna was not connected with the proceedings at all.[17] Danti contributed both the sculptural group to the catafalque and a painting to the decoration of one of the pulpits. He was one of the few important artists to make such an effort. Most of the work was assigned to younger artists, which was the usual practice of the Accademia.[18] Danti's office may have made participation more or less man- datory; at the same time he seems to have been what few artists in Florence were, a good academician.

Danti's painting for the pulpit in San Lorenzo, opposite the bronze pulpit of Donatello from which Benedetto Varchi delivered the funeral oration, depicted Fame tri- umphant over Death and Time. It is Danti's first recorded painting and was described--as his paintings usually were-- as being of "excellent design."[19] Both the dimensions--four braccia high by two wide--and the description--a woman with a trumpet in her right hand and her feet upon Time and Death-- suggest that the composition was similar to that of the Onore group of 1561, one of the triumph themes to which, whether by chance or inclination, Danti turned so often during his career. His sculptural group for the catafalque was a composition of the same kind.

There were eleven pieces of sculpture on the
catafalque.[20] At the bottom reclined the <u>Arno</u> and the
<u>Tiber</u>. At each corner of the first tier stood four groups,
Danti's among them, symbolizing the victory of various aca-
demic virtues over corresponding vices; on the tier above
were allegorical figures of the four arts, <u>Poetry</u>, <u>Painting</u>,
<u>Sculpture</u> and <u>Architecture</u>; surmounting the catafalque, atop
a pyramid, was a figure of Fame. Danti's group showed <u>Genius</u>
<u>overcoming Ignorance</u>. It is described as "a slender youth,
all animation and beautiful liveliness. . . with two small
wings at his temples such as one sometimes sees in repre-
sentations of Mercury. Under this youth was a marvelous
figure with asses' ears, signifying ignorance, mortal enemy
of Genius."[21]

There is no record that Danti had any part in the
formulation of the program for the catafalque of Michelangelo,
although his friendships, inclinations, and position in the
Accademia suggest that he may have had a hand in it. Also,
since he was the most important sculptor to execute a figure
for the catafalque, he might have provided models for some
of the others. Whether he was simply assigned the task
or devised the problem for himself, Danti modelled the dia-
lectic resolution of concepts which was to be the foundation
of his <u>Trattato delle Perfette Proporzioni</u>, an academic
systematization of Michelangelo's injunction that the artist
should have his compasses in his eyes and not in his hands.
As Wittkower has noted, the interpretation by an anonymous

spectator of the exequies of Danti's group as <u>Giudizio</u> overcoming Ignorance is both proper and informative, and makes a qualification which Vasari also made when he explained Michelangelo's dictum saying that above all the artist must possess judgment.[22] In the chapter of his <u>Trattato</u> on grace Danti wrote that what "we call beauty of mind I do not understand to be other than fine genius and good judgment." In chapter IX he combined Michelangelo's statement with its prevailing interpretation and spoke of the "compasses of judgment."[23]

Danti described "beauty of mind"--which he identified with <u>ingegno</u> and <u>giudizio</u>--as "mental aptitude for being able to discuss things with skill, of knowing and judging well whether they have been done well or badly".[24] This is almost a simple definition of the idea to which <u>giudizio</u> soon yielded its place, the idea of taste. Danti was very near to believing that judgment could be taught. But it is significant that his basic discussion of the concept occurs in the chapter on grace, which was heaven-sent. The proper relationship of opposition and mutual definition between talent and education would have been neatly diagrammed in his sculpture group on the catafalque. Genius, that is natural talent, fulfilled itself though instruction and learning, just as nature's intentions were fulfilled by art. Ignorance was thus the opposite and mortal enemy of genius because it prevented its realization, just as without cultivation Danti believed the natural world would run to weeds.

Danti himself was described together with the works which
he executed for the funeral as living proof of "how much
careful study can help a fine talent (un bell'ingegno)
and guide it to that perfection and excellence beyond which
nothing remains to be desired."[25]

The Great Lost Horse:

In December 1565 Francesco de'Medici, the son of
Cosimo I, future Granduke of Tuscany, married Giovanna,
the sister of Emperor Maximillian II of Austria. The
marriage contract was the fruit of five years' negotiation
and was a major diplomatic and dynastic triumph for Cosimo
I. As might be expected, the wedding was one of the most
splendid in the history of Medici festivals.[26] All the
artistic talent of Florence was mustered for the fantastic
and lavish transformation of the city. The members of the
Accademia del Disegno played a central part in the execution
of the decorations and Vasari wrote with pride of their
accomplishment.[27] The program which they realized was the
work of Vincenzo Borghini, luogotenente of the Accademia del
Disegno, and frequent artistic advisor to Vasari. Borghini
devised a procession which began at the villa of Poggio a
Caiano and passed through a series of triumphal arches, from
the Porta al Prato--where the procession entered the city
itself--to the Palazzo Vecchio. The arches and subsidiary
decorations were connected by elaborately interlocking
concetti glorifying the Medici and the royal house of Austria.

The wedding was agreed upon in March, 1565. By April 5 Borghini presented his first proposal for the decorations of the city to Cosimo I. The plans must have been substantially fixed by late May when material began to be dispensed to the artists.[28] Danti, who at the time of the wedding was working on the marble group of Equity and Rigor, was assigned two parts in the decoration. A temporary portal was built for the Duomo with carved wooden doors and relief panels of gilded stucco. Danti was assigned one of these reliefs, a Visitation, which has disappeared with the rest of the portal.[29] The relief was completed by September 21, 1565.[30]

Danti's principal part in the decorations was an allegorical equestrian portrait of Cosimo I, victorious over Fraud, in the Piazza San Apollinare.[31] When Borghini presented the scheme for the great horse to the Duke with the first draft of his program, Borghini did not specify whom the statue was to honor, nor did he insist upon it as an indispensable part of his whole scheme. The Duke was asked to decide who the statue should be if he wished that it should be done at all. He was also invited to contribute whatever ingenious additions might strike his fancy.[32]

The choice of who the statue was to represent was so obvious that one suspects Danti and Borghini of conspiring to plant the idea of an equestrian statue in the Duke's mind. Since the statue was intended to show the victory of the "prudence and justice of our lords" over the "fury that

destroys the people", Cosimo must have immediately thought
of himself as a perfect subject.[33] And having decided that
the statue should be himself, he could hardly have refused
to finance it. Borghini had discussed the matter with Danti
beforehand, and suggested his name to the Duke. Borghini
seemed to consider an equestrian portrait peculiarly suited
to Danti's capabilities.[34] Danti intended to deal with
the anatomy of the horse in considerable detail in his
Trattato, and perhaps Borghini knew of his studies.[35] The
publication of the first book of Danti's treatise was less
than three years away at the time.

Whatever the case, Danti took the plum of Borghini's
program. It was a stroke of good fortune because Cosimo I,
being a ruler of imperial pretensions, would sooner or later
require an equestrian monument. The city of Florence was
without an equestrian statue, even though it had provided
the artists who had cast the great bronze monuments of the
previous century. The equestrian monuments of Donatello
and Verrocchio stood in Padua and Venice. Similarly, Leonardo
had taken the commission for his Sforza and Trivulzio mon-
uments in northern Italy. Cosimo's forebears had not been
eager to press their position of leadership in Florence,
least of all by so flagrant a gesture as the commissioning
of an equestrian statue. Such statues were traditionally
the monuments of military commanders and emperors.[36] The
Quattrocento Medici wished to appear as neither. By 1565,
however, all this had changed,and Cosimo I fancied himself

both. He could have seen only too clearly that the eques-
trian portrait had become the prerogative of the rulers of
the great states against whom he had spent his life matching
political wits for the continued existence of his tiny duchy.
In 1536 Niccolò Tribolo had modelled a temporary equestrian
statue of Charles V for the entry of the emperor into
Florence after the battle of Tunis.[37] In the years immed-
iately before 1565 Daniele da Volterra, under the guidance
of Michelangelo, was working on an equestrian statue of
Henry II of France.[38] So matters stood when Vincenzo
Borghini informed the Duke that although Vincenzo was busy
in his excellency's service, so "gifted and spirited" was
he that should a horse be needed, he would be glad to be
of assistance.[39]

The building of Danti's horse was a considerable
enterprise, and its expenses fill page after page in the
journal kept of payments for the decorations.[40] Danti
first received materials on June 14, 1565.[41] The work
proceeded from this time without interruption through the
building of the base, the wooden armature, the modelling
and final finishing.[42] Most of the payments concerned with
the horse are to minor craftsmen of one kind or another; all
of the other payments are to Danti, with two important
exceptions. Although he does not appear in the day by day
record of the expenses, Giovanni Bologna--who executed the
bronze equestrian statue of Cosimo I in the Piazza della
Signoria some twenty years later--was paid for work on the

horse and Danti must at least have profited from his advice.[43]
There are also payments during the months of October and
November to a certain "M° Bastiano di Giovanni da Roma
M° di stucco."[44] Both the late date and the master status
of the stuccatore suggest that Danti enlisted his aid to
assist in the modelling of the figural group. There were
several foreign artists involved in the decorations and at
least one other stuccatore from Rome. Lionardo Ricciarelli,
the nephew of Daniele da Volterra, who had learned his
craft from his uncle and had worked on the Palazzo Vecchio
decorations, also took part in the program.[45] Assuming
what is likely, that Danti had chosen his own assistant,
the collaboration might indicate association with Rome and
the circle of Daniele da Volterra, an association suggested
earlier in the account of Danti's first years in Rome.

Like the rest of the decorations for the wedding of
Francesco I and Giovanna of Austria, all trace of Danti's
great horse has disappeared. The statue was one of the
marvels of the occasion, however, and was described several
times. From these descriptions the appearance of the horse
can be reconstructed in some detail, perhaps in sufficient
detail to aid in the eventual identification of studies
connected with it.[46] Danti's equestrian group stood between
nine and "over eleven" braccia tall, or between eighteen and
twenty two feet.[47] The horse was painted with turkish lacquer
to simulate bronze and its accoutrements were gilded. The
horse stood on its hind legs and was "very fierce" in appearance.

This immediately suggests Leonardo as a precedent. It seems just as likely,however, that Danti took his pattern from Roman models of similar allegorical intent (fig.).[49] The figure beneath the horse was half woman and half serpent.[50] It was described as "grandissimo" and must have been fairly large, since it undoubtedly supported much of the weight of the rearing horse. The rider was "a heroic youth" in armor who had struck the monster a mortal blow with his lance which lay broken at his feet. He was shown reaching for his sword, as if to strike the prostrate beast a second time.[51]

Since the main figure was ostensibly unidentified when Borghini first presented the projected group for the Duke's consideration, Borghini expressed a more precise definition of the lower figure--the monstrous personification of Fraud--in the first stages of planning. The image which first occurred to him was a description of Avarizia from Ariosto, which he traced back immediately to Dante's description of the wolf, Invidia, in the first Canto of the Inferno. He also thought that "it might not be bad" to add the description of Rage from the Aeneid to his growing concetto.[52]

Once it was decided that the statue was to honor Cosimo I, the whole concetto could begin to take final shape. The governing allegorical identification was Hercules, one of Cosimo's favorite guises. The combination of the theme of Herculean virtue with an equestrian portrait provided a conceptual framework similar to that which lay beneath Bernini's

equestrian statue of Louis XIV a century later.[53] That Danti's statue was an image of "herculean virtue" was explained by Giovanni Battista Cini, who wrote the official description of the marriage decorations with reference to Borghini's program. Cini was also an outspoken admirer of Danti.[54] Another friend, Timoteo Bottonio, wrote a sonnet on Danti's group around the theme of Cosimo's surpassing Hercules.[55] Bottonio's sonnet and its introduction provide a more sobering view of the intention of the group. The Piazza San Apollinare was the square in which criminals of state were executed. Cosimo's victory over Fraud was thus the victory of his own will over his personal enemies, and his symbolic portrait insisted once again upon the identification of his will and the law of the state.[56]

The equestrian monument which was finally erected to Cosimo I by Giovanni Bologna was not commissioned until 1587, thirteen years after the Duke's death and fourteen years after Danti left Florence.[57] Danti's statue of 1565 seems to have impressed everyone but Cosimo I, and the bronze group at which it hinted never came about. The horse and rider were both elaborate and successful, and it might be wondered why the achievement yielded no results. Memories of Danti's failure in bronze when he first came to Florence no doubt still dogged his career, and the Duke's favor was hard won and quick to change. There is probably a more important reason, however. Danti had become involved in a complex allegory to his disadvantage. Vincenzo Borghini was no doubt

substantially responsible for the <u>concetto</u> which was none-
theless altogether in the spirit of Danti's own work. The
predominance of literary devices in visual compositions was
far from unusual. It pervaded the whole program which Borghini
devised and Danti's group was praised first of all for its
"arguta invenzione."[58] Despite the popularity of these
schemes, however, they were not appropriate in all circum-
stances. On the intimate scale of his bronze reliefs Danti's
<u>concetti</u> were permissable. But on a public scale they were
not. The two portraits of Cosimo I that Danti carved in
connection with the Uffizi Testata group are neither one
portraits in any common sense of the word. Their impersonal
marble features are a faithful application of Michelangelo's
notion that no one would know what Cosimo I looked like in
a thousand years anyway. How kindly these abstractions of
the ducal person were received can be concluded from the fact
that Danti's <u>Cosimo I</u> was taken down from the Uffizi and re-
placed with a portrait by Giovanni Bologna in the 1580's.
Like any ruler, Cosimo I must have calculated the propaganda
value of his large public monuments, and he must have pre-
ferred the unambiguous identification of his own image with
the power of the state to mythographic speculation upon the
idea of a ruler as such. Danti was capable of direct and
sensitive portraiture, as his monument to the jurist Pontano
demonstrated; and he was capable as well of the semi-ideali-
zation of the <u>Julius III</u>. In representing Cosimo I he chose
to do neither. Michelangelo's heroic ideal of the human

figure had frozen in courtly allegory and Danti found
himself incapable of the freedom to which his early work
showed him most suited.

The Altar of San Bernardino:

While Danti was in Perugia repairing the Fontanà
Maggiore, between 1559 and 1561, he submitted the design
for the altar of San Bernardino in the large chapel flank-
ing the right side of the main entrance of the Duomo. He
received payment for the sculpture on the altar in 1567,[59]
the year that Federico Barocci was brought from Urbino to
paint the altarpiece, the Deposition from the Cross, con-
sidered his first mature work.[60] As years passed, admir-
ation for Barocci's painting increased while appreciation
for Danti's architecture and sculpture declined. Finally
in 1793 the altar was demolished as unsuitable to house
such a noble painting, and was replaced by the present
stone altar.[61]

The contract for the original altar was drawn up
November 8, 1559.[62] It was to be constructed by Lodovico
Scalza from Orvieto and Giovanni Fiorentino, the muratore
who installed the statue of Julius III.[63] It was specified
as 32 Perugian feet (38 feet, 8 inches) in height.[64] The
base of the altar was to be of travertine, the rest of wood
and stucco, covered with leafwork and gilded where appropriate.
All that now remains of the altar, besides Barocci's

altarpiece, is a drawing by the eighteenth-century
architect Vincenzo Ciofi, made just before its demolition.[65]
(fig. 52) This unsympathetic record has probably simpli-
fied the altar, since ornateness was the quality which most
impressed the writers who described it.[66] No doubt many
of the grey areas in the drawing were filled with decorations,
and the columns, at least in the lower registers , must
have been canellated.

The design for the altar of San Bernardino has been
attributed to Lodovico Scalza.[67] The contract, which pre-
sumably provides the basis for this attribution, does not
make it clear that Lodovico Scalza was more than a muratore,
and there is no reason to doubt Ciofi's statement that
the altar was designed by Vincenzo Danti.[68] The attribution
of the altar to Lodovico Scalza is not without foundation
in the monument itself, since the prototype is Michele
Sanmichele's Altar of the Magi in the Duomo at Orvieto.[69]
(fig. 127) A design for the same altar at Orvieto, made in
competition with Sanmichele by Antonio da Sangallo the
Younger, provides a precedent for the treatment of the upper
part of Danti's altar.[70] (fig. 128)

Fundamentally different from the earlier designs is
the comparative lack of interest in the basic triumphal arch
motif and the dominant emphasis upon the large upper gable.
The constantly broken but insistent vertical frames which
support the gable, running through columns, caryatids,
mascheroni, and finally through the gable itself, to end in

the crowning heraldic griffins, is strongly suggestive of
Galeazzo Alessi's use of similar devices in his design for
the facade of Santa Maria presso San Celso in Milan. (fig.150)
Galeazzo Alessi was a Perugian, and he had given his native
city a taste of such mannered play along plumb lines in
his portal installed on the side entrance of the Duomo--
next to the statue of Julius III--in 1568.[71] The gable
and the caryatids supporting it may have been an afterthought
since according to Ciofi's scale Danti's altar reached its
prescribed height of 32 feet just above the second, round
pediment. The upper part may then have been a remodelling
in the course of construction and, since the altar was not
finished until 1569, may record the impact of Alessi's
decorative mannerisms.

The altar of San Bernardino was commissioned by the
Collegio del Mercanzia. It had the important Quattrocento
precedent of Agostino di Duccio's Oratorio di San Bernar-
dino, and was dignified by the presentation of an impor-
tant relic of San Bernardino, the greater part of his habit,
by the Bishop of Chiusi in 1567.[72] A seventeeth-century
chronicler, Ottaviano Lancellotti, wrote that the altar
cost 3000 scudi.[73] Its contracted price was 525 scudi, and
the extensive use of stucco argues for the lower price.[74]
The figures were defined in the contract as full round and
are so described in the later sources. Not counting the
griffins, there were eleven figures on the structure, none
of which survives. According to Ciofi's drawing, these

stucco figures would have stood between 4 1/2 and 5 1/2
Perugian feet (or between 5 1/2 and 6 3/4 feet), the figures
largest in scale being placed at the bottom.[75]

The identity of the figures on the altar is not
altogether clear from the drawing, and no specific mention
of them is made in the contract. The lowest are SS. Costanzo
and Ercolano, the patrons of the city of Perugia, just as
they are shown on Agostino di Duccio's facade;[76] the two
figures in the register above them are perhaps prophets or
apostles. The ignudi reclining on the pediments are prob-
ably, like the caryatids, purely decorative, and are not
as one writer suggested, Christian virtues and angels, appar-
ently extended the similarity of the program to the Oratorio
of San Bernardino.[77] Topping the structure is the risen
Christ.

The altar of San Bernardino reveals Danti as an
architect who used motifs much as he used themes in sculp-
ture. Possibly his patrons required that he pattern his
altar after those in the Duomo at Orvieto. Whether or
not this was the case, his clever synthesis of an early
classicizing altar with the more current style of Alessi
resulted in a monument very different from the Michelangel-
esque classicism of the Monument to Carlo de'Medici. At the
same time the aediculae in which the lower figures sit on
the altar of San Bernardino do not differ especially from
the correct aedicula which framed Danti's most mannered
figures, the Decollation group for the Florentine Baptistry

of 1570 (fig. 60). This suggests that in architecture,
perhaps to a greater extent than in sculpture for Danti,
the manner of Michelangelo was simply an alternative.

The Cappella di San Luca:

The decoration of the Cappella di San Luca in
Santissima Annunziata was begun by the Servite sculptor
Giovanni Angelo Montorsoli in 1535, after he had begun
carving the St. Cosmos in the Medici Chapel on Michelangelo's
design. Montorsoli modelled two clay figures, a St. Paul
and a Moses, the second based on Michelangelo's Sistine
Ceiling Jeremiah.[78] (figs. 129, 130) These figures are
still in the chapel and since they form an iconographic
pair, are probably in their original positions, on either
side of the old altar.[79] After an absence of twenty-five
years, Montorsoli returned to Florence and resumed the
program, this time with the intention that the chapel should
be made a burial chapel for artists. It was ceded to him
for this purposes and dedicated to the Trinity in 1560.[80]

Mortorsoli's idea for the painter's chapel was
quickly amplified, notably by Vasari, and initiated the
chain of events leading to the formation of the Accademia
del Disegno under the patronage of Cosimo I. Montorsoli
died in August 1563, shortly after the official foundation
of the Accademia. He seems to have done little in his second
campaign , although he probably determined the design which

was subsequently followed.[81] For two years after Montorsoli's
death nothing was added to the chapel. Finally in June
1565 a contract was signed between the Accademia del Disegno
and the brotherhood of Santissima Annunziata. It was agreed
that the chapel should be decorated with ten stucco statues
in niches, three large paintings, plus small histories
and grotteschi.[82]

The entry, altar and axis of the chapel were changed
in the nineteenth century, and the academicians' labors
are scattered. The remodelling resulted in the loss of
two sculptures and the addition of a painting. These
changes, together with the reorientation of the chapel,
have obscured the original sense of its arrangement.[83]
(fig. 131) From the small histories above the niches and
the attributes below them, hosever, the original order of
the chapel can be easily reconstructed.[84] (fig. 132) The
dedication of the chapel to the Trinity provided the theme
of the altarpiece and, by analogy to the three arts of
design, the conceptual framework for the program.[85] At
the sides of the chapel were two large frescoes, St. Luke
painting the Virgin and the Construction of the Temple of
Solomon, symbolizing painting and architecture respectively.
The art of sculpture was embodied in two series of six larger
than life size biblical figures.[86] To the left of the
altarpiece were the apostles Paul and Peter and the four
evangelists. To the right were Moses, Abraham, and four
kings, Melchisedech, Joshua, David, and Solomon.

Six months after the agreement to complete the program, on February 1, 1566, the Academy met to discuss its obligation. A committee was appointed--five "riforma-tori" and four "aroti"--to dispense the tasks among the members as they saw fit. All of the "riformatori" were painters with the exception of Francesco da Sangallo. The "aroti" were sculptors, Benvenuto Cellini, Vincenzo de' Rossi, Bartolommeo Ammannati, and Vincenzo Danti.[87] Given this division, it may be concluded that each group had charge of the art which its members practiced. Danti was the only one of the sculptors who finally executed a statue.

The committee seems to have reached no decision for over a year. Finally in November of 1567 the following allotment of tasks was recorded:[88]

```
Antonio di Gino and Stoldo Lorenzi. . . . .David
Vincenzo Danti. . . . . . . . . . . . . . .St. Luke
Giovanni Bologna. . . . . . . . . . . . . .St. Mark
Giovanni Vincenzo Casali. . . . . . . . . .Solomon
Battista Lorenzi. . . . . . . . . . . . . .Abraham
Francesco Cammillani. . . . . . . . . . . .Melchisedech
Zanobi Lastricati . . . . . . . . . . . . .Joshua
Domenico Poggini. . . . . . . . . . . . . .St. Peter
Giovanni Balducci . . . . . . . . . . . . .St. Matthew
Valerio Cioli. . . . . . . . . . . . . . .St. John
```

Nearly two more years passed before work in the chapel actually began with the issue of materials to Francesco Cammillani and Valerio Cioli. In the meantime Santi di Tito and Giorgio Vasari had switched paintings, setting the precedent for further exchanges by the sculptors. the payments for the figures drag on for six years, and between 1567 and the completion of the last statue in 1575

many of the original assignments were forgotten. Only four sculptors can be shown to have executed the figures assigned them on the evidence of the payments.[89] These four were Domenico Poggini, Francesco Cammillani, Giovanni Vincenzo Casali, and Vincenzo Danti. Examination of the payment documents nevertheless yields information about the original state of a program of considerable interest for the early history of the Accademia del Disegno and the later history of Florentine Renaissance sculpture. It also sheds light on the attribution of the sculpture now in the chapel, a question which has never been completely settled.[90]

Domenico Poggini was the first member of the Accademia to finish his statue, the St. Peter (fig. 133). It had been assigned to him, and payment for the transportation of the figure to the chapel was recorded on April 30, 1570.[91] The second figure to be completed, the St. John, was assigned to Valerio Cioli. The St. John now in the chapel has been attributed to Giovanni Vincenzo Casali (fig. 134).[92] This attribution is strengthened by a payment to Casali in October 1570 for an unnamed figure, perhaps identical with the "figura di Valerio Cioli" carried to the chapel in July, 1570.[93] This would mean that Casali finished a figure begun by Cioli. Francesco Cammillani fulfilled his assignment and completed the Melchisedech by October 29, 1570.[94] (fig. 135) A sculptor called "Michelangelo Schultore"--certain Michelangelo Naccherino--completed the statue of St. Matthew, originally assigned to Giovanni

Balducci,[95] before March 12, 1571.[96] This figure is lost.

Vincenzo Danti had been charged with the statue of St. Luke, the traditional patron saint of painters, and the patron of the old fraternity which the Accademia del Disegno had supplanted. The figure was begun before December 1570 and completed by June 1571.[97] (figs.66,67) The St. Luke is a departure from the earlier figures both in quality and style. The complicated, heavy drapery of Casali's St. John or Cammillani's Melchisedech has been replaced by a clear contrast of mass and line. The torso is left free for the play of the abstract anatomy, strongly dependent upon Michelangelo's Medici Chapel Day. The figure also evidences an unmistakable debt to Giovanni Bologna. The St. Luke, like the other sculpture in the chapel modelled just after it, bears the clear impression of Giovanni Bologna's river gods for the Fountain of Oceanus in the Boboli Gardens. The model for the fountain was completed in the same year, 1571, and its immediate echoes in these sculptures are a precise indication of the growing impetus of Giovanni Bologna's style in Florence.[98]

More than any other figure in the chapel, Danti's St. Luke was worked out in a graphic relationship to its niche. Like his bronze figures for the Florentine Baptistry, cast slightly earlier, and the Madonna and Child in Santa Croce, (figs. 53 , 62) the St. Luke is defined by an ovoid contour, within which counterpoised forms are supported by the linear tension of curves of drapery. This play is

governed by strong axes and united by the thin edges of
drapery working around and through the shallow space of the
sculpture itself. The result is an abstract monumentality
in which sculptural mass is symbolized by parabolic contour.
Danti worked the figure in degrees near the extremes of
volume and line, and drew out the central mass of his figure
so that the line formed by the drapery becomes the flat,
sketched left hand. The combination of generalized but
carefully worked surface and spatially involved but simple
linear contours is a successful compound of the formal
severity of his marble Madonnas (figs. 37, 53) and the
elegant linear play of the Julius III and the Onore group.

The portrait of Cosimo I as Joshua (fig. 69) has
been attributed to Giovanni Bologna.[99] There is no record
that Giovanni Bologna participated in the program after
he was assigned the St. Mark in 1567. It seems certain
that he supplied a design for the statue, however, and may
have been partially responsible for its execution.[100] This
figure, heavily reworked, but compositionally intact is now
in Solomon's niche. (fig. 136) It bears little
resemblance to the portrait of Cosimo I, here ascribed
to Vincenzo Danti and Zanobi Lastricati, the artist to
whom the Joshua was originally assigned. Lastricati was
paid for materials for an unnamed figure on June 20, 1570,
but there is no record of when he completed it.[101] If the
statue which he began at that time was the Joshua and was
finished within a year, as was more or less usual, its

installation would have coincided with the completion of
Danti's St. Luke. Lastricati's part in the statue cannot
be supported on stylistic grounds because none of his works
are known to have survived, although it is known that he
did large scale sculpture in stucco.[102] Still, he cannot
have been a sculptor of much consequence, and it is unlikely
that the most important figure in the chapel would have been
left to his unassisted execution.

Several circumstances suggest Danti's participation
in the figure. He became console of the Accademia del
Disegno for the third time in October 1570.[103] During
the last month of his term in office, in April 1570, he
wrote to Vasari describing the progress of the work in the
chapel, and so must have had some direct responsibility for
it.[104]

The stylistic connections of the Cosimo I (Joshua) (fig. 69)
to Vincenzo Danti's St. Luke are evident. Despite the
relationship of the St. Luke itself to the contemporary
sculpture of Giovaani Bologna, Danti received the influence
only with characteristic modifications, and it is toward Danti
rather than Giovanni Bologna that the conception of the
Cosimo I points. The heavy torsoes of the Cosimo I and
the St. Luke are virtually the same in their elaborate
herculean anatomy and the loose articulation of the arm at
the shoulder. The decoration of Cosimo's armor is close to
Danti's Baptistry group Herodias. The juxtaposition of brittle
line, underscaled with respect to the large simplified masses

is the same in both figures. A minimum number of changes
in the arrangment of the parts would be necessary to trans-
form one figure into the other, and the parts themselves on
close examination are quite similar; the left legs might
be compared. The surfaces of the Cosimo I are monotonous
compared to those of the St. Luke, however, and such
details as the solid extended hand indicate another hand
than Danti's. The responsibility for the conception, and
perhaps some of the modelling, would seem to lie with Danti,
the finishing being left to Zanobi Lastricati.

The statue of Cosimo I is now in St. Matthew's
niche, and was originally Joshua. The identification as
Joshua may be argued on two grounds. First, all of the
figures in the chapel can be accounted for except Michelangelo
Naccherino's St. Matthew, the only figure taken intact from
the chapel whose appearance is not definitely known.[105] It
was inevitable that a portrait of the patron of the Accademia
should have been placed in the chapel, but it is unlikely
that he would have been cast as an apostle. The portrait
is an unlikely St. Matthew and an unlikely example of
Naccherino's style. On the other hand there was a precedent
for Cosimo's role as an Old Testament leader, and the parallel
to Joshua would have been particularly apt. Cosimo I had
received the long-awaited title of Granduke of Tuscany from
Pius V in Rome, August 27, 1569, at almost the same time that
the Academy's decoration of the chapel began. It was Joshua
to whom the promise was made that "Every place that the sole

of your foot shall touch, that have I given unto you. . ."
(Joshua I, 3). As Joshua had won the Promised Land, with
the laws of Moses behind him, and in full assurance of
divine support, Cosimo I had consolidated the land of
Tuscany.[106]

After 1571 whatever enthusiasm for the project that
might have existed among the members of the Academy began
to flag. Stoldo Lorenzi received payment for materials in
May and June of that year, and must have finished the
Abraham before 1573 when he left Florence for Milan.[107]
(fig. 137) He had originally been assigned the David along
with his borther, Antonio di Gino. The Abraham had been
given to Battista Lorenzi, who seems to have chosen instead
to busy himself with the tomb of Michelangelo.[108] Andrea
Corsali received payments for an unnamed figure between
November 1573 and February 1574.[109] This was perhaps for
the figure of St. Mark, now in Solomon's niche, done after
a model by Giovanni Bologna, to whom the St. Mark was
assigned in 1567.[110] It was finished in 1574, the same
year that the original figure of Solomon was finished by
the Servite Giovanni Vincenco Casáli.[111] The last figure,
David, was modelled by another Servite sculptor, Giovanni
Angelo Lottini, and cemented in place in 1575.[112] It was
the first to go. Lottini's David was probably replaced by
someone in the shop of G. B. Foggini with the figure now
in the niche (fig. 152) at the end of the seventeenth
century, just after Baldinucci reported the loss of the
original.[113]

Only a part of the Cappella di San Luca has survived,
and the intention which lay beneath it has been almost com-
pletely covered over. Nevertheless, the program is a model
history of Florentine sculpture in the second and third
quarters of the sixteenth century, and its culmination
helps to set the stage for the consideration of Danti's
late sculptural style. The series began in the shadow of
Michelangelo's work in San Lorenzo with Montorsoli's Moses
and St. Paul. It was resumed shortly after his death, and
the sequence of figures which followed plots the decline of
Michelangelo's manner in Florence. Michelangelo left for
Rome shortly before Montorsoli modelled his figures. The
years between his departure and the first figure in the new
program, Domenico Poggini's St. Peter, had seen the exhaust-
ion of the influence of his difficultly personal manner.
To a large extent the difference was between genius and the
lack of it, and it is perhaps unfair to analyse style in
general in the work of so unassuming a talent as Domenico
Poggini. Still, his St. Peter is clearly a pallid but
stubborn memory of the example of Giuliano de'Medici, and
may be taken as a sign of the already crystallized doctrine
of the aesthetically excellent as canonical form. The
figure is altogether apart from the inevitable and vital
transformations which continual personal contact with an
artist of genius might have produced. Sculptural form
changed slowly by repetition and not by significant reinter-

pretation. This was less dramatically true of sculptors who formed their styles around the caricature-Hellenism of Bandinelli (Francesco Cammillani and Michelangelo Naccherino in the chapel, Vincenzo de'Rossi outside it) which was the principal alternative in Florence to the manner of Michelangelo. Academic at its inception, the tradition sired by Bandinelli survived more tenaciously amd merged more docilely with later styles.

The critical weakening of the impulse of Michelangelo's influence is clear in the sculpture of such an avowed disciple as Vincenzo Danti who, in spite of his receptivity to other styles, had championed Michelangelo's manner in Florence for over a decade. The brittle, elliptical abstractions, enclosing quotations from Michelangelo, the generality of expression and form and the fragility of the extremities point unmistakably away from the Medici Chapel to the bronzes of the Fountain of Neptune, done at almost the same time.

By 1575, when the last sculpture was finished, new stylistic poles had been defined. In contrast to the universality implicit in the forms of Michelangelo and Bandinelli, the new possibilities were circumscribed and severely courtly. The old styles were reintrepreted and gradually forgotten as the brilliant formal and spatial innovations of Giovanni Bologna determined the nature of sculpture in Florence to an ever greater extent. At the same time a consciously historical recapitulation of the beginnings of Florentine mannerism occurred, and the artists of the Studiolo of Francesco I drew very near the transformations of the same

forms of the early school of Fontainebleau. It was a style
exhausted with the burden of meaning, artificial to the
point of the exclusion of meaning, and at the same time
almost romantically nostalgic. The influence of Michel-
angelo did not outlive the decade in which he died, and
during the most vital years of the academy founded in his
name, the city of Florence became one of several centers
of late International Mannerism.

Notes to Chapter IV:

[1]
Vasari-Milanesi, VI, p. 659. ". . .in molte
altre cose e per non essere indegni accademici, cose
maravigliose operato: ma parlicolarmente nelle nozze
dell' illustrissimo signor Principe. . .don Francesco, e
della serenissima reina Giovanna d'Austria."

[2]
Frey, Nachlass, I, p. 739

[3]
On the parallel of Michelangelo and Dante see E.
Steinmann, Michelangelo im Spiegel seiner Zeit, Leipzig,
1930, p. 42. The locus classicus of the comparison is
in Pierfrancesco Giambullari's introduction to Carlo
Lenzoni's In Difesa della lingua fiorentina, Florence,
1557.

[4]
Vasari recounts the circumstances of the foundation
of the Accademia del Disegno in his life of Montorsoli
(Vasari-Milanesi, VI, p. 655-60). No detailed history
of the early history of the Academy exists, and N. Pevsner,
Academies of Art, Past and Present, Cambridge, 1940, is
most useful; a brief history is in K. Frey, Nachlass, I,
p. 708 ff. Most histories derive from C. I. Cavallucci,
Notizie Storiche intorno all R. Accademia delle Arti del
Disegno, Florence, 1873; see also G. Ticciati, Storia

dell'Accademia del Disegno, in P. Fanfani, Spigolatura Michelangelesca, Pistoia, 1876, p. 193-307. Information and bibliography is also to be found in L. Biagi, L'Accademia di belle arti di Firenze, Florence, 1941.

5
The funeral of Michelangelo in all its aspects is laid out in exemplary fashion by R. and M. Wittkower, The Divine Michelangelo, the Florentine Academy's Homage on his Death in 1564, London, 1964, p. 9-47.

6
The propagandistic intent of the funeral of Michelangelo is dealt with at length by R. and M. Wittkower, The Divine Michelangelo, p. 42-47. The letter from the Venetian artists—Andrea Palladio, Giuseppe Salviati, Danese Cataneo, Battista Veronese, Tintaretto, and Titian—requesting membership in the Accademia del Disegno because (as it is recorded in the records of the Proveditore) they had heard of "la grandezza della nostra academja e lopera del catafalcho" is found in ASF. Arti, Libro del Proveditore "E", fol. 17r, October 27, 1566. A more touching document of the success of the Academy's public relations is the request of the heirs of Jacopo Sansovino, who died in 1570, that exequies be conducted in his honor. ASF. Arti, Accademia del Disegno, Libro del Proveditore, "E", fol. 29v, Jan 14, 1571. It was decided that "si dovessi onorare detta memoria del sansovino con i statue picture e altro." The celebration (in which Danti

had a part, see below Chapter V, n1) was nothing of the
magnitude of Michelangelo's, and nothing of the magnitude
that Sansovino's heirs had hoped for.

[7]
Danti's group on the catafalque, for instance,
was Genius Triumphant over Ignorance (see notes 20-23 below).
On the later iconography of academies of art, S. Pigler,
"Neid und Unwissenheit als Widersacher der Kunst (Ikonogra-
phische Beitrage zur Geschichte der Kunstakademien)", Acta
Historiae Artium, I, 1954, p. 216-135.

[8]
Danti first paid his dues in the Accademia del
Disegno November 14, 1563 (ASF. Art. Accademia del Disegno,
Entrata e Uscita, f. 5v.); he was elected console May 9,
1564 (Libro del Proveditore, "E", f. 7r) camerlengo
October 18, 1565 (f. 14v) and console again in 1568 (f. 22r).
On Danti's later activity in the Accademia see Chapter V,
note 1 below.

[9]
See Chapter VI, note 11 below, for Danti's role
in the foundation of the Accademia del Disegno in Perugia.

[10]
D. Heikamp "Rapporti fra accademici ed artisti nella
Firenze del '500", Il Vasari, XV, 1957, p.135-145 Annali del Accademia
degli Umidi poi Fiorentina, Florence, Biblioteca Marucelliana, BIII.
54,f.15r.) Vincenzo Danti and Alessandro Allori were both
admitted to the Accademia Fiorentina on the same day, Sept-
ember 26, 1565. Both wrote treatises within a very short

time of their initiation. Allori's <u>Dialogo</u> <u>sopra</u> <u>l'arte</u>
<u>di</u> <u>disegnare</u> <u>le</u> <u>figure</u>, begun in 1565 (Thieme-Becker, I,
p. 32) exists in manuscript only (BNF, Codex Palatina,
E. B. 16, 4a, carte 39a; and Florence, Biblioteca
Marucelliana. A 302, copy made in 1886 of the Biblioteca
Nazionale manuscript) and was never published. It is
possible that Allori's well-known drawings of skeletons
(P. Barocchi, A. Bianchini, A. Forlani, M. Fossi,
<u>Mostra</u> <u>dei</u> <u>disegni</u> <u>dei</u> <u>fondatori</u> <u>dell'</u> <u>Accademia</u> <u>del</u>
<u>Disegno</u> <u>IV</u> <u>Centenario</u> <u>della</u> <u>Fondazione</u>, Gabinetto disegni
e stampe degli Uffizi, Florence, 1963, no. 52-53) were
illustrations for this treatise rather than "una sorta di
atteggiata danza macabra." This is an important point
since it might indicate the tone of the illustrations of
Danti's treatise, the first book of which was published
in 1567. Other artists who were members of the Accademia
Fiorentina were Tribolo, Bronzino, Michelangelo (an honor-
ary member), Francesco da Sangallo, Cellini, Ammannati,
and Buontalenti. Other persons of interest not mentioned
by del Vita who were initiated on the same day as Danti were
Don Silvano Razzi, "Monacho degli Angioli", the close
friend of Bronzino and literary collaborator of Vasari,
and M. Ascanio da Ripa (Ascanio Condivi?} See Chapter
III, note 19).

11
 Vasari-Milanesi, VII, p. 632. ". . .lavora. . .
nel monasterio degli Angeli di Firenze, dove si sta

quietamente in compagnia di que'monaci suoi amicissimi, nelle stanze che già quivi tenne messer Benedetto Varchi, di cui fa esso Vincenzio un ritratto di bassorilievo." For Varchi's distich on the <u>Onore che vince l'Inganno</u> see Chapter III, note 19; and for the sonnets exchanged, see Appendix VII.

12
Vasari-Milanesi, VII, p. 632.

13
See note 11 above and Catalogue XXXVIII.

14
Ibid., and Catalogue XIX, doc. no. 2, where it is clear that Danti wished to cast the Baptistry bronzes in 1570 in his own shop in Santa Maria degli Angeli and thus no doubt to establish a foundry of his own.

15
The <u>inchiesta</u> and Varchi's <u>Della maggioranza delle arti</u> have been published in a new edition by P. Barocchi, <u>Trattati d'arte del Cinquecento</u>, Bari, 1960, I, p. 59-82; for the commentary on Michelangelo's sonnet, see B. Varchi, <u>Opere</u>, II, Trieste, 1859, p. 615-17. On the date of the publication see Chapter I, note 54 above.

16
Danti's debt to Varchi is considered in some detail in P. Barocchi's annotations to Danti's <u>Trattato</u>, See P. Barocchi, <u>Trattati</u>, I, 324-28 and 494-525. The theories of the two men are also considered together by

M. Tafuri, L'Architettura del manierismo nel cinquecento europeo, Rome, 1966, p. 131-140.

17
On this dispute see R. and M. Wittkower, The Divine Michelangelo, p. 18-21. The organizers of the exequies Vincenzo Borghini and Giorgio Vasari, (not to mention Duke Cosimo) had little patience with this new manifestation of the paragone dispute. The academy consistently suppressed such arguments, as did Danti in his Trattato. (p. 236). The practical tack taken in solving the dispute is pithily stated by Vincenzo Borghini in a discourse delivered to the Accademia del Disegno in 1566. A Lorenzoni, Carteggio Artistico inedito di D. Vinc. Borghini, Florence, 1912, p. 10-14. He recommends that each of the disputants prove the excellence of his art by performing excellently in it, and further advises that sculptors try drawing, and painters modelling, since relief has given so much force to the paintings of Michelangelo, and design so much grace to his sculpture, and concludes that "è Academia di FARE et non di RAGIONARE."

18
See for example the letter of Vincenzo Borghini to Duke Cosimo of November 4, 1564 (Gaye, Carteggio, III, p. 150-1) on the matter of choosing sculptors to carry out the marbles for the tomb of Michelangelo in Santa Croce. "Io ero di questa fantasia ch' vedendo parte di quelli scultori occupati in servitio di V. E. I., per dare che fare a ogn' uno et dare animo et occasione a certi di quelli giovane, che

hanno voglia di fare et virtù di poter condurre affine i
loro concetti, di mettergli in campo, et dare questo aiuto
alla virtù loro. . ." The painting is lost. See Catalogue
XXXI.

19
 Raffaello Borghini (Il Riposo, Florence, 1584,
p. 522) describes Danti's Crucifixion in San Fiorenzo in
Perugia (Catalogue XXXIII) of about 1575 as "lavorate con
buon disegno", although poorly colored because of his
inexperience in using colors.

20
 The catafalque is reconstructed in detail by R.
and M. Wittkower, The Divine Michelangelo, p. 149-158.

21
 The group is lost. It has been suggested by
Wittkower that it perhaps resembled the small clay figure
of Virtue Triumphant over Vice in the Museo Nazionale in
Florence; see Catalogue XVII.

22
 R. and M. Wittkower, The Divine Michelangelo,
p. 96, n71.

23
 Danti, Trattato, p. 233. "Si può ricorrere con
le seste del giudizio, che at termine degli ordini dell'
architettura con le seste materiali: e questo sarà il fine
delle perfette proporzioni."

24
Danti, _Trattato_, p. 229. "E questa che noi
diciamo bellezza d'animo, la quale non intendo io che sia,
in universale, altro che il bell'ingegno e il bel giudizio;"
and p. 233 ". . . la bellezza della quale intendo io è
quell'attezza, che è nella mente, di poter ben discorrere
e ben conoscere e giudicare le cose, comunche sieno, o
bene o male operate".

25
R. and M. Wittkower, _The Divine Michelangelo_,
p. 122-3; ". . . .Vincentio Danti Perugino, il quale, vivendo
mostrerà quanto un sollecito studio aiuti un bell'ingegno,
& conduca altrui a quella perfezzione, & eccellenza, oltre
la quale non si può alcuna cosa disiderare." _Giudizio_ was
a central concept in Cinquecento critical thought; an
exemplary discussion of the concept and its development is
given by R. Klein, "Giudizio et Gusto dans la Theorie de
l'Art an Cinquecento," _Rinascimento_, 1961, p. 105. A
classic academic formulation of the idea is to be found in
Benedetto Varchi's "Del Giudizio e de'poeti tragici," _Opere_,
II, p. 727-31. ". . . .diremo, che come in tutte l'altre
cose, così nella poetica niuno può giudicare perfettamente,
il quale non intenda perfettamente l'arte poetica; e questo
non puo fare niuno da sè (se bene da natura sono alcuni
più atti alle poesie, che alcuni altri, mediante quel giudizio
chiamato. . .da noi naturale), ma Bisogna, che egli abbia o
udito da altri, o studiato da sè cotale arte."

26

Sketches by Vasari and others for the decorations,
as well as documentation and a detailed reconstruction and
background are provided by P. Ginori Conti, L'Apparato per
le nozze di Francesco de'Medici e di Giovanna d'Austria,
Livorno, 1936. See also L. Verani, Apparato per le nozze
di Francesco I de'Medici con Giovanna d'Austria, Livorno,
1870. Vincenzo Borghini's first draft for the program is
published by Bottari-Ticozzi, Raccolta di Lettere, I, p. 125-
205. Two descriptions of the event were written, one by
Giovanni Battista Cini, published as his own by Vasari in
1568 (Vasari-Milanesi, VIII, p. 521-622). Cini's author-
ship is established by A. Lorenzoni, Carteggio inedito
di D. Vincenzo Borghini, Florence, 1912, p. 154-59.
Milanesi appends to Cini's part of the other description
(Vasari-Milanesi, VIII, p. 625-40) written by Domenico
Mellini, Descrizione dell'entrata della Serenissima Reina
Giovanna d'Austria e dell'apparato fatto in Firenze. . .,
Florence, 1566. Numerous references and documents are to
be found in K. Frey, Literarische Nachlass, II, and H. W.
Frey, Literarische Nachlass, III. Studies and sketches for
the decorations are scattered and continue to come to light.
See E. Pillsbury, "Drawings by Vasari and Vincenzo Borghini
for the 'Apparato' in Florence in 1565," Master Drawings,
III, 1967, p. 281-83. On the festival itself, on the theme
of the genealogy of the gods, see G. Nagler, Theatre
Festivals of the Medici, New Haven, 1964, with numerous
drawings by Vasari and others. For a discussion of the

iconography of the festival see J. Seznec, <u>The</u> <u>Survival</u> <u>of</u> <u>the</u> <u>Pagan</u> <u>Gods</u>, New York, 1961, p. 279ff. with bibliography; more specifically see also J. Seznec, "La Mascarade des Dieux à Florence en 1565," <u>Mélanges</u> <u>d'Archéologie</u> <u>et</u> <u>d'Histoire</u>, LII, 1935, p. 224-37.

[27]
Vasari-Milanesi, VI, p. 659

[28]
See note 40 below.

[29]
See Catalogue no. XXXIV.

[30]
The Porta Coeli, as it was called, was finished by this date, as Borghini wrote to Vasari. See Frey, <u>Nachlass</u>, II, p. 209.

[31]
Now the Piazza San Firenze, behind the Palazzo Vecchio. In Vincenzo Borghini's first draft of the program the horse was in the Piazza San Michele Bertelli. (Bottari-Ticozzi, <u>Lettere</u> <u>sulla</u> <u>Pittura</u>, I, p. 166, 173) The Piazza San Apollinare was to have had a female statue representing the order of St. Stephen, her foot on a vanquished Moor, symbolic of Cosimo's naval feats. The arrangement was not final, however, and the relocation of the group was considered at the time.

[32] Bottari-Ticozzi, Lettere sulla Pittura, I, p. 166-7.

[33] Bottari-Ticozzi, Lettere sulla Pittura, I, p. 167.

[34] Bottari-Ticozzi, Lettere sulla Pittura, I, p. 197. "Vincenzo Danti Perugino sebbene ha fra mano l'arme che va in testa de' magistrati (Danti was at the time working on the Equity and Rigor group), pure è tanto fiero e valente che ei ci aiuterà anche a questo, e se si arà a fare una statua a cavallo, sarà a proposito di lui. . ."

[35] Danti, Trattato, p. 258.

[36] In Florence Danti had only the precedent of the painted statues of the condottieri John Hawkwood and Niccolo da Tolentino by Paolo Uccello and Andrea del Castagno.

[37] Vasari-Milanesi, VIII, p. 258-60.

[38] Vasari-Milanesi, VII, p. 66.

[39] Bottari-Ticozzi, Lettere sulla Pittura, I, p. 197. See note 9 above.

[40] ASF. Depositeria Generale 575, "Debitori e Creditori di Giovanni Caccini per chonto di feste dell'anno 1565," f. 8r

and v.; f. 15r and v.; f. 51r; f. 95r and v; f. 143r and
v; f. 146v.

[41]
The horse was progressing to Borghini's satis-
faction in September 1565 when the reliefs for the portal
of the Duomo were completed. See note 5 above.

[42]
W. Gramberg, Giovanni Bologna: Eine Untersuchung
uber die Werke seiner Wanderjahre (bis 1567), Libau, 1936,
p. 109 provides the date. The relevant documents are
found in ASF. Depositeria Generale 415, f. 192-198r.
"Addi 14 di Giugno 1565 Vincentio danti perugino scultor'
ha riceuto li sotto scrippti robe per servitio del Cavallo
et figur' che vi va sotto e sopra per li nozze di S. E.
Ill^ma." The materials were for the most part consigned to
Lorenzo del Berna legnaiuolo and "pierantonio suo fator."

[43]
This payment has been published by E. Dhanens,
Jean Boulogne: Giovanni Bologna Fiammingo, Brussels, 1956,
p. 147; W. Gramberg, Giovanni Bologna, p. 110; and
Frey, Nachlass, III, p. 244. The document bears the date
November 6, 1566 almost a year after the wedding. "Addi
affar' debitor' il cavallo di S. Pulinari di fi. cento
trentacinque p. li et creditor Gianbologna scultor anzi
Vincentio Danti Perugino Scultor et sono per la stima fatta
per il suo cavallo et huomo sotto et sopra di terra messo
in detto luogho per hornamento di detta piazza." On the

basis of this document the horse is included in the catalogue raisonné of Giovanni Bologna's work by Gramberg (Giovanni Bologna, p. 109) as a work done in collaboration with Danti. Giovanni Bologna, who had a quadriga of his own to make for the Sapienza as his part of the decorations, is considered to have played only a minor part in the equestrian Cosimo by E. Dhanens. The fact that both artists were modelling large groups involving horses may have made a certain amount of collaboration desirable. Payments for Giovanni Bologna's horses might easily have been confused with payments for Danti's horse. See ASF. Depositeria Generale 415, f. 63. "Addi 29 di Maggio 1565 M⁰ Gianbologna scultur' fiammingho ha riceuto l'appresso robe per servitio delle figur' e cavalli che il detto fa per l'nozzi di S. E. Illma." The group is referred to on the same page as "i cavalli alla sapienza." Dhanens' conclusion that Giovanni Bologna played a small part in the Cosimo I group is supported by the documentation. Danti was paid 120 fiorini less that the amount Giovanni Bologna was paid for all his labors on the festival including the quadriaga. Danti is mentioned in payments "per aver lavorato il cavallo" (Depositeria Generale 575, f. 51, 143) and is credited with the horse in the descriptions when it is attributed to anyone. (Vasari-Milanesi, VIII, p. 619; Bottonio, Poesie Sacre, II, p. 161) as well as in the references of Vincenzo Borghini cited in the notes above and below.

44
ASF, Depositeria Generale 575, f. 95r.
"Spese per fare il cavallo alla piazza di s$\overset{m}{a}$ pulinarj . .
. E. addj XIII di novembre paghati a mo bastiano di
Giovanni mo di stuccho. . .E addj X detto y 27 d paghati
a mo bastiano di Giovanni da roma mo di stuccho per avere
lavorato. . ." A. E. Colnaghi, A Dictionary of Florentine
Painters, London, 1928, p. 37 lists a Bastiano di Giovanni
recorded in the records of the Accademia del Disegno February
13, 1569.

45
A. del Vita, Lo Zibaldone di Giorgio Vasari,
Arezzo, 1938, p. 45 n6.

46
A small sketch of the group as Borghini first
envisioned it was included in his letter of April 5, 1565
to Duke Cosimo published by Bottari-Ticozzi, Lettere sulla
Pittura,. I, p. 125-204.

47
The group is described as nine braccia tall in
Vasari-Milanesi, VIII, p. 559; and "over eleven" by
Timoteo Bottonio, Poesie Sacre, II, p. 161.

48
Vasari-Milanesi, VIII, p. 560. The emblem was
a pithy recapitulation of the group above. Virtue had
overcome vice, and restored peace and harmony to the city,
as displayed in the triumph of the warrior over fraud. "Il
che non meno era maestrevolmente dichiarato dall' impresa

accomodatamente nella gran base oista, in cui si vedeva
dentro ed in mezzo ad un tempio aperto e sospeso da molte
colonne, sopra un religioso altare, l'egiziano Ibi, che
alle gambe avvolte se gli erano, e col motto che accomodata-
mente diceva: PROEMIA DIGNA."

[49] The rampant horse and rider was a standard theme
of Roman imperial symbolism and must have been known in
numerous examples. See R. Brilliant, Gesture and Rank in
Roman Art, Memoirs of the Connecticut Academy of Arts and
Sciences, XIV, New Haven, 1963, esp. p. 55-58. See also
G. Soos, "Antichi modelli delle statue equestri di
Leonardo da Vinci," Acta Historiae Artium, IV, 1956-57,
p. 129-135. One of Danti's reliefs for the statue of
Julius III shows a figure on horseback which is generally
similar to a drawing by Michelangelo in the Ashmolean
Museum (L. Dussler, Die Handzeichnungen des Michelangelo,
Berlin, 1959, no. 190) The horse in the relief, stocky
and sway-backed, with loosely hinged forelegs, is very similar
in its simplified contours and disregard for the mechanics
of movement to a drawing in the Uffizi (Barocchi, Michelangelo
e la sua scuola, no. 269verso); it is by a late sixteenth-
century imitator of Michelangelo, and Barochhi notes affin-
ities with Alessandro Allori. Aside from designs which can
be directly connected with Leonardo, there is a Florentine
rearing horse and rider group, attributed to Rustici, in
the Museo Horne in Florence. (Il Museo Horne a Firenze, a

cura di F. Rossi, Milan, 1967, p. 153) Also of interest
is a bronze Pegasus in the Rijksmuseum, Amsterdam, attributed
to Cellini. See H. Weihrauch, Europaische Bronzestatuetten,
Braunschweig, 1967, p. 181. A bronze horse and rider
group in the Museo Nazionale, Florence (Weihrauch, p. 184)
usually attributed to Giovanni Bologna, is more reasonably
attributed to Baccio Bandinelli by Weinhrauch and probably
reflects thoughts of an equestrian portrait of Cosimo I
prior to 1560.

50
 In a list of things to be done sent to Giorgio
Vasari and Giovanni Caccini (the proveditore of Pisa)
by Vincenzo Borghini on September 18, 1565, it was re-
quested that Danti be told that "la statue che va sotto il
cavallo ha a finire in serpente o ha essere tutta intoriniata
et involta di serpenti." See Frey, Nachlass, III, p. 112;
P. Ginori-Conti, L'Apparato, p. 115.

51
 Vasari-Milanesi, VIII, p. 559-60.

52
 Bottari-Ticozzi, Lettere sulla Pittura, I, p.
116-67. Ariosto's monstrous Invidia was one of several
reliefs carved on a marble fountain by the magician Merlin.
These reliefs were described as lacking only breath to live.
In the next verse (Orlando Furioso, XXVI, 31)--to which
Borghini specifically referred-the relief had come alive.

 Quivi una bestia uscir de la foresta
 parea, di crudel vista, odiosa e brutta,

> che' avea l'orecchio d'asino, e la testa
> di lupo e i denti, e per gran fame asciutta;
> branche avea di leon; l'altro che resta,
> tutto era volpe: e parea scorrer tutta
> e Francia e Italia e Spagna et Inghilterra,
> l'Europa e l'Asia, e al fin tutta la terra.

This beast was slain (XXVI, 34) by a cavalier "d'imperiale alloro/ cinto le chiome" together with three youths of regal bearing and a lion. This represented the alliance of Francis I of France, Maximillian of Austria (the father of the bride), Charles V, and Henry VIII of England. The lion was the Medici Pope Leo X. Ariosto identified Invidia as such by his clear reference to Dante's Inferno, which Borghini, like most commentators after him, has noted. The wolf Invidia appears twice in the first canto of the Inferno. Borghini seems to refer to both appearances, but loosely quotes the second. (Inferno, I, 100-111)

> Molti son li animali a cui s'ammoglia
> e più saranno ancora, infin che 'l Veltro
> verrà, che la farà morir con doglia.
> Questi non ciberà terra nè peltro
> ma sapienza, amore e virtute
> e sua nazion sarà tra feltro e feltro
> Di quella umile Italia si salute
> per cui morì la vergine Cammilla
> Eurialo e Turno e Niso di ferute
> Questi la caccerà per ogni villa
> fin che l'avra rimessa nello'nferno,
> là onde invidia prima dipartilla. . .

The first part of Dante's description (97-99) of the monster though simpler than Ariosto's, is in general agreement with it. Both Danti and Ariosto referred to political salvation, and the monster includes everything from the vice of envy to the blackest evils of social discord and heresy. The reference to Virgil (Aeneid, I, 294-96, ". . .

dirae ferro et compagibus artis/ Claudentur Belli portae;
Furor impius intus/ saeva sedens super arma et centum
vinctus aënis/ post tergum nodis fremet horridus ore cruento.")
was thrown in, as Borghini suggests, for good measure.

[53]
R. Wittkower, "The Vicissitudes of a Dynastic
Monument: Bernini's Equestrian Statue of Louis XIV," De
Artibus Opuscula XL, Essays in Honor of Erwin Panofsky,
New York, 1961, p. 497-531, for a study of Hercules in
imperial symbolism.

[54]
". . .Vincenzo Danti perugino, giovane singolare
e d'ingegno sublime e acuto, grazioso e gentile, la cui virtù
e stupenda maestria nell. adoperare nell'arte della scultura
e degna d'imortale onore: il che si è conosciuto dalla
grandissima e perfetta opera, oltre all'altre sue fatte in
marmo, del Cavallo, che si vede a San Pulinari, la bellezza
del quale non mi basta l'animo d'esprimere, come nè anco
di lodar lui a bastanza." (Vasari-Milanesi, VIII, p. 560)
Cini was a close friend of Danti's brother Ignazio. See
I. del Badia, Egnazio Danti, Florence, 1881, p. 15.

[55]
T. Bottonio, Poesie Sacre, II, p. 161; also pub-
lished by J. von Schlosser in Jahrbuch d. Kunstsammlungen
in Wien, 1913, p. 79. "Nelle nozze pomposissime celebrate
in Firenze fra il Sig. D. Francesco De Medici, e la Signora
D. Giovanna d'Austria, fu tra gli altri apparati ricchissimi,
e maravigliosi, un cavallo grandissimo fatto da M. Vincenzo

Danti Scultore Perugino con un Gigante sopra di 11. braccia,
che rappresentava il Sig. Duca Cosmo Vincitore della Fraude,
significate per un Mostro mezzo Donna, e mezzo Serpe, che
sotto il Cavallo giaceva morto per le mani del Cavaliero.
Era questo spettacolo nella piazza di S. Apollinaire, dove
sogliono giustizarsi i Delinquenti per cagione di Stato.
Entrò la detta Sig. D. Giovanna in Fiorenza alli 12
Dicembre l'Anno 1565, ed alli 18 fu celebrato lo sposalizio
nel Duomo pubblicamente. . .

<div align="center">

Sonetto
Colla data di Firenze 4 Novembre 1565

</div>

Chi è costui, che'l bello alto Destriero
Più d'Erculeo valor, che d'armi cinto
Affrena, ed ha si crudo serpe estinto
Che fra l'erba giazza squammoso, e nero?
 Se miro all'onorato aspetto altero
 Un magnanimo cor vi scorgo accinto
 Ad alte imprese, e da giust'ira spinto
 Ator dal mondo ogni empio mostro, e fiero
Certo è il gran Cosmo, il qual non mem che forte
Saggio, vince ogni frode, ogn' ardir folle,
E sol col guardo i più superbi atterra
 Arno felice, alla cui lieta sorte
 Invidia il Mare omai porta, e la terra,
 Poichè il gran Duce suo tanto l'estolle!

56
 The cheerless message of Danti's poetically overloaded
group was apparent. See A. Lapini, Diario Fiorentino,
ed. Corazzini, Florence, 1922, p. 149. ". . .secondo si
comento fu figurata la genetrice delle discordie a la semin-
atrice degli odi, e finalmente che è inimica delle buone
leggi e della giustizia." It was also Borghini's intention.
When he considered moving the group to the Piazza San Apollin-
are, he thought the change appropriate because it was near

the Palazzo della Giustizia and "il esterminio delle
scelleratezze e ribalderie. . .è il vero senso di quel
concetto." (Bottari-Ticozzi, I, p. 173)

[57] For a brief history of Giovanni Bologna's equestrian
statue of Cosimo I and additional bibliography, see J.
Pope-Hennessy, Italian High Renaissance Sculpture, III, p.
86-87.

[58] Vasari-Milanesi, VIII, p. 559.

[59] Catalogue no. XXIX. Payments for the altar
date from 1561 to 1569. One one payment to Danti, dated
simply 1567, is published by W. Bombe, Urkunden, p. 119.

[60] H. Olsen, Federigo Barocci, Copenhagen, 1962,
The most detailed treatment of the altar is W. Bombe,
"Federico Barocci a Perugia," Rassegna d'Arte, XII, 1912,
p. 189-196. Bombe announced in that article that he was
about to publish a more detailed study of the altar and
Vincenzo Danti in the Repertorium fur Kunstwissenschaft,
but the study did not appear.

[61] For the history of the present altar see A.
Mezzanotte, La Deposizione dalla croce quadro di Federigo
Barocci di Urbino nella Cattedrale di Perugia. . .con una
lettera storico-critica di Gio. Battista Vermiglioli,

Perugia, 1818, p. 22-23; and S. Siepi, Descrizione,
Perugia, 1822, I, p. 61-67.

62
Catalogue XXIX.

63
See Catalogue III, "History".

64
The Perugian foot is equal to 14.5 in.; See
Catalogue III, "History."

65
The drawing, in the Archivio del Nobile Collegio
della Mercanzia in Perugia, bears the legend: "Prospetto
dell'Altare spettante al Nobil Collegio della Mercanzia
esistente nella Chiesa Catedrale di S. Lorenzo di Perugia
ideato ed in quanto alle Statue esseguito dall'Architetto
e Scultore Vincenzio Dante, e rapporto ai Festoni, e
Mascheroni mandati ad effetto da Ludovico Scalza nell!anno
1563 e da Vincenzio Ciofi disegnato prima della sua demol-
izione seguita nell'anno 1793." It was published by W.
Bombe, Urkunden, Abb. 21.

66
For example, C. Crispolti, Perugia Augusta, Perugia,
1648, p. 64. "Qui vedonsi molte statue di tutto rilievo
. . . qui sono bellissimi festoni & altri ornamenti di stucco
. . .il tutto poi è messo in luoghi convenevoli ad oro. . ."

67
C. Crispolti, Perugia Augusta, p. 64. ". . .Scalza

di cui è anche il disegno dell'opera." The other sources
are noncommittal.

68
The contract (Catalogue XXIX) reads: "In questo
foglio se fara mentione per noi Ludovico Scalzi da orvieto
et Giovanni de domenico fiorentino como noi promettiamo di
fare la capella de san bernardino in san lorenzo de la
magnifica arte de la mercantia, di stucco secondo il disegno
fatto per noi. . ." For Ciofi's statement see Note 65 above;
"ideato ed in quanto alle Statue esseguito dall'Architetto
e Scultore Vincenzio Dante. . ."

69
On Michele Sanmichele see P. Gozzola, _Michele
Sanmicheli_, Venice, 1960. Documentary material for the
Duomo at Orvieto is provided by L. Fumi, _Il Duomo di
Orvieto e i suoi restauri_, Rome, 1891. Sanmichele's altar
dates 1514. The altar was finished by Simone Mosca in 1546,
and copies in a twin altar of the _Annunciation_ by Mosca and
Raffaello da Montelupo. The Duomo at Orvieto was a busy
center of marble carving all through the sixteenth century.
Some of the artists--most notably Raffaello da Montelupo--
worked on projects in Rome, near Michelangelo; Francesco
Moschino, the son of Simone Mosca, who also worked at Orvieto,
may have been associated with Danti in Florence. See Frey,
Nachlass, III, p. 6, 55. Both letters concern marble which
Moschino was arranging to have sent to Florence for Danti's
use. Relations between Orvieto and Perugia were fairly close,

and it is likely that Danti was familar at first hand with the nondescript classicism, of the sort associated with the upper register of the tomb of Julius II in S. Pietro in Vincoli, which characterized the school.

According to Siepi, <u>Descrizione</u>, I, p. 62, decoration of the chapel in Perugia began in 1519, making it possible that the correspondence between Danti's altar and the Orvieto altar is the result of earlier planning or construction. There is nothing in the sources, however, to suggest that the San Lorenzo altar was no begun in 1559.

[70] See U. Tarchi, <u>L'Arte del Rinascimento nell'Umbria e nella Sabina</u>, n. p., 1954, tav. CCXVIII.

[71] U. Tarchi, <u>L'Arte del Rinascimento</u>, tav. CCIL.

[72] O. Lancellotti, <u>Scorta Sagra</u>, Mss., PBA, f. 147; quoted by W. Bombe, "Federico Barocci," p. 190-1, n3.

[73] Ibid.

[74] See Catalogue XXIX.

[75] All eleven full round figures have always been attributed to Danti. W. Bombe, Thieme-Becker, VIII, p. 384, added the griffins as well. On the fate of the figures see Catalogue XXIX.

76
 U. Tarchi, L'Arte del Rinascimento, tav. VIII.

77
 S. Siepi, Descrizione, I, p. 62.

78
 Vasari's biography of Montorsoli packs work in
Rome, a trip to France, a touristic jouney through northern
Italy, and work around Florence between the departure of
Michelangelo from Florence late in 1534 and the arrival of
Charles V in May of 1536. During this time the statues in
SS. Annunziata were modelled. ". . . nel suo convento de'
Servi fece, similmente di terra, e le pose in due nichie
del capitolo, due figure maggiore del naturale, cioè Moise
e San Paolo, che gli furono molto lodate. . ."(Vasari-
Milanesi, VI, p. 637). C. Manara, Montorsoli e la sua
opera genovese, Genoa, 1959, p. 18, includes the figures
in the period of direct contact with Michelangelo, toward
1533. Such clay figures could have been done quickly, and
Montorsoli was known for doing them in little time (Manara,
Montorsoli, p. 19). Since he probably did not return to
Florence just to execute the figures, a date near one of
the two terminal dates is most likely. Vasari's account at
least indicates that Montorsoli modelled the figures after
he had left Florence in 1534, and a date in 1535 therefore
seems best.

 A drawing of the St. Paul ascribed to Montorsoli
is to be found in the Gabinetto dei Disegni of the Uffizi, no.
14367F. Definition of Montorsoli as a draughtsman is still

in an early stage. See _Mostra di disegni dei Fontatori dell'_
Accademia delle Arti del Disegno, Florence, 1963, catalogo
a cura di P. Barocchi, A. Bianchini, A. Forlani, and M.
Fossi, nos. 22-24; and E. Battista, "Disegni inediti del
Montorsoli," _Arte Lombarda_, _Studi in Onore di Giusta Nicco_
Fasola, X, 1965, p. 143-8.

[79] The figures mentioned by Vasari were considered to
be the same as those now in the chapel by Milanesi (Vasari-
Milanesi, VI, p. 636). Gronau-Gottschewski, _Die Lebens-_
beschreibungen der berühmtesten Architekten, Bildhauer und
Maler, trans. by A. Gottschewski and G. Gronau, Strasbourg,
1910, VII, p. 402, n19 questioned the identification, followed
by Thieme-Becker, XXV, p. 99 and Paatz, _Kirchen_, I, p. 117-
118, rejected it. Manara, _Montorsoli_, p. 24 accepts the
figures without comment. Paatz assigns both the figures to
"a late sixteenth-century master". Since there were always
twelve figures (there are twelve frescoes, on which see
Geisenheimer, "Di alcune pitture") and only ten were assigned
in 1567, and since the frescoes (the _Crossing of the Red_
Sea and _Conversion of St. Paul_ make it certain that _Moses_
and _St. Paul_ were always where they are now, the coincidence
of their twin destruction at the end of the sixteenth century
seems remote. There is also no stylistic inconsistency in
the attributions to Montorsoli.

[80] The circumstances surrounding the cession of the

chapel to Montorsoli, leading to the foundation of the
Accademia del Disegno, are recounted by Vasari. (Vasari-
Milanesi, VI, p. 655-660) The record of the cession, dated
September 10, 1560, was included in A. Nocentini, <u>Mostra
Documentaria</u> <u>e</u> <u>Iconografica</u> <u>dell'Accademia</u> <u>del</u> <u>Disegno</u>,
Florence, Archivio di Stato, February-March, 1963. The
signature of the document (ASF, Conv. 119, f. 53, c. 4v)
is given in the catalogue but the document itself is not
published. Montorsoli cannot have been in Florence contin-
ually after his return, since his high altar for S. Maria
dei Servi in Bologna was not finished until 1562. See E.
Battisti, "Disegni inediti," p. 148, n3 for the notice
establishing this date.

81
The documents yield little information about the
niches, whether they had already been completed by Montorsoli
when the Academy assumed responsibility for the chapel, or
whether they were done as the figures were done. Whatever
the case, Montorsoli was probably substantially responsible
for the present design of the chapel and for the design of
the niches. The simple bead and reel mouldings are much the
same as those by Montorsoli in S. Maria del Parto in Naples
(see Venturi, <u>Storia</u>, X, 2, fig. 92) and the general format
of figures with identifying histories over each of them
appeared earlier in his work at the Duomo at Messina.
(C. Ricci, <u>L'Architettura</u> <u>del</u> <u>Cinquecento</u> <u>in</u> <u>Italia</u>,
Turin, 1923, pl. 204). The <u>capitoli</u> of the Accademia

drawn up in 1563 specify that Montorsoli's design should
be followed by anyone wishing to add painting or sculpture
to the chapel. See N. Pevsner, Academies of Art, Past and
Present, Cambridge, 1940, p. 300. "C. XVII. Dettono
licentia anchora a chi vi volessi fare pitture o sculture
o altre memorie di suo, che possa farle in detto dapitolo
osservando quello che haveva cominciata Fra Giovann'Angelo
nel suo disegno." The closest precedent for such a series
of seated figures is the Santa Casa at Loreto, a monument
which the older generation of Florentine sculptors had reason
to know well. See J. Pope-Hennessy, Italian High Renaissance
Sculpture, III, p. 48-50. On the relationship of the
architecture of the chapel to the Medici Chapel see C. de
Tolnay, Michelangelo, II, p. 305.

82
The history of the chapel and a description of
its present state are given by W. and E. Paatz, Die
Kirchen von Florenz, Frankfurt am Main, 1940, I, p. 117-119,
131-32, 179-82, 193. The agreement between the brotherhood
of Santissima Annunziata and the Accademia del Disegno,
dated June 25, 1565, was published by H. Geisenheimer,
"Di alcune pittore fiorentine eseguite intorno al 1570. II.
Gli affreschi nella Cappella dei Pittori (Vasari, Santi di
Tito, Al. Allori)", Arte e Storia, 1907, no. 3-4, p. 19-21
". . . detto collegio abbia a fare l'ornamento ovvero ripieno
di detto Capitolo di Statue di Stucco in dieci nicchie, e tre
storie in tre quadrid. . ." It should be pointed out that the

figures are not stucco, but painted clay, "terra da montelupo" as it is called in the documents.

83
The nineteenth century modifications are described in considerable detail by P. Tonini, Il Santuario della Santissima Annunziata, Florence, 1876, p. 237-42; and E. Casalini, La Basilica Santuario della SS. Annunziata, Florence, 1957, p. 101-5.

84
These histories are identified by Paatz, Kirchen, I, p. 119.

85
The academicians were required to meet in the chapel at least once a year, on the feast of the Trinity, for solomn mass, See N. Pevsner, Academies, p. 229. The Academy also celebrated the feast of St. Luke. The association with the Trinity is by far the more important. St. Luke was a reminder of the old guild of St. Luke, and Vasari (Vasari-Milanesi, VI, p. 658-9) tells of a movement afoot to do away with him altogether. The Trinity, on the other hand, was a convenient symbol of the newly exalted status of the arts. Vasari in a well-known passage (Vasari-Milanesi, I, p. 168) calls Disegno "the father of our three arts". At almost the same time Vincenzo Borghini, the luogotenente of the Accademia, compared the three arts to the three graces. ". . . il padre disegno. . . ha tenute sempre queste sue figliuole come le tre gratie insieme

Unitiss. e et concordissime. . ." A. Lorenzoni, Carteggio inedito artistico di D. Vincenzo Borghini, Florence, 1912, p. 13. The arts were depicted as the three graces in the decorations for the wedding of Francesco I and Giovanna of Austria in 1565. (Vasari-Milanesi, VIII, p. 530) The identification of the graces and the Trinity was a neo-Platonic commonplace, and the arts were thus made the forms of Divine Love. Federico Zuccaro, closely associated with both Vasari and Borghini, made frequent use of the metaphor of the Trinity in expounding the unity of the arts, and in his ceiling fresco in the Sala del Disegno in the Palazzo Zuccaro in Rome the figure of Disegno merged with the representation of God the Father. See W. Körte, Der Palazzo Zuccari in Rom, sein Freskenschmuck und seine Geschichte, Leipzig, 1935, p. 35-47. Körte finds the closest parallel to the figure of Disegno in Raphael's Vision of Ezekiel now in the Palazzo Pitti. The fresco bears the inscription VNA LVX IN TRIBVS REFVLGENS. The theological tone of the parallel is also clear in the motto of the Accademia del Disegno, which together with the three interlaced wreaths (considered a personal emblem of Michelangelo—"sua antica impresa"; see Vasari-Milanesi, VIII, p. 528; and R. Wittkower, The Divine Michelangelo, p. 121, n135) appears among the grotteschi decoration between the niches of the chapel: LEVAN DI TERRA AL CIEL NOSTRO INTELLETTO.

86
That the arrangement symbolized the three arts of

design was recognized by F. L. Del Migliore, Firenze Città Nobilissima Illustrata, Florence, 1684, p. 296-97.

[87]
Archivio di Stato, Florence, Art. Accademia del Disegno, Libro del Proveditore, "E", f. 154. The 'riformatori' were Francesco da Sangallo, Angelo Bronzino, Giorgio Vasari, Pierfrancesco di Jacopo (di Sandro Foschi; see R. and M. Wittkower, Divine Michelangelo, p. 102, n83), and Michele di Jacopo di Ridolfo Tosini, called Michele di Ridolfo Ghirlandaio. Bartolommeo Ammannati appears as M. Bastiano Amonini. The order to distribute the paintings and sculpture dates October 18, 1567, (Libro del Proveditore, "E", f. 21r.)

[88]
By Giovanni Vincenzo Casali. It is found in the archives of Santissima Annunziata and not of the Accademia del Disegno; see Nocentini, Mostra Documentaria. The signature given is ASF, Conv. 119, no. 122. The part of the document listing the assignments to the painters (A. Bronzino, and A. Allori, The Trinity; Giorgio Vasari, the Old Testament fresco; and Santi di Tito, the New Testament fresco) was published by Geisenheimer, "Di alcune pitture." Geisenheimer omitted the sculptors, who were added in G. Vasari, Die Lebensbeschreibungen, ed. A. Gottschewski and G. Gronau, VII, p. 402, n19.

[89]
The question of the attribution of the sculpture

in the chapel has been clouded by the existence of two lists of artists and figures which do not perfectly corres- pond; the list of Casali (see note 88 above) and another list published by C. I. Cavallucci, Notizie Storiche intorno alla R. Accademia delle Arti del Disegno, Florence, 1873, p. 105-6; and G. Ticciati, Storia dell'Accademia del Disegno, in P. Fanfani, Spigolatura Michelangelesca, Pistoia, 1876, p. 193-307, esp. p. 283-88. The second list was taken from the payment records in the archives of the Accademia del Disegno, from which the documents upon which the discussion below was based were taken. The disparity in the lists charts the swapping and abandonment of the commissions of 1567.

90
The standard attributions are to be found in Paatz, Kirchen, I, p. 119. The are based on the opinions of Friedrich Kriegbaum.

91
ASF. Arti. Entrata e Uscita, f. 114v. "giovedi. adj. 30. daprile. 1570 a quatro fachinj che portonno la figura del sta. piero. ch. fece domenico pogginj. . . alla. noziata. lire tre soldj diecj & soldi venti per gesso per aconciare la detta figura nella nicia. . ." See also Entrata e Uscita 114v, October 19, 1570. "Al detto Dom.co y nove e mezo sono per tanta terra da montelupo per fare il p.mo san piero, la quale poi servi per fare la statua che ha fatto Fra Giovan Vincenzio per il capitolo della nunziata."

"Il primo San Pietro" no doubt means that it was the first
figure done, not that Poggini did more than one of them, that
is, that the first was a failure. The clay left over after
the effort must have gone to Giovanni Vincenzo Casali for
the St. John. See note 92 below. The St. Peter has been
attributed to Giovanni Bandini by U. Middeldorf, "Giovanni
Bandini, detto Giovanni dell'Opera," Rivista d'Arte, XI,
1929, p. 481-518. Following this attribution the figure
was also published by A. Venturi (Storia, X, 2, fig. 229).
It is the only figure in the chapel of which a photograph
has been published. Middeldorf based his argument on style
and not on the documents, which seem unambiguous. On
Domenico Poggini see U. Middeldorf and F. Kriegbaum,
"Forgotten Sculpture by Domenico Poggini," Burlington
Magazine, LI, 1928, (II) p. 9-17.

[92]
Paatz, Kirchen, I, p. 118. Casali was a follower
of Montorsoli; on his relationship to Montorsoli see
Battista, "Disegni inediti", p. 148.

[93]
See note 91 above and Entrate e Uscita, f. 115r.

[94]
Libro del Proveditore, "E", f. 59v. ". . .a sei
facchinj che portonno la figura sioe il Melshisedech a fatto
franco Cammillanj schultore. . ." Cammillani had been given
materials October 18, 1569. Entrata e Uscita, f. 114r.
On Francesco Cammillani see A. Venturi, Storia, X, 2, p.530-45.

95 Giovanni di Bastiano di Marco Balducci (or de'
Cosci) was active in Florence, Rome and Naples as a painter.
See Theime-Becker, II, p. 402; and D. E. Colnaghi, A
Dictionary of Florentine Painters, p. 28-9. Since Balducci
must have been closer to seventeen than to seven when he was
assigned the St. Matthew, his birth date should probably
be ten years earlier than the date of 1560 which is usually
given. In that case, the date of death given by Venturi
(Storia, IX, 6, p. 133), 1658 must also be in error. Balducci
seems to have died before 1605.

96 ASF, Libro del Proveditore, "E", f. 61v; Entrata
e Uscita, f. 117r. Both are payments to four porters
"che condusono nel capitolo la fiura del San Mateo di mano
di Micolagniolo ischultore. . ." Most recently Michelangelo
Naccherino has been connected with Vincenzo de'Rossi in
contradiction to his own statement that he was a student of
Giovanni Bologna before leaving Florence for Naples in 1573.
See A. Parronchi, "Resti del presepe di Santa Maria Novella,"
Antichità viva, V, 1965, p. 9-28. Naccherino's bronze St.
Matthew in the Duomo at Salerno, done around 1600, very
similar in type to the figures in the chapel, may provide
some clue to the appearance of the lost figure, taken out
in the nineteenth century. See Venturi, Storia, X, 2, fig.
505.

97 See Catalogue no. XXI.

98
The history of the _Fountain of Oceanus_ is recounted in detail by E. Dhanens, _Jean Boulogne_, p. 167-173; and in less detail by J. Pope-Hennessy, _Italian High Renaissance Sculpture_, III, p. 82.

99
Paatz, _Kirchen_, I, p. 118

100
See note 110 below.

101
ASF, Entrata e Uscita, f. 115r. The document reocrds a general payment for expenses "fatte nella sua figura che fa per il capitolo dall'accademia."

102
Lastricati executed figures for the wedding of Francesco I and Giovanna of Austria in 1565. See G. Palagi, _Di Zanobi Lastricati, scultore e fonditore fiorentino del secolo XVI_, Florence, 1871. He also executed the figure of _Fame_ atop the catafalque of Michelangelo. See Wittkower, _Divine Michelangelo_, p. 105-6. A marble figure by his hand which may be identifiable is described in the 1691 inventory of Poggio Imperiale. ASF, Mediceo, Guardaroba 991, f. 58r. "Una figura di tutto rilievo di marmo bianco d' un giovane tutto nudo con carcasso a armacollo, e cane in Guinzaglio posa su d'un piano tondo incavato in Base di marmo simile alta $\frac{1}{4}$; e la figura alta 2 3/4. Scrittovj in d:[a] (di pietra scartocciata alta 2/5,) Zanobi Lastrica, e posa

sopra altra Base di pietra scartocciata alta 2/5, con
cartella scrittovj, cede l'Arco, e gli strali." Lastricati
is mistakenly credited with Cammillani's Melchisedech in
Thieme-Becker, XXII, p. 414.

103
ASF. Arti. Accademia del Disegno, Libro del
Proveditore, "E", f. 27v., October 18, 1570.

104
Frey, Nachlass, II, p. 579; April 7, 1571.
The letter is from Vincenzo Borghini to Vasari, and mentions
a letter from Danti to Vasari.

105
See note 96 above.

106
Cosimo I was represented as David in the decorations
for the marriage of Francesco I and Giovanna of Austria.
(Vasari-Milanesi, VIII, p. 546) and as Solomon in his
quarters in the Palazzo Vecchio (Lo Zibaldone di Giorgio
Vasari, ed. A. del Vita, Arezzo, 1938, p. 11.) He is
shown with Moses at his back as the patron of Pisa in
Pierino da Vinci's marble relief in the Museo Vaticano.
That Cosimo's patronage of the Accademia del Disegno occupied
an important place in the minds of its members can be inferred
from the following letters proposing new devices for the
academy. Here is Domentdo Poggini: "E perchè tutte e tre
(arts) si partono da un solo gambo e da una sola scienze,
figuro ch'elle (Minerva) si riposi e regga sul Capricorno

come virtù di S. E. Ill.; e nello scudo, che Minerva
tiene nel braccio sinistro, formo l'arme di S. E. Ill.,
col quale scudo elle si difende, e guarda da cui volesse
offenderla, siccome questa compagnia si regge, si guarda e
si difende con la virtù, forza e favore di S. E. Ill."
(Bottari-Ticozzi, Raccolta, I, p. 265) Or the following
letter, of Stefano Pieri to Baccio Valori (p. 267) in
which COsimo's image approaches the present statue of
Joshua. "in primo fingo un tempio, in memoria e stabilità
dell'arti, di poi dentrovi la statua dell'Illustrissimo et
eccellentissimo Duca di Firenze e di Sieno, armato con
bastone in mano, e dall'altra l'arme di S. E. Ill. . . "

The series of Old Testament figures in the chapel
corresponds closely to medieval series. In a tenth-century
coronation ordo cited by A. Katzenellenbogen (The Sculptural
Program of Chartres Cathedral, Baltimore, 1961, p. 28-9)
the king is characterized as strengthened by the faith of
Abraham, possessed of the clemency of Moses, fortified by
the strength of Joshua, exalted by the humility of David,
and adorned by the wisdom of Solomon. This list exactly
parallels the series in the chapel, omitting only Melchi-
sedech who was both priest and king.

107
ASF, Entrata e Uscita, f. 118 recto , "E", f.
64 r. On Stoldo Lorenzi in Milan see E. Kris, "Materialen
zur Biographie des Annibale Fontana und zur Kunst-Topographie
der Kirche S. Maria presso S. Celso in Mailand," Mitteilungen

des <u>Kunsthistorischen Instituts in Florenz</u>, III, 1919-32, p. 201-53.

108
The history of the tomb of Michelangelo in Santa Croce has been unraveled by J. Pope-Hennessy, <u>Italian High Renaissance Sculpture</u>, III, p. 66-69. Battista Lorenzi contributed considerable labor to the tomb.

109
See P. Ginori Conti, <u>L'Apparato per le nozze di Francesco de'Medici e di Giovanna d'Austria</u>, Florence, 1936, p. 146 where Casali is listed among the sculptors who took part in the decoration of 1565 as "Andrea Corsali con Battista Lorenzi." Payments to Andrea Corsali are first recorded November 23, 1573 for "i spese per la sua figura del Capitolo," Entrata e Uscita, f. 123r. See also <u>Libro del Proveditore</u>, "F", f. 92r and 93r., February 17, 1574, the last recorded payment "per conto della fiura dandrea corsali del capitolo della nutiata."

110
There is a bozzetto for the <u>St. Mark</u> in the Galleria dell' Accademia di San Luca in Rome; see V. Golzio, <u>La Galleria e le collezione della R. Accademia di San Luca in Roma</u>, Rome, 1939, p. 13, ill. p. 59. See also "Le Terrecotte della R. Accademia di S. Luca," <u>Atti e Memorie della R. Accademia di S. Luca</u>, X, 1933, p. 54. The authorship of the figure and the date of its completion are settled by an engraving of the figure as St. Mark published

in J. Ainaud de Lasarte and A. Casanovas, "Catalogo de
la Biblioteca de el Escorial," Anales y Boletín de los
Museos de Arte de Barcelona, XVI, 1963-64, I, p. 357, lam.
68. It bears the inscriptions "Z. Bologna inven., 1574,
Apresso Nicolo Nelli, In Venetia con Privilegio, S. Marco."
This engraving was kindly brought to my attention by Catherine
Wilkinson of Yale University. I have been unable to consult
a recent article which may have reached the same conclusion
as to Giovanni Bologna's role in the execution of the figure.
See. E. M. Casalini, "Due Opere del Giambologna all'
Annunziata di Firenze," Studi Storici dell' ordine dei
Servi di Maria, XIV, 1965, p. 261-76.

111
 Libro del Proveditore, "F", f. 56r. July 11,
1574. "E adj detto Pagherese allo Sebastiano renaiuolo per
4 some di terra per la fiura di fra gio vinczio casalj."
Also see Entrata e Uscita, f. 115r, 123 r, Libro del
Proveditore, 56v, 58v, and 59r. "xii Dicembre 1574 Maggo
mo Valerio pagherese a Domco di Zanobi Landinj pittore
lire tre e soldi dieci che tanti sdi fa buonj per avere
dipinto la figura del Salamone di fra gio: Vinczio nel
nostro capitolo."

112
 Libro del Proveditore, "F", f. 61r. "Addj 8
dj Maggio 1575 Mag.co mo Valerio paghare a Piero di
Santi bruschinj lire quattro. . . per dipintura della figura
che a fatto fra Giova agnolo nel nostro capitolo cioè il
davide e dato di pagonazo all nicchia. . ." Fra Giovanni

Angelo was mistakenly identified with Montorsoli (dead
twelve years at this time) by Cavallucci, Notizie storiche,
p. 106.

113
Baldinucci, Notizie, III, p. 660. On the work
of the shop of Foggini in SS. Annunziata in the late
Seicento see K. Lankheit, Florentinische Barockplastik,
. . .1670-1743, Munich, 1962; Abb. 32 and 33 for the Feroni
chapel (1691-93) and Abb. 198 for the monument to Donato
dell'Antella (1702) both in Santissima Annunziata.

CHAPTER V

THE LAST WORKS IN FLORENCE
THE COURTLY STYLE UNDER FRANCESCO I

è fatto con tanta grazia e
tanta leggiadria, che, se la
cosa dovesse essere vera, per
ch'ella altramente non potesse
avenire di quello ch'egli la
ci dipinge.
-----Bernardino Daniello

CHAPTER V

THE LAST WORKS IN FLORENCE
THE COURTLY STYLE UNDER FRANCESCO I

Introduction:

Vincenzo Danti remained in Florence for sixteen
years. These years were spent winning the necessary cred-
entials to assure him continued work at major commissions.
His first ducal commission, the Monument to Carlo de'Medici
at Prato was a relatively inconspicuous task, and away from
the light of the city square, Danti contented himself with
a lackluster performance. The Testata group was a more
important commission, but for several reasons it was a
difficult one. Not only did the position of the group,
high on the dark walls of the Uffizi, threaten the fruits
of Danti's ingenuity and industry with invisibility, the
work itself was fraught with endless disappointment and delay.
Danti's career nonetheless advanced despite occasional set-
backs, and by 1570 his reputation seemed firmly established.
He was employed in the ducal cannon foundry, continued to
be active in the affairs of the Accademia del Disegno,[1] and
was engaged in the completion of the decoration of the
Florentine Baptistry.

During the same years that Danti gained experience
and united his often contradictory inclinations into a

personal style, circumstances in Florence itself changed, and Danti was not untouched by these changes. In 1564 Cosimo I had for all intents and purposes relinquished the government of the city to his son Francesco.[2] Cosimo's years of systematically gathering power into his own hands made it certain that Florence would be responsive to the policies, tastes, and even the whims of his successor, and the difference in character between Cosimo and his heir was soon apparent. Cosimo I conducted his affairs with an eye to the powers of Europe. His little duchy had an importance in political reckonings all out of proportion to its real power. In Florence itself Cosimo's sense of empire was relfected in commissions on a scale consistent with the traditions of Florence and the propagandistic legend of the Medici as enlightened patrons of the arts. With Francesco, Cosimo's vision faded along with the European importance of the city. Art turned away from the glorification of Florence under the Medici to the satisfaction of a courtly, eccentrically personal and rather more stingy taste. Perhaps most important for Danti, Francesco's pleasures did not run to monumental sculpture.

The new taste was not simply Francesco's, and he was as much shaped by events as responsible for them. Quite apart from political and social considerations, fundamental changes in the artistic community took place during the same years. The generation of artists associated with the name of Cosimo I was virtually at an end. Bronzino and Cellini

died in 1572, and Giorgio Vasari, long the kingpin in
Florentine art circles, died in 1574, the same year as
the Duke he had so copiously served. The end of the
activity of these artists meant the end of styles defined,
directly or obliquely, by the patterns of the High Renaissance,
by the examples of Raphael, Andrea del Sarto, and especially
of Michelangelo. Nor did these styles simply grow old.
Flemish artists flocked to Florence, most important among
them Giovanni Bologna and Giovanni Stradano, and contributed
to the rapid development of the new courtly style. The
manner of Michelangelo, which had undergone a process of
crystallization in the hands of his followers, was replaced
by the elegant sculptural equations of Giovanni Bologna,
the momentum of whose formally conceptual, non-iconographic
art drew other sculptors into its wake as it moved more and
more surely away from the problems, set by the sculpture of
Michelangelo, of the 1560's. Danti had a background in the
decorative tradition of the maniera, and his academic ex-
ploration of Michelangelo's sculpture had lead him to
severely abstract principles of formal synthesis. In res-
ponse to the quality of Giovanni Bologna's sculpture, Danti
distilled his previous experience into the mute elegance
of his last Florentine works.

While the two marble figures of Equity and Rigor
were in progress, Danti had been given another commission.
Two figures, a St. Peter and a St. Cosmos were to have
been placed "nella nichie che mettono in mezzo la porta di

San Piero Scheraggio"--that is, in the first two niches in the pillars of the arcade of the Uffizi nearest the Palazzo Vecchio. Danti was to have carved the St. Peter, and stones four braccia high were ordered from Carrara by the Proveditore in January, 1565.[3] This marble did not come to Florence, and when next the project is heard of, in October, 1569, Andrea Calamech, who was to have carved the St. Cosmos, had left for Messina, apparently confident that nothing much was to come of the matter, leaving word that he would return to Florence to carve the figure whenever the Duke desired.[4] In 1569, stone was once again enroute to Florence, and Larione Ruspoli had asked to be given Calamech's old commission.[5] It was done.

The marble for the figures had arrived in Florence by August 9, 1570 together with the marble for the second statue of Cosimo I.[6] None of the Uffizi sculpture had been completed since Equity and Rigor in 1566, and the first statue of Cosimo I stood in Danti's shop as a ponderous monument to the failure of the second phase of the project. Before granting the money that Danti requested in order to start work again, then, the Duke ordered an appraisal of the whole enterprise. The results were in less than a month later. Danti had completed a model for the statue of Cosimo I, but had not begun work on the marble; the statue of St. Peter had not been begun either, and a model which had been done previously had not turned out well. Danti's Uffizi project was thus at a standstill. The Duke grumbled that

the appraisal was simply a long way of saying that nothing
had been done at all.[7] In the meantime, Danti either could
not or did not pay his rent for the shop he had set up in
San Piero Scheraggio.[8]

The Decollation of the Baptist:

The chief reason given in the report to the Duke for
Danti's inability to finish the Uffizi sculpture was his
involvement in the bronze group of the Decollation of the
Baptist for the south door of the Baptistry. (fig. 60)
Danti began his work on the Baptistry with the completion
of Andrea Sansovino's Baptism of Christ over the Gates of
Paradise. The clear difference between the heads of Christ
and St. John the Baptist (fig. 123) and the comparison of
the head of Christ to Danti's characteristic mannerisms (fig.
39) suggest Danti as the author, although it is difficult
to say how much more of the final surface is his. Danti
also modelled a terracotta angel to complete the Baptism
group. This angel was replaced by the present disproportion-
ate angel in the eighteenth century.[9] Probably as a result
of the successful completion of this project, Danti was
awarded the commission for the bronze Decollation over the
south portal, which completed the scheme of decoration. The
records of the commission have only partially survived; but
from what bits there are it is most evident that the Arte
di Calimala, the traditional patrons of the Baptistry, were

none too happy under the burden of paying for the sculpture.
Their constant references to the bronzes "ordered by his
excellency" and their hangdog offers to sell their quarters
to pay for materials are measures of the dependence of the
once proud Florentine guilds upon Cosimo I and the power-
lessness to which he had brought them.[10] When in 1571, the
time came to actually pay for the bronzes, the affair ended
in dispute. Danti asked 500 scudi for each of them, while
the proveditore of the guild held out for only 300. The
matter was eventually arbitrated by the Duke, who struck
a precise compromise, 400 scudi for each figure, 1200 scudi
in all. Danti was in addition granted Florentine citizen-
ship.[11]

Danti had the difficult task of relating a violent
scene to a rigid, traditional format. Rustici's Preaching
of the Baptist over the north portal and Sansovino's Baptism
over the east set this format--three dramatically united
figures on separate socles--following an earlier Trecento
system.[12] Danti departed from the formula only in adding
small, extremely sketchy allegorical reliefs to the socles.
the narrowness of the ledge upon which the group stands was
also an imposing limitation. Not only was the group dic-
tated to an uncommon degree by architectural circumstances,
but it also seems that Danti was required to bring his
composition into some conformity with the mosaics inside
the Baptistry. Whether or not this was stipulated, he
did so.[13] Danti also carefully adjusted his group to its
setting, and the contours of the great bronze forms play

elegantly against the marble and serpentine patterns behind them. (fig. 60) The tabernacle enclosing St. John the Baptist repeats the order of the doorway below in miniature but in rather precise detail. (fig. 61) Danti also allowed the Quattrocento doorjambs to sound the melody which he resumed in the decoration of the socles, and which finally animated the surfaces of the statues themselves. (fig. 62)

In the Baptistry group Danti fused his concern for pure volume and linear organization. Decoration became more important in direct proportion to the refinement of contour. The limits of the forms themselves are defined with the same delicacy as the drawing with light and shadow that moves over their surfaces. Forms change from two to three dimensions with perfect ease, like the wisp of hair at Herodias'cheek which passes imperceptibly from relief to soft incision. (fig. 63)

Danti was best in bronze, and after fifteen years the Baptistry group gave him the opportunity once again to work his favorite material on a monumental scale. His group is a masterpiece of stylistic synthesis. His admiration for Cellini's Perseus is clear, especially in the head of the Executioner. (fig. 64) Danti united the volumetric severity of his earlier Madonnas with a classically extracted nobility, courtly artificiality, and the mysterious decorative caprice of Michelangelo's teste divine, all in a pure realization of his principal means as a sculptor, volume-surface

and disegno.[14] When he modelled the head of <u>Herodias</u>
(fig. 63) the freedom, outside the technical limitations
of marble, which he had exercised in the statue of Julius
III returned. At the same time his earlier exuberance was
tempered by the intervening experience in marble, and the
sere volumes now play in a clear tension against the decor-
ation and contours. In the splendidly modelled figure
namelessly struggling in the coiffure of <u>Herodias</u> (reminis-
cent of the figure at the breast of Salviati's <u>Charity</u> in
the Uffizi) the questions that he explored in his first
work, on the reality of things created, and the haunting
wordless life and logic of decoration are taken up again.

As in the <u>Onore</u>, the volumes comprising the figures
move slowly in the light, maintaining even, planar surfaces
bounded by thinly drawn contours. The forms are weightless
and have flat useless feet. To a certain extent Danti was
working according to the kind of <u>maniera</u> formula defined
in such works as the allegorical figures on designs by Bronzino
in the Villa Imperiale at Pesaro. But the lack of physical
support also has the effect of mysteriously suspending the
figures. <u>Herodias</u> (fig. • 62) is sustained by the visual
tension of the great arc that defines her. The same sweeping
force-in-itself that transfixes the figures of the Rondanini
<u>Pietà</u> is blunted and muted in <u>Herodias</u>' choreographic revul-
sion. The drama of the group is simply and silently manifested
in the symmetrical deviation of the two flanking figures from
the vertical. Both the demurring <u>Herodias</u> (waiting nonetheless

with a large salver) and the coiled Executioner just
depart--and depart in equal degree--from the axial balance
of the victim at whom they gaze.[15]

The weightlessness of the figures, and the con-
ception of the group as a unique, aesthetically relational
system, provided the basis for seeing the figure from below.
It was related to its context in two dimensions (as it is
seen at a considerable distance) but was also to be seen at
close range from below. From a vantage point immediately
beneath the group the spaces become active, and the levi-
tation of the forms assumes a new function in spatial comp-
ostion of the kind that Danti attempted in his seated statue
of Cosimo I. (figs. 64, 50)

The Venus Anadyomene:

Relief was basic to Danti's conception of sculpture.
The Julius III was pictorial and frontal, and the Onore,
one of his few sculptures which seems certainly to have been
intended to be seen outside a defining architectural sit-
uation, was a kind of prismatic relief. Equity and Rigor
were cut on the faces of shallow blocks of marble, and in
the Prato and Santa Croce Madonnas this relief conception
crystallized in strongly axial figures in which no effort
was made to control space, and even the place defined by
the sculpture itself was compressed, and subjected to graphic
control and organization. In the Baptistry group, Danti

once again was faced with a problem in monumental relief,
and in one of his last works, the <u>Venus</u> <u>Anadyomene</u>, for
the Studiolo of Francesco I he was once again given the task
of a frontal figure in a niche, this time on the scale of
the taste of the new ruler of Florence. (fig. 71)

The Studiolo of Francesco I is a small room with-
out light, off the Salone dei Cinquecento in the Palazzo
Vecchio. In it, as if in retreat from the booming dynastic
propaganda outside, the second Granduke of Tuscany per-
formed experiments in alchemy and stored the small things
that appealed to him. It was conceived as a kind of
encyclopedic universe, filled with the wonders of Art and
Nature, symbolized in the vault above by Diana of Ephesos
and Prometheus. At either end of the room were paintings
of Cosimo I and Eleanora of Toledo. On the walls, along
with a great many subsidiary paintings, were eight bronze
statuettes, two symbolizing each of the four elements.
Danti's <u>Venus</u> together with Stoldo Lorenzi's <u>Amphitrite</u>
symbolized the element of water. The Studiolo was an
emblematic universe shot through with the eccentricity
of one man, and it was the last monument of the Renaissance
in Florence.[16]

Danti's Studiolo <u>Venus</u> is the precipitate of his
late style. Her ancestry--the bronzes for the base of
Cellini's <u>Perseus</u>, drawings variously connected with the
Florentine circle of Michelangelo, the sculpture-derived
figures of Bronzino, and Danti's own female figures from

statue of Julius III--is apparent, as is her relationship
to her sister, Giovanni Bologna's Vienna Astronomy (figs.
9, 10, and 138).[17] Like Astronomy, she is a creature of
icily conscious artifice, but the art, the maniera, revealed
with such essential clarity is Danti's own. The salient
axis and near-axis of the Prato and Santa Croce Madonnas
maintains its purity but relaxes, undulant in the shallow
space, drawing her body to the attenuation of Primaticcio's
stucchi at Fontainebleau. This linea serpentinata, around
which the parts of her body languidly roll, plays a var-
iation in the decorative-pure movement of the dolphin at
her side, echoed in her hair, and reflects with a decorous
restraint the abandon of the serpentine movement of the
monumental bronzes for the Fountain of Neptune in the
Piazza della Signoria. (fig. 139) With a formal necessity
of the same degree as the movement of the linea serpentinata
she turns her head into the plane through which the anima-
ting line works. The simple volumes of her body are reiter-
ated by the coiling plaits of her hair. (fig. 72) The
contours that define these move with an astonishing ease
from definition in three to definition in two dimensions.
Traces of Danti's working in the wax are for the most part
smoothed away, but despite the careful chasing, are still
apparent in the drawn detail, in the back of her neck and
in her hair. Danti drew her hairline with one stroke. (fig.
73) The handling of the swiftly traced lines working in-
differently in two and three dimensions (as well as details

in the heads of the two figures and the general cast of
classical sobriety) is the same as the Santissima Annunziata
St. Luke.[18] (fig. 68)

The priority of the compositionally unifying ser-
pentine line and the plane in which it moves were both
clearly stated. The volumes of the Venus Anadyomene are as
pure in themselves as those of the Onore or the figures of
the Baptistry group, and once again lend themselves to the
freedom which this severe formal structure permits: the
unique aesthetic adjustment of individually axial parts in
space. Here Danti moved toward Giovanni Bologna. Still,
his Venus remains within the plane, and only incorporates
Bologna's multi-axial, relational composition at the most
abstract level of his own style, subjecting compositions of
a kind with which he had been conversant since the statue
of Julius III to a new clarity of formal relationship.
(figs. 10, 71) The result of this ordering of the parts
has the same necessity as the movement of the serpentine
axis. In the face of this formal priority, the meaning
of Venus' movement, wringing water from her hair as she
rises new-born from the sea, is like a part of a ritual
dance of great antiquity, whose movements have been per-
fected with each repetition, but the significance of which
has long been forgotten. Like the other works in the
Studiolo her obscured intrinsic identity is secondary to
the identity afforded her by position in an emblematic order
as unyielding as her own formal order.

The Second Statue of Cosimo I:

When Danti's Uffizi figures were appraised in 1570, it was estimated that it would take him eighteen months to complete the statue of Cosimo I.[19] Assuming that he worked at the Baptistry group more or less steadily until it was set up in June, 1571, he could not have begun serious work on the marble until after that time, and if the sculptors' professional estimate was accurate, Danti would not have finished the standing portrait of Cosimo I until early in 1573, three or four months before he left Florence. There is another circumstance which might date the beginning of the carving to 1571 or 1572. In that year Francesco de' Medici bought Michelangelo's Bacchus from the heirs of Jacopo Galli in Rome, and it was brought to Florence.[20] Perhaps this fact explains why Danti's last marble statue departs so dramatically from the other sculptures of his last years. (fig. 75)

Danti's reliance upon the Bacchus is suprisingly close, so close in fact that he must have had the sculpture close at hand and not simply worked from drawings of it. (figs. 76, 140) The contours of the legs, and whole lower configuration of the two statues are quite similar. The torso was also transposed in detail, and from there, at the extremities, changes were made in the composition as the need arose. Danti's alterations in the pattern are evident. The soft, feminine textures of the Bacchus gave

way to a more soberly articulated musculature. The negative areas of the <u>Cosimo I</u> are stronger than those of the <u>Bacchus</u> and the forms consequently separate themselves from the core of the figure, to be assembled as separately axial forms in a less organic and more artifical composition. The proportions of the <u>Bacchus</u> were also changed, and the still youthful slenderness became the heavy, relatively planar torso of the <u>Cosimo I</u> moving with the same shallow torsion of the <u>Herodias</u> of the Baptistry group and the Studiolo <u>Venus</u>. Decorative linear detail, which Danti used to such good advantage in the Baptistry group, is much tighter and was uniformly worked to the metallic silveriness that characterizes all the surfaces of the statue.[21] (fig. 77) The lurching spiral movement and numb relaxation of form in the <u>Bacchus</u> is adjusted to a suave serpentine axis. This was a vital modification, since the prospect of Cosimo reeling at the height at which he ultimately had to stand could not have been anything but unnerving. The easy sway of the <u>Bacchus</u>, however, Danti retained, and it blended smoothly with the liquidly slouching allegories of <u>Equity</u> and <u>Rigor</u>. (fig. 78)

Danti had never before worked so close to a sculpture of Michelangelo. His approach to the problem of following the example of his great master changed from the attempt to determine and apply the principles of Michelangelo's art-- exemplified in Danti's sculpture of the 1560's and in his

Trattato--to the kind of literal reverence usually associ-
ated with the great models of antiquity, the kind of respect
that impelled Bandinelli, or Girardon, or Canova to repeat
the Apollo Belvedere. The Cosimo I is a difficult statue,
as distant as any of Danti's others. The shield with the
capricorn which identifies Cosimo is turned not to the
passers by below, but to the wall behind, just as the
attributes of Equity and Rigor were almost concealed.
(fig. 79) In Danti's last sculpture, Cosimo I appears
at a smaller scale than before, but in full imperial splen-
dor, allegorized to the point of unrecognizability, the
image once again of a ruler as such, cast in the mould
of antiquity, and in the forms of Michelangelo, which for
Danti already had the distance and unapproachability not
of another nature, but of another antiquity.

Notes to Chapter V:

[1] Danti's employment in the bronze foundry is
mentioned without archival citation by W. Bombe in
Thieme-Becker, VIII, p. 385; the record dates December
19, 1571. As for the academy, Danti was elected console
October 18, 1570 (ASF, Art, Accademia del Disegno, Libro
del Proveditore, "E", f. 27v) and, with Larione Ruspoli,
revisore dei conti (ibid., fol. 26r) April 9, 1570. On
January 14, 1570, Danti was delegated with Giovanni Bologna,
Alessandro Allori, and Maso da San Friano to superintend
the esequies of Jacopo Sansovino ("E", fol. 29v). In
1570 and 1571 he modelled the St. Luke for the academy's
chapel in Santissima Annunziata, and to 1570 should be
assigned the gesso copies of the Allegories in the Medici
Chapel which were finally taken to Perugia in 1573. See
Catalogue XXVI a.

[2] The character, tastes, and accomplishments of
Francesco I as well as detailed chronological data con-
cerning his life and reign are provided by L. Berti,
Il Principe dello Studiolo: Francesco I dei Medici e la
fine del Rinascimento, Florence, 1967, p. 278 on the
regency.

[3] Frey, Nachlass, II, p. 143. January 20, 1565.

[4] Frey, Nachlass, III, p. 203, October 31, 1569.

[5] Ibid.

[6] Frey, Nachlass, III, p. 203-204;"San Pietro. . .
San Cosimo dette al Calamec, che poi l'ha hauta larion rus-
poli, et. . . la statua della grandezza sua che va in mezzo
delle due figure nella testata du Lungarno, senza far'
conventione alcuna. Feciensi venire i marmi, quale hoggi
si trovono nelle stanze loro per lavorari."

[7] Frey, Nachlass, III, p. 204.

[8] ASF. Mediceo. Carteggio Universale. "Rescritti
del Gran Duca di Toscana in absentia del Principe da
Agosto 1570--a agosto 1571. (September 13, 1570) "Giovanni
di Danti rettore di san leonardo in arcetri domanda sia
con messo a carlo pitti che ritenga a Vincentio danti
scultore delle paghe che ha dalla fabbrica de magistrati
alla Zecca quanto ha debito con il supplicante per pigione
di stanze da san piero scaraggi che non lo paga." The
reply:"A chi tocca gli faccia Justitia."

[9] Catalogue XIX.

[10] Catalogue XIX, documents: 1, 4, and 5

11
Catalogue XIX, doc. 6. On the question of
Danti's Florentine citizenship see O. Scalvanti, "La
Cittadinanza fiorentina conferita a Vincenzo Danti," L'Umbria,
rivista d'arte e letteratura, Perugia, 15 Aprile, 1889, II,
no. 7-8, p. 59-60. Danti is not listed among the citizens
in the Consiglio dei Duecento, Florence, Biblioteca Marucell-
iana, cod. B. VII; Bibl. Riccardiana cod. 2427. Weigh-
ing the evidence, Scalvanti concludes that Danti was a
Florentine citizen. The fact that he was repatriated
by the governor on his return to Perugia would seem to
indicate it. (see below Epilogue, note 8) It may be
that Danti's citizenship was a step in the movement under-
foot at that moment to make all members of the Accademia
del Disegno citizens of Florence. See G. Ticciati,
Storia della Accademia del Disegno, in P. Fanfani, Spigo-
latura Michelangiolesca, Pistoia, 1876, p. 193-307.

12
A Trecento group is shown over the East door of
the Baptistry in a cassone by the Adimari master. See
Paatz, Kirchen, II, p. 195-200.

13
Danti's figure of Herodias might be taken as the
figure from the mosaic of the Decapitation of the Baptist
reversed and done alla maniera moderna. A similar argu-
ment might be made for the Executioner. The costume of
Herodias also recalls the Salome in the Feast of Herod
mosiac. Danti's Executioner also maintains the posture of

Andrea Pissano's executioner in the <u>Decollation</u> panel below.

[14] Danti's attraction to the sculpture of Cellini in his last years in Florence has been pointed out by H. Keutner, "The Palazzo Pitti 'Venus' and other Works by Vincenzo Danti," <u>Burlington Magazine</u>, C, 1958, p. 427-431. This attraction, however, seems to have been intermittent, and was also evident in Danti's first Florentine works. See Chapter III, pp. 133-160.

[15] Danti's cool performance was seen as violent drama by Raffaello Borghini (<u>Il Riposo</u>, p. 521)." . . . nel mezzo si vede l'humiltà, e la patienza di San Giovanni, che ginocchioni con le man giunte attende il dispietato colpo, che gli dee venir sopra: della parta sinistra la fierezza dell'ardito ministro co' capelli rabbussati: e con la spada alta in atto di tagliarli la testa, e dalla parte destra la crudeltà mescolata con horrore d'Erodiana, che con un bacino sotto il braccio aspetta di portare il dimandato dono all'iniquia madre."

[16] The program of the Studiolo, also devised by Vincenzo Borghini, (<u>Lo Zibaldone di Giorgio Vasari</u>, ed. A. del Vita, Arezzo, 1938. p. 47-60) is set forth in detail by L. Berti, <u>Il Principe dello Studiolo</u>, p. 61-84.

17
On the lineage of Danti's _Venus_ type see
Catalogue XIII. On the theme of Venus Anadyomene and
its sources see W. S. Heckscher, "The Anadyomene in the
Medieval Tradition (Pelagia-Cleopatra-Aphrodite). A Prelude
to Botticelli's 'Birth of Venus'," _Nederlands Kunsthistorisch_
Jahrboek, VII, 1956, p. 1-39.

18
Danti's relationship to antique sculpture is diff-
icult to define. H. Keutner (_Burlington Magazine_) has stated
that we know that Danti restored antiques. I have been
unable to uncover any such certain information. There are,
however, persistent references to four heads beginning in
1564. Frey, _Nachlass_, III, p. 79. ". . .quatro pezzi
per 4 teste, che sono una carrata, quali sono di messer
Vincentio Danti scultore. . ."; III, p. 77-78: ". . .
quattro teste che non inportavano niente, perche non se
arano a mettere in opera adesso. . ." Four braccia equalled
about seven _carrate_ (Frey, Nachlass, II, p. 143). A block
for a statue (probably standing, since it would have gone
in one of the niches in the arcade of the Uffizi) is being
described. If the block was 4 x 2 x 2 braccia approximately,
then a cubic braccia would weigh 7/16 _carrate_; and a
carrate would be equal to about 27. 5 in. The four heads,
might have been for restorations since there was no par-
ticular rush about getting them. Perhaps Danti can be
credited with the head of a _Dancer_ in the Uffizi (Catalogue
XXV) and if so, it should belong to about this time. The

statue was probably acquired by Cosimo I before 1568 and the
head is comparable to the Studiolo <u>Venus</u> and the posture to
the <u>St</u>. <u>Luke</u> in Santissima Annunziata. The cutting of the
hair is unlike Danti, but none of his sculpture is left so
directly carved, and it is difficult to judge. In any
case, it seems altogether possible that he absorbed the
classical elements in his late style at first hand.

[19] See note 7 above.

[20] The record of the purchase of the <u>Bacchus</u> from
the Galli family is in the Giornale della Depositera,
ASF, Florence, for 1571 and 1572; C. de Tolnay, <u>Michel-
angelo</u>, I, p. 143.

EPILOGUE
THE LAST YEARS IN PERUGIA

EPILOGUE

THE LAST YEARS IN PERUGIA

In May of 1573, Vincenzo Danti left Florence and
did not return. His departure was noted tersely but with
some finality by Vincenzo Borghini in a letter to Giorgio
Vasari in Rome--"il Perugino sen' è ito a Perugia."[1] Why
he left can only be guessed. Perhaps the statue of Cosimo
I had not been well received. As the correspondence of
Prince Francesco and the Proveditore of the Uffizi repeat-
edly shows, the Prince had never had much enthusiasm for
the project and he had had Giovanni Bologna begin the
statue which replaced Danti's Cosimo I by the fall of 1581.[2]
Danti had never managed to parlay his successes into a
position on the roster of court artists, and probably in
the last years of Cosimo's life, when Francesco's rule
became more and more a reality, hope of ever doing so
faded. Francesco's hatred for Danti's brother Ignazio--
who had been a great favorite of Cosimo I--was not in the
least disguised, and in 1572 he denounced him to his super-
iors for an unnamed but mortal transgression.[3] It is diffi-
cult to tell how closely entwined the fates of the two
borthers were during their years in Florence, but given
the seriousness of Ignazio's situation and the autocratic
perversity of Francesco I, it seems unlikely that Danti could
have been left completely uninvolved. In any case, events

in Florence seem to have been such as to convince Danti that he should forsake the gains he had made over the years for what--at the age of forty-three--would certainly be the end of his career as a sculptor in the poor papal city of Perugia.

But there were simpler and less ominous reasons for Danti's returning to his native city; and worse things could happen than to come back, late in the spring,to the Umbrian countryside. Danti returned to Perugia to marry Angela Crisostomo.[4] Raffaello Borghini, writing ten years later, said that Danti had chosen to return to Perugia and marry rather than go to Spain to superintend the construction of his oval plan for the church of the Escorial which had so pleased Philip II.[5] Whether or not this sympathetic biographer's account of the success of Danti's Escorial plan is accurate, Danti does seem to have turned from sculpture to architecture, and he is mentioned in connection with two projects which might have been lucrative enough (even if they were not his own designs) to lure him away from an uncertain future in Florence. In the testament of Vincenzo Danti's younger brother, Girolamo, written in 1580, it was stipulated that his money should be distributed partly according to the wishes of his brother Vincenzo who had made the money in the first place at the _fabbriche_ of the Gesù in Perugia and Sta. Maria degli Angeli at Assisi.[6]

Danti's final design for the Altar of San Bernardino in the Duomo in Perugia acknowledged the architecture of

Galeazzo Alessi, and Danti was no doubt personally acquaint-
ed with the architect of the colossal church of Sta. Maria
degli Angeli. Alessi designed a tabernacle for the lower
church of San Francesco at Assisi, and Danti is supposed
to have executed it. The small gilt bronze caryatids near
the top of the tabernacle bear a certain resemblance to
Danti's work, but they are crudely cast, poorly chased,
far from the standards of his work in Florence, and were
probably executed on Danti's designs by his father or his
brother Girolamo.[7] (figs.

Two months after his departure from Florence, Danti,
who had been repatriated, was appointed to a five year term
as architect for the city of Perugia.[8] This position was
not as imposing as the title it bore, and involved no major
undertaking in the three years Danti served before his death.
His job was not to construct new buildings but to inspect
old ones and to recommend ways in which they might be re-
paired should the need arise. Danti worked on the walls of
the city, rebuilt the stairway and refurbished the windows
of the Palazzo del Capitano.[9]

Danti brought his experience and devotion to the
academy of art to Perugia, along with casts of Michelangelo's
Four Times of Day from the Medici Chapel.[10] The foundation
of the Accademia del Disegno in Perugia dates from the year
of his return.[11] Once again, the question as to whether
Danti was an actual member of this Academy must be settled
indirectly. In the deliberations following his death in 1576

it was argued by the members of the Academy that the position of city architect should be given to one of them since the precedent had been set by Danti, "anche academico."[12]

Danti's last years in Perugia were uneventful. He still had the bronze foundry from the days of the statue of Julius III at his disposal, but nothing issued from his shop.[13] In 1574 he was elected prior of the goldsmith's guild and entered into a contract for painting and other work in the church of San Fiorenzo, including a fresco on the entrance wall of the <u>Martyrdom</u> <u>of</u> <u>the</u> <u>Ten</u> <u>Thousand</u>.[14] There is no trace of this work, nor any record that it was ever done. In the appraisal of the Testata group the possibility was mentioned that Danti might not live to complete the sculpture. Then, in 1570, he was described as young; in 1573, he was described as old, and perhaps a dwindling constitution lay behind the inactivity of Danti's last years.[15] Pascoli filled the quiet of these years with reflection, and pictures Danti as retiring to his villa at Prepo to write.[16] This may be correct, and perhaps during this time Danti wrote his autobiography in <u>terza</u> <u>rima</u> and the <u>Lives</u> <u>of</u> <u>the</u> <u>Modern</u> <u>Sculptors</u>. These works too slipped into the almost unbroken silence of the last three years of Danti's life and are lost. In May of 1576, Danti was taken ill with a fever, and made his testament on the 21st of the month.[17] He died five days later, and was buried on the following day in the family church of San Domenico.[18] A marble bust was carved to mark the place by Valerio Cioli,

commissioned by his brother Ignazio.[20]

Notes to Epilogue:

[1]
Frey, _Nachlass_, II, p. 784.

[2]
H. Keutner, "Über die Entstehung des Standbildes im Cinquecento," _Münchner Jahrbuch der Bildenden Kunst_, VIII, 1956, p. 138-168. Giovanni Bologna's _Cosimo I_ was set up in 1585.

[3]
I. del Badia, "Egnazio Danti Cosmografo, Astronomo e Matematico e le sue opere in Firenze," _Rassegna Nazionale_, VI, p. 621-31; VII, p. 434-74, Florence, 1881. What Ignazio Danti, a personal favorite of Cosimo I might have done to warrant such a vendetta as Francesco set out upon is shrouded in mystery. Francesco went so far as to request Ignazio's head at the end of a pike, a favor which was not granted him. Ignazio was by this time famous throughout Italy and his friends in the Church saved him. At the same time, Ignazio was censured by his superiors, since the Granduke of Tuscany was a man of great influence. And although Ignazio's career flourished in Rome in the next two decades, he never lived down the blight of Francesco's denunciation.

[4]
Frey, _Nachlass_, II, p. 784. Vincenzo Borghini added to his report of Danti's departure "et non so quelche

io m'habbia sentito buzzicare di moglie." Angela Crisostomo
is mentioned as Danti's wife in his testament. See Appendix
III.

⁵R. Borghini, Il Riposo, Florence, 1584, p. 522.
For a discussion of the Escorial project see Appendix VI.

⁶ASP. Not. Giacomo Marci, 1580, f. 218v-220v. ". .
. .mentre sarà vivo frate Egnatio Danti siano il detto Messer
Giovanni Antonio et donna Luchretia tenuti a darli ogni anno
l'usufrutto di detta heredità interamente, quando però egli
lo domandi, et non lo dimandano lui medesimo non siano a
ciò in modo alcuno obligati; con questa dichiaratione appresso
che dopo morte di detto frate Egnatio la metà di tutta
l'heredità si dia per l'amor di Dio, secondo l'intentione,
come disse, della bona memoria di messer Vincenzo Danti suo
fratello, il quale acquistò detta roba per una rata alla
fabrica de'preti del Gesù et per l'altra alla fabrica della
Madonna degli Angeli di Assisi dettratto però prima di detta
metà tanto che basti per maritare una povera zitella; et
l'altra metà resti libera di essa donna Luchretia." Danti
is not mentioned in a recent study of the Gesù in Perugia,
P. Pirri, Giovanni Tristano e i primordi della architettura
gesuitica, Bibliotheca Instituti Historici Societatis Iesu,
VI, Rome, 1955. Although he is not mentioned in this rather
complete study, it is not impossible that he worked at
the project, which was begun in 1561, and the patron of which

was Cardinal della Corgna. Santa Maria degli Angeli at
Assisi is much less well-studied. Vincenzo Danti has not
been linked with it either, although Giulio Danti has.
Pascoli, Vite Moderni, I, p. 284 and 288, writes that
Giulio Danti assisted "alla fabbrica del Tempio della
Madonna degli Angeli," much as Vincenzo Danti must have
done if the inference from the document is correct.

7
Catalogue XLa

8
A. Mariotti, Lettere pittorische perugine,
Perugia, 1788, p. 258-59: "era allor rimpatriato, con
approvazione di Monsignore Ghislieri Giovernatore." For
Danti's appointment as city architect see Appendix IV.

9
The best source for Danti's activity as city
architect in Perugia is R. Borghini, Il Riposo, p. 521-
22. ". . .intese molto di fabbricare, e di fortificare; la-
onde fu fatto in Perugia sopra le fortificationi di quella
Città: e con suo ordine, e disegno si redusse à quella buona
forma, che hoggi si vede il palagio de' Signori, e partico-
larmente vi rifece le scale. . ." The "palagio de'Signori"
of which Borghini wrote is the Palazzo del Capitano del
Popolo near the Gesù and Danti's modifications earned him
the heartfelt rebuke of A. Rossi, Il Palazzo del Popolo in
Perugia, Perugia, 1864, p. 14 ". . . nel 1575. . .con ordine
e disegno di Vincenzo Danti, architetto della città (Dio gli

perdoni tanto peccato!) si demoliva la scala del chiostro,
per costruirno una nuova a traverso di mura maestre,
mozzando la sala dei notari e quella del mal consiglio, e
aggiungendo alla facciata principale finestri indecenti pel
luogo e per la forma."

[10] See Appendix IV

[11] G. Cecchini, L'Accademia di Belle Arti di
Perugia, Florence, 1955 provides the history of the
Accademia; see also A. Mariotti, Lettere pittoriche, p.
258-261.

[12] PBA. MSS 1712, Miscellanea di A. Mariotti,
f. 43r. The question concerns the right of the city
architect to the use of the foundry which had been conceded
to Danti, ". . .la quale stanza altre volte come si dice
fù concessa alla bon. mem. di M. Vincentio Danti pure
Accademico, et hoggi (July 20, 1578) si ritiene a pigione
da M. Girolamo Danti. . ."

[13] The use of this foundry was one of the terms of the
city architect agreement. See Appendix IV.

[14] Danti was Prior and Camerlengho of the Goldsmiths'
guild. W. Bombe, Thieme-Becker, XIII, p. 385. On the
paintings in San Fiorenzo see Catalogue XXX.

15
In the appraisal of the Uffizi project Danti is
described as "giovane et persona habile et destra al andare
sempre migliorando." In the city architect agreement
(Appendix IV) he is described as "Vincentio Danti. . .che
in sua gioventù ha fatte apresso il Serenissimo Sig. granduca
di toscano. . ."

16
L. Pascoli, Vite Moderni, p. 292-3. "Lavoravaví
dunque in defessamente collo scarpello non meno, che col
pennello, nè altro divertimento aveva, chi di ritirarsi
ne' giorni di festa a godere la quiete nella sua villa di
Prepo."

17
Appendix III.

18
The date of Danti's death, May 26, 1576 is found
in the records of the goldsmiths' guild. See Chapter I,
note 12 above. For his burial: Basilica di S. Domencio
di Perugia, Archivio Parrocchiale, Libro de'Morti, 1562-
1608, f. 30r. "Messer Vincentio Danti fu seposta (sic)
nella nostra Chiesa et fu posto il suo corpo nella sepoltura
della sua casa, questo di 27 di Maggio nel MD76."

19
On Cioli's bust of Vincenzo Danti see M.
Weinberger, "A Sixteenth century Restorer," Art Bulletin,
XXVII, 1945, p. 266. All biographers follow Borghini
(Il Riposo, p. 523) in giving this bust to Cioli. except

G. B. Vermiglioli, <u>Biografia</u> <u>degli</u> <u>Scrittori</u> <u>Perugini</u>,
Perugia, 1829, I, p. 375: "Nel monumento vi è il suo
ritratto scolpito per mano di Valerio Cioli, per quanto scrive
il Borghini, ma in un libro mss. esistente nella sagrestia
di S. Domenèco, si dice peraltro che quel ritratto fu
lavorato dallo stesso Vincenzio e dal medesimo libro si
apprende, che quel deposito fu trasportato da una ad altra
capella." Borghini, however, is a reliable source, writing
seven years from the fact, and Cioli's authorship of the
bust has not been questioned since. On the Chapel of
San Vincenzo see C. Crispolti, <u>Perugia</u> <u>Augusta</u>, Perugia,
1648, p. 107 and 109. Another portrait of Danti is
listed by G. Cecchini, <u>La</u> <u>Galleria</u> <u>Nazionale</u> <u>dell'Umbria</u>
<u>in</u> <u>Perugia</u>, Rome, 1932, p. 210, no. 697 as by an unknown
artist of the seventeenth century.

CONCLUSION

CONCLUSION

Vincenzo Danti was a Mannerist sculptor and his
case is an instructive example of what this means. The
attempt to define the usefulness of the stylistic term
"mannerism" has recently taken a pronounced etymological
turn, centering around the word maniera and its sixteenth-
century usages. The Cinquecento was a period of intense
critical activity, when artist and critic lived in a kind
of symbiotic relationship similar to that in which they
live today, and indeed a period in which every self-res-
pecting artist was expected to be able to propound the
principles of his art on demand. Few words in the common
critical vocabulary were less well defined than maniera.
And even if such a concept can be ostensibly defined, that
is if works possessing maniera can be distinguished from
those that do not, it is not clear that what is thus isolated
is coextensive with what may yet be an identifiable late
Renaissance style. Criticism tends now toward the notion
that Mannerist art was an art of elegance rather than a
primarily expressionist art as it was earlier considered to
be. It is not enough however to say that Mannerist art is
elegant, because this fails to distinguish it from works of
art of other periods, animated by other principles, to which
the word 'elegant' might also be applied. Since, hen, it
is refinement in its own terms, it is these terms which must

be defined.

Danti's sculpture exhibits two important characteristics throughout, characteristics which are perfectly representative of the art around him. First is the fusion of the arts of painting and sculpture. The traditional ideal of _rilievo_ in painting might be thought to point to the hegemony of the art of sculpture. But just as Bronzino painted marble, Danti was content to draw in space. The relationship between relief and full round in Danti's sculpture is never clear, as it had not been in Florentine sculpture after Donatello. Danti's forms are not simply forms which occupy space, rather, they are forms which seem to occupy space in a certain way and from a certain point of view. Art in two dimensions and art in three dimensionsthus met not in conflict but on the level of the illusion in which they both partook. In view of this fact the resurgence of the _paragone_ debate at mid-century is more than a coincidence, and Benedetto Varchi's conclusion that there was no essential difference between the arts of painting and sculpture has more than merely academic implications.

Danti's sculpture also exhibits a concern with formal relationships as such. It is on this level that he habitually conceived and upon which he sought his clarity. In this respect he was again typical of his period, and the kind of visual saliency of intelligible relationship which was the end toward which his conception

invariably moved was an important basis of much of the art
of the sixteenth century. From the Sistine Ceiling where
the creation of Adam took its force from one magnificent
axis running cornice to cornice, and this axis was made
to become the ineffable necessity of the unity of divine
will and power, to the School of Athens, where symmetry
and balance are unquestionable metaphors of the happy
consonance of the human spirit and the world in which
it found itself, the energy of form as such, of pure
intelligible visual relationship, of what Danti called
ordine, was essential. For Danti this order was dif-
ferent from what it had been in the High Renaissance.
It was no longer harnessed as it had been in the Sistine
Ceiling nor made to dance as it had been by Raphael. It
became what Panofsky called "unclassical symmetry",
legislative rather than animating. On the one hand this
desire for visual order was related to a return to iconic
images, paralleling a conscious archaism in which Danti
himself was involved. It also became emblematic of a
rigorous, neo-scholastic cosmological order rigidly
paralleled in political order. In Danti's early works
formal relationship was the basis of a kind of visual
poetry, brittle and self contained. In his late work
formal relationship lost its metaphoric value and at the
same time ceased to exist in relationship to iconographic
meaning. Danti's last works are unique formal systems,

having no implications beyond themselves. They are,
however, pure memories of forms of the imagination
that preceded them, and they burn with the brightness
of a candle which is nearly spent.

CATALOGUE

CATALOGUE

Introduction:

What follows is a complete catalogue of works which
are certainly by Vincenzo Danti, as well as those which have
been attributed to him over the years. In assembling the
catalogue, primary consideration has been given to extant
works, considered chronologically. A complete working
bibliography is provided with each entry and, when available,
the basic documentation has been cited for authentic works,
extant and lost. References to published material are
abbreviated here, however, and complete citations are given
in the Bibliography. Spelling in documents which have not
been published has not been corrected. Only abbreviations
in the documents have been completed where necessary.

The intention has been to provide a supplement to
the text in which complete basic information could be found
about each work. Beyond location, date, and dimensions,
the format is flexible, and the discussion of each work
varies with the case at hand. The chronology of extant
works is followed by the consideration of lost works and
miscellaneous attributions. The questions of bronzes
and drawings are considered separately in Appendices I
and II.

I. FLAGELLATION
 (fig. 1)

Location: Paris, Musée Jacquemart-André

Dimensions: H. 20. 8 in. W. 15 in. (53 x 38 cm)

Description: Painted terra cotta

Date: c. 1549-51

Bibliography: Musée Jacquemart-André, Catalogue Itineraire, Deuxième édition, Paris, n. d., p. 115, no. 800; U. Middeldorf, "Additions to the Work of Pierino da Vinci," Burlington Magazine, LIII, 1928, p. 299-306; A. Venturi, Storia, X, 2, p. 526.

Discussion: The relief is attributed to Pierino da Vinci in the Musée Jacquemart-André catalogue. It was reattributed to Vincenzo Danti by Middeldorf because of the discrepancies with the style of Pierino da Vinci and similarities to Danti's bronze reliefs of 1559-60. Comparison with certain of the Julius III reliefs (e. g. fig. 16) seems to add strength to Middeldorf's contention that the relief is Danti's earliest known work. The Paris catalogue states that the relief was bought in 1884. Without further evidence, it may perhaps be identified with the cast of a relief (although it is not a cast) bought by the Florentine dealer Caucich in Perugia at some time before 1882 (see Cataloque II). If so, a Perugian provenance would strengthen its attribution to Danti.

II. CHRIST DRIVING THE MONEY CHANGERS FROM THE TEMPLE
 (fig. 2)

Location: Perugia, Galleria Nazionale dell'Umbria, no. 816

Dimensions: H. 28 in., W. 34.6 in. (71 x 88 cm.)

Description: Plaster cast after a marble or bronze relief;
surface is broken and patched on the right side; details lost
in casting have been crudely incised.

Date: c. 1553-1554 (original) Date of cast unknown

Principal Bibliography: C. Cecchini, La Galleria Nazionale
dell'Umbria, Rome, 1932, p. 219. The cast has not been
further published.

Discussion: The provenance given by Cecchini is Musei dell'
Università. It is perhaps one of the casts of reliefs
mentioned in a catalogue of 1882 (Indicazione degli oggetti
. . .nella Università di Perugia, Perugia, 1882, p. 65n).
Two casts ascribed to Danti, besides a cast of Francesco
di Giorgio's Flagellation (see Catalogue XLIII) are
mentioned as having been bought in Perugia and placed
on view in the Museo. A third was bought by the Florentine
dealer "Signor Caucich". The two figures on the left should
be compared to those on the left in Danti's marble Flagellation
of 1559 (Cat. VII). The relief from which the cast was made
has here been assigned the date 1553-4 because of its close
reliance on Michelangelo's drawings on the same theme, and
because of Danti's presence in Rome during those years.

Because of its resemblance to the Florentine <u>Flagellation</u>,
however, it may have been done as late as 1556. A later
date and the apparent Perugian provenance might argue for
its being a cast of one of the della Corgna Chapel reliefs(?)
which would provide this <u>terminus</u> <u>ante</u> <u>quem</u>.(Cat.XXVII) It
is not possible to say when the cast might have been made.

III. MONUMENT TO POPE JULIUS III
(figs. 3-16)

Location: Perugia, to the left of the side portal of the
church of San Lorenzo, facing the Piazza IV Novembre

Dimensions: 99.4 in. (252.5 cm) from foot of bronze base

Description: Bronze, in places badly encrusted; inscribed
in the bronze at the statue's left hand base VINCENTIUS
DANTES PERUSINUS ADHUC PUBER FACIEBAT. The travertine
base, an approximation of the original, was made in 1816.
The front face bears the inscription: IVLIO. III. PONT.
MAX./ OB. RESTITVTOS MAGISTR./ PIE. DEPRECANT./ FULVIO.
S. R. E. CARD. ET. ASCANIO/ CORNEIS/ EX. SOR. NEPOT./
AD MVNERIS. GRATIQ. ANIMI./ PERPETVITATEM/ P. PERVS.
DEDIC. This and two other inscriptions on the original base
were recorded by Lione Pascoli. This record served as the
basis of the modern inscriptions. A fourth was added when
the statue was re-erected in 1816 and all are recorded
by Serafino Siepi. See bibliography below.

Date: Commissioned May 10, 1553; cast May 8, 1555; in
place December 20. 1555.

Principal bibliography: Vasari-Milanesi, VII, p. 630; R.
Borghini, Il Riposo, Florence 1584, p. 519-20, where it is
identified as a statue of Paul III; C. Crispolti, Perugia
Augusta, Perugia, 1648, pp. 19, 59; L. Pascoli, Le Vite de'
Pittori, Scultori ed Architetti Moderni, Rome, 1730, I,

p. 289-290; and Le Vite de'Pittori, Scultori ed Architetti
Perugini, Rome, 1732, p. 138; S. Siepi, Descrizione Topo-
logico-Istorico della Città di Perugia, Perugia, 1822, I,
p. 392-393; W. Hager, Die Ehrenstatuen der Päpste, Leipzig,
1929, p. 44-45. Unless otherwise cited the documents published
by M. Guardabassi, "Documenti intorno alla statua di Giulio
III", Giornale di Erudizione Artistica, I, 1872, p. 16-24,
provide the basis for the following discussion. These docu-
ments were also published in a shorter form by A. Venturi,
Storia dell'arte italiana, X, 2, p. 507-511.

History: On March 11, 1553 the Conservatori dell'ecclesias-
tica obbedienza of Perugia, together with the camerlinghi
of the guilds received from the hands of Cardinal Fulvio della
Corgna the brief of Julius III restoring the ancient rights
of the city of Perugia withdrawn by the previous pope, Paul
III. As an official gesture of gratitude, a bronze statue
of Julius III was immediately proposed. 1000 scudi were to
be raised and set aside for it, and a useless bell was to
have provided the bronze. The proposal was voted upon May
3 and May 7 and on May 10 a contract was made with the gold-
smiths Giulio and Vincenzo Danti. This contract (Document 1
below) specified that the statue should be a bronze likeness
of the pope, seated between two griffins symbolic of Perugia.
It was to have been six feet tall, more or less as the "giusta
prospettiva" of the place it would be set demanded. (A Peru-
gian foot was equal to 14.5 in. (36.5 cm.), and in fact the
standard measure is marked just a few steps from the present

position of the statue. See B. Giliano, Compendium iuris
municipalis civitatis Perusiae, Perugia, 1635, p. 192-193.
"Pes est quindecim digitorum. . .et est designatus in campanili
ecclesiae cathedralis Sancti Laurentii. . .id est in pariete
sub porticu, seu loggia in capite plateae.") The height of
the statue is 6.85 Perugian feet.

No place for the statue is specified in the contract,
and its final location may not have been chosen. There are
programmatic similarities between the Julius III and Bellano's
Paul II of 1467, destroyed in 1798, whose aedicula stands
high on the wall of the Duomo to the other side of the ent-
rance from the Julius III. Much like Julius III, Paul II
had restored peace to Perugia and the statue, seated in pon-
tifical robes, its arm outstretched in benediction, was erected
in gratitude. (See W. Hager, Die Ehrenstatuen, p. 35; U.
Tarchi, L'Arte del Rinascimento nell'Umbria e nella Sabina,
n. p., 1954, tav. XLV.) The shallowness of Danti's statue
(figs. 4 and 5) suggests that the figure might have been in-
tended for a niche or a position against a wall, and the ex-
aggerated length of the pope's right arm suggests that it
was meant to have been placed higher than it is at present.
Many papal statues were set at a considerable height and in
Perugia, in addition to Bellano's Paul II, the statue of Paul
III over the entrance of the Rocca Paolina (W, Hager, Die
Ehrenstatuen, p. 43; illus. U. Tarchi, tav. CCXXIVB) which
is also destroyed, must have stood 25 feet above the ground.
The reliefs on the other hand suggest that the Julius III

was to be seen from all sides, and at fairly close quarters. It is possible that the statue is the somewhat anomalous result of a late decision. The provision in the contract for "giusta prospettiva" indicates more than a patron's concern, and Danti may have specified some of the terms of the agreement himself.

If it is the case that Danti entertained the notion of putting the statue at a greater height, it seems that he must also have considered it in much its present circumstances. A miniature by Giambattista Caporali--the title page of the records of the Priors for the year 1553--shows the pope in an attitude similar to Danti's completed statue, and is probably an inept transcription of Danti's intention at a fairly advanced stage of the planning. (See fig. 143 , W. Bombe, Urkunden zur Geschichte der Peruginer Malerei, Leipzig, 1929, Abb. 14, p. 83) Caporali was an architect himself, with an edition of Vitruvius to his credit, and the elaborate set for the statue is probably his invention. Since both Paul II and Paul III were housed in aediculae, the core of the design might reasonably be thought to be Danti's own, or, if Caporali's, at least a part of the scheme as originally presented. This would mean that the statue was intended to stand nearer a wall than at present, at about the height it is now. This must all remain conjectural, however, since in a project which is fairly fully documented, there is no mention of architecture.

The relative size and proportion of the base in the

miniature are the same as those of the base upon which the statue now stands. In all probability Caporali's miniature shows the statue as it was originally intended, and certainly as it was executed. Early descriptions inform us that it stood on a base with the inscriptions, much as it does now. (L. Pascoli, _Vite_. . ._Perugini_, p. 138) In considering the question of "giusta prospettiva" it should be remembered that the statue faces a short flight of stairs. Its position immediately at the top of this flight forces a viewpoint from the bottom of the stairs, that is, about ten feet in front and ten feet below it. The statue overlooks the Fontana Maggiore, also in the sixteenth century one of the prides of Perugia, and faces across the Piazza and down the Corso Vanucci, the main street of the city.

Caporali's miniature shows a relief on the base of the statue, which must be the pope helping the city of Perugia to her feet, or some such theme. This was not executed, since the original base had an inscription on the front (Pascoli, _Vite_. . . _Perugini_, p. 138).

On May 18, 1553, the Priors elected Borgaruccio de' Ranieri "in superstitem super constructione statuae sine aliquo salario". Most probably the Priors never had near 1000 scudi, and on May 27, they sold the bell which was to have supplied the bronze for the statue to the church of Santa Maria di Castel Rigore. The bell weighed 1000 pounds and was sold for 100 scudi. This sum was to be paid

to "egregii viri Iulii Dantis Perusini pro parte operis incipiendi pro fabrica statuae per ipsum conductae ad faciendum S. D. N. pp. Iulii III". He was to receive 25 scudi the same month and the rest in February of the following year.

On June 6, 1554 the Priors ordered their treasurer to pay Giulio Danti 50 scudi more, and on June 14 ordered that 500 scudi should be given "Iulio Dantis propediem ad civitatem Venetiarum profecturo per ipsum erogandos in emptione metallorum pro condicienda dicta statua". Another 148 scudi were paid to Giulio Danti "per ipsum erogandos in dicto opere et ilius constructione" on June 20.

On June 30, 1554 the council of the Priors granted a payment voucher of 4 fiorini, 8 soldi to Vincenzo Danti "pro vestura equi ac viatico in eundo Romam cum Sixto Caesario nuntio seu agenti nostri comunis pro interesse civitatis". An additional 2 scudi, 58 baiocchi were dispatched to Danti in Rome, "ad quam destinatus fuit ex causa statuae Iulii tertii construendae", on July 31.

Nearly a year later, on May 8, 1555, late in the afternoon ("in quo hora XXIII"; see E. H. Ramsden, The Letters of Michelangelo, Stanford, 1963, I, app. 7, "The Italian Hours," p. 237) while the Priors offered prayers for its success "conflata fuit statua aenea facta ad imaginem sanctae memoriae (Julius III had died March 23, 1555) Iulii olim pp. III per Vincentium Iulii Dantis aurificis."

News of the successful casting and opinions as to
the worth of the statue were taken to Rome by Vignola, who
was largely responsible for the price set, since neither
of the prelates who were to have appraised the statue had
personally seen it. Vincenzo Danti also went to Rome. On
June 21, 1555 the Priors recorded receipt of letters from
Cardinal Fulvio della Corgna and Cardinal Giulio Feltrio
della Rovere legate of Umbria. (see Appendix, Documents
II and III)

The contract had specified that the Priors should
pay the artists according to the value fixed by themselves
and the two cardinals. Both cardinals agreed on 300 scudi
as a fair initial payment. The Priors did not have 300 scudi.
There follows a tedious series of attempts to settle the
resulting problem which, since they provide a certain amount
of information about the commission and throw a certain
amount of light of Danti's affairs in Perugia, are worth
recounting in some detail. Instead of 200 scudi of the
amount owed the Danti, it was agreed that they would be given
a "bottega con magazzino" which they were to build at their
own expense "dove era il carcere del Capitano in Sopramuro"
(On the foundry of the Danti, see S. Siepi, Descrizione, I,
p. 341) They were to pay an annual rent, and contracted
to build a new jail over the old one. In case the bottega
was bought back, the city of Perugia was obligated to pay
for the cost of its construction, but not for the costs of
the jail. This was all agreed to on October 14, 1555. The

statue was set up December 20, 1555. (Siepi, _Descrizione_, I,
p. 392)

The financial arrangement did not satisfy the Danti
for long. The Priors still owed them 100 scudi of the
original payment, and on June 10, 1556 the two artists took
up their suit again. The statue was now completely finished,
and the artist reported that in addition to the money pre-
viously owed them, they had to pay the _muratore_, Giovanni
di Domenico fiorentino (elsewhere da Settignano; this is
probably the son of Domenico Fancelli, called Topolino, who
worked with Michelangelo in the Medici Chapel, and was active
in Umbria) 9 scudi for the transportation and location of
the statue, and that it had cost them 39 scudi, 90 baiocchi
to refurbish their new bottega.

Stock was taken of the whole project. Giulio and
Vincenzo Danti had received 696 scudi from the tesoriere,
100 scudi from the operai of Santa Maria di Castel Rigore,
and they had been paid 67 scudi, 51 baiocchi for wax and
tin used in making the statue. In all 863 scudi and 51
baiocchi had been paid out.

For their part, the Danti had spent 701 scudi, 70 1/2
baiocchi on bronze, tin, wax and other expenses, plus the
9 scudi they had paid the _muratore_. They insisted on the
fulfillment of the contract, but were finally persuaded by
arguments aimed for the most part at their love of city.

As the Priors suggested, the artists agreed to the
drafting of a workable contract, and the statue was finally

appraised at 550 scudi. This was the entire sum which the Danti were to be paid, and included the 152 scudi, 80 baiocchi already held by Giulio Danti. The Priors still had no money. The Danti were given the bottega in the place of the 397 scudi, 19 1/2 baiocchi still owed them, not including the money spent for the conversion of the bottega. The bottega could be redeemed whenever the two goldsmiths wished, and, if they did so, they were entitled to rent it at a price to be set.

The Priors had added the price of the bronze in the amount paid the Danti, and the Danti had tallied it into their expenses. At least part of the money for it had been lent by Ascanio della Corgna--brother of the Cardinal, nephew of the Pope and commander of his guard--and the city was to repay the debt owed him. The Danti still had in their possession 540 pounds of metal, more than half the weight of the bell first intended for the job. This extra bronze was to be returned to the Priors should the need arise.

The Priors also agreed to pay the muratore's fee, and he was caught in the squeeze. On June 29, 1556, Giovanni di Domenico settled for 8 scudi less than the appraisal for the transportation of the statue. The commune paid him 11 scudi in addition to the 9 already paid him by the Danti.

On December 31, 1557, after Vincenzo Danti had been gone from Perugia for about six months, Giulio Danti, in his own name and the name of his son sold 4/7 of the bottega back

to the Priors. For this he received 400 fiorini. He was to begin paying rent on 4/7 of the bottega, which amounted to 12 scudi, on April 1, 1558. Finally on May 12, 1559 the Priors bought the rest of the bottega for 187 scudi and rented it to Giulio Danti for 22 fiorini a year, with a three year lease.

The statue of Julius III remained beside the entrance to the Duomo, facing on the Piazza, until March 1798 when it was taken down by the republican government. At this time Bellano's statue of Paul II was destroyed, and Julius III narrowly escaped the same fate. The statue was saved by the Perugian scholar Annibale Mariotti and hidden in various places around the city. Finally on October 9, 1816, with a new travertine base, the statue was re-erected in what is still called the Piazza del Papa. (for a fuller history of the statue during this period, as well as the inscriptions on the base see S. Siepii, Descrizione, I, p. 392; Brogi photo. no. 8883 shows it in this location) Exactly when it was put back in its original position is not certain, although it must have been there in 1859 when Nathaniel Hawthorne described it in his Marble Faun (Boston and New York, 1889, p. 355-371). The relief on the pope's stole was taken in 1911 and recovered. (L. von Pastor, History of the Popes, XIII, London, 1924, p. 49, nl.)

Document 1: Contract for the monument to Pope Julius III
ASP. Annale Decemvirale, 1553-1557, f. 6.

Eisdem millesimo 1553 indictione et ponificatu et die
X maii actum Perusie insuprascripto loco, presentibus Jacobo
Gasparis Gilioli barbitonsore de Perusia Porta Sancte Susanne
et domino Pirro Arrigutio de Perusia Porte Sancti Angeli testi-
bus vocatis ad infrascripta

Locatio statue Julio Dantis conficiende in honorem Sanc-
tissimi Domini Nostri

Supranominati Magnifici domini Priores omnes decem volen-
tes devenire ad executionem fabrice statue Sanctissimi Domini
Nostri, de qua in precedentibus consiliis ideo per se et eorum
in officio successores obligantes res et bona magnifice comuni-
tatis Perusie pro observatione infrascriptorum dederunt et
locaverunt Julio Pervincentii Dantis et Vincentio eius filio
civibus perusinus presentibus stipulando et recipiendo pro
se etc. fabricam dicte statue Sanctissimi Domini Nostri Julii
pape III cum capitulis, conventionibus, obligationibus et pac-
tis infrascriptis videlicet

Capitula fabrice dicte statue

Imprimo che decti Giulio et Vincentio suo figlio loro
se obbligano a fare una statua de metallo simile a la immagine
de N. S. papa Giulio terzo de altezza de sei piedi stando a
sedere in una sedia o de magiore o minore grandezza secondo
il luogho dove harà stare per la sua giusta prospectiva in
mezzo de doi grifoni o in altro modo che lo fusse ordinato
per li M. S. P. o loro successori

Item che la magnifica Comunità di Perugia habbi a dare
il metallo o la spesa del metallo che sarà bisogno per detta
statua la quale tutta si habbia a fare a spese de essa Comu-
nità. Et sopra questo se habbi a deputare un depositario ap-
presso al quale deporranno tutti li denari et altre cose che
bisognaranno per questa opera il quale debba pagare per bol-
letino delli M. S. P. che saranno alli tempi.

Item che dal giorno che sarà dato alli decti Giulio et
suo figlolo l'ordine et modo de detta opra essi siano ubligati
continuamente lavorare detta statua et conducerla al debito
fine sensa alcuna tardanza non mancando però di mano in mano
decta magnifica Comunità di sovvenire di dinari secondo il
bisogno che alla giornata occorrerà per la spesa di detta
opra

Item che fatta detta statua et finita detta opra vogliono
li prefati M. S. P. et detto Giulio et suo figlio che la mer-
cede della loro fatiga sia giudicata per li R.^{mi} et Ill.^{mi}
Mons.^{ri} il Cardinale della Corgna et il Legato presente o
quello che fosse per li tempi et per li M. S. P. de l'Arti
de detta Città al giudicio de' quali li prefati Giulio et
Vincentio se remettono, et quelli in loro estimatori arbitri
arbitratori et amicabili compositori elegono et deputano et
promettono dette parte voler stare tacite et quiete al giu-
dicio lodo estimatione o recurso o reductione ad arbitrio
de bono homo

Item per parte della mercede de essi Giulio et Vincentio
della loro fatiga detta magnifica Comunità sia ubligata

pagarli alcuna somma de dinari in principio secondo che
dechiararanno o diranno li prefati R.^mi et Ill.^mi Legato
et Cardinale della Corgna et così el mezzo de l'opra
alcuna altra parte et poi finita l'opra pagare il resto
secondo la dechiaratione giudicio et lodo delli sopra nomi-
nati da farsi come de sopra

Instrumentun dictorum capitulorum

Que omnia et singula suprascripa prefati Julius et Vin-
centius--agens tamen idem Vincentius supra st infrascripta
cum presentia, voluntate et consensu dicti sui patris presen-
tis et consentientis et se ipsum obligantis--obligantes se
et omnia et singula eorum bona mobilia et stabilia presentia
et futura, promiserunt prefatis magnificis dominis prioribus
et mihi notario et publice persone presenti, stipulanti et
recipienti pro magnifica comunitate Perusie, premissa contenta
in dictis capitulis observare facere et contra non venire
etc. et reddere computa de pecuniis et rebus percipiendis
pro fabrica dicte statue et alia omnia servare de quibus supra
in capitulis continentur, omni exceptione etc., remota; pro
quibus et eorum precibus et mandato, spectabilis vir Caesar
Bevegnatis de Alexiis de parochia Porta Solis sollemniter
in forma iuris valida fideiussit quod scienter se non teneri
sponte etc., per se etc., obligavit etc., promisit et convenit,
prefatis magnificis dominis prioribus et mihi notario ut supra
stipulanti etc., se facturum et curaturum ita et taliter cum
effectu quod prefatus Julius et dictus eius filius promissa
faciente et servabunt, alias de suo proprio facere et attendere

promisit, et hoc fecit quia sic voluit etc. et quia prefati
Julius et Vincentius sub dictis obligationibus promisserunt
eidem Cesari presenti etc., ipsum etc., indemnes etc., con-
servare, renunciantes etc., iurantes etc., sub pena dupli
dicti quantitatis etc., quam penam etc., qua pena etc., vol-
uerunt pro premissis posse converiri hic Perusie, Rome,
Florentie, etc. et ibi promisserunt facere confessionem coram
quocumque iudice etc., rogantes etc.,

Document 2: Cardinal Fulvio della Corgna in Rome to the Priori
in Perugia (Annale Decemvirale, 1553-1557, f. 149)

Magnifici Signori Mastro Vincentio presente latore
havendome facto intendere il bon termine nel qual si truova
l'edificio della statua che la Città designò altre volte de
fare a papa Iulio S.ta mem. et el capitolo che ha con essa
Città che della sua mercede ne habbiano ad essere judici Mon-
signor Ill.^{mo} Legato et Io fa istantia che per la presente
mea voglia dechiarare quello che io giudeche che li si con-
vengha onde essendone informati da molti che han veduta l'
opera et particolarmente dal Vignuola truovo che si ben
non si possa farne giuditio interamente finchè ditta opera
non si conduca a perfectione et non li se dia l'ultima mano
con collocar decta statua dove haverà a stare recognoscerlo
per addesso almeno de trecento scudi dovendo andare molto
più innanzi finita che sirà secondo che cercherò de inform-
armi alhora si che per decta somma le SS. VV. non glini fac-
cino dificultà che cusì Io judico che lo possono farlo sensa

alcuno scrupolo che la Città ne vengha lesa et me le reco-
mando. Di Roma a XXJ de giugno M. D. LV.

Document 3: Cardinal Giulio Feltrio della Rovere, legate
of Umbria in Rome to the Priors and people of Perugia (Annale
Decemvirale, 1553-1557, f. 149)

Magnifici nostri Carissimi havendo Vincentio de Giulio
secondo intendiamo conducto homai a prefectione la statua
di papa Iulio Terzo de s.ta me. la quale prese a fare a re-
quisitione de contesto publico con haver facto del suo quasi
tucta la spesa che vi è andata nei lavoranti oltre la fatica
et opera che vi ha messo sensa che per anchora sia stato satis-
facto de alcuna cosa per l'opera et mercè sua et percio es-
sendo molto honesto che si comenci a satisfarlo ci è parso
de dirve et exhortarvi per la presente nostra che vogliate
dare ordine che per adesso gli si paghino sino a dugento o
trecento scudi a bon conto di quello che deve havere per la
sodecta opera che si presume che sia per ascendere a molto
maggior summa et in quisto modo la predicta statua sirà del
tucto finita et in termine da mettersi in publico et alhora
poie se exprimerà el valore de essa et si salderà il conto
tra voie et il prefato Vincentio et oltra che sia ragionevole
che di presente egli consegnisca quanto di sopra è decto a
noie sirà di grato piacere che ciò faciate volontiere et sensa
alcuna dificultà. Et stati sani. De Roma alli XXI de giugno.
M. D. LV.

 Il Cardinale de Urbino

IV. MONUMENT TO GUGLIELMO PONTANO (fig. 17)

Location: Perugia, San Domenico

Dimensions: Life-size

Description: Reddish clay; lower part of the tomb was re-
stored in 1959. The original white surface of the figure
itself has been removed, leaving it scrubbed and damaged.
The inscription reads: D. GVILIELMO. PONTANO/ PROB. ET. IVR.
PRVD. PRÆCL./ QVAM. AN. XLV. SVMM. CVM. / GLOR. PVBL. PROF.
EST. VIXIT/ AN. LXXVI. OB. M. D. L. V. The figure once held
an object in his left hand which is now missing.

Date: c. 1555-1556

Principal bibliography: The most complete biographies of
Guglielmo Pontano are A. Oldoini, Atheneum Augustum, Perugia,
1678, p. 137-138; and G. B. Vermiglioli, Biografia degli Scrit-
tori Perugini, Perugia, 1829, II, p. 246; see also G. Panci-
roli, De Claris Legum Interpretibus Libri Quatuor, Lipsiae,
1721, p. 268. On the statue itself, C. Crispolti, Perugia
Augusta, Perugia, 1648, p. 189; S. Siepi, Descrizione Topo-
logico-Istorico della Città di Perugia, Perugia, 1822, II,
p. 516; L. P. Saraceni, Descrizione della Chiesa di San Dom-
enico, Perugia, 1778, p. 35; and O. Gurrièri, La Chiesa di
San Domenico in Perugia, Perugia, 1960, pages unnumbered,
illus., attributed to "a follower of Sansovino".

<u>Discussion</u>: The jurist Guglielmo Pontano died in 1555 at the age of 77 (Vermiglioli, <u>Biografia</u>, p. 246). A contemporary account of his funeral is cited by Vermiglioli. ". . .gli fu data onoratissima sepoltura nella chiesa di S. Domenico in uno bellissimo Sepolcro a lato la sua capella." No statue is mentioned, nor is it mentioned in the documents relating to the Pontano chapel (ASP. San Domenico. Entrata e Uscita della Sacrestia, 1548-1564, f. 96v. and ASP. Archivio Notarile. March 8, 1555, f. 368-370v.) although the words "bellissimo sepolcro" might indicate something out of the ordinary. C. Crispolti (<u>Perugia Augusta</u>, p. 189) refers to the tomb, but does not describe it ("In alcuni altri tumuli sono. . ."). Saraceni (<u>Descrizione</u>, p. 35) mentions the tomb in passing but does not attribute it. Finally in 1822 S. Siepi (<u>Descrizione</u>, II, p. 516) described the figure in what must have been its original position. "Nella parete in fondo a questa crociata sono le 2 porte della sagrestia e del convento ornate di una cornice di pietra intagliata e colorata a guisa di pietra serena. Sopra la porta sinistra presso alla descritta cappella in una nicchia sémicircolare è una urna con figura giacente di stucco". Siepi gives the inscription and continues: "Immediatamente segue un'Altare con semplice ornato della stessa pietra colorata. Due pilastroni scanalati chiudono in mezzo il quadro colla discesa dello Spirito Santo sugli Apostoli dipinto da Plautilla Suora domenicana da Prato in Toscana circa l'anno 1554, in cui fu cominciato l'altare

da Guglielmo Pontani e terminato da suoi eredi." Siepi also
adds that over the other door was "un sarcofago simile", that
of Benedetto Guidalotti, another jurist, dated 1429 (see A.
Oldoini, Atheneum, p. 52-53. This tomb is attributed to Urbano
da Cortona. The figure has evidently been moved from a po-
sition near the sacristy to its present position at the end
of the right nave, near the side entrance) The figure of
Guglielmo Pontano was first attributed by O. Gurrieri (La
Chiesa di San Domenico) to a follower of Sansovino, presumably
Jacopo. Gurrieri was also responsible for the restoration
of the figure.

The attribution of the Guglielmo Pontano to a follower
of Sansovino is not satisfactory. It is too indefinite and
it raises historical difficulties. There are few followers
of Jacopo Sansovino who could have modelled a figure of such
quality and there is no reason to believe that any of them
were in Perugia in 1555. Documents for the figure have not
been found, but it is probably not beside the point that
San Domenico was the Danti family church and that Girolamo
Pontano, the brother of Guglielmo, is mentioned in a contract
of 1554 between Danti and the Priors for a gilt silver bowl.
(Catalogue LIII)

The slow-moving, constantly modelled surfaces broken
by heavy patterns of felt-like drapery are also to be found
in the statue of Julius III (figs. 3 and 17) The difference
in degree of detail between the two statues is largely due

to the relative quality of the materials used. Pontano's
extraordinarily large right hand is an optical liberty simi-
lar to the large arm and hand of the statue of Julius III.
In detail, such fine points as the ears and the characteris-
tic veins of the hand (compare to the arms and hands of the
Onore group of 1561, fig. 32) point to Danti's authorship.
The general conception of the figure, heaped in fictile strips
to the small head is quite comparable to the Julius III.
The figure was probably modelled after the completion of the
Julius III, in late 1555 or early 1556.

V. DEPOSITION (figs. 18 and 19)

Location: Washington, National Gallery of Art

Dimensions: H. 17.5 in., W. 18.5 in (44.5 x 47 cm.)

Description: bronze relief, unchased

Discussion: The attribution of the Deposition relief to Danti
has never been questioned. There is no documentary evidence
although the relief has been connected with "alcuni bassi-
rilievi. . .di bronzo, che furono tenuti bellissimi" mentioned
by Vasari as having been made, presumably in the years im-
mediately following 1560, for Cosimo I. (Gronau-Gottschewski,
Giorgio Vasari, Die Lebensbeschreibungen, vol. VII, 2, p. 269,
n. 7) This at least gives assurance of the probable, that
Danti did more than the two bronze reliefs which are documented.
On stylistic grounds the relief has been dated 1565-1570
(Duveen Sculptures in Public Collections of America, New York,
1944, no. 223) and 1560-1561 (Charles Seymour Jr., Master-
pieces of Sculpture from the National Gallery of Art, New
York, 1949, p. 181, n. 44). In spite of similarities of
drawing and modelling there is a considerable distance between
this and the documented bronze reliefs. The Deposition is
purged of detail and more rigorously composed and shows the
impact of early Florentine Mannerist painting as well as the
continuing influence of Michelangelo's drawings. The robust
forms, with their comparatively large, solid heads and limbs

should be contrasted to the oval figures of the earlier reliefs, and the larger passages of modelling, as well as the clarification of the space perhaps indicate experience with sculpture in marble. The rather straightforward perspective construction formed by the two crosses of the two thieves was also used by Santi di Tito in his Santa Croce Crucifixion. It seems most probable that the stylistic anomalies of the relief are explainable by Danti's being strongly under the influence of a manner which is difficult to specify (perhaps Bandinelli's bronze reliefs?-- see J. Pope-Hennessy, Victoria and Albert Catalogue, no. 475 and 476 and U. Middeldorf, "A Bandinelli Relief", Burlington Magazine, LVII, 1930, p. 67-72) during his first years in Florence.

The relief was formerly in the collection of Stefano Bardini, Florence; Oscar Hainauer, Berlin; and P. A. B. and J. E. Widener.

Additional Bibliography: W. Bode, Die Sammlung Oscar Hainauer, 1897; Widener Collection Handlist, Washington, 1942; W. R. Valentiner, Art News, XXVI, 1928, p. 21.

VI. MOSES AND THE BRAZEN SERPENT
 (figs. 20-25)

Location: Florence, Museo Nazionale

Dimensions: H. 32. 3/8 in., W. 67 3/4 in. (82.2 x 171.1 cm)

Description: bronze, cast in two parts and joined at center

Date: 1559

Discussion: The most complete source for the Moses and the
Brazen Serpent--and the most accurate for Danti's early work
in Florence--is a note to a sonnet dated November 15, 1559.
(T. Bottonio, Poesie Sacre, I, p. 29; also published by
J. von Schlosser, "Aus der Bildnerwerkstatt", p. 73)
"Doveva Vincenzo Danti Scultore Perugino fare un Ercole di
bronzo, che uccidesse Anteo, ad istanza del Duca Cosimo, ed in
tre volte che la gittò, non gli venne mai bene. Occorse poi ch'
egli ebbe a gittare per il medesimo Duca un quadro grande di
bronzo, dove era scolpita l'istoria del Serpente di Mosè, la
quale opera gli riuscì con molta felicità. E nel medesimo
tempo lavorò due marmi di basso rilievo, nell uno de'quali scolpì
la Resurrezione di Cristo, nell'altro la Flagellazione alla
Colonna; di che riportò lode grandissima. . ." Since the
commission was given Danti after the failure of the Hercules
and Antaeus, which must have taken up most of 1558 (see cata-
logue XXXV), the relief must have been modelled and cast in
1559, and finished by November 15 of that year, when Bottonio

wrote his sonnet honoring its success.

The relief has been dated March, 1560 by U. Middeldorf and F. Kriegbaum, "Forgotten Sculpture by Domenico Poggini", Burlington Magazine, LIII, 1928, p. 10n., presumably on the basis of the following document, which they did not publish.

Document 1: ASF. Fabbriche, "Copia di lustre e conti del Palaco Ducale 1558-1560", f. 145r.

Ricordo come e si peso per infino a dj 19 di marzo 1559 (1560 st. c.) si peso la istoria di 1/2 rilievo di bronzo dientrovi la istoria di moise la quale gitto m vincenzo da perugia e peso H 400 la quale si consegnjo a m. jsforzo cameriere delo jllustrissimo sre duca per infino a detto di dice sette fece la polizia a franco di S Iacopo callo bacci creditore di 23 Genajo 1560 (1561)

This document substantiates rather than contradicts the slightly earlier date provided by Bottonio's sonnet, since payment would have been made for a completely finished work.

The relief has also been dated around 1557--about the time that Danti left Perugia and arrived in Florence--by J. Pope-Hennessy, "Italian Bronze Statuettes, II", Burlington Magazine, CV, 1963, p. 64, on the basis of the similarity to the reliefs of the statue of Julius III. The documentary evidence, however, is unequivocal in placing the relief in the year 1559, and there is no real stylistic difficulty in that date. There is a considerable difference between the

graceful, rounded figures of the Julius III and the "Rodin-like" forms of the Brazen Serpent.

In the same article Pope-Hennessy suggests that the extraordinarily large relief may have been intended as the antependium of an altar. This seems a likely hypothesis, especially in view of the two marble reliefs--a Resurrection and a Flagellation--which Danti carved at the same time. Both of these themes are iconographically compatible with the Brazen Serpent, which is a prefiguration of the passion of Christ, and the reliefs might be reasonably thought to have been a part of such a scheme as the Chapel of Leo X in the Palazzo Vecchio. The chapel of the Quarters of Leo X was finished by June 24, 1558 for the wedding of Lucrezia de'Medici and Alfonso d'Este (P. Barocchi, Vasari Pittore, Milan, 1964, p. 136) A letter from Vasari to Cosimo I (Frey, Nachlass, I, p. 501-502) makes it clear that work was cut short for the wedding. It is probably the chapel of Leo X to which Vasari referred in Danti's biography (Vasari-Milanesi, VII, p. 631) when he wrote: "Appresso gettò, pur di bronzo, la grata della nuova cappella fatta in Palazzo nelle stanze nuove dipinte da Giorgio Vasari. . ." which is included in the discussion of Danti's two reliefs. A payment to Danti for just such a grate bearing the date July 15, 1558 has been preserved (ASF. Fabbriche, 1556-1558, f. 140v.; "E di 15 di luglio 1558 per H 36 di fero robusto per lo telajo per gitarvi. . .la rete di bronzo amiglie per la finest. da la capella la quale ha gittare M. Vincenzo perugino").

Although the chapel is not named, the correspondence with
the date of the termination of the chapel seems to make it
virtually certain that the document refers to the Chapel of
Leo X. The theme of Moses and the Brazen Serpent also stands
in the general tradition of papal iconography. Clement VII
used the theme of Moses striking the Rock on the reverse of
one of his medals, and more nearly at the same time, Paul
III appeared with scenes from the life of Moses in his por-
traits by Guglielmo della Porta. (Chapter I, note 52)

The marble Resurrection relief mentioned by Bottonio
went immediately into the Guardaroba, and appears in inven-
tories from 1560 (catalogue XXX). This is probably an early
indication of the disintegration of the project of which the
Brazen Serpent was a part. The Flagellation dropped out of
sight. The Brazen Serpent, as the document shows, was con-
signed to Sforza Almeni, the Duke's chamberlain and Danti's
friend, patron and voice in court. This perhaps explains
the absence of the bronze relief from early inventories.
Sforza Almeni was murdered by Cosimo I in 1566, and the re-
lief may have returned to Medici possession shortly thereafter
since it was in the possession of the Duke when Vasari wrote
(Vasari-Milanesi, VII, p. 631-632). "Appresso gettò. . .un
altro quadro alto un braccio e mezzo, e largo due e mezzo,
dentrovi Moisè, che per guarire il popolo ebreo dal morso
delle serpi, ne pone una sopra il legno." It is described
as "appresso detto signore". A similar account, indicating

only that the relief was in the guardaroba, is given by R.
Borghini (Il Riposo, p. 521). ". . .un'altro (rilievo) è
in guardaroba alto un braccio, e mezo, e largo due, e mezo,
in cui è figurato Moisè, che pone una serpe sopra il legno
per guarire il popolo da'morsi de'serpenti. . ." It seems
also to have been in the Guardaroba fourteen years earlier
in 1570 (ASF. Guardaroba 75, f. 67; "Uno quadro di bronzo.
lungo B III alto uno 1/3 entro vi piu figure") where it is
also described by G. Cinelli at the end of the seventeenth
century (Bozze per le Bellezze di Firenze, FBN, Magl. XIII,
34, f. 90r.). It was in the Galleria (L. Pascoli, Vite. . .
Moderni, 1730, I, p. 292, Vite. . .Perugini, p. 140; L.
Lanzi, La Real Galleria di Firenze, p. 51) and went from there
to the Bargello (Vasari-Milanesi, VII, p. 632) where it has
been since.

The possibility should also be considered that Danti
intended his relief as a trial piece for the bronze reliefs
for the choir in the Duomo which Bandinelli was at work at
at the time. The reliefs projected by Cellini are described
as follows: (D. Heikamp, "Nuovi documenti celliniani", Rivista
d'Arte, 1958, p. 35-38) "di lunghezza di tre braccia e di
altezza di un braccia e mezzo: e volendo fare le storie del
nuovo o del vechio testamento, ne i detti quadri v'andrà
gran quantità di figure". Three braccia is c. 66 inches,
and a braccia and a half is 33 inches. Danti's relief is
68 x 32.5 inches. Danti's affinity for (and perhaps association

with?) Bandinelli can be concluded from the style of his
Onore che vince l'Inganno, which stands very near the Duomo
choir reliefs, and from a poem fragment by Cellini which
links the two artists (Chapter III, 2, n. 9) Perhaps
Cellini's proposals for reliefs were still in the air in
1559.

VII. FLAGELLATION (fig. 26)

Location: Kansas City, Rockhill Nelson Gallery

Dimensions: H. 20 1/4 in., W. 17 1/8 in. (51 x 43 cm.)

Description: marble; perhaps cut down to present oval shape

Date: 1559

Discussion: This relief was attributed to the school of
Pierino da Vinci by U. Middeldorf ("Additions to the Work
of Pierino da Vinci", Burlington Magazine, LIII, 1928, p.
299-306). Middeldorf has since reconsidered this attribution
(in a letter to the Rockhill Nelson Gallery dated October 21,
1966) finding the relief "close also to Vincenzo Danti whose
work is not always quite so easy to separate from that of
Pierino". One of the marble reliefs mentioned by Timoteo
Bottonio (catalogue VI) was a Flagellation. Assuming that
it and the Resurrection were made together the relief would
have been about a braccia (c. 22 in.) since the Resurrection
relief was a braccia (catalogue XXX). If, as Middeldorf sug-
gested, the relief was cut down to an oval from a rectangle
this would have been done not many years after it was carved,
if it can be identified with the following record. ASF. Guarda-
roba 126, "Guardaroba del fu Granduca Francesco 1587, f. 30v.
"Uno Aovato di marmo di B uno In circa entrovj un christo
alla colonna con ornamento di noce in una cassetta d'albero"

The style of the relief can be explained by inexperience in marble (it is Danti's first known work in marble), the impact of Bandinelli's marble relief, and Danti must also have studied Pierino da Vinci's reliefs with some care.

VIII. SPORTELLO RELIEF. THE EMPEROR AUGUSTUS BURNING THE
SPURIOUS SYBILLINE BOOKS (fig. 27)

Location: Florence, Museo Nazionale

Description: Bronze relief on the surface of a heavy bronze
safe door; decorative framing retains traces of gilding

Dimensions: H. 39 in., W. 25.8 in. (99 x 65.5 cm.)

Date: Payment for the relief was made January 23, 1561

Discussion: The same date, January, 1561, was also given by
U. Middeldorf and F. Kriegbaum, "Forgotten Sculpture by Do-
menico Poggini", Burlington Magazine, LIII, 1928, p. 10n.,
apparently on the basis of the following document, without,
however, citing it. The transcription which follows differs
slightly from that given by A. Lensi, Il Palazzo Vecchio,
Milan-Rome, 1929, p. 271, n. 55.

Document 1: ASF. Fabbriche, "Copia di lustre e conti del
Palaco Ducale 1558-1560", f. 145r.

R. di 23 di Genajo 1560 si peso 1⁰ isportello di bronzo
di 1/2 rilievo per metelo al⁰ armario nella anticameretta
del duca dovera la stufa alat⁰ alucio delo jscrittoio nuovo
peso H. 216 netto el quale jsportello lo fece dett⁰ m. Vin-
cenzo da perugia

Datto a pierant⁰ paganuci calobacj creditore del sopra
detto lavoro

Danti's sportello relief was part of the program of decoration
of the personal quarters of Cosimo I, carried out by Giorgio
Vasari. Vasari set a stone cabinet into the wall of the
"scrittoio segreto" which was to contain the Duke's papers.
He had planned to line it with cedar, but the Duke, fearing
fire, had it coated instead with stucco. It was closed by
Danti's sportello (A. Lensi, Il Palazzo Vecchio, p. 58-59).
Betraying its function, a keyhole is to be seen on the right
side of the relief at the feet of Prudence.

The careful chasing of the relief, as well as the sever-
ity of its structure would seem to place it nearer the Onore
of 1561 than to the Brazen Serpent relief of 1559, and it
was probably modelled and cast late in 1560.

The relief is briefly mentioned by Vasari (Vasari-Milanesi,
VII, p. 631-632) "Appresso getto, pur di bronzo, la grata
della nuova cappella fatta in Palazzo nelle stanze nuove di-
pinte da Giorgio Vasari; e con esse un quadro di molte figure
di bassorilievo, che serra un armario, dove stanno scritture
d'importanza del Duca. . ." Nothing is added to this account
by R. Borghini, Il Riposo, 1584, p. 521; and L. Pascoli, Vite
. . .Perugini, 1732, p. 140. The quarters of Cosimo I were
redecorated in 1814 (Lensi, Il Palazzo Vecchio, p. 296)

The lower part of the relief was illustrated by L. Cico-
gnara, Storia della Scultura, Prato, 1825, tav. LVI, who noted
that the relief was thought by some to be by Michelangelo.
Cicognara acknowledges the stylistic dependence of the relief

upon Michelangelo, but suggests that it should be identified with the sportello described by Vasari and Pascoli. Following the older attribution, a fine reproduction of the relief was published by A. L. Tuckerman, A Selection of Works of Architecture and Sculpture belonging chiefly to the Period of the Renaissance in Italy, New York, 1891, pl. LXXVI. The relief was accepted without qualification by G. Milanesi (Vasari-Milanesi, VII, p. 632).

For the identification of the central scene as Augustus burning the spurious sibylline books see Chapter II, part 1 above. Milanesi (Vasari-Milanesi, VII, p. 632) identified the youth in the center as an emperor, and Bombe (Thieme-Becker, VIII, p. 386)advanced the name of Trajan, suggesting that the scene was the remission of the tax returns, followed by Pope-Hennessy, Victoria and Albert Catalogue, p. 459.

Fragments, perhaps of a trial cast of the relief, are in the Victoria and Albert Museum (J. Pope-Hennessy, Victoria and Albert Catalogue, p. 458-459, fig. 479) The upper fragment measures 8 7/8 in. x 1ft., 1/8 in. (22.5 x 30.8 cm.); lower fragment measures 5 5/8 in. x 5 3/8 in. (14.3 x 13.7 cm.) See fig. 142 . These fragments are described as "in exact conformity with the relief in Florence, save that the surface has not been worked. . .it is unlikely to have been cast from the Bargello relief. The figures of Romulus and Remus in the lower left corner of the finished relief are barely indicated in the present version. In facture and style it closely recalls the unchased Descent from the Cross. . ."

IX. HONOR TRIUMPHANT OVER DECEIT
(figs. 28-33)

Location: Florence, Museo Nazionale

Dimensions: H. 74. 8 in. (1.9 m)

Description: Marble; "unfinished" areas at the back of the
figure and on the base

Date: 1561

Discussion: L'Onore che vince l'Inganno was Danti's first
major work in marble and his first for Sforza Almeni. Neither
the date of its beginning nor of its completion is documented.
The earliest reference to the group is in a short introduction
to a sonnet by the Dominican Timoteo Bottonio (Poesia Sacre,
PBA, Mss. G. 73; also published in Perugia,1779; and by J.
von Schlosser, "Aus der Bildnerwerkstatt," p. 76

Sopra una statua di marmo di Messer Vincenzio
Danti Scultor Perugino, fatta per il Sig. Sforza Almenio,
dove apparisce l'Onore, che ha soggiogato l'Ingegno (sic)

(È argomento scritto dall'autore)

Sonetto

Colla data di Firenze 1561

Alto pensier, saggio concetto, e degno
Signor, l'Alma v'impresse, allorchè avvinto
Nel proprio laccio vide, e n'terra spinto
Da vero onor fallace inganno, e indegno
Indi la dotta Man, l'industre Ingegno
Del nuovo Fidia nostro, or l'ave effinto
In vivo marmo, e puro; ond'Egli ha vinto
Tutti i miglior, ch'invidia n'hanno, e sdegno

Quanto beltà, quanto splendor si vede
Nel volto giovenil, nei chiari lumi
Di Lui, ch'è di virtù sola mercede
 Come ne scopre ben, che sogni, e fumi
 Son nostre gioje, e che tutt'altro eccede
 L'onor, ch' han l'Alme in Ciel tra gli altri Numi!

The date 1561 has been accepted by all later writers (U. Middeldorf and F. Kriegbaum, "Forgotten Sculptures", Burlington Magazine, LIII, 1928, p. 10n; A. Venturi, Storia, X, 2, p. 509; J. Pope-Hennessy, Italian High Renaissance Sculpture, 3, p. 78). The Onore group is usually considered to have been finished just after the Sportello for Cosimo I (Catalogue VIII). It was probably begun shortly after the competition for the Fountain of Neptune was over in 1560 (Chapter III, introduction).

Vasari's account implies an earlier date since he places the execution of the marble immediately after the failure of the Hercules and Antaeus. This is no doubt an opposition of failure and success for literary purposes and need not reflect the actual order of events. "Voltossi dunque, per non sottoporre le fatiche al volere della fortuna, a lavorare di marmo: condusse in poco tèmpo di un pezzo di marmo due figure, cioè l'Onore che ha sotto l'Inganno, con tanta diligenza, che parve non avesse mai fatto altro che maneggiare i scarpelli ed il Mazzuolo; onde alla testa di quell'Onore, che è bella, fece i capelli ricci, tanto ben traforati, che paiono naturali e propri, mostrando oltre cio di benissimo intendere gl'ignudi: la quale statua è oggi nel cortile della

casa del signore Sforza Almeni nella Via de'Servi." R.
Borghini (Il Riposo, p. 520) and L. Pascoli (Vite. . .Peru-
gini, p. 139) add nothing to Vasari's version.

The Onore group stood in the Palazzo Almeni in the
Via de'Servi (Bocchi-Cinelli, 1678, p. 404; R. Borghini,
1730 ed., p. 425; Richa, 1758, VIII, p. 47) until 1775
when it was bought by the Granduke Leopoldo de'Medici and
placed in the Boboli Gardens (Gronau-Gottschewski, VII, 2,
p. 269, n. 6) where it was appreciatively described by F. M.
Soldini (Descrizione del Giardino di Boboli, 1789, p. 45,
tav. XVI). "In seguito si viene ad incontrare un Gruppo di
marmo, il quale nell'esecuzione di quel che rappresenta può
veramente chiamarsi uno dei portenti della Scultura. È gloria
di S. A. R. PIETRO LEOPOLDO Nostro Gran Signore che n'abbia
fatto il bellissimo acquisto negli anni indietro, e siasi
determinato di collocarlo in questo posto per decorazione
maggior del suo Reale Giardino. Può disegnarsi in più aspetti
o punti di veduta, tutti ugualmente mirabili, dei quali però
abbiamo preferito quello, che di dietro fa mostra di due
Figure. . ." The group was still in the Boboli Gardens in
1881 (Vasari-Milanesi, VII, p. 631) "al principio dello stra-
done o viale di quel delizioso giardino, ove si vede anche
prsentemente a man destra di chi si accinga a salirlo." It
was subsequently transferred to the Bargello. The group was
cleaned with excellent results following the flood of November
1966.

X. PUTTO

<u>Location</u>: Fiesole, Villa Rondinelli

<u>Dimensions</u>: Life-size

<u>Description</u>: Marble; hands and feet were left roughly sketched in the block; the figure is broken across the neck and below the right arm; the surface is badly weathered and pitted.

<u>Discussion</u>: The present Villa Rondinelli was given to Sforza Almeni by Cosimo I in 1552 (ASF. Misc. Medicea 514, no. 21; 'Item L'Anno 1552 gli fù donato il Podero di Fiesole che fù di Mattio delo Macchio stimato 1386 scudi") On the subsequent history see Lensi Orlandi, <u>Le Ville di Firenze qua d'Arno</u>, p. 89; and G. Carocci, <u>I Dintorni di Firenze</u>, Florence, 1881, p. 66-67. Lensi Orlandi describes the villa as decorated with gardens, terraces, <u>giochi d'acqua</u>, a grotto, piscina, and a <u>gran sala da ballo</u>. Much of this (the villa is construc- ted on a steep hillside) was destroyed in 1944, and the rest has gone to ruin. The villa itself has been the subject of several refurbishings. The grotto mentioned is a very well- preserved late 16th century grotto with a small marble statue of Neptune.

The putto is all that certainly survives of the deco- rations which Danti did at the villa described by Vasari. "A Fiesole, per lo medesimo signore Sforza, fece molti orna- menti in un suo giardino ed intorno a certe fontane".

(Vasari-Milanesi, VII, p. 631) One wonders if Vasari had
ever actually seen these decorations, and it is difficult
to tell from this pithy account what the extent of Danti's
efforts might have been. There is a second putto at the villa,
also on a pillar; if it was ever similar to Danti's, it is
difficult to tell, since it has been subjected to a thorough,
very ugly eighteenth-century recutting. If there were more
than one such putto, then it might have belonged to a group
such as Giovanni Bologna's Fountain of the Fishing Boys,
which is dated "c. 1561-2" by E. Dhanens (Jean Boulogne,
Brussels, 1956, p. 100-103) and if this date is correct
it would have been done about the same time as Danti's
putto. Giovanni Bologna's group has been connected with the
marble putto on the Fontana delle Scimmie (the scimmie have
been attributed to Giovanni Bologna by A. Venturi, Storia,
X, 2, p. 740) in the Boboli Gardens by B. Wiles, Fountains
of the Florentine Sculptors, p. 85. This putto is attributed
to Pierino da Vinci. Perhaps it was once a part of Danti's
group at Fiesole, the dead-pan head, and unfinished hands
and feet having been recut when the Fontana delle Scimmie
was assembled.

XI. LEDA AND THE SWAN
 (fig. 35)

Location: London, Victoria and Albert Museum

Dimensions: H. 54 1/2 in. (138.4 cm.)

Description: Marble; "unfinished" sections on figures left
leg

Date: c. 1562-1563

Discussion: The group is undocumented, and was bought in
1865 by Sir John Everett Millais in Florence as the work
of Michelangelo (J. Pope-Hennessy, Victoria and Albert Cata-
logue, p. 457-458 for history and provenance of the group).
Danti's name was first mentioned in connection with the
Leda by E. McLagan (J. Pope-Hennessy, Catalogue, p. 458)
and a complete argument in favor of its attribution to Danti
was first advanced by H. Keutner (Burlington Magazine, C,
1958, p. 427-431). Keutner included it among Danti's latest
works. Attribution and date are both accepted by J. Pope-
Hennessy (Catalogue, p. 458; High Renaissance Sculpture, 3,
p. 77) who accounts for the unfinished parts of the figure
by hypothesizing that Danti left in incomplete when he de-
parted Florence in 1573.

 The style of the figure is anomalous. The heavy, softly
modelled thighs and general surfaces are distinctly remini-
scent of such a figure as Bartolommeo Ammannati's Nari

Monument **Victory**. U. Middeldorf (in conversation) has sug-
gested that the figure may be identified with a **Leda** **and** **the**
Swan "alte due braccia" which Ammannati carved for the Duke
of Urbino mentioned by R. Borghini (**Il** **Riposo**, p. 590). This
has always been thought to refer to the Michiangelo-based
reclining **Leda** in the Bargello, although Middeldorf convin-
cingly argues that the reference is to a standing figure.
A date in the 1540's, however, when Ammannati would have to
have carved the **Leda**, seems inconsistent with the extreme
formal refinement, and with the unfinished parts of the
figure. Leaving aside for the moment the suggestion that
the group is in fact incomplete, such passages were frequently
evident in Florentine sculpture of the 1560's and were es-
pecially favored by Danti. Both his **Onore** and the Villa
Rondinelli putto are similarly "unfinished".

Keutner (**Burlington** **Magazine**) notes the affinity which
the group exhibits for the work of Cellini. The conclusion
which Keutner draws from this influence can be avoided if
it is observed that Danti seems to have been drawn to Cel-
lini's example from the very beginning of his work in Florence
and not just at the end, in the 1570's. Stylistic location
of the group in the early 1560's can perhaps be postulated
on the basis of the suggestions afforded by the "unfinished"
sections of an otherwise highly finished sculpture and the
date of a lost **Leda** by Cellini, which may provide an ap-
proximate **terminus** **post** **quem** for the figure. In 1559 Cellini
was at work on a small marble Leda "one braccia tall", as

he reported to Cosimo I (E. Cameresca, Tutta l'opera del Cellini, Milan, 1955, p. 63). If this little figure was similar to Cellini's own Narcissus (also carved in the '50's) it may have provided the pattern at least for the upper part of Danti's figure; this would suggest that Danti's Leda was carved around 1559.

Despite the great compositional prototypes of the Leda's of Michelangelo and Leonardo, Danti chose as his pattern Bandinelli's mannered neoclassical and undramatic small bronzes on the theme, related to the classical Leda type (see G. A. Mansuelli, Galleria degli Uffizi. Le Sculture, no. 34) as noted by Keutner. A statue of similar composition appears in Francesco Salviati's Triumph of Camillus fresco in the Sala dell'Udienza in the Palazzo Vecchio (ill. A. Venturi, Storia, IX, 6, fig. 85) A mysterious Leda which may be relevant is mentioned by Vasari in connection with the visit of Daniele da Volterra to Florence in 1557-1558 (Vasari-Milanesi, VII, p. 63) Vincenzo de'Rossi also has a Leda and the Swan to his credit, "grande quanto il vivo" (R. Borghini, Il Riposo, p. 595).

Pope-Hennessy's suggestion that the Leda and the Swan is a fountain group seems plausible. The conception of the group seems closer to the suavity of Equity and Rigor than to the planar formal severity of Danti's late style. It can perhaps be included among the works executed for Sforza Almeni at Fiesole.

A drawing of or for the group is in the Museum of

Fine Arts in Boston (Appendix II).

XII. MONUMENT TO CARLO DE'MEDICI

Location: Prato, Duomo

Dimensions: Over life-size.

Description: Marble; Madonna and Child above a sarcophagus
flanked by two candelabra-bearing putti, with an oval portrait
of Carlo de'Medici below and surrounding architectural frame.
The monument bears the inscription:

<div align="center">

CAROLO . MEDICI . COSMI . F.
PRAEPOSITO . QVI . OBIIT . M.CD.XC . II.

COSMVS . MEDICES . FLORENTIN . ET , SENEN . DVX . I
AD . CONSERVANDAM . GENTILIS . OPTIMI
MEMORI M . N. MDLXVI.

</div>

Date: begun in 1562, finished 1566

Discussion: The project was first mentioned in a letter from
Duke Cosimo to Giorgio Vasari, May 1, 1562. It must have
been substantially completed in April 1564 when Vasari
wrote Cosimo "cosi dell'opera di Messer Carlo de Medici
quale si fini et torna benissimo" (Chapter III, part 2
above). An inscription for the monument had been chosen
by March 13, 1564 (Frey, Nachlass, II, p. 50, with alter-
native inscriptions) The present inscription is 1566.

Vasari discusses the monument to Carlo de'Medici at
considerable length (Vasari-Milanesi, VII, p. 632).
". . .d'ordine del quale (Cosimo I) fece la porta della
sagrestia della pieve di Prato, e sopra essa una cassa di

marmo con una nostra donna alta tre braccia e mezzo col figli-
uólo ignudo appresso; e due puttinia che mettono in mezzo la
testa, di bassorilievo, di Messer Carlo de Medici, figliuolo
naturale di Cosimo vecchio, e già proposto di Prato; le cui
ossa, dopo essere state lungo tempo in un depositio di mat-
toni, ha fatto porre il Duca Cosimo in detta cassa, a onor-
atolo di quel sepolcro. Ben' è vero, the la detta Madonna,
e il bassorilievo di detta testa, che è bellissima, avendo
cattivo lume, non mostrano a gran pezzo quel che sono".
Vasari's defense of the group perhaps indicates that it was
not well received. The account of R. Borghini (Il Riposo,
p. 520) adds nothing to Vasari, and is simply a resumè of
the earler version. Similarly, L. Pascoli (Vite. . .Perugini,
p. 140) supplies no additional information, and provides an
even briefer summary. The group is discussed briefly by
C. Guasti, Bibliografia pratese, Prato, 1844, p. 126n.;
and G. Marchini, Il Duomo di Prato, n. p., 1957.

XIII. VENUS WITH TWO AMORINI

Location: Florence, Casa Buonarroti

Dimensions: 71.6 in. (182 cm.)

Description: marble, worked with a toothed chisel; there is a putto on either side of the "Venus"; the putto on her left is near full round, the other is drawn in relief; the base bears the shallow inscription DANTE

Discussion: The so-called Palazzo Pitti Venus was first published by M. Marangoni ("Una Scultura di Michelangelo", Bolletino d'Arte, 1958, p. 156-163) as the work of Michelangelo. Marangoni offered no argument as to the purpose of the sculpture, and its publication took place amidst a shower of alternative attributions. M. Salmi, U. Procacci, G. Morazzi and C. Ragghianti argued that it was a follower of Michelangelo; U. Middeldorf claimed it for Pierino da Vinci, and R. Longhi assigned it to the circle of Bartolommeo Ammannati (see La Nazione, June 12, 14, and 15, 1958; and L'Europeo, June 22, 1958. These attributions are noted by H. Keutner ("The Palazzo Pitti 'Venus' and other Works by Vincenzo Danti", Burlington Magazine, C, 1958, p. 427-431) who passes them all by in favor of Vincenzo Danti. Marangoni's original attribution to Michelangelo has since been vigorously defended by C. de Tolnay ("La Venere con due Amorini già a Pitti ora in Casa Buonarroti", Commentari,

1966, p. 324-332, and presumably as a result of the same
investigations, "Sur des vénus dessinées par Michel-Ange a
propos d'un dessin oublié du Musée du Louvre", Gazette des
Beaux-Arts, LXIX, 1967, p. 193-200).

Keutner's argument supporting the attribution to Vin-
cenzo Danti is both stylistic and documentary. The docu-
mentary evidence will be considered first. Keutner identi-
fies the present statue with that mentioned by R. Borghini
(Il Riposo, p. 521) "Nel palagio de Baroncelli è di suo
una Venere di marmo maggiore del naturale. . ." A note ap-
pended to this statement by Borghini's later editors (1787
ed., 3, p. 80) provides the information that "la villa del
Poggio Imperiale era anticamente de Baroncelli, oggi del
Granduca. Non si sa, se il Borghini parli di quel palagio."
Borghini himself refers to the "Villa di Baroncelli" of
"Signora D. Isabella Medici" (p. 597) which is clearly Poggio
Imperiale. As evidence that Borghini did mean Poggio Im-
periale and that Danti's statue remained there, Keutner
offers a late seventeenth century inventory (P. Galletti,
"I Quadri del Poggio Imperiale nel secolo XVII (da un mano-
scritto esistente alla Torre del Gallo)", Arte e Storia,
1883, p. 318; no more precise date is given for the inven-
tory than end of the Seicento (Arte e Storia, 1883, p. 229-
230)). The relevant entry reads as follows: "A piè della
scala dei Mezzanini. Venere con puttini ai piedi". The
entry is admittedly inexact, especially since no measurement

is given. Keutner also mentions a "Venere di marmo al Naturale" which appears in an inventory of 1654, although he hesitates to identify it with the <u>Venus</u> <u>with</u> <u>two</u> <u>Amorini</u>, preferring the later inventory as more precise. To these might be added two more inventorial notices which are complete with measurements. (ASF. Guardaroba 479. Inventario di Poggio Imperiale, 1634, f. 2. "Nel ricettino che va nel Salotto della Ser.^{ma} Una statua di marmo alta B 2 1/2 figurata per una Venere e cupido sotto"; and ASF. Guardaroba 991, Inventario di Poggio Imperiale, 1691, f. 58. "Nel Giardino Segreto. Una Figura di marmo simile d'una Venere in atto di reggersi un panno, e un Puttino ritto di d:^a alta B 3 posa su d'una Base di pietra rozza") The first is quite evidently not the statue in question, and this fact is worthy of note since it means that a <u>Venus</u> <u>and</u> <u>Cupid</u> was at Poggio Imperiale which may be the same as that in Keutner's notices. The last entrance is fairly surely the Casa Buonarroti <u>Venus</u>, describing its height, the uprightness of the putto, and the roughness of the base.

There was, however, heavy traffic in sculpture between Florence and Poggio Imperiale and a review of the history of the villa makes it difficult to identify the Casa Buonarroti <u>Venus</u> with the Venus listed by Borghini.

In the Quattrocento Poggio Imperiale was the castle of the Baroncelli. When the house fell on bad days at the end of the century, the land passed to the Pandolfini, then in

1548 to the Salviati. When the Salviati were proclaimed
banditi the villa was confiscated by Cosimo I, who in 1565
made a gift of it to his daughter Isabella, the wife of
Paolo Giordano Orsini. During this period it was extensively
redecorated. Isabella Orsini died in 1576, leaving a host
of creditors (ASF. Misc. Medicea 514, no. 24, "Nota dei
Creitori dell Ill.mo et Ecc.mo S. D. Paolo Giordano Orsini
Duca di Bracciano, et della Illma Sra Isabella Medici sua
moglie. . .5 Maggio 1583). The only familiar names on the
list are Domenico Poggini, Santi di Tito and "mo Francesco
schultore" (Cammillani?). If Danti--who had been gone from
Florence ten years at the time of the settlement--worked for
Isabella Orsini, as Keutner suggests, he was paid for his
labor. The fact that Danti does not appear in this list is
not conclusive since Vincenzo de'Rossi, who is known to have
worked at Poggio Imperiale does not appear either.

Toward 1620 the Villa was reclaimed by the Granduke. The Or-
sini, who had invested considerable money in it demanded a
settlement (ASF. Misc. Medicea, 514, no. 3, "Memoria per
il S.re Luigi Vettori intorno al particolare di Baroncelli".
The Granduke was reminded that when the Villa was given to
Isabella Orsiini by Cosimo I "non erano nè la Villa di quella
bellezza, grandezza et magnificenza, che sono hoggi perche
il Palazzo fu abbilito, et accresciuto da Sra Isabella Medici
sua nonna, come ancora si vede dalle iscrizioni del suo nome
in più parti, con havervi ancora fatte di pianta le stalle,
et ricinto di mura de i Giardini, et la Villa ancora abbilita,

et migliorata di Ragnaie et delli Stradoni. . .siccome vi fu speso assai ancora ogn'anno dal Sre Don Virginio suo padre mentreche visso, in fontane, in Giardini. . ."

In 1619 an inventory was taken (ASF. Misc. Medicea 514, no. 3) "Nota di robe, che di presente si trovano nella villa del Poggio Imperiale, già detto Baroncelli, rimaste sotto d. 11 di Marzo 1619 quando si rimandò altre robe al sigre Fulvio Buonaparte, che erano in dta Villa di quelli delli Eccmo Sigre D. Paolo Giordani, rimandato d'ordine alla buona mema della Serma, che sia cielo, come si può vedere per ricevuta del d: S: fulvio Buonaparte, sotto di xi di Marzo 1619 etc.$^{a.}$

Nello stanzino a Terreno a lato al Cortolino due teste di Marmo di Mezzo busto alte 3/4 inca

Un idolino di Marmo alto br. 2 inca

Nel Giardino Segreto al lato alla Porta del Giardino grande due Statovine che gettano acqua alte bra. 1. tutte rotte

A lato alla Porta del Palazzo che entra in d:o Giardino una Statuina, che getta l'acqua alta br. 1 1/4 (possibly 2 1/4)

Un orso di marmo, che sopra la fonte del Giardino, che gettava acqua alte bra 2 inca

Cinque statue di marmo nel d: Giardino alte bra 3 inc, tutte restaurate

Nel Giardino grande due Sedie di Marmo alte br 2 1/2 inca

Nel Prato un pezzo di Marmo Lungo bra 2 1/2 alto b. 1 1/2 inca mezzo vota à caso di fare un Pilo

The last item is a long note on Andrea del Sarto's unfinished Assumption with twelve Apostles

There is nothing resembling the statue under discussion in this inventory, save the indefinite "five marble statues three braccia tall" which seem to have been restored antiques. This is also true of the short list which follows, "Nota delle Statue et Pitture che Restano nel Palazzo di Baroncellj dell Ecc^{mo} Sig^{re} Duca di Bracciano".

1^a Statua Nuda che posa figurata un Ercole di Marmo

1^o Orso di marmo

1^o Nurna di grandezza B 2--------con 1^o statua a giacere marma

The Andrea del Sarto is listed again

Another short inventory, "Nota di Marmi che restano fora del palazzo di Baron^{li}, del Ecc^{mo} Duca di Bracc^{no}, contains nothing of interest.

The sculpture at Poggio Imperiale in the sixteenth century, then, seems to have been removed or noted, and the Venus with two Amorini must have been brought in the seventeenth century, as in fact a great many sculptures were. The inventories make it clear that sculpture circulated freely, and no conclusion about the villa's sixteenth century contents can be drawn on the basis of seventeenth century records. As a check of the early documents, Vincenzo de'Rossi's Dying Adonis, mentioned by Borghini as having been bought by Isabella Orsini for the Villa (Il Riposo, p. 597) and which remained there until late in the eighteenth century may be

identified with the "statue a giacere marma", evidently
part of a fountain, in the last inventory.

In a late eighteenth century inventory--around 1780--
of sculpture brought from Poggio Imperiale to the Boboli
Gardens is the following entry: (ASF. Fabbriche 191, Ins.
1, "Nota delle Statue, che sono state portate dalla Reale
Villa del Poggio Imperiale, e che si trovano attualmente
nel Luogo detta Palla-a-Corda". Statue cavate dal Cortile
nuovo. N° 3 Statue di marmo; una rappresentante una Donna.
Si dice, che questa sia della Scuola di Michelangelo. L'altre
due sono state lasciate presso l'Isola dalla porta Romana".)
The incompleteness and indefiniteness of the description
could be taken as a reflection of the statue's own thematic
indefiniteness, and it could have been ascribed to the school
of Michelangelo on the basis of its incompleteness. Since
the Venus almost certainly was at Poggio Imperiale it seems
that, as Keutner conjectured, it returned at this time to
Florence.

The foregoing argument has called into question the iden-
tification of the Venus with 2 Amorini with Vincenzo Danti's
Venus for the Palazzo Baroncelli mentioned by Borghini, and
it has shown that the Venus with 2 Amorini was at Poggio
Imperiale in the late seventeenth and all through the eigh-
teenth century. Another question which has been asked is
whether or not the "Palagio Baroncelli" mentioned by Borghini
is Poggio Imperiale. De Tolnay (Commentari, 1966, p. 324)
notes that there was a Palazzo Baroncelli in Via Lambertesca.

This does not seem to have belonged to the Baroncelli in
the sixteenth century, however, and much of the Baroncelli
holdings around the building were demolished long before
for the construction of the Loggia dei Lanzi. Since most
artistic commissions led in one way or another to the ducal
treasury, the most likely Baroncelli to have had dealings
with Danti was Tommaso Baroncelli, the Duke's maggiordomo,
who died of joy in 1569 when Cosimo returned from Rome after
his investiture as Granduke of Tuscany. While he lived,
the Baroncelli lived in the Palazzo Medici in Via Larga
(Cosimo Baroncelli, Cronica della Famiglia Baroncelli, Flo-
rence. Biblioteca Moreniana, Mss. Moreni, vol. 96, no. 1,
f. 4). It is unlikely that this would have been referred
to as the Palazzo Baroncelli.

There were, however, other Baroncelli properties.
An engraving for Scipione Ammirato (ASF. Carte Pucci 2. 27,
fig. 143) shows quite recognizably the church of San Leo-
nardo in Arcetri, and next to it the villa of San Leonardo.
Both bear Baroncelli arms. In front of the villa, on a
pedestal, stands a nude female figure which, if drawn at
all to scale, would be considerably larger than life size,
and would thus fit Borghini's description of Danti's Palazzo
Baroncelli Venus more precisely than the Venus with 2 Amorini.
The villa of San Leonardo belonged to the Baroncelli until
November, 1580, when it was sold to Vincenzo di Francesco
Lenzi del Nicchio by Maria, the widow of Francesco Baroncelli

(Lensi-Orlandi, Le Ville di Firenze, II, p. 82). Francesco
was the brother of Tommaso Baroncelli (G. Carocci, I
Dintorni di Firenze, II, p. 222). In any event, when the
genealogical tree of the Baroncelli was made, at about the
same time that Borghini's Il Riposo was published, San
Leonardo was certainly regarded as the Palazzo Baroncelli.
No trace of the statue depicted in the engraving remains
in situ, and I know of no similar statue with one arm
raised. (The engraving in the Carte Pucci has been mis-
placed since I saw it, and a drawing of an already crude
rendition (fig. 143) must suffice.) One wonders if
this Venus is not identical with "una Venere, parimente
di marmo, che fu messa altrove" mentioned by L. Pascoli
(Vite Moderni, p. 292, or, as he had it in his Vite Peru-
gini, p. 140, "altrove fu trasportata.") Like R. Borghini,
Pascoli deals with a marble Venus and the Santa Croce Madonna
in the same sentence. If this is more than a coincidence,
then, since Pascoli does not simply repeat Borghini, the
whereabouts of Danti's Palazzo Baroncelli Venus must have
been unknown in 1730.

The examination of the documentary evidence so far
suggests the following conclusions: 1) The Venus under
discussion was not at Poggio Imperiale in the sixteenth
century, although it was taken there by 1691; 2) the
Palazzo Baroncelli referred to by Borghini is not Poggio
Imperiale, and therefore Danti's statue was not made for
Poggio Imperiale and consequently; 3) there is no documentary

basis for the identification of the Venus mentioned by
Borghini and the Venus under discussion, and no document-
ary basis for an attribution of the figure to Danti.

Although another candidate has been put foward as
Danti's Venus described by Borghini, it does not mean that
Danti did not execute the Venus with Two Amorini, and the
problem has been approached from an entirely different
direction. C. de Tolnay has argued that the Venus is an
early work of Michelangelo adducing S. Fanti, Triompho
di Fortuna, Venice, 1527, p. 38 (fig. 124) as visual
evidence, and identifying it with "una figura abbozzata da
Michelangelo" recorded in catalogues of the collection of
the Uffizi in the eighteenth century. A figure of this
description was destroyed in a fire of August 12, 1762.
(G. Bianchi, Ragguaglio di Antichità e Rarità che si
trovano nelle Gallerie. . ., Firenze, 1759, p. 104;
"un marmo abbozzato per figurare una donna a cui (nono-
stante che nulla di certo rappresenti) fu dato luogo fra
le fin ora descritte oer esser lavoro del Buonarroti, e di
cui strapazzi ancora trovano giustamente venerazione fra
gli intendenti, per la maniera singlolare di quel gran
maestro nelle bozze medesime".) There is no doubt that the
figure was destroyed. (G. Pelli, Saggio Istorico della
Real Galleria di Firenze, Firenze, 1779, I, p. 404-5;
"perirono. . . sei statue (b. . . .un bozzo di Michelangelo
rappresentante una femmina nuda) and destroyed beyond repair
(. . .altri marmi rimasero fracassati ma si poternono rifarcire

This does not end the discussion, however, since there were originally two such statues, as we see in G. Cinelli, Bozze per le Bellezze di Firenze, FBN, Magli. XIII, 34, f. 203r and v.

Porta dl Corridore de Pitti. . .

Rimpetto la Porta. . .

Femmina abbozzata di Michelangelo (after the word Michelangelo is the note" 'ora nella Cappa di Sto L. fatta per una delle Nicchie."

f. 209r

Corridore da S. P. Scheraggio (from the Palazzo Vecchio) Trofei di Michelgo

.

Porta Sop.a le supplice (to the Pitti) Trofei di Michelag.o fatti p. la Capp.a di S. Lor.

f. 222v

Corridore da S. P. Scheraggio

Femmina abbozzata di mano di Michelangelo da q.ta banda med.a figura intesa per una (lacuna) e fu fatta per una nicchia dlla capp.a della Cappella o per dir meglio sagrestia nuova di (following crossed out: la gle si crede che per la Sagrestia nuova) di S. Lor.o ove stette molti anni fusse f(unreadable) e di poi fu qui trasportata. . .

Cinelli's notes are rough and repetitive, and it is not entirely clear that the two female figures are not the same. Their location provides the clue, however, which is

corroborated by the two trophies (now back in San Lorenzo, in the corridor to the New Sacristy, assigned to Silvio Cosini). One female figure and one trophy were put at the entrance ot the Gallery from the Palazzo Vecchio and the exit to the Pitti. Only one figure is listed in the later catalogues, which means that one of them must have been taken away. Perhaps it was taken to Poggio Imperiale, and since Cinelli wrote his Bozze after the publication of the Bellezze in 1677, it may have been taken there by 1691.

The argument thus leads to the conclusion that the Venus with Two Amorini is from the Medici Chapel. This tallies with another fact: the dimensions of the proposed allegories for the niches beside the Capitani which were to have been about 180 cm tall (M. Weinberger, Michelangelo the Sculptor, p. 350), the same size as the Venus with Two Amorini. This leads back to Niccolò Tribolo who in 1533 began one of these figures (see above, Chapter III, n. 83). His activity thereafter is uncertain, and the project was never carried to completion. At this point it is necessary to consider the statue itself, which is evidently the result of more than one carving. It has been noted that the method of treating the marble is Michelangelo's (F. Arnau, Three Thousand Years of Deception in Art and Antiques, London, 1961, p. 94 and fig. 9 provides a discussion of the statue based on the remarks of Procacci and others). But according to Vasari, Pierino da Vinci by 1554 had mastered this manner of carving to the degree that

his unfinished marbles were indistinguishable from those of Michelangelo (Vasari-Milanesi, VI, p. 131);and the Boboli _Slaves_ were to serve as examples for the members of the Accademia del Disegno (Vasari-Milanesi, VII, p. 273) Michelangelo's method of carving into the block was thus the object of academic scrutiny. Danti was one of the sculptors mentioned in Vasari's letter to Michelangelo on the proposed completion of the Medici Chapel by the members of the Accademia del Disegno.

Keutner's stylistic arguments relating the _Venus with Two Amorini_ to Danti are unconvincing; and the head and arms of the figure seem certainly to have been his. Still, the _Venus with Two Amorini_ is unusual in Danti's work; he did not for the most part copy Michelangelo's procedures, and was much more interested in a kind of graphic reformulation of the principles of Michelangelo's sculpture. Such an essay in Michelangelo's manner would not be surprising, however, especially if the figure had been begun in a similar way. Such a procedure would also have been sanctioned by the Accademia del Disegno. The argument, in short, would be that Danti, on stylistic grounds around 1563-1565 (and perhaps in conjunction with the Accademia project to complete the sculpture of the Medici Chapel) worked at a figure which had been begun by Tribolo, who is perhaps responsible for the torso. The putti do not seem to be Danti's, and perhaps the figure was transformed into a

Venus at a still later date, in the seventeenth century, by someone literally copying Michelangelo's tondi. The figure at which Danti worked was important for his later sculpture, and the type, with modifications, recurs in the Studiolo Venus and the Baptistry Herodias.

On this Venus type, studies by Michelangelo of female torsoes from classical modds in the Casa Buonarroti and the British Museum (identified as the type of the Aphrodite of Cnidos by J. Wilde, Michelangelo and his Studio , no. 44 and P. Barocchi, Michelangelo e la sua scuola, no. 69-70) have been connected with the Medici Chapel by Wilde; see also C. de Tolnay, "Sur des vènus dessinées par Michel-Ange" for a review of all the connected drawings. Drawings of complete figures by followers of Michelangelo such as Barocchi, 174recto and 243 recto have been connected with the figures which were to have flanked the Capitani in the Medici Chapel, by M. Weinberger, Michelangelo the Sculptor, p. 348-51 and further related to the Danae and Athena of the base of Cellini's Perseus. Barocchi, 243recto has been tentatively attributed to Ammannati by H. Keutner, "Die Bronze Venus des Bartolommeo Ammannati, Ein Beitrag zum Problem des Torso im Cinquecento", Munchner Jahrbuch der bildenden Kunst, XIV, 1963, p. 79-92.

XIV. MADONNA AND CHILD
 (fig. 42)

Location: Milan, Museo Archeologico

Dimensions: 12. 5 x 8 in. (32. 20 cm)

Description: marble relief

Date: c. 1564

Discussion: This little relief, hardly more than a sketch
on the surface of an oval piece of marble has drifted between
attributions to Pierino da Vinci and Vincenzo Danti. U.
Middeldorf, "Additions to the work of Pierino da Vinci,"
Burlington Magazine, LIII, 1928, p. 299-306 attributed it
to Pierino da Vinci, followed by E. Kris, "Zum Werk des
Pierino da Vinci, Pantheon, III, 1929, p. 94-98. W.
Gramberg, "Beitrage zum Werk und Leben Pierino da Vincis,"
Jahrbuch der Preuszichen Kunstammlungen, LIII, 1931, p. 266,
assigned it to Danti, noting the relationship to the Santa
Croce and Prato Madonnas. Gramberg also noted the pronounced
"anticlassical" qualities of the relief: the extreme elong-
ation of the Virgin and the vast, whimsically irrational
architectural construction behind. This is not characteristic
of Danti's style, and as Middeldorf points out in his argu-
ment, Danti preferred a grander manner than this reliefs
exhibits. In detail it resembles Pierino's Madonna and
Child with Saints formerly in the Museo Nazionale in Florence
(Alinari, no. 2704), itself a compound of figures from Lucas

van Leyden (<u>Virgil in the Basket</u>; <u>Esther and Ahasuerus</u>) and
the Christ Child from one of Michelangelo's drawings,
(Barocchi, <u>Michelangelo e la sua scuola</u>, no. 121) This
relief is, however, quite different from the Milan <u>Madonna</u>,
although it suggests a mode of procedure that may account
for its stylistic anomaly. The <u>Madonna</u> might be explained
as an essay in another manner, and it is possible that
Danti had Pierino in mind when he carved it. Danti's
graphic habits are clearly in evidence in the face of the
Virgin, the dry, broken folds of drapery and the polished
sleeves of the Virgin's robes which clearly recall the
portrait of Carlo de'Medici. It is also a variation on
one of the female figures in Danti's <u>Julius III</u> reliefs
(fig. 16). In degree of rather perverse refinement and
use of graphic detail, the Milan <u>Madonna</u> recalls another
oval relief in the Victoria and Albert Museum (J. Pope-
Hennessy, <u>Victoria and Albert Catalogue</u>, no. 515) which
has been related to Danti by Pope-Hennessy and which is
certainly by someone near him but clearly not by Danti
himself.

XV. MEDICI COAT OF ARMS WITH ALLEGORIES OF EQUITY
 AND RIGOR
 (figs. 43-47)

Location: Florence, Uffizi, Testata

Dimensions: over life-size

Description: Marble; two reclining figures, on the left an allegory of Rigor holding a short rod; on the right a female allegory of Equity holding, in her left hand, a bent plane symbolizing an architect's rule; beneath a shield with Medici palle.

Date: begun 1564, finished by September 1566

Discussion: The sculpture which was to adorn the Testata of the Uffizi was first mentioned in a letter from Giorgio Vasari, "architetto di quella fabrica" to Giovanni Caccini, the Proveditore of Pisa, on September 11, 1563 (Frey, Nachlass, III, p. 54). The marble had arrived in Florence by May 13, 1564 (Frey, Nachlass, III, p. 81) and the terms of the commission were sent to Cosimo I by the Proveditore of the Uffizi on June 7, 1564. They were approved by June 9 (Frey, Nachlass, III, p. 200). The figures were finished before the agreed upon eighteen months had passed, by September 11, 1566 (Frey, Nachlass, III, p. 200). Equity and Rigor were probably put up shortly after their completion, and were in place when Vasari wrote of them (Vasari-Milanesi, VII, p. 632). Danti made two attempts to complete the

group with statues of Cosimo I, one seated (Catalogue XVI),
and one standing (Catalogue XXVI). Since 1585, the group
has been topped by a standing portrait of the Granduke by
Giovanni Bologna. The chronology of the project is dis-
cussed by H. Keutner, "Über die Entstehung und die formen
des Standbildes im Cinquecento," Münchner Jahrbuch der
bildenden Kunst, VII, 1956, p. 148-50 and U. Dorini,
"Come sorse la fabbrica degli Uffizi", Revista Storico degli
Archivi Toscani, V, 1933, p. 35. An unappreciative
criticism of the group is given by R. Borghini, Il Riposo,
Florence, 1584, p. 65-66. Style and iconography of the
two allegories are given in Chapter III above.

XVI. "PERSEUS"
(figs. 48-50)

Location: Florence, Boboli Gardens

Dimensions: base 34 x 31 in. (84. 5 x 77 cm)

Description: marble; the figure's right arm is a separate piece of stone, and the left hand has been joined at the wrist. It is partly supported by the original block to which the legs, head, and wings of the dragon have been grafter, carved of another stone. It seems that there was a figure at the foot of the figure in Danti's scheme since a claw clutches the edge of the base. The lumpy form on the right may originally have been a small female torso, similar to that at the foot of the Onore, the head of which has been cut away and changed to stylized stones.

Date: 1568

Discussion: This figure was to have topped the Uffizi Testata group (fig. 44 and Chapter III above) according to the first project, and should be identified with "la statue d' esso signore Duca, maggiore assai del vivo di cui ha fatto un modello; la quale va posta a sedere sopra detta arme per compimento di quella opera," mentioned by Vasari (VV, p. 632). It was finished in 1577 at Pratolino (Gaye, Carteggio, III, p. 402. Niccolo Gaddi to Cavalier Serguidi, November 23,1577 "havessi tenuto gli huomini a lavorare spora la figura a sedere che

fece Vincentio Perugino, la quale è a bonissimo termine.")
This "figura a sedere" was identified with Michelangelo's
Cupid in the Victoria and Albert Museum (J. Pope-Hennessy,
Victoria and Albert Catalogue, no. 482) until 1958 when it
was correctly identified as the figure under discussion by
Keutner (Burlington Magazine, LXXXIII, 1958, p. 425).
Keutner assumes that the statue was a Perseus begun at
Pratolino by Danti and that it was left incomplete when he
left Florence in 1573. Its correspondence with Vasari's
description, however, seems convincing. James Holderbaum
(in a letter) had also concluded that it was the figure
mentioned by Vasari which "had been cut to pieces". The
figure is described in its position at Pratolino by C. da
Prato, Firenze ai Demidoff-Pratolino e S. Donato, Relazione
Storica e Descrittiva, Florence, 1886, p. 239. "Dall'Orsa
proseguenda dell'altro verso mezzo-giorno, andiamo fino alla
Fontana del Perseo, che consiste in un monte grazioso, fatto
anche questo spugne, contornato da balustri e da sedili di
pietra. Al di sopra di una nicchia che riceve l'acqua, sta
un serpente di diaspro il quale sostiene la statua del greco
eroe che è di marmo bianco." On the program at Pratolino see
L. Berti, Il Principe dello Studiolo, Florence, 1967, p.
85-108. It is described in its present position in the
Boboli Gardens by Soldini, Descrizione del Giardino Reale
detto di Boboli, Florence, 1789, tav. XXXII, p. 80. The
figure was published without attribution by B. Wiles, Fountains
of the Florentine Sculptors, fig. 163.

XVII. VIRTUE TRIUMPHANT OVER VICE
 (fig. 51)

Location: Florence, Museo Nazionale

Dimensions: 11. 8 in (31 cm)

Description: terracotta modello,severely broken and
repaired.

Date: c. 1560

Discussion: The attribution of this modello to Vincenzo
Danti has never been questioned. A. E. Brinckmann, Barock-
Bozzetti, I, p. 64-65 considered it to be a preliminary
study for the Onore che vince l'Inganno (Catalogue IX) of
1561. A Venturi (Storia, X, 2, p. 515) and J. Pope-Hennessy,
(Italian High Renaissance Sculpture, III, p. 77) consider
it a later variant made in preparation for a bronze statuette
in the Museo degli Argenti (See Appendix I). Most interest-
ing is the suggested possible connection of the group to
the catafalque of Michelangelo. (R. and M. Wittkower, The
Divine Michelangelo, p. 162, n18) As Wittkower notes, the
lower figure in the modello is an allegory of Deceit and
is therefore related to the marble in the Museo Nazionale.
The openness of the composition relative to the marble
version of the theme seems explainable by its formal deriva-
tion rather than by the hypothesis that it is a later con-
ception. The figure of Virtue is a direct transposition of

Pierino da Vinci's <u>Samson</u> <u>and</u> <u>the</u> <u>Philistine</u>. (See also a drawing in the British Museum by a late follower of Michelangelo identified as a drawing of the River God model now in the Casa Buonarroti in Florence. (J. Wilde, <u>Michelangelo</u> <u>and</u> <u>his</u> <u>Studio</u>, no. 104) This drawing bears a remarkably close resemblance to Pierino's figure particularly if the right leg is modified as suggested by the few lines which made it straighter and apparently capable to bearing weight. The <u>Onore</u> was related to Michelangelo's <u>River</u> <u>God</u> by A. Gottschewski, "Ein Original Tonmodell Michelangelos," <u>Münchner</u> <u>Jahrbuch</u> <u>der</u> <u>bildenden</u> <u>Kunst</u>, I, 1906, p. 58) If this is true, then the modello is an important record in the conception of Danti's <u>Onore</u> group, beginning with Pierino's <u>Samson</u> <u>and</u> <u>the</u> <u>Philistine</u> (to which it is still related even in the final marble version) and progressing to its final solution fusing this model with that of another Michelangelesque example.

The care with which the statuette is related to the space created by its square base--just as was done with the marble--suggests that it is a study for the same group. The modelling and anatomy also are perfectly consistent with the torsoes of the <u>Brazen</u> <u>Serpent</u> relief of 1559.

Danti's <u>modello</u> was dashed to bits in the flood of November 1966, and has since been restored. On the restoration see <u>Pantheon</u>, XXVI, 1968, p. 148-50.

XVIII. MADONNA AND CHILD
 (Figs. 53-59)

Location: Florence, Santa Croce

Dimensions: H. 83.8 in (2.13 cm) without base; original
base is encased in later base. Base height 5.9 in. (15 cm),
width 23. 2 in. (59 cm), depth 23. 2 in. (59 cm); total
height including base 89. 75 in. (2.28 m.).

Description: Marble; despite the square block from which the
group seems to have been cut, the width of the figure of the
Madonna is far out of proportion to the depth, and the back
of the figure was left unfinished.

Date: c. 1567

Discussion: A Madonna and Child no doubt identical with the
present group was first mentioned by Vasari in Danti's bio-
graphy (Vasari-Milanesi, VII, p. 631) "Ha anco fra mano, e
condotta a benussumo termine una Madonna di marmo, maggiore
del vivo, ritta, e col figiulo Gesù di tre mesi in braccio,
che sarà cosa bellissima; le quali opere labora, insieme con
altre, nel monasterio degli Angioli di Firenze. . ." Although
Vasari ends his remarks in the future tense, it seems likely
that he was describing a group which was nearly completed.
Vasari specified no destination for the Madonna and Child,
and perhaps it was done without a commission. Presumably it
went some years later to the Archbishop's Palace where it

seems to have been when Borghini wrote (<u>Il Riposo</u>, p. 521)
"E nell Arcivescovado di Firenze una Vergine alta quattro
col figliuolo il collo". The dimension given (4 braccia
or about 88 inches) is almost identical with the dimensions
of the group now in Santa Croce. Possibly Danti's statue
was left in his shop in Santa Maria degli Angeli when he
left Florence in 1573, and loaned to the Archbishop's
Palace, later to be returned. Whatever the case it does
not appear in early descriptions of the palace, and was next
mentioned in connection with Santa Maria degli Angeli. (F.
Moisè, <u>Santa Croce di Firenze illustrazione storico artist-
ica</u>. . .<u>con note e copiosi documenti inediti</u>, Florence,
1845, p. 150-1: "La famiglia Giugni, attual patrona, ha
pur dato un posto in questa cappella a una Madonna col
Figlio, gruppo in marmo di Vincenzo Perugino, ma non finito.
Era già questo gruppo nel convento degli Angioli, alla
soppressione ne fu levato dai Giugni che n'erano i pro-
prietari e condotto alle loro case; ora l'hanno fatto qui
collocare a spese dell'Opera, crescendo in questo modo i
tesori del nostro tempio.") It has been suggested by
F. Kriegbaum (in E and W. Paatz, <u>Die Kirchen von Florenz</u>,
I, p. 559, n297, that the <u>Madonna and Child</u> was once over
the main portal of the Duomo, identifying it with the Madonna
shown in a sixteenth-century drawing of the facade of the
Cathedral and in one of Giovanni Bologna's Salviati Chapel
reliefs. The Madonna shown in the drawing and in the relief
seem smaller than Danti's <u>Madonna</u>; but the argument—since

there is no evidence either for or against it--is difficult
to put completely aside, especially since the <u>Madonna</u> <u>and</u>
<u>Child</u> is done in the severe, archaizing style of the Prato
<u>Madonna</u> and the monument to the Beato Giovanni da Salerno
in Santa Maria Novella. Why a position on the facade of
the Duomo would make the statue's "silent tribute to
Michelangelo. . .all the more significant" as observed
by C. Eisler, "The Madonna of the Steps," p. 116 n7,
is not clear.

XIX. DECOLLATION OF THE BAPTIST
 (figs. 60-64)

<u>Location</u>: Florence, Baptistry, south portal

<u>Dimensions</u>: Figure of <u>Herodias</u>, 95. 7 in. (243 cm) in-
cluding base; <u>St. John the Baptist</u>, 64. 7 in. (164. 2 cm);
<u>Executioner</u>, 105. 5 in (268 cm)

<u>Description</u>: Bronze; on the base of each of the statues are
small reliefs representing, from the left, Lust, under
Herodias; the three theological virtues, under <u>St. John
the Baptist</u>; and Intemperance, under the <u>Executioner</u>.

<u>Date</u>: Casting of the figures began after July 5, 1570; the
third figure was cast by December 9, 1570; the group was
set in place on the 15th or 16th of June 1571, and was
unveiled June 22 of that year.

<u>Discussion</u>: Danti probably began work on the <u>Decollation</u>
group for the south door of the Baptistry in 1569 after
he had completed the marble <u>Baptism of Christ</u> begun by
Andrea Sansovino. The Baptism group (Catalogue XXXIX)
was placed over the east door of the Baptistry and unveiled
on June 23, 1569. The documentation of the <u>Decollation of
the Baptist</u> is sparse owing to the destruction by fire of
the archives of the Arte dei Mercatanti--the traditional
patron of the Baptistry--in the 18th century. (See R.
Krautheimer, <u>Ghiberti</u>, Princeton, 1956, p. 362 on the

history and state of the records of the guild). None of
the surviving notices, extracted by Carlo Strozzi from the
records of the guild prior to their destruction, dates
before 1570. With the exception of Document no. 5, all
of the notices below are taken from Strozzi's abbreviated
version.

Documents no. 3, 6, and 8 were published by O.
Scalvanti, "La cittadinanza fiorentina conferita a Vincenzo
Danti,"; documents 2a and 6a were published in Frey-Vasari,
I, 1911, p. 349 and by J. Pope-Hennessy, Italian High
Renaissance Sculpture, III, p. 77. Documents 1,2, 4, 5,
and 7 have not been published.

Document no. 1: ASF. Carte Strozziane, serie II°,
LI, vol. I (Fatti e Memorie dell'Arte dei Mercatanti),
f. 109r. "22 Giugno 1570. l'Arte de Mercatanti propone
di vender il sito vecchio della sua residenza perche il
nuovo incontro alla Zecca era quasi in grado di tornarvi
e per potere supplire alla spese delle tre figure di bronzo
che si facevano per porre sopra la porta di. S. Gio. che
guarda verso la Misericordia, e S. E. rescrive che per
ancora non lo venda."

Document no. 2: Ibid., f. 109r. "5 luglio 1570.
Statue tre di bronzo che si facevano da Perugino per mettere
sopra la porta di S. Giovanni, che guarda verso la Miseri-
cordia, si gettano, dove lavora l'Ammannato e Gio. Bologna,
e non negli Angioli dove voleva il Perugino."

Document no. 2a: Carte Storzziane, series II°, LI,

vol. II, f. 116v. "Statue tre di bronzo che si facevono dal Perugino per mettere sopra la Porta di. S. Gio. che guarda verse la Misericordia si gettano dove lavora l'Ammannate e Gio Bologna 1570. Fa dal 1564 al 1573.

This an document 6a below which appear together and without precise dates are probably Strozzi's notes on the fuller transcriptions to which they are here appended. The last line of these documents has nothing to do with the dates of the program itself and refers to the dates covered by the volume from which the documents were excerpted. See Carte Strozziane, II°, LI, I, f. 107r. where the following title is given: "Filza de consoli dell'arte de Mercatanti di Suppliche e altro dal 1564 al 1573."

Document no. 3: Carte Strozziane, Serie II°, LI, vol. I, f. 343v. "15 Dicembre 1570. Figure tre di bronzo, si pagha M. Vincenzio Danti scudi 4 per settimana per che ritenga quattro huomini di continue a lavorarvi."

Document no. 4: Ibid., f. 341r. "18 Dicembre 1570. Figure tre di bronzo che vanno sopra la porta di. S. Giov. fatte fare per ordine del Gran Duca si paghano."

Document no. 5: ASF. Art dei Mercatanti, "Deliberazione e Partiti de Consoli, 1567-70", f. 33v. "18 Dicembre 1570. A spese depera di S.to Giovannj. . .spesi per infine a d°. di per le tre figure di Bronzo che vanno sopra la porta di Sto Giovannj fatte ci fare per ordine del Gran' Duca come per sue benigniss° Rescritte appare in filza di iustificazione. . ."

Document no. 6: Carte Strozziane, serie II0,LI, vol. I, f. 109v. "21 luglio 1571. Vincenzo Danti perugino scultore a che per ordine di S. E. s'erano date a fare le tre Statue di bronzo da mettersi sopra la porta della chiesa di S. Gio. verse la misericordia, havendole finite, domanda per sue fatica e spese, non comprese il metallo, scudi 500 dell'una, il Provveditore dell'Arte glie ne vuole dare scudi 300, ma datone conto a S. E. I. ordina che se li paghine 400 l'una."

Document no. 6a: See Document 2a above. "Statue tre di bronzo sudo fatte per Vincenzio Danti Perugine Scultore si pagano scudi 400 l'una la fattura solamente. 1571 fa dal 1564 al 1573."

Document no. 7: Carte Strozziane, serie IIO, LI, vol. I, f. 344r. "1 Agosto 1571. Architrave che va sopra la porta di S. Giov. dove sono le tre figure di bronzo, si paghi y 28 la settimana a MO Aless$^O_.$ del Lastricate per do conte."

Document no. 8: Ibid., f. 344r. "4 Agosto 1571. Tre figure di bronzo che sono sopra la porta del Battistero di San Giovanni si paghine a M. Vincenzo Danti scudi 1200 a tutte sue spese dal bronzo in fuori."

Casting of the figure must have been begun shortly after the decision had been made as to where the figures should be cast, July 5, 1570 (Document no. 2). The third and last figure was cast by December 9, 1570 (Frey, Nachlass, II, p. 548; ". . . Et per non melo sdimenticar', il Perugino

gitto la 3^a et ultima statua e tutto e venuto bene.")
They were set up and unveiled in June of the following
year. (See J. Pope-Hennessy, <u>Italian High Renaissance</u>
<u>Sculpture</u>, III, p. 77 for a review of the sources; the
unveiling of the group was recorded by A. Lapini, <u>Diario</u>
<u>Fiorentino</u>, June 22, 1571. "A' di 22 giugno 1571, in venerdi,
che fu l'antivigilia di San Giovanni Battista, a ore 23 in
circa, si scoperse quella decollazione di S. Giovanni
Battista, di bronzo che è sopra la porta di detto S. Gio-
vanni, che guarda verso Mercato Vecchio, condotta e fatta
per mano di Vincenzo Perugino. Ritornossi su a' di 15 e
16 di detto mese, ma si scoperse poi a' di 22 com' è detto.")

The question of whether or not Danti was given
Florentine citizenship for his successful completion of
the group is considered and answered in the affirmative
by O. Scalvanti, "La cittadinanza fiorentina conferita a
Vincenzo Danti," The tabernacle is discussed in a general
review of the published sources by Paatz, <u>Kirchen</u>, III, p.
197, 245.

Terra cotta reliefs in the Kaiser-Fredrich Museum,
Berlin, measuring 6.7 in x 11.8 in (17 x 30 cm.), almost
the same dimensions as the present socle reliefs, and iden-
tical with them in theme, have been catalogued as "after
Vincenzo Danti" by F. Schottmüller, <u>Bildwerke des Kaiser-
Friedrich-Museums</u>, I, Berlin-Leipzig, 1933, nos. 2613-5.
The reliefs, which were bought in Florence in 1901, are
probably correctly considered to be <u>bozzetti</u> for the

socle reliefs by A. Brinckmann, <u>Barock-Bozzetti</u>, I,

p. 66-67.

XX. ST. LUKE
 (fig. 65)

Location: Arezzo, Pinacoteca

Dimensions: 13 in. (32. 5 cm.) including base

Description: terra cotta

Date: 1570

Discussion: This figure has been published by L. Berti,
Il Museo di Arezzo, Rome, 1961, p. 36, ill. p. 48 where
it is given without supporting argument to Vincenzo Danti.
There seems to be no reason to question its being a modello
for Danti's firmly documented St. Luke in the Cappella di
San Luca in Santissima Annunziata in Florence (Catalogue
XXI).

XXI. ST. LUKE
 (fig. 66-68)

Location: Florence, Santissima Annunziata, Capella di San
Luca

Dimensions: Height: 68 in. (1. 73 m.)

Description: Clay painted white, cemented in a niche.
Recently restored at the bottom after the flood of 1966

Date: Begun before December 20, 1570; complete by June
9, 1571

Discussion: It has been known that Vincenzo Danti executed
the St. Luke in the Cappella di San Luca in Santissima
Annunzuata since 1873. (C. I. Cavallucci, Notizie storiche,
p. 105-106; also G. Ticciati, Storia della Accademia del
Disegno, in Fanfani, Spigolatura Michelangiolesca, p. 193-
307; and Paatz, Kirchen, I, p. 118) The figure first
entered the list of Danti's work in 1958 (H. Keutner in
Burlington Magazine, C, 1958, p. 247, n5). A photograph
of the St. Luke was not published, presumably because of
the documentary snarl surrounding the chapel. This is
untangled in my forthcoming article ("The Sculptural
Program of the Cappella di San Luca in Santissima Annunziata,"
Mitteilungen des Kunsthistorischen Instituts in Florenz)
and it seems certain that Danti modelled the figure now oc-
cupying the niche of St. Luke. The following documents

provide the necessary information:

ASF. Arti. Entrata e Uscita, f. 116r.

E a di 20 di dicembre (1570) per libre octo di
cimatura lire una e soldj sei e dj 8 la quale se mando
a M. Vincenzo danti da perugia per fare la fiura che va
nel capitolo de frati de servj: y 1. 6. 8

E per libre dua di spajo per decta fiura soldj
quatordici a decto M. Vincenzio Dantj: y 14

E per libre 25 di sieno per decta fiura soldj undicj
et dj 8 a decto M. Vincenzio: y 11 8

E per 12 some di terra che porto atalante renaiolo
a M. vincenzo per fare decta fiura lire una soldj sei dj 8.

Similar documents, bearing the same date, are to
be found in ASF. Arti, Libro del Proveditore, "E", f. 60r.
In addition, Libro del Proveditore, "E", f. 63v.

A di 9 detto (9 June 1571)

Una Poliza a franc° Cammillanj per paghi a dua dj
pintorj, e quali dettano di bianco alla sua figura ('il
perugino' written in above) cioe il santo luca fatto nel
capitolo della nunziata e il gesso di loro.

Also ASF. Arti. Accademia del Disegno. Entrata
e Uscita, f. 118v.

A di 9 di giugno (1571)

E a dua di pintori che detono di biancho alla fiura
di M. Vincenzio perugino cioè al san luca fatto nel capitolo
della nunziata: 1. 6 8

A small modello for the St. Luke is in the Pinacoteca
in Arezzo. See Catalogue XX.

XXII. SEATED PORTRAIT OF COSIMO I AS JOSHUA
 (fig. 69)

Location: Florence, Santissima Annunziata, Cappella di
San Luca

Dimensions: Height 72 in. (182. 5 cm.)

Description: clay painted white, cemented in a niche,
recently restored after the flood of 1966 damaged the bottom
of the statue

Date: c. 1571

Discussion: This figure was first attributed to Giovanni
Bologna (Paatz, Kirchen, I, p. 119). The figure of Joshua
in the Cappella di San Luca was originally assigned to Zanobi
Lastricati, who was probably substantially responsible for
its execution if not for its conception. For a complete
assessment of Danti's responsibility for the figure and its
identification as Joshua see my forcoming article, "The
Sculptural Program of the Cappella di San Luca in Santissima
Annunziata" in the Mitteilungen des Kunsthistorisches
Instituts in Florenz, and above Chapter IV, p.

XXIII. MONUMENT TO THE BEATO GIOVANNI DA SALERNO
(fig. 70)

Location: Florence, Santa Maria Novella

Dimensions: width 100 in (2. 5 m)

Description: marble with some modern restorations in
plaster. It bears the inscription: CORONA AVREA SVPER
CAPVT EIVS

Date: c. 1571

Discussion: The original monument to the Beato Giovanni
da Salerno, the founder of the Dominican chapter of Santa
Maria Novella, who died in 1242, was destroyed around 1565
when Vasari redecorated the church. The present monument
was described by F. Bocchi (Le Bellezze di Firenze, Florence,
1591, p. 120) as under the organ in the second bay of the
right aisle (from the crossing). It stayed there until
the second half of the nineteenth century (Paatz, Kirchen,
III, p. 703, n185). It was then placed in the Rucellai
Chapel and was finally put in its present location (Paatz).
The relief is a pendant to Bernardo Rossellino's Monument
to the Beata Villana. The date, 1571, given by Bombe,
Thieme-Becker, VIII, p. 385 refers to an 1836 edition of
a guide to Santa Maria Novella by V. Fineschi which I have
not been able to consult. No mention is made of the date,
nor is any documentation mentioned in V. Fineschi, Il For-
estiero Istruito in S. Maria Novella di Firenze, Florence,

1790, p. 36. There is, however, an attribution to
Vincenzo Danti. "L'altro Altare poi è una piccola
Cappellina, che una volta era il luogo del deposito del
B. Giovanni da Salerno, vedendosi, ancora una statua
giacente di bassorilievo di marmo, lavorato da Vincenzo
Danti Scultore Perugino. . . "

The style of this ugly monument is clearly Danti's,
and seems to be better explained as a further extension of
the manner of the Santa Croce and Prato Madonnas toward
an extreme archaization as suggested by C. Eisler, "The
Madonna of the Steps,"p. 116, than by the hypothesis
that it is a workshop product, (Paatz, Kirchen, III, p. 703)

XXIV. VENUS ANADYOMENE
 (figs. 71-73)

Location: Florence, Palazzo Vecchio, Studiolo of Francesco
I.

Dimensions: 38. 6 in. (98 cm.)

Description: bronze statuette

Date: 1572-1573

Discussion: The Studiolo of Francesco I was begun in 1570
on a program by Vincenzo Borghini (Frey, Nachlass, II, no
DCCXLVIII, letter of August 29, 1570; and A. del Vita,
Lo Zibaldone di Giorgio Vasari, p. 150-163). The bronzes
were removed, and in the seventeenth century, were at Poggio
Imperiale (ASF, Guardaroba 991. Inventory of Poggio Imperiale,
1691, f. 39) The Studiolo was reassembled by G. Poggi,
"Lo Studiolo di Francesco I in Palazzo Vecchio," Il Marzocco,
December 11, 1910. A general history of the Studiolo is
provided by A. Lensi, Il Palazzo Vecchio, Milan-Rome, 1929
p. 231-241) and the scheme is summarized by M. Buccio,
Lo Studiolo di Francesco I, Forma e Colore, Florence, 1965
and L. Berti, Il Principe dello Studiolo, Florence, 1967,
p. 61-84.

 The Venus Anadyomene has been attributed to Elia
Candido (Alinari files) and to Bartolommeo Ammannati (Venturi,
Storia, X, 2, p. 428, Mostra del Cinquecento Toscano, 1940)

Documentary clarification of the bronzes in the Studiolo was
first made available by H. Keutner, "The Palazzo Pitti
'Venus' and other works by Vincenzo Danti," Burlington
Magazine, C, 1958, p. 428. From the documents Keutner
published we know the names of seven of the eight masters
who took part in the project between 1572 and 1575:

> Giovanni Bandini--Feb. 1572 to Aug. 1575: Juno
>
> Giovanni Bologna--Dec. 1573 to Apr. 1575: Apollo
>
> Elia Candido-- June-August 1573: Aeolus
>
> Domenico Poggini--February 1572 to July 1573: Pluto
>
> Stoldo Lorenzi--Agusut 1573: Galatea
>
> Vincenzo de' Rossi--July-September 1572: Vulcan

Two statuettes are unaccounted for, Venus and Ops, but
only one more artist is mentioned in the documents, Bartolo-
mmeo Ammannati. H. Keutner was the first to attribute the
Venus to Danti, arguing that the Ops, formerly attributed
to Andrea Calamech (who left Florence for good in 1564) should
be reassigned to Ammannati, leaving the Venus for Danti, who
although he is not named in the documents was the other
major sculptor in Florence at the time, and would probably
not have been passed by in allotting the commissions. Keutner
connects the bronze with the statement in Pascoli (Vite
Moderni, II, Rome, 1730, p. 292) that Danti made a "Venere
in atto di rilegarsi le trecce." This attribution is accepted
by J. Pope-Hennessy, (Italian High Renaissance Sculpture, III,
pl. 78, p. 78-79) If Danti's execution of the bronze followed
the pattern of the other sculptors the Studiolo Venus would be
one of his last works in Florence.

XXV. RESTORATION OF DANCER ADJUSTING HER SANDAL
(fig. 74)

Location: Florence, Uffizi

Dimensions: 40 in., 31 in. without restorations (1.01 m; .79 m)

Description: Roman copy in Pentelic marble after a Hellenistic statue to which the head and neck, right hand, left knee, foot and ankle and the front part of the base have been restored.

Date: c. 1568

Discussion: This attribution must be made on the basis of style and reference in the documents to marble for "four heads" to be carved by Vincenzo Danti (Chapter V. note 18 above). The head of the figure (fig.74) is comparable to the Studiolo Venus (fig. 73) and the almost Rococo prettiness of the Dancer is an ingredient in the Santissima Annunziata St. Luke (fig. 68). The faceted carving of the hair is unusual in Danti's work, but may simply be the result to adaptation of his style to the problem, being a "state of relative completion which would conform to the condition of the lower part", as noted by J. Pope-Hennessy in the case of the Cupid in the Victoria and Albert Museum, which was probably restored by Valerio Cioli. (Victoria and Albert Catalogue, no. 482) On the statue itself see G. A.

Mansuelli, _Gallerie degli Uffizi_: _Le Sculture_, Rome, 1958,
I, no. 52. Mansuelli identifies it with a statue in the
Pitti mentioned by Vasari in 1568, "Femminetta a sedere
vestita dal mezzo in giù in atto di rimettersi una scarpa".
The _Satyr_ who complements the _Dancer_ (Mansuelli, no. 51)
was skillfully restored by a "follower of Michelangelo"
although since they were not recognized in the Cinquecento
as belonging to the same group, the two statues need not
have been restored at the same time.

XXVI. STANDING ALLEGORICAL PORTRAIT OF COSIMO I DE'MEDICI
(figs. 75-79)

Location: Florence, Museo Nazionale

Dimensions: H. 110. 2 in., W. 30. 7 in., D. 29.1 in.
(280 x 78 x 74 cm)

Date: c. 1572-1573

Description: Marble, recently cleaned after the flood of
1966 had stained the marble. The figure holds a shield
on which there is a capricorn

Discussion: This is the second statue of Cosimo I which was
to have finished the Uffizi Testata group (see above Catalogue
XV and Chapter III) following the abandonment of the seated
figure now in the Boboli Gardens (Catalogue XVI). The
stone for the present figure was probably that quarried in
June of 1568 (Gaye, Carteggio, III, p. 250-51):"uno pezzo
di 5 br., grosso 2 e largo 2, che nescie la fiura che debbe
fare Vincenzo Danti Perugino per i Magistrati". All docum-
entary references to the project after this date must
refer to the statue under discussion and not its seated
predecessor, since the stone seems clearly to be for a
standing figure, and since the measurements (5 braccia
equals c. 110 in.) almost perfectly coincide. The marble
stood in Danti's shop in San Piero Scheraggio, awaiting
the Duke's decision that work on the project should continue,

by August 9, 1570 (Frey, Nachlass, III, p. 203-04) A
letter from the Proveditore of the Uffizi to Cosimo de'Medici
dated September 7, 1570 (Frey, Nachlass, III, p. 204)
gives the results of an appraisal of the project made
by Giovanni Bologna, Vincenzo de'Rossi, Battista Lorenzi,
and Francesco da Sangallo. The estimate for the "statua
grande" was made on the basis of the model, "non sendo fatto
la statua". It was estimated that it would take eighteen
months to complete it. As the sculptors mentioned, Danti
was at that time at work on the Baptistry group, which must
have been occupying most of his time, since the last figure
was cast three months later (Catalogue XIX). It does
not seem that Danti could have begun to work in earnest on
the statue until after June 1571 when the Baptistry group
was completed. In this case, Cosimo I could not have
been finished before early 1573, assuming that the sculptors'
estimate of time required to carve it was correct. It is
not certain when the statue was put up, but Giovanni
Bologna was at work on a statue to replace in by 1581.
(H. Keutner, "Über die Entstehung und die Formen des
Standbildes im Cinquecento," Münchner Jahrbuch der Bild-
enden Kunst, VII, 1956, p. 148-150) A. Lapini, Diario
Fiorentino, p. 239-40 describes the location of Giovanni
Bologna's figure on February 11, 1585 and it s unveiling on
March 23, but he makes no mention of Danti's statue. R.
Borghini (Il Riposo, Florence, 1584, p. 587-88)wrote that
"di marmo ha (giovanni Bologna) sculpito il gran Duca Cosimo,

che si dee porre agli Vffici nouvi donde fu levato quello
di Vincentio Danti Perugino." F. Baldinucci (Opere,
Florence, 1808-1812, VIII, p. 117) also mentions that Danti's
statue was taken down, apparently basing his story on
Borghini. "Fece (Giovanni Bologna) poi con suo scarpello
la grande statua del Granduca Cosimo Primo in testa agli
Uffizj nuovi fra le due statue giacenti, una rappresentata
per l'Equità, l'altra per lo Rigore; essendo prima stata tolta
via quella di Vincenzo Danti Scultor Perugino".

 W. Bombe, Thieme-Becker, VIII, p. 386 stated that
the figure of Cosimo I stood in the Salone dei Cinquecento
before being moved to its present location in the courtyard
of the Bargello. See Bocchi-Cinelli, 1678, p. 90 "Vi è
anche sceso la scalinata ove tutte queste sono collocate
in primo luogo una statua a sedere che rappresenta Cosimo
I del Bandinelli: vi è anche una Femmina effigiata per una
Vittoria, che conculca l'inganno o l'tradimento (a mis-
taken identification of Giovanni Bologna's Florence Tri-
umphant over Pisa) ed una statua che rappresenta D. Gio.
Medici Padre di Cosimo ambedue mano di Vincenzo Danti Per-
ugino." This misidentification was followed by Richa, Le
Chiese di Firenze, Florence, 1761, II, p. 25 but was re-
pented of by Cinelli, Bozze per le Bellezze di Firenze,
FBN. Magl. XIII, 34, f. 42v. "Salone dei Cinquecento.
Giovanni Padre di Cosimo p.° in abito militare col baston
di comando in piedi di mano di Vincenzo Danti Perugino, benche
a mio credere anzi Cosimo giovanetto rappresenti, avendo nello

scudo il Capricorno con le stelle ritrovate nel suo
nascim.to è ripigliando dell'altra parte sotto la storia
che la rotta di Marciano esprime. . ." The figure is
given to Domenico Poggini by A. Venturi, _Storia_, X, 2, p.
273, although it is also discussed among Danti's works, p.
509-527.

XXVII. SCULPTURE FOR THE DELLA CORGNA CHAPEL (lost)

Location: Perugia, San Francesco al Prato

Date: 1555-1557

Discussion: On may 24, 1555 Ascanio della Corgna and Master
Giovanni di Domento da Settignano agreed to the terms for
the chapel of San Andrea in the church of San Francesco al
Prato (ASP. Arch. Not. Francesco Patrizzi, 1555, f. 772-
773)

Document no. 1: "In prima sonno da cordo le dicte
parte chel detto Mastro Giovann' sia tenuto e obbligato a
tenere suoi opre fatighe et spese' fare' fabricare construire'
erigere et edificare la detta capella secondo il modello a
disegno ch' li dara Mastro Jacomo barozzi detto il Vignola
bene diligentemente et legalmente ad uso di bono et legal
Mastro in fra tempo de uno anno proximo da venire qual
capella debba essere finita conpiuta et perfecta di ogni et
qualunche' cosa in tucto et per tucto exo et pro ch' di
pictura et di auratura. . .Item. Sonno da cordo le dette
parte chel detto Mastro Giovanne non sia tenuto di fare
due statue quali siranno nel modello e disegno di la detta
capella. . ."

The sculptures must have been given to Danti shortly
after this date. Almost exactly two years later Danti's
father accepted payment for the figures. (Arch. Not. Francesco

Patrizzi, 1557, f. 576, May 18, 1557)

Document no. 2: ". . . magistro Joanni Dominici da
Settignano dominii florentini presentii stipulanti et
recipienti pro se et suis heredibus, de scutis viginti ad
rationem XX grossorum pro quolibet scuto eidem Vincentio
debitis per dictum magistrum Joannem quarundarum figurarum
per dictum Vincentium factarum ad instantiam dicti magistri
Joannis in et super capella illustrissimi domini Ascanii
Cornei di Perugia, situata in ecclesia sanct. Francisci
de conventu civitatis Perusiae. . ."

W. Bombe, Thieme-Becker, VIII, p. 382 cites Simonis
Silvestris, f. 576. The name of this notary appears on
the second page of the document, and is apparently the name
of the notary to whom the original agreement was made. I
was unable to find this notary. The reference to the Vignola
document and the payment to Giulio Danti was published in
the Bolletino della Regia Deputazione di Storia Patria per
l'Umbria, XXIX, p. 14.

Danti's work in the chapel is mentioned by L.
Pascoli, Vite Moderni, I, p. 290; "ed a concorenza di
Ferrante dal Borgo, altre ne eresse nella cappella di S.
Andrea in S. Francesco de'Frati conventuali." Who Ferrante
dal Borgo might be, I have been unable to determine. Only
passing mention of the chapel is made by O. Gurrieri, Il
Tempio di S. Francesco al Prato e l'Oratorio di San Bernar-
dino in Perugia, Perugia, n. d., p. 14-15; and V. Ansidei,
La Chiesa di S. Francesco al Prato in Perugia, Città di

Castello, 1925, p. 22. It would seem that the statues, which are no where described in the notarial documents might have been marble statuettes. The chapel, however, is described in the following terms by C. Crispolti, _Perugia Augusta_, Perugia, 1648, p. 139: ". . . gli ornamenti di stucco di detta cappella sono di Lodovico Scalza da Orvieto; le statue di rilievo, parte sono di Vincenzo Danti Perugino, parte di Ferrante dal Borgo. . ."

XXVIIa. CASTS AFTER MICHELANGELO'S FOUR TIMES OF DAY
(figs. 148 and 149)

Location: Perugia, Accademia delle Belle Arti

Dimensions: Complete measurements of the casts in comparison
with the Medici Chapel figures together with diagrams are
to be found in U. Tarchi, L'Arte del Rinascimento nell'
Umbria e nella Sabina, n. p., 1954, "I Calchi Michelangioleschi
nell' Accademia di Perugia ei marmi nella Cappella Medicea."

Description: hollow gesso casts without backs, freely
modelled at the extremities

Date: c. 1570

Discussion: The gesso casts in the Sala dei Gessi of the
Accademia delle Belle Arti in Perugia have provided fuel for
controversy for over half a century. The Medici Chapel
origin of the figures has never been questions, but the
relationship to their models has not been satisfactorily
defined. There are two basic arguments: either the casts
were made after the marbles or else they were made after
Michelangelo's own full scale models from which the Times
of Day were carved.

First mention of the figures was published by A.
Mariotti (Lettere pittoriche perugine, 1788, p. 256, with
note to C. Crispolti, Mss. Cronaca, f. 56v) who conjectured
that the group was made in 1573 and brought from Florence

to Perugia. A notice of 1630 published by G. Cecchini (L'
Accademia delle Belle Arti di Perugia, Florence, 1955, p.16,
ref. to ASP, "Libro del adunanzi della Confraternità di
S. Domenico da 1607 al 1635," f. 242) is noncommittal:
"quattro statue di Michelangelo fatte venire dal Dante da
Fiorenza." S. Siepi (Descrizione, I, p. 259) specified
that the Danti who brought the figures to Perugia was Vincenzo's
brother Ignazio. ". . .i quali modelli furono dono fatto all'
Accademia dal Ill. Ignazio Danti come vedremo all' artic.
dell' antico locale." A relevant document which has not
before been considered in this regard was published by I.
del Badia (Ignazio Danti Cosmografo e Matematico e le sue
opere in Firenze, Florence, 1882, p. 15, n1. See ASF.
Mediceo. Carteggio universale, "Rescritto del Gran Duca
di Toscana in absentia del Principe ad Agosto 1570 -a
Agosto 1571", 30 Agosto 1570)

> Fra Timoteo refati et Fra Egnatio Danti
> domandano poter formare le dua statue di michelagnolo
> che sono in sagrestia a na. di san lorenzo.

> reply: Il Priore lo permetta loro senza
> detrimento delle figure.

Although the document mentions only two statues, and
therefore may even refer to the Capitani, it seems safe to
conclude that it must approximately fix the time of the
execution of the Perugia casts. Vincenzo Danti's partici-
pation in the enterprise is not mentioned, but should probably
be assumed since he was an experienced sculptor. Timoteo

Refati was a Mantuan medallist who signed himself Timotheus
Refatus (Thieme-Beckerp XXVIII, p. 80). His self portrait
of 1566 is illustrated and discussed by G. F. Hill
(Portrait Medals of Italian Artists of the Renaissance, no.
48, text p. 67-68) From his association with Ignazio
Danti the surmise that he was a Domenican can perhaps be
added to what little is known of him.

The discussion as to what exact relationship the
casts bear to Michelangelo's figures began in 1909. (W.
Bombe, "I Marmi di Firenze e i gessi di Perugia," Il Marzocco,
Florence, 1909, no. 5 and G. Urbini, "I Gessi di Vincenzo
Danti nell'Accademia di Belle Arti di Perugia,", Il Marzocco,
Florence, 1909, no. 50). U. Tarchi (L'Arte del Rinascimiento,
appendice, "I Calchi Michelangioleschi) carefully examined
the measured the casts, concluding that the differences in
size from the marbles should be explained by the casts'
being made from Michelangelo's own modelli. His argument
was reiterated by G. Nicco Fasola ("Di nuova dei gessi
Perugini: nota michelangiolesca," Commentari, VI, 1955,
p. 164-172)

The last word in the debate is L. Goldscheider
(Michelangelo's Bozzetti for Statues in the Medici Chapel,
London, 1957, p. 18-19) where the casts are described as
free stucco copies, slightly larger than the originals.
Goldscheider observes that the "small heads and long legs
of the four stucco copies at Perugia are characteristic of
Vincenzo Danti's style." It seems certain, however, that

the figures are casts and not free copies since seams are
visible except in the extremities where obvious liberties
were taken. The differences in dimension from the marbles
can probably be explained by slight adjustments to later taste
in assembling the casts, perhaps in Perugia.

XXVIII. MODEL FOR THE FOUNTAIN OF NEPTUNE IN THE
 PIAZZA DELLA SIGNORIA IN FLORENCE (lost)

Date: 1560

Discussion: The history of the competition for the Fountain
of Neptune in the Piazza della Signoria is found in Vasari's
life of Baccio Bandinelli (Vasari-Milanesi, VI, p. 186-192).
Detailed histories of the competition and construction of
the present fountain are provided by B. Wiles, The Fountains
of the Florentine Sculptors, Cambridge, 1933, p. 116-119;
and J. Pope-Hennessy, Italian High Renaissance Sculpture,
III, p. 73-75. Models were prepared by Ammannati, Cellini,
Giovanni Bologna, and Vincenzo Danti in Florence, and
Francesco Moschini prepared one in Pisa. Of the models
prepared in Florence, Danti's--which was built in the
house of Ottaviano de'Medici--was the only one not paid
for by the Duke (Wiles, Fountains, p. 119). None of the
models, which were full scale, survives.

 Danti's proposed fountain is probably recorded
in a sketch in the Dubini Collection published by E.
Dhanens, Jean Boulogne, fig. 25 and connected with
Giovanni Bologna's Fountain of Neptune in Bologna. The
drawing, however, is in no way similar to Giovanni Bologna's
fountain or to the modelli done in preparation for it. The
whole conception of the drawing is much too deeply imbued
in the patterns of Michelangelo to be by Giovanni Bologna.

The figure is essentially the same figure that Danti used in his first marble group, the <u>Onore che vince l'Inganno</u>, carved a few months later. (fig. 28) The design was repeated in Battista Lorenzi's Fountain of Perseus in the Palazzo Nonfinito, Florence. (ill. B. Wiles, <u>Fountains</u>, fig. 67)

XXIX. ALTAR OF SAN BERNARDINO (lost)

Location: Perugia, San Lorenzo

Date: 1561-1567

Discussion: The earliest description of the program of the
Altar of San Bernardino in the Duomo in Perugia is given
by O. Lancellotti, Scorta Sagra, Mss. Biblioteca Augusta,
Perugia, f. 147, quoted at length by W. Bombe, "Federigo
Barocci a Perugia", p. 190-191, n. 3. Lancellotti recounts
that the altar was completed in 1569, that the statues were
the work of Vincenzo Danti, the ornamental stucco work
by Lodovico Scalza, and the altarpiece by Federigo Barocci.

The altar of San Bernardino, according to the contract
of November 8, 1559 (A. Rossi, "Documenti per la storia
della scultura ornamentale in pietra", Giornale di Erudizione
Artistica, III, 1874, p. 234-235) was to be constructed by
Lodovico Scalza and Giovanni Fiorentino and was to be 32 feet
high, reaching to the cornice of the facade; the base of the
altar was to be of travertine, the frontispiece of wood, and
the rest of stucco, all gilded and painted; there were to
be figures and fogli of stucco. The price agreed upon was
525 scudi, and the work was to be complete in 20 months.

In the Libro Verde of the archives of the Mercanzia,
cap. 51 there are payments from 1561 to 1569 to the two
scarpellini, to Federigo Barocci and Vincenzo Danti. See
Bombe, Urkunden, p. 119. "1567 E deve dare sc. trenta

di moneta pagati à Mastro Lodovico scultore, et per lui

a Vincentio di Giulio di Dante per resto delle statue, e dell'

opera fatta a detta Capella, come al credito di Fabio Ansidei

priore, al suo Guoderno."

The design for the altar seems to have come from Danti,

(Chapter IV, n. 65 above) although it is difficult to say

on the basis of the size of the payment or the terms of the

contract that Danti executed all of the stucco sculpture

himself.

In 1796-7 the decision was made to replace the stucco

altar with the present marble altar (Siepi, Descrizione, p.

62). At that time a drawing was made by the architect Vin-

cenzo Ciofi (fig. 52, published by W. Bombe, Urkunden, Abb.

21). B. Orsini (cited by W. Bombe, "Federigo Barocci", p.

190-191, n. 3) in his Memorie istoriche dell'Accademia del

Disegno (Mss. of the Accademia di Belle Arti in Perugia)

stated that before their dispersal the figures were offered

as a gift to the Accademia; but the director--Orsini himself--

not having the money for their transport, "contented himself

with a few heads". Bombe found no trace of the figures and

neither did I.

Another history of the altar is given in A. Mezzanotte,

La Deposizione dalla Croce quadro di Federigo Barocci di

Urbino nella Cattedrale di Perugia. . .con una lettera

storico-critica di Gio: Battista Vermiglioli, Perugia,

1818, p. 22-23.

XXX. RESURRECTION (lost)

Date: 1559

Discussion: Timoteo Bottonio in the introduction to a
sonnet on Danti's <u>Moses</u> <u>and</u> <u>the</u> <u>Brazen</u> <u>Serpent</u> mentions
"due marmi di Basso rilievo, nell uno de'quali scolpi la
Resurresione di Cristo, nell'altro la Flagellazione alla
Colonna. . ." (Catalogue VI, "Discussion") The <u>Flagellation</u>
has here been identified with a relief now in Kansas City
(Catalogue VII). The <u>Resurrection</u> is probably the same
relief that begins to appear in Medici inventories in 1560.
ASF. Guardaroba 45. Inventario delle robe. . . di S. E.
I. . . .luglio 1560. f. 69r. "un quadro di basso rilievo
d altezza di B 1 incirca entrovj la risuressione di Cristo";
Guardaroba 65, f. 171. Under 1561. "Un quadretto di basso
rilievo con la resuretione di Cristo nro' redemptore orna-
mento di noce Invenariato con altre robe a la presentia del
s' Cav: m. thom. so de Medici"; Guardaroba 75. Inventari
Originale della Guardaroba del Serenissimo Gran Duca di
Toscana. 1570. f. 67r. "Una resurezzione di Christo di marmo
di baso. rilievo di mano di vinc°. perugino inor.to di noce;"
and Guardaroba 126, f. 22v. "Un quadro di basso rilievo d'
una resurrezione con ornamento di noce." From these inven-
tories it can be gathered that the relief was one braccia
high,in low relief, and probably square (un quadretto). It
was thus about the same size as the Kansas City <u>Flagellation</u>

which, if they were a pair, as similar dimensions and Bottonio's statement suggest they were, must have been cut down from a square to an oval. The <u>Resurrection</u> and the <u>Flagellation</u> may have been intended to flank the <u>Brazen Serpent</u> relief in an altar antependium (Catalogue VI).

XXXI. FAME, DEATH AND TIME (lost)

Location: Florence, San Lorenzo

Date: 1564

Discussion: Danti's first recorded painting was done for
the exequies of Michelangelo. It decorated the pulpit on
the right in San Lorenzo, opposite the pulpit from which
Benedetto Varchi delivered Michelangelo's funeral oration.
(See R. and M. Wittkower, The Divine Michelangelo, p. 120)
"Nel Pergamo, dove l'Ec. M. Benedetto Varchi fece l'oraz-
ione funerale (la quale io insieme con questi avisi vi mando
stampata) non era ornamento alcuno: perche essendo di Bronzo,
e di storie di mezzo, e basso rilievo, dall'Ec. Donatello
stato lavorato, sarebbe stato senza dubbio ogni ornamento,
che sopra se gli fusse posto, di gran lunga men bello; Bene
era in su le colone, un quadro alto quattro braccia, & largo
due in circa, dove con bella invenzione, & bonissimo disegno
era dipinto la Fama, o vero l'honore in attitudine bellissima,
con una tromba nella man destra, & con piedi addosso al
tempo, & all morte, per mostrar, che la fama, & l'honore;
mal grado della morte, & del tempo serbano vivi in eterno
coloro, che virtuosamente in questa vita hanno operato. Questo
quadro ha fatto Vincentio Danti Perugino, il quale, vivendo
mostrerà quanto un sollecito studio aiuti un bell'ingegno,
& conduca altrui a quella perfezzione, & eccellenza, oltre

la quale non si puo alcuna cosa disiderare." The same
description, with changes in punctuation, and without the
tribute to Vincenzo Danti at the end was repeated by
Vasari (Vasari-Milanesi, VII, p. 313-14)

The paintings from the decorations for Michelangelo's
funeral are all lost. One was given to Vincenzo Borghini,
another to the doctor of the Academy. Twenty-five were
taken to the Ospedale degli Innocenti, where they were to
be sold at modest prices. There was scanty market for
them, and they finally disappeared. (R. and M. Wittkower,
The Divine Michelangelo, p. 27)

XXXII. GENIUS AND IGNORANCE (lost)

Date: 1564

Discussion: The sculptural group which Danti executed for
the catafalque of Michelangelo, showing Genius Triumphant
over Ignorance, stood on the right hand side of the lower
tier of the catafalque (see R. and M. Wittkower, The
Divine Michelangelo, Appendix III for a complete recon-
struction of the catafalque). The statue is described in
the following terms: "Equesta parte piu bassa, & come
dire la Base di tutta la machina, haveva in ciascun canto
piedestallo, che risaltava, & sopra ciaschedun piedestallo
era una statua grande piu, che'l naturale, che sotto come
soggetta, & vinta n'haveva un'altra, di simile grandezza,
ma raccolte in diverse attitudini & stravaganti. La prima,
andando verso l'Altar maggiore à man ritta era un giovane
suelto, tutto spirito, & di bellissima vivacità, figurato
per l'ingegno, con due aliette sopra le tempie, come si
vede dipinto alcuna volta Mercurio: & sotto a esso giovane
era con orecchi Asinini una bellissima figura fatta, per
l'gnoranza mortal nimico dell'ingegno, . ." (Wittkower,
p. 97) A similar description is given in Vasari (Vasari-
Milanesi, VII, p. 300-301) See also Wittkower, p. 145,
where the group is described by an anonymous spectator of
the exequies as "il Iuditio, che ha sotto la Iggoranza".

The figures were described as "grande più ch'l

naturale" (Wittkower, p. 97). The figures were clay
painted white, to simulate marble. (Frey, Nachlass, II, p.
86). Wittkower (The Divine Michelangelo, p. 162, n18)
reservedly relates the Virtue Triumphant over Vice terra-
cotta in the Museo Nazionale (Catalogue XVII) to Danti's
group for the catafalque.

The grisly end of the sculptures is also recounted
by Wittkower (p. 26-7); from Libro del Proveditore "E",
f. 16r, October 27, 1566) After the celebration of the
funeral on the 14th of July, 1564, the decorations had to
be taken down because of the upcoming funeral of the
Emperor Ferdinand on the 21st of August. It was moment-
arily considered that some of the sculpture might be cast
in bronze, but nothing came of it. The figures were stored
in a room in back of the sacristy of San Lorenzo, where they
stood for over a year, during which the landlord of the place
clamored for rent which was never paid him. In 1565 the
landlord convinced the powers that were that the space was
needed to stable horses for the entry of Giovanna of Austria.
The statues were removed, although by this time they were
broken and covered with grime ("tucte rotte fracasate e
ricoperte da litame")

The single figure which was still intact was given
to Agnolo Guicciardini, the luogotente of the Academy,
replacing Vincenzo Borghini. All the rest were thrown away
except one, broken, which was given to the landlord as a bit
of symbolic rent and a souvenir ("per ricordanza e per pigione

che più volte gli havevo promessa di pagare e questa
fù la fine delle figure del catafalcho.") It is not
known which of the figures was given to Guicciardini.

XXXIII. ALTARPIECE OF THE CRUCIFIXION (lost)

<u>Date</u>: 1574-1576

<u>Discussion</u>: Vincenzo Danti contracted to paint an altar-
piece of the <u>Crucifixion</u> for Giovanna Baglioni della Corgna
on April 4, 1574 (W. Bombe, Thieme-Becker, VIII, p. 385).
On September 15, 1574 he entered into another contract
with the brothers of San Fiorenzo in Perugia for various
work, together with a fresco, which he was to do at his
own expense.

 ASP. Arch. Not., Ottaviano Aureli, 1574, f. 206 r
and v. (in index of 1574: Vincentij Julij a fratribus sti
Florentij die 15 7bre mano di ottaviano aureli--concessio)
Danti agrees "pro d. ecca fare due finestroni di qua et
di la dall'altar grande di d. chiesa, cioè uno sopra l'
altare di Rosato di Cesario, che stà à man dritta dell'altar
grande et l'altro sopra l'altro altare, che stà à man
manca all'altar grande, con proportione conforme et corispon-
dente all'ornamento di detto altar grande. Et à detti
finestroni farvi le gelosie et a uno di detti finestroni
farvi il poggiuolo da potervi porsar' l'organo. Et tutto
ciò a spese di esso ms. Vincentio. Et in oltre detti frati
concessero à d. ms Vincentio tutta la facciata di d.
chiesa sopra la porta grande, dalla parte di dentro attorno
l'invetriata, accioche egli vi possa et debbia dipingere a
tutte sue spese l'istoria dei dieci mila martiri, et far'

anco uno altare à lato detta posta da una banda." It
would seem that Danti's paintings were not in too much
demand. "Si mese ultimamente a dipignere, & in San Firenze
alla Capella della Sig. Giovanna Baglioni dipinse la tavola
entrovi il Crocifisso in mezo a'Ladroni, & à pie della croce
molte figure lavorate con buon disegno, e con bell'ordine,
opera degna d'esser lodata, se bene non è molto ben col-
orita, per non esser egli avezzo à maneggiare i colori."
(R. Borghini, Il Riposo, p. 522)

On June 20, 1567 Girolamo Danti accepted in Vincenzo's
place 200 scudi for the painting of the Crucifixion (Bombe,
Theime-Becker, VIII, p. 381) ASP. Arch. Not. Agapito
Nerucci, 1575-1579, f. 160v-162r: "pro opere altaris
maioris in ecclesia Sancti Florentii facto per dictum Vinc-
entium dum vixit et vigore publici et iurati instrumenti
promissionis et obligationis ac conductionis et locationis
dicti operis manu mea notarii. Et hoc fuit quia sic voluit,
et quia fuit sponte confessus et contentus dictum Vincentium
eius fratrem dum vixit habuisse et secepisse in pluribus
vicibus et partiti scutos centum sexaginta similes, ipsum-
que Hieronimum post mortem Vincentii pro residuo habuisse
scutos quatraginta menete per manos dicti domini Camilli.
. ."

W. Bombe (Thieme-Becker, VIII, p. 381 and p. 385)
confuses San Fiorenzo in Perugia for San Firenze in Florence
following Richa (II, 1755, p. 258) who identifies the
Crucifixion mentioned by Borghini with an altarpiece on the

the north wall in S. Firenze by Bacchiacca of the <u>Martyr-dom</u> <u>of</u> <u>the</u> <u>Ten</u> <u>Thousand</u> (coincidentally). This is corrected by Paatz, <u>Die</u> <u>Kirchen</u> <u>von</u> <u>Florenz</u>, II, p. 108, n55 with bibliography. C. Gamba, in <u>Bolletino</u> <u>d'Arte</u>, IV, 1924/5, p. 207 discusses and illustrates Bacchiacca's painting. The whereabouts of Danti's <u>Crucifixion</u> is not known, and there is no indication that his <u>Martyrdom</u> <u>of</u> <u>the</u> <u>Ten</u> <u>Thousand</u> was ever painted.

XXXIV. RELIEF OF THE VISITATION (lost)

Date: 1565

Discussion: For the decorations of the wedding of Giovanna
of Austria and Francesco I, Vincenzo Danti was assigned one
of the ten gilded terra cotta reliefs which decorated the
main portal of Santa Maria del Fiore, apparently on the model
of Ghiberti's facing Gates of Paradise, with scenes from the
life of the Virgin. See P. Ginori Conti, L'Apparato per le
Nozze di Francesco de'Medici e di Giovanna d'Austria, Florence,
1936, p. 133, Appendix V, "dal libretto di appunti delle
cose fatte o da farsi per l'apparato, tenuto da Vincenzo
Borghini." This list was drawn up August 15, 1565.

On the left half of the door reading top to bottom,
the reliefs were assigned as follows:

Domenico Poggini: Birth of the Virgin

Giovanni dell'Opera: Presentation

Vincenzo de'Rossi: Marriage

Francesco della Camilla: Annunciation

Vincenzo Danti: Visitation

On the right half of the door reading top to bottom, the
reliefs were assigned as follows:

Giovanni Bologna: Birth of Christ

Jacopo Centi: Epiphany

Stoldo Lorenzi: Circumcision

Francesco Moschino: Pentecost

Jacopo Centi: <u>Assumption</u> <u>of</u> <u>the</u> <u>Virgin</u>

At the top were two figures holding a shield with arms
by Tomaso Boscoli. The painting above was by Tommaso
Mazzuoli da S. Friano. This scheme is illustrated in a
sketch of the portal in Ginori Conti, p. 41.

Payments for the reliefs are found in ASF. Depositeria
Generale 575, <u>Debitori</u> <u>e</u> <u>Creditori</u> <u>di</u> <u>Giovanni</u> <u>Cacchini</u> <u>per</u>
<u>chonto</u> <u>di</u> <u>feste</u> <u>dell'anno</u> <u>1565</u>, f. 177:

"Spese per la porta fatta a Sta Maria del fiore. . .
21 novembre. . .a giovanni dell'opera per una storia per detta
porta . . . a stoldo lorenzi per due storia

 . . . a domenico poggini per una storia

 . . . a vinco de rossi per una storia

 . . . a tomaso dal boscho per dua storie

 . . . a vinco danti per una storia

 . . . a jaco conti per avere lavorato due storie

Giovanni Bologna and Francesco Camillani were paid the
same day (f. III and XVIII; the payment to Giovanni Bologna
is for "una storia di terra servita per la porta"). Thus
everyone who was assigned a relief executed one except
Francesco Moschino. Only Jacopo Centi was originally given
two reliefs. Stoldo Lorenzi did one more than he was assigned
which would account for Moschino's absence. Since there are
payments for twelve "storie", the "storie" of Tomaso del
Bosco must be the "statue che reggono un arme" in Borghini's
scheme.

In Vasari-Milanesi, VII, p. 619 are the attributions of

the reliefs by the contemporary <u>Descrizione dell'Apparato</u>
<u>per le nozze di Francesco de'Medici</u> of Domenico Mellini.
"De bassirilievi della porta di Duomo furono i meastri
messer Vincenzo de Rossi. . .fece il quadro dello Sposalizio
della Madonna; Giambologna fiammingo. . .la Natività di
Cristo; Vincenzo Danti Perugino. . ." whose relief is not
identified. This attributions agree with the original
assignments, and since there were no major re-arrangements
of Borghini's plans, it seems likely that they were executed
as assigned.

The reliefs for the portal were finished by September
21, 1565 (Frey, <u>Nachlass</u>, II, p. 209) as Giorgio Vasari
reported to Vincenzo Borghini. "La porta è finita di Santa
Maria del Fiore. Resta larme del papa. . ." The whole en-
semble, reliefs and arms alike, was gilded (Depositeria 575,
f. 142).

Another payment to Danti was published by Frey,
<u>Nachlass</u>, III, p. 240. "Assi affar'debitor la porta di Sta
Maria del Fior' di fj diecj p. di et creditor' Vincentio
Dantj Perugino scultor' et sono per la stima fatta per una
storia di terra messa in detta porta per hornamento di essa".

XXXV. EQUESTRIAN MONUMENT FOR THE NOZZE OF 1565 (lost)

Date: 1565

Discussion: The materials for Danti's horse in the Piazza
San Apollinaire were issued to him on June 14, 1565 (Chap-
ter IV, n. 42). The wedding of Francesco I and Giovanna
of Austria took place December 18, 1565. Danti was paid al-
most a year later (Chapter IV, n. 43). The horse and rider
group was between nine braccia and "over eleven braccia"
tall, that is, between 18 and 22 feet (note 47). It showed
a noble youth who had just transfixed a creature half woman
and half serpent, and who was about to strike her again with
an upraised sword.

The logical outcome of Danti's clay group would have
been an equestrian portrait of Cosimo I in bronze. A pen
and ink drawing in the Graphische Sammlung, Munich, records
a project for an equestrian statue (fig. 146). On the recto
is an alternative study for the catafalque of Michelangelo.
This drawing stands in a close relationship to a study for
the Fountain of Neptune (fig. 144 ; Appendix II) The three
drawings, all related to projects in which Danti was involved,
seem mutually corroborating, and the sketch probably affords
some notion of the appearance of Danti's equestrian statue.

The chronology and iconography of the equestrian group
are considered in detail in Chapter IV, n. 26-58 above,

XXXVI. HERCULES AND ANTAEUS (not completed)

Date: 1558

Discussion: A larger than life size bronze group of Hercules
and Antaeus which was to have topped Tribolo's fountain of
Hercules at Cosimo's favorite villa of Castello was Danti's
first commission in Florence. It is first mentioned in the
introduction to a sonnet by Timoteo Bottonio (Catalogue VI)
where it is stated that the group was ordered by Duke Cosimo
and that Danti cast it three times unsuccessfully. The
next source, Vasari (Vasari-Milanesi, VII, p. 631) also
states that it was cast three times. "Venuto poi a Fiorenza,
al servizio del signor duca Cosimo, fece un modello di cera
bellissimo, maggior del vivo, d'un Ercole che fa scoppiare
Anteo, per farne una figura di bronzo da dovere essere posta
sopra la fonte principale del giardino di Castello, villa
del detto signor duca; ma fatta la forma addosso al detto
modello, nel volere getterla di bronzo, non venne fatta,
ancoraché due volte si rimettersi o per mala fortuna o per-
ché il metallo abbruciato, o altra cagione". A final
pungent source is Cellini's poem fragment ridiculing the
failure (see Chapter III, note 9). There are no payments
to Danti in the documents of Castello, only payments to
Ammannati for the group which now completes the fountain.
(B. Wiles, The Fountains of the Florentine Sculptors,
Cambridge, 1933, p. 112) The only documents which may be

relevant are found in the Fabbriche of the Palazzo Vecchio
(See Chapter II, note). There is no trace of what
Danti's design for the group might have been,

XXXVII. ST. ANDREW (lost)

<u>Date</u>: 1567 (?)

<u>Discussion</u>: A silver statue of St. Andrew is mentioned in
inventories after 1567. ASF. Guardaroba 65, f. 5. "1567.
Un'sant' Andrea apostolo. . . fece m.o vincentio dante perugino
com' al giornale sotto li xii di marzo." There is a payment
dated December 30, 1567 (f. cccxlviii) to "mo vincentio
dante perugino per far' un' sant' Andrea alle Legne. . ."
On November 5, 1569 silver was consigned to Danti "per farne
con altro che ha di sua. . .un'Apostolo" (f. 351) This last
apostle seems never to have been executed, since there are
six silver apostles mentioned in an inventory of 1562
(Guardaroba 65, f. 5) and seven listed in 1570 (Guardaroba
75, f. 3: "Sette. . .apostoli d'argento di ½ B. incirca,)
rather than eight as there would have been if Danti had
done two. There is no mention of who might have done the
others, and none of them seem to have survived. As the
las document indicates, they were about ½ braccia, 11 inches,
in height.

XXXVIII. PORTRAIT OF BENEDETTO VARCHI

<u>Date</u>: c. 1567

<u>Discussion</u>: At the time that Vasari wrote his biography
of Vincenzo Danti he was in the midst of carving a portrait
of Benedetto Varchi, in whose former cell he was living in
Santa Maria degli Angeli (Vasari-Milanesi, VII, p. 633).
". . . lavora. . .nel monasterio degli Angeli di Firenze,
dove si sta quietamente in compagnia di que' monaci suoi
amicissimi, nelle stanze che già quivi tenne messer Benedetto
Varchi, di cui fa esso Vincenzo un ritratto di bassorilievo,
che sarà bellissimo." The portrait is mentioned in no later
sources. Benedetto Varchi died December 18, 1565 at the age
of 62. He was bired in Santa Maria degli Angeli after
appropriate exequies at the expense of Duke Cosimo. The
plaque marking the place of burial is described by Richa,
<u>Chiese di Firenze</u>, 1759, VIII, p. 169-170, and if Danti's
relief was to have marked Varchi's tomb, it had disappeared
by that time.

Varchi was portrayed in a medal by Domenico Poggini
(Venturi, X, 2,) which served as the basis for profile
portraits published by E. Steinmann (<u>Michelangelo im
Spiegel seiner Zeit</u>, Taf. XIV) and R. and M. Wittkower,
(<u>The Divine Michelangelo</u>, fig. 6). Varchi was also painted
by Titian, and the portrait is now in the Kunsthistorisches
Museum, Venice (H. Tietze, <u>Titian</u>, fig. 163) Tietze (p. 401)

questions the identification of the figure as Varchi,
stating that the identification was first made in 1783.
An earlier identification of Titian's portrait seems to be
the portrait of the title page of the 1721 edition of
Varchi's <u>Storia Fiorentina</u>.

There is no trace of Danti's portrait and no certain
indication that it was ever completed.

XXXIX. COMPLETION OF THE FIGURES OF ANDREA SANSOVINO'S
 BAPTISM OF CHRIST

Location: Florence, Baptistry, South portal

Date: c. 1567-1569

Discussion: The commission for the Baptism of Christ
which was to replace the group of Tino di Camaino over
the south door of the Baptistry (eventually replaced instead
by Danti's Decollation of the Baptist, Catalogue XIX) was
awarded on April 29, 1502; the last payments to Sansovino
are from January 31, 1505 (G. Milanesi,"Documenti riguar-
danti le statue di marmo e di bronzo fatte per le porte di
San Giovanni di Firenze da Andrea del Monte San Savino e da
Giovanni Francesco Rustici," Giornale storico degli archivi
toscani, IV, 1860, p. 63-75. The history of the group is
set forth in detail in J. Pope-Hennessy, Italian High
Renaissance Sculpture, III, p. 46-7) At the tme of the
preparation of Sansovino's biography for the second edition
of Vasari's Vite of 1568, the figures were still in the
Opera di S. Giovanni. A.Lapini, Diario Fiorentino, p. 164
stated that the group was unveiled on June 23, 1569. ". . .
e l'Angelo che vi è, è di stucco; perche quello di marmo
che vi ha a stare, non era fatto; furon fatto e condotte
per opera di maestro Vincenzo Perugino." Danti's part in
the groups is also mentioned by Borghini (Il Riposo, 1584,
p. 162-3). ". . . le due statue. . .Fueron fatte da Andrea

dal Monte à Sansovino. . .ma perche egli non le lasciò del tutto finite, le finì poi Vincentio Danti Perugino." Borghini does not mention the angel. The question of the angel in the group is discussed by W. Paatz, "Seit wann gehört zu Sansovinos Taufgruppe am Baptisterium eine Engelfigur?" Mitteilungen des Kunsthistorischen Instituts in Florenz, IV, 1933, p. 141 It is variously described in later literature as stucco and as terra cotta, and must have been executed by Danti. There is no indication that Sansovino had begun or even planned a third figure. Danti's angel is mentioned by Del Migliore, Firenze Città bellissima, Florence, 1684, p. 91; but it was removed in 1791 (Follini-Rastrelli, Firenze antica e moderna, Florence, 1791, iii, p. 30) and replaced by the present disharmonious figure by Innocenzo Spinazzi. It is not possible to say whether or not the rather unusual angel--recalling Stoldo Lorenzi's Angel of the Annunciation for the facade of Santa Maria presso San Celso in Milan--translates Danti's design into permanent material and eighteenth-century manner, or whether it was made up by Spinazzi from whole cloth.

As for the marble figures, the head of Christ stands in clear contrast to that of the Baptist , and in close relationship--with its heavy lidded eyes, fine beard, and small straight mouth--to Vincenzo Danti. (Compare figs. It is difficult to determine his role in the completion of the group beyond this, but the relationship of anatomical structure to volume in both marble figures is distinctly

reminiscent of the <u>Onore</u> <u>che</u> <u>vince</u> <u>l'Inganno</u> of 1561.
(fig. 28)

XL. FIGURES FOR A STUDIOLO FOR FRANCESCO I ON A DESIGN
BY BUONTALENTI (lost)

Date: c. 1567-1568

Discussion: A "studiolo" ordered by Francesco I on a design
by Bernardo Buontalenti is described by Vasari as nearly
then completed. It was one of the early clear statements
of the taste of Francesco I. (Vasari-Milanesi, VII, p. 615)
". . . con bell'architettura. . .uno studiolo con partimento
d'evano e colonne d'eliotrope e diaspri orientali e di lapis-
lazzeri, che hanno base e capitelli d'argento intagliati;
ed oltre ciò, ha l'ordine di quel lavoro per tutto ripieno
di gioie e vaghissimi ornamenti d'argento, con belle figurette:
dentro ai quali ornamenti vanno miniature, e fra termine
accoppiati, figure tonde d'argento e d'oro, tramezzate da
altri partimenti di agate, diaspri, elitropie, sardoni,
corniuole, ed altre pietre finissime." It is described
by Borghini (Il Riposo, p. 610-11) as follows: "uno
Studiolo d'Ebano, il quale è composto di tutti gli ordini
di Architettura con colonne di Lapis Lazzeri, di Elitropij,
d'Agate, e d'altre pietre fini, e nella facciata sono alcuni
termini d'oro fati a concorrenza da Benvenuto Cellini, da
Bartolommeo Ammannati, da Giambologna, da Vincentio Danti,
da Lorenzo della Nera, e da Vincentio de' Rossi. . . " This
treasure was damaged during a robbery in 1580. Unfortunately
the thief was caught. See A. Lensi, Il Palazzo Vecchio, p.
358; and L. Berti, Il Principe dello Studiolo, p. 241. Its
fate after repair is unknown.

XLa. TABERNACLE OF THE SACRAMENT
 (fig. 147)

Location: Assisi, San Francesco

Dimensions: 8 feet, 8. 5.in (2. 65 m.)

Description: wooden tabernacle sheathed in bronze, silver
and gold

Date: c. 1570-1575

Discussion: The tabernacle for the high altar in the lower
church of San Francesco at Assisi was designed by Galeazzo
Alessi in 1565 (Miscellanea Francescana, LXIII, 1963, p.
514, n450, reference to a document of November 4, 1565).
Work was not begun until at least 1570, when, on November
26 Galeazzo Alessi visited the basilica to ask that the
tabernacle be executed as degined. (Ibid.,p. 520) The
execution has been traditionally assigned to Giulio Danti.
See L. Carattali, M. Guardbassi, G. B. Rossi-Scotti,
Descrizione del Santuario di S. Francesco d'Assisi, 1863,
p. 162; C. G. Bulgari, Argentieri Gemmari ed Orafi d'
Italia, p. 240, following W. Bombe, Thieme-Becker, VIII,
p. 382, in turn after G. Fratini, Storia della basilica
e del convento di S. Francesco in Assisi, Prato, 1882;
p. 319. Also B. Kleinschmidt, Die Basilika S. Francesco
in Assisi, Berlin, 1915; and I. Supino, La Bascilica di
San Francesco d'Assisi, Bologna, 1924; and Catalogo della

Mostra d'Antica Arte Umbra, Perugia, 1907, p. 185 no. 2.

More recently the execution has been given to Vincenzo Danti. See Bolletino della Regia Deputazione di Storia Patria, XXVII, 1930, p. 162, where it is stated that from documents it was known that "fu eseguita da Vincenzo Danti". This is followed by E. Zocca, Catalogo delle cose d'arte e di antichità, Rome, n. d., p. 152. Padre Giuseppe Palumbo, Bibliotecario of the Biblioteca Comunale in Assisi who was most helpful in every way, knew of these documents, but could not locate them.

The objects of greatest interest on the tabernacle are the small caryatids at the top. These have some resemblance to Danti's works, the Studiolo Venus and the Victories on the throne of Julius III, but they are much lower in quality, and even if Danti contracted to do the work, it is unlikely that he did more than supply models for these figures, probably to his father or brother, who must be responsbile for the crude casting and inexpert finishing.

The tabernacle was removed from the altar by Cavalcaselle, after which it was placed in the chapel of St. Anthony Abbot, then in the treasury where it is now gathering dust and losing parts to thieves.

XLI. NARCISSUS (mistaken attribution)

Location: London, Victoria and Albert Museum

Dimensions: 2 ft., 11. 7 in. (90. 8 cm.)

Date: c. 1565-1570

Discussion: This statue was for a long time considered to be the Cupid carved for Jacopo Galli by Michelangelo. It was first attributed to Vincenzo Danti by F. Kriegbaum, "Zum 'Cupido des Michelangelo' in London", Jahrbuch der Kunsthistorischen Sammlungen in Wien, n. f. III, 1929, p. 247-257; and C. de Tolnay, Michelangelo, I, p. 203-204. The documentary basis of Kriegbaum's argument, that the Victoria and Alberti figure is the same as that referred to in a letter of 1577 as a "figura a sedere" by Vincenzo Danti is no doubt incorrect, since this refers to the Cosimo-Perseus now in the Boboli Gardens (Catalogue XVI) The sources and scholarly history of the statue have been exhaustively considered by J. Pope-Hennessy,("Michelangelo's Cupid: the end of a Chapter," Burlington Magazine, XCVIII, 1956, p. 403-11; and Victoria and Albert Catalogue, no. 482) concluding that the Cupid is a restoration of a classical Narcissus statue probably by Valerio Cioli. One wonders if it is not the same as a figure mentioned in ASF. Guardaroba 65, f. 171. "Un cupido di marmo che fa forza di caricar' un arco, consegnassi a Valerio scultore per a pitti in ornamento

di quel luogo come al gior. le sotto li 2 di Marzo, 1564."

XLII. DYING ADONIS (mistaken attribution)

Location: Florence, Museo Nazionale

Date: c. 1570

Discussion: This figure, which is undoubtedly the Adonis
bought by Isabello Orsini for the Villa of Poggio Imperiale
mentioned by R. Borghini (Il Riposo, p. 597), gradually
accumulated an attribution to Michelangelo in successive
Medici inventories. It was attributed to Danti by H.
Thode, Michelangelo, Kritische Untersuchungen über seine
Werk, Berlin, 1908, I, p. 43; and J. von Schlosser, "Aus
der Bildnerwerkstatt der Renaissance, II. Eine Bronze des
Vincenzo Danti," Jahrbuch der Kunsthistorischen Sammlungen
in Wien, XXXI, 1913-14, p. 73-86; the correct identification
of the figure as by Vincenzo de'Rossi had already been made
by A. Grunwald, "Über einige unechte Werke Michelangelos",
Münchner Jahrbuch der BildendenKunst, V, 1910, p. 22.
See also C. de Tolnay, Michelangelo, I, p. 234-35; and
B. Wiles, Fountains, p. 91, 132; and H. Utz, "Vincenzo
de'Rossi," Paragone, 197, July, 1966, p. 29-36. The
attribution to Danti may have a certain value in pointing
to a stylistic dependence of the figure upon Danti's sculpture,
especially in the carving of the head.

XLIII. FLAGELLATION RELIEF (mistaken attribution)

Location: Perugia, Galleria Nazionale dell'Umbria

Discussion: A bronze relief now in the Galleria Nazionale
dell'Umbria in Perugia (no. 746) was originally attributed
to Vincenzo Danti (Indicazione degli oggetti. . .nella
Università di Perugia, Perugia, 1882, p. 65, no. 16).
The relief was grouped with others attributed to Verrocchio
by A. Venturi,(L'Arte, V, 1902, p. 43) and was attributed
to Leonardo by W. Bode (Preuszisches Jahrbuch, XXV, 1904,
p. 134) and to Bertoldo. See A. S. Weller, Francesco di
Giorgio, Chicago, 1943, p. 151, for the currently accepted
attribution to Francesco di Giorgio. The provenance given
(Indicazione, p. 65) is "un antica casa perugina" and it
is tempting to think that Danti might have been familar with,
or even the owner of, this remarkable essay in low relief.

XLIV. MODELS ÉCORCHÉ (mistaken attribution)

Location: London, Victoria and Albert Museum

Discussion: These seven studies (J. Pope-Hennessy, Victoria
and Albert Catalogue, 456-462) were regarded as the work
of Michelangelo by E. Maclagen and M. Longhurst, Catalogue
of Italian Sculpture, London, 1932, p. 127-129. Maclagen
also connected one of the studies (no. 459 with the Victoria
and Albert Cupid (Catalogue XLI above) which he accepted as
the work of Michelangelo ("The wax models by Michelangelo
in the Victoria and Albert Museum," Burlington Magazine, XLIV,
1924, p. 11) De Tolnay, Michelangelo, I, p. 233 dismisses
"these weak models", and assigned them on the basis of their
slender proportions to the work "of the Mannerists about
1570- 1580". Charily, J. Pope-Hennessy, Catalogue, p.
421 relates them to the preparation of Danti's Trattato,
"or some similar work". He also suggests a relationship
to modelli of the school of Giovanni Bologna. Danti no
doubt prepared anatomical studies for the illustration of
his Trattato (Appendix V) but these slender models differ
significantly from any of his sculpture, particularly in
the years during which the treatise might be thought to have
been in preparation, before 1567.

XLV. RECUMBENT FIGURE OF A YOUTH (mistaken attribution)

Location: Victoria and Albert Museum, London

Discussion: First published by Brinckmann, Barock-Bozzetti,
p. 60 as the work of Vincenzo de'Rossi, comparing it to
the Dying Adonis (Catalogue XLII). E. Maclagen and M.
Longhurst, Victoria and Albert Catalogue, p. 143 attributed
it to Vincenzo Danti, comparing it to the terra cotta Virtue
Triumphant over Vice and the Equity and Rigor. It had also
been connected with Ammannati by J. C. Robinson, Italian
Sculpture of the Middle Ages and the Period of the Revival
of Art. A descriptive catalogue, London, 1862, p. 148.
J. Pope-Hennessy has attributed it with some certainty
instead to Pietro Francavilla (Victoria and Albert Catalogue,
no. 510). The figure is still considered to be the work
of Vincenzo Danti by M. Weinberger, Michelangelo the Sculptor,
New York, 1967, p. 358.

XLVI. MARINE GOD (mistaken attribution)

Location: Florence, Piazza della Signoria

Discussion: The execution of the bronze figures for
Ammannati's Fountain of Neptune was begun in March 1571
(B. Wiles, The Fountains of the Florentine Sculptors, p.119)
at about the same time that Danti was finishing the Baptistry
figures in the shop of Giovanni Bologna and Ammannati.
(Catalogue XIX, doc. 2) The attribution of the figure to
Danti was advanced by A. Venturi (Storia, X, 2, p. 346-432)
following the suggestions of Friedrich Kriegbaum (See J.
Pope-Hennessy, Italian High Renaissance Sculpture, III, p.
75) There is not documentary basis for Danti's participation
and in fact no indication that any of these figures, some
of the most beautiful in late Renaissance sculpture, were
modelled by artists of any stature. As the most conspicuous
master of bronze casting in Florence at the time, Danti might
have been expected to have done one of the figures, and this
River God does bear a certain resemblance in kind of grace
and languidness to Danti's St. Luke in Santissima Annunziata.
If the figure is his, however, it must have been done under
the close direction of Ammannati. The attribution of the
figure to Danti is accepted by M. Weinberger, Michelangelo
the Sculptor, p. 358.

XLVII. THE HEAD OF MICHELANGELO'S <u>VICTORY</u>

<u>Location</u>: Florence, Palazzo Vecchio

<u>Discussion</u>: The head of the <u>Victory</u> was given to Danti
by R. Wittkower, (<u>Burlington Magazine</u>, LXXVIII, 1941, p.
133, in a review of L. Goldscheider, <u>The Sculptures of
Michelangelo</u>, London, 1939. The <u>Victory</u> was presented to
Duke Cosimo I de'Medici March 22, 1564 and taken to the
Palazzo Vecchio in December 1565. It is not known in what
state of completion Michelangelo had left the statue in the
Via Mozza, and it is true that the head is cut differently
than the rest of the statue. If it were carved by Danti,
it must have been nearly complete, since the underlying
forms of the head bear little relationship to Danti's own
work.

XLVIII. BUST OF A YOUTH

Location: Rome, private collection

Discussion: This head, strongly dependent upon the Victory
and the Giuliano de'Medici is published by G. Papini, Vita
di Michelangelo, opp. p. 273. L. Goldscheider, Michelangelo.
Painting, Sculpture, and Architecture, London, 1963, p. 225,
n[4], notes that it is a copy of the Victory and that it
vaguely resembles Raffaello da Montelupo's St. Damian in
the Medici Chapel or the prophet for the Tomb of Julius II
in San Pietro in Vincoli in Rome; but he finds it closer to
Vincenzo Danti, who "worked on the Victory".(See Catalogue
XLVII) There is, however, no parallel for such literal
dependence upon Michelangelo or for such handling of marble
in Danti's authenticated works.

XLIX. BOZZETTO OF A CROUCHING GIRL(mistaken attribution)

Location: Munich, private collection

Discussion: The attribution of this forgery to Vincenzo
Danti was suggested by L. Goldscheider, Michelàngelo,
p. 225; it had been put foward as the work of Michelangelo
by F. Kieslinger in the Preusziches Jahrbuch, 1928, p. 50,
an assignment which was questioned by Hekler in the Wiener
Jahrbuch für Kunstgeschichte, VII, 1930, p. 219.

L. ENTOMBMENT

Location: Berlin, Staatliche Museen

Discussion: The attribution of this figure to Danti was
suggested by L. Goldscheider, Michelangelo, plate XXXII,
Appendix. The wax relief was attributed to Vincenzo de'
Rossi by F. Schottmuller, Bildwerke des Kaiser-Friedrich-
Museums, Berlin-Leipzig, 1933, pointed out its relationship
to the Palestrina Pietà and to the Pietà relief in the
Vatican assigned by U. Middeldorf, "Additions to the Work
of Pierino da Vinci", p. 305.

LI. HEAD OF A POPE (lost)

Discussion: S. Siepi, _Descrizione_, I, p. 344 describes
in the Palazzo Goga in Perugia "un busto di terracotta,
ritratto di un Papa, opera forse di Vincenzio Danti." It
is not known what became of this or whether it was correctly
attributed.

LII. MELEAGER

Discussion: This statue was advertised and illustrated by
the F. A. Drey Gallery in London in the Burlington Magazine,
LXXVIII, 1941, February, p. ii. It seems a likely prospect
and is very close to the modello of Virtue and Vice in the
Museo Nazionale in Florence. It has since dropped out of
sight, however, and cannot be considered among Danti's
works until it can be found and more closely examined. It
is marble, 32. 5 in. (82 cm.) in height.

LIII. GILT-SILVER VESSEL

<u>Discussion</u>: On April 7, 1554 Vincenzo Danti entered into
a contract to execute a silver and gilt vessel for the
Priors of the guilds. He did not complete it, as implied
by J. Pope-Hennessy, <u>High Renaissance Sculpture</u>, 3, p. 77.
Rather it was executed by his father, Giulio Danti, who was
paid for it on May 12 of the following year. Both the con-
tract and the payment were published in the <u>Giornale di Eru-
dizione Artistica</u>, III, 1874, p. 229-230.

APPENDICES

APPENDIX I

BRONZES

Since Danti was a trained goldsmith, and since his chosen medium was bronze it is surprising that he devoted so little time and energy to small bronzes. None have been attributed to him with any degree of certainty. Among his known works, fixed points are provided at the beginning by the Victories on the throne of Julius III (figs. 10, 11) and by the Studiolo Venus (fig. 71) at the end. Points of reference are also afforded by the Virtue overcoming Vice modello in the Museo Nazionale (fig. 51) and the St. Luke modello in Arezzo. The documented small scale works, the silver St. Andrew of 1567 (Catalogue XXXVII) and the small figure for Buontalenti's Studiolo (Catalogue XL) are lost. The following is a list of bronzes which have been attributed to Danti.

1) Hercules; Vienna, Kunsthistorisches Museum attributed to Danti by J. von Schlosser, "Aus der Bildnerwerkstatt", the attribution is correctly rejected by H. Keutner, "The Palazzo Pitti 'Venus', p. 427; it is still maintained by H. Weihrauch, Bronzestatuetten, p. 185.

2) Bacchus-David. Several versions of this bronze exist, most frequently characterized as David. The Bacchus in the National Gallery in Washington was attributed to Danti by J. Pope-Hennessy (Kress Collection, no. 468) and the

composition of the figure has been related to Michelangelo's
Bacchus by M. Weinberger (Michelangelo the Sculptor, p. 361)
who includes it among Danti's earliest works, arguing that
the memory of it surfaced some twenty years later in Danti's
statue of Cosimo I (Catalogue XXVI) for which the Bacchus
served as a model. Weinberger assumes that Danti saw
Michelangelo's statue in Rome. Since, however, the Cosimo
I dates very late in Danti's Florentine period, around 1572,
and the Bacchus was bought by Francesco I at about that time,
there seems a simpler reason for the compositional reference.
It might also be added that the statuettes are inconsistent
with what we know of Danti's early style.

The existing casts of the figure are not of sufficient
quality to permit unequivocal ascription to Danti, or, if
the documentary and circumstantial evidence is accepted, to
allow us to conclude much about Danti's manner of working
small bronzes.

These bronzes are related to a modello, usually con-
nected with the marble David, in the Casa Buonarroti by
Weinberger (Michelangelo, p. 360). Versions of the bronze
as David are to be found in Hamburg (Münchner Jahrbuch der
Bildenden Kunst, 1965, p. 236-237, ascribed to Florence,
first half of the sixteenth century) and in the Schweizerisches
Landesmuseum, Zürich (W. Trachsler, Zeitschrift für Schweizer-
ische Archäologie und Kunstgeschichte, XX, 1960, p. 139);
a "kunstlerisch bedeutenderes" example was destroyed in 1944.

3) <u>Latona</u> <u>and</u> <u>her</u> <u>Children</u>. Four versions of this bronze are known. A version from the Ashmolean Museum (<u>Bronzetti</u> <u>Italiani</u> <u>del</u> <u>Rinascimento</u>, Florence, 1962, Catalogue no. 106) is a replica of a bronze in the Victoria and Albert Museum. There is another in the von Hollitscher Collection (W. Bode, <u>Italian</u> <u>Bronze</u> <u>Statuettes</u>, II, CXXXVI listed as by a follower of Michelangelo); and one in L. Planiscig, <u>Piccoli</u> <u>Bronzi</u>, p. 45, CXCII (as Guglielmo della Porta). It is concluded in <u>Bronzetti</u> <u>Italiani</u> <u>del</u> <u>Rinascimento</u> that "this and other bronzes connected with it were probably done in Florence from models by Vincenzo Danti", comparing the head to the Studiolo <u>Venus</u> and the hair to the <u>Herodias</u> of the Baptistry group. See also E. Maclagan in <u>Burlington</u> <u>Magazine</u>, XXXVI, 1920, p. 239 (attributed to Guglielmo della Porta).

4) <u>Reclining</u> <u>Venus</u> <u>and</u> <u>Cupid</u>. One version of this bronze is known in the Museum of Fine Arts, Boston. See <u>Renaissance</u> <u>Bronzes</u> <u>in</u> <u>American</u> <u>Collections</u>, exhibition catalogue, Smith College, May 1964. This attribution is based on the previous <u>Latona</u> <u>and</u> <u>her</u> <u>Children</u>.

5) <u>Virtue</u> <u>and</u> <u>Vice</u>. This bronze now in the Palazzo Pitti has long been considered a cast by Danti from the terra cotta <u>Virtue</u> <u>and</u> <u>Vice</u> in the Museo Nazionale (A. Venturi, <u>Storia</u>, X, 2, p. 519). At 35.4 cm it is somewhat smaller than the terracotta. After the 1962 catalogue (<u>Bronzetti</u> <u>Italiani</u> <u>del</u> <u>Rinascimento</u>) it was judged to be a late seventeenth century cast. See M. Ciardi Dupré,

review of <u>Bronzetti</u> <u>Italiani</u> <u>del</u> <u>Rinascimento</u> in <u>Paragone</u>, 151, 1962, p. 67 based on the opinion of U. Middeldorf; Keutner in <u>Kunstchronik</u>, XV, 1962, p. 175. J. Pope-Hennessy, "Italian Bronze Statuettes, II," <u>Burlington Magazine</u>, CV, 1963, p. 64, does not agree, arguing that the detailing which is not characteristic marks a shift in Danti's artistic attentions from Michelangelo to Bronzino, and he "is not convinced that it was not made in Danti's lifetime".

6) <u>Copy after Michelangelo's Victory</u>. This bronze in the Residenz-museum, Munich is attributed to Danti by H. R. Weihrauch, <u>Europäische Bronzestatuetten</u>, p. 44 apparently on the basis of of the literalness of the transcription of a model by Michelangelo.

7) <u>Female Allegorical Figure</u>. See Cecchini, <u>La Galleria Nazionale</u>, Rome, 1932, no. 250 . This figure does bear a certain relationship to the <u>Victories</u> of the throne of Julius III; but the quality of the cast and workmanship suggest that perhaps the bronze was cast after a model by Danti, perhaps by someone with access to his shop in Perugia.

A bronze group of <u>Tarquinius and Lucretia</u> mentioned by W. Bombe, Thieme-Becker, VIII, p. 386, and J. von Schlosser, "Aus der Bildnerwerstatt," p. 80, refers to G. Campori, <u>Raccolta di Cataloghi ed Inventarii inediti</u> , Modena, 1870, p. 172 catalogue of the works of art in the Casa Meniconi in Perugia, dated October 10, 1651: "Due statuette di metallo in un gruppo a sedere figurate per Tarquinio e Lucretia

d'altezza circa un piede e ½ benissimo ripolite, mano
di Gio. Bologna o di Vincentio Danti con base di pietra
lustra. Sc. 80". This is perhaps the same as the bronze
group in F. Goldschmidt, <u>Die</u> <u>Italienischen</u> <u>Bronzen</u> <u>der</u>
<u>Renaissance</u> <u>und</u> <u>des</u> <u>Barock</u>, <u>Erster</u> <u>Teil</u>, <u>Büsten</u>, <u>Statuetten</u>,
<u>und</u> <u>Gebrauchsgegenstände</u>, Berlin, 1914, no. 156, which is
not by Danti but rather by a northern follower of Giovanni
Bologna.

APPENDIX II

DANTI'S DRAWINGS

A small number of drawings have been associated with
Vincenzo Danti, although no drawings certainly by his hand
are known, and there is consequently no sure basis for the
attributions. For the most part assignment of drawings
to Danti has been premised on the general notion that he was
a literal follower of Michelangelo. An attempt to form a
nucleus of Danti's drawings by A. E. Popham, Catalogue of
Drawings in the Collection formed by Sir Thomas Philipps
now in the Possession of his Grandson T. Fitzroy Philipps
Fenwick, Privately Printed, 1935, p. 51-52 was swatted
down by K. T. Parker, Catalogue of the Collection of
Drawings in the Ashmolean Museum, Oxford, 1956, p. 388
who convincingly reassigns the drawings to Niccolò Tribolo.
See also C. Lloyd, "Drawings Attributable to Niccolò Tribolo,"
Master Drawings, VI, 1968, p. 243-45.

There is a small profile pen sketch of a hag in the
Biblioteca Reale in Turin which purports to be signed by
Vincenzo Danti. (A. Bertini, I Disegni Italiani della
Biblioteca Reale di Torino, Rome, 1950, no. 136) It is a
curiously ugly drawing, outstanding for its simple single
stroke contours and scribbled fringe on the lower edge of
the headpiece. It is not incompatible with other small
drawings that can be connected with Danti on other grounds.

A drawing published by E. Dhanens (Jean Boulogne, fig. 25) and identified as an early study for Giovanni Bologna's Fountain of Neptune in Bologna (fig. 144) seems more likely to record Danti's project for the Fountain of Neptune competition in Florence in 1560. Such a Michelangelesque posture as the Neptune holds is without precedent in Giovanni Bologna's work, and the figure is substantially the same as Danti's Onore (fig. 28) carved a few months after the competition. The small prisoner figure at the base of the fountain is--as nearly as can be judged on the basis of the drawing--also found on the Altar of San Bernardino in the Duomo in Perugia, in the third register of figures on the left hand side. The figure of Neptune--especially in the lower parts--also bears a striking resemblance to a drawing in the Louvre formerly attributed to Danti by C. de Tolnay (Michelangelo, IV, fig. 271) an attribution recently retracted in favor of Michelangelo himself. (C. de Tolnay, "Sur des vénus dessineés par Michel-Ange", p. 193-200) A third drawing in the Graphische Sammlung, Munich (fig.145-6) showing a sketch of an alternative project for the catafalque of Michelangelo on the recto and a plan and elevation for an equestrian monument on the verso is closely related to the Neptune drawing; the blockily sketched, footless statues being precisely comparable to the prisoner at the foot of the fountain. Compare also the lightly sketched beginnings of figures in the Brazen Serpent relief (figure 24, left). The basic elements of the architecture--rectangles with a narrowly banded inner

field, and a sharply angled cornice above are shared in
both drawings. The same may be said of the study for
an equestrian monument on the verso. The contours are
drawn and swiftly redrawn as they are on the Neptune
drawing. The horse's tail compares to the vase-carrying
tritons below the Neptune. The fringe on the bottom of
the horse's saddle is the same as that in the headpiece of
the Turin drawing.

The Munich sketch bears a traditional attribution to
Zanobi Lastricati, and has always been considered a sketch
for the final arrangement of the figures on the catafalque.
Wittkower (The Divine Michelangelo, p. 156 and p. 161)
relates the drawing to the circle of Cellini, suggesting
that it was done after the final design of the catafalque
had been settled upon, in order to test out the different
locations of the allegorical figures. He notes that the
draughtsman "must have been a man of exceptional ability,
for on the verso of the sheet is a highly competent design
by his hand for an equestrian monument. . .distinctly remini-
scent of Cellini." Whether or not Danti was a partisan
of Cellini's in the dispute over the catafalque it is
not possible to say, but he might have been expected to
have a role in the planning of the catafalque; and less than
a year after the funeral of Michelangelo he began work on
the equestrian statue in the Piazza San Apollinare.

All of these drawings are merely sketches, and provide
only a clue to what Danti's finished drawings might be like,

if there are such drawings to be found. The Turin head is similar to the head of an old Woman in the Casa Buonarroti variously attributed to "Andrea di Michelangelo", Antonio Mini, and Bacchiacca (Barocchi, Michelangelo e la sua scuola, no. 190)

In view of the discussion above a drawing in the Museum of Fine Arts, Boston must be a drawing after rather than a study for Danti's Leda and the Swan, as has been suggested by J. Pope-Hennessy,(Victoria and Albert Catalogue, p. 458). A drawing in the Uffizi, Saul Anointing David (Santarelli 9202) also does not seem associable with the drawings attributed to Danti above.

The report that Danti was a master of niello (G. B. Vermiglioli, Biografia degli Scrittori Perugini, Perugia, 1829, I, p. 373) is surely in error. He refers to A. Duchesne, Essai sur les Nielles, Gravures des Orfévres florentins du XVI e. Siècle, Paris, 1826, where a "Danti" is listed. In P. Zani, Enciclopedia metodica critico-ragionato delle belle Arti, Parma, 1820, VII, p. 246, also cited by Vermiglioli, this Danti is referred to as "orefice-intagliatore--viveva 1450."

APPENDIX III

DANTI'S TESTAMENT

ASP. not. Ottavio Aureli. Liber testamentorum,
1566-1586, f. 97r-98r.

Eisdem millesimo inditione et pontificatu quibus
supra, die vero vigesima prima mensis maii. Actum Perusiae
in domo infrascripti testatoris sita in civitate Perusiae
in Porta Solis et parochia Sancti Florentii, iuxta viculum,
boba ecclesiae Sancti Florentii, domum dominae Faustinae
uxoris Ludovici Lupatelli et alia latera. Presentibus
ibidem Barnabeo Ser Joannis Baptistae de Francischinis,
Sylvestro Antonii Jasonis, Pauolo Hieronimi de Pazoniis,
Nicolo Francisci Andreae, Simone Ugolini, Pauli di Picciolis,
Bartholomeo Francisci Bartholomei furnario, omnibus de
Perusia, et Joanne Maria Francisci de Magis de castro
Fractae testibus ad infrascripta ab infrascripto testatore
vocatis habitis et rogatis

Vincentius Julii Dantis de Perusia, sanus mente et
intellectu, et in bona et recta scientia constitutus, licet
corpore languens, et in lecto iacens, considerans hominum
vitam labilem esse et caducam, et nil esse

morte certius, et hora mortis incertius, timens
casum furturae mortis nemini evitabilis, nolens decedere
intestatus ne de suis bonis post eius obitum aliqua inter
aliquos valeat exoriri discordia, presens testamentum

nuncupativum, quod de iure dicitur, sine scriptis facere
procuravit et fecit subsequentis tenoris, videlicet

Imprimus commendando animam suam omnipotenti Deo,
iudicavit et reliquit eius cadaver, cum ei mori contingerit,
sepeliri in ecclesia Sancti Dominici in sepultura suorum
maiorum.

Item iudicavit et reliquit iure legati dominae
Apolloniae adpresens ipsius testatoris famulae florenos
quatuor moneta Perusina, ultra eius salarium, quod sibi
debetur pro eius servitute, pro tempore quo stetit ad
servitia ipsius testatoris et eius familiae.

Item iudicavit et reliquit iure legati dominabus
Jacobae et Finitiae Antonii Balconis florenos decem pro
qualibet earum.

Item iudicavit et reliquit iure legati dominabus
Aureliae et Franciscae filiabus Petri ad presens laboratoris
vineae dicti testatoris florenum unum pro qualibet earum,
eis, et earum cuilibet persolvendum quando nupserit

Item iudicavit et reliquit iure legati et omni
alio meliori modo etc. dominae Angelae Chrisostomi de
Perusia eius uxori omnes vestes, anulos, cathenas, monilia,
et alia qualcunque ornamenta per ipsum testatorem pro
ornatu et ad donum ipsius dominae Angelae facta, quae modo
in esse reperiuntur.

Item iudicavit et reliquit eidem dominae Angelae
reddi et restitui florenos septigentos monetae perusinae
per ipsum testatorem abitos pro parte dotis dictae dominae

Angelae, videlicet florenos quatringentos in bonis stabilibus,
prout ipse habuit, et florenos tricentos in pecuniis; et
donec eidem non restituuntur dicti floreni tricenti
mandavit eidem consignari tot bona stabilia ipsius testa-
toris in loco dicto "il piano del Tevere", quae ascendant
ad valorem dictorum tricentorum florenorum per ipsum fruct-
anda donec sibi restituantur dicti tricenti floreni.

In omnibus autem aliis suis bonis, rebus, iuribus
et actionibus ubicunque sunt et inveniri possunt et
poterunt eius heredem universalem instituit, fecit et
esse voluit Hieronymum eius fratrem carnalem. Et hoc
est eius ultimum testamentum, ultima voluntas, et suorum
bonorum ultima dispositio, quod et quam valere voluit
iure testamenti; et si, iure testamenti non valerit vel non
valebit, valere voluit iure codicillorum, aut donationis
causa mortis, vel alterius cuiuscumque ultimae voluntatis,
prout metius et validus de iure valere et tenere poterit,
cassans, irritans et annullans omne aliud testamentum, codi-
cillos, donationum, causa mortis, et quancumque aliam ultimam
voluntatem per eum forsan hactenus factam et conditam; volens
presens testamentum omnibus aliis prevalere; rogans me no-
tarium infrascriptum, ut de predictis publicum conficerem
instrumentum etc.

APPENDIX IV

DANTI'S APPOINTMENT AS
CITY ARCHITECT OF PERUGIA

ASP. Consigli e Riformaze, n. 142, a. 1573, f. 189 r,v.
20 Luglio, 1573.

Havendo li Mag.ci s. Priori delle arti e popolo
di Perugia hauto piu e diversi ragionamenti con mon
(signore) R.mo Gover(nato)re sopra la conservatione degl'
edifitij publici i quali come per isperientia si vede
parte per l'antichità loro et parte per non haver la
città una persona, che tenga particular cura di visitarli
e rivederli sene vano tutta via in perditione percioche
se ben vi sono i mastri di strada essi non dimeno non hanno
altra cura che di ripararli quando son rovinati e per questo
havendo S. S. (Sua Signoria) R(everendissi)ma con molto
prudenza discorso e ricordato loro, che per conservarli e
per riparare con poca spesa quello che spesse volte convien
fare con doppia maggior non si potrebbe fare la più utile
ne la più necessaria previsione, che di condurre un archi-
tetto pub.co il quale pigli non solamente il carico d'
andare spesso per la Città e contado scomendo e rivedendo
i ponti le fonti e loro aquedutti e tutti gli altri edificij
communi et trovandoli difetto alcuno lo notifichi ai magistrati
che per e' tempi risiedeno, et dia loro il disegno che l'
ordine di ripararli con quella stabilita e con quell'orna-
mento utile e vantaggio che conviene ma possa anco giovare

alle fabriche de particolari le quale importano anco al pub-
lico che sieno ben regolate et con giuditio ordinate, et che
le cose di ciaschun cittadino sieno bene usate et con-
siderando pertenato che in fare tale uff(iti)o sarebbe
più utile uno dell' istessa Città il qual zeloso de l'honor
proprio e del decoro et ornamento della patria piu tosto
che del guadagno, l'essercitasse con più fedelta e con
maggiore affectione che non farebbe un forestiero essendosi
massimamente ripatriato m(esser) Vincentio Danti il quale
per il buon saggio che ha dato di se ne suoi primi anni
facendo la statua di PP. Giulio tertio, et restaurando
l'arquedutto della fonte di piazza e per l'opere maravigliose,
che in sua gioventu ha fatte apresso il Serenissimo Sig.
granduca di toscano merita d'esser abracciato aiutato e
favorito di comun volere di ciaschuno di loro. M. S.
(Magnifici Signori) et di expresso consenso e volunta del
p(refa)to Mons(ignor) Gover(nato)re, fatte le debite pro-
poste e servate le cose da servarsi tra di loro per segreti
suffragij tra di loro elessero e deputarono per architetto
pub(li)co per tempo di cinque anni incominciati a primo di
luglio e da finire come segue il p(refa)to m(esser) Vincentio
Danti con gl'infras(crip)ti oblighi, cap(ito)li salario et
emolumenti cioè

 Sia obligato non solamente quando ne sarà ricerco dai
magistrati della Città visitare gl'edificij pub. sudetti e
darli il suo disegno ma anco per se stesso sensa loro richiesta
almeno una volta l'anno andare in persona a rivederli et

investigare in che termine si trovino et apparendovi manca-
mento alcuno notificarlo alli Mag.ci SS. priori et alli
mastri di strade et mostrare il modo di ripararli ne possi
perciò di mandare

che si li dia pagamento e spesa alcuna eccetto l'
infras(crip)to salario e quando sarà ricerco la cavalcatura

Tutte le volte che sarà chiamato da particolari a
vedere alcuna fabrica non essendo impedito per causa pub
(li)ca sia obligato andarvi a dare il suo dissegno e per suo
viatico se sarà fra due miglia fuori della Città non possa
pigliar piu che mezo scudo il giorno e fuori di doi miglia
uno scudo et in ciò contra i renitenti sia obligato il
podesta a ministrarli summarià et expedita giustizia

Che per suo salario debbia havere per il servitio
che farà al pub(li)co scudi dodeci di moneta l'anno da pag-
arseli per man(da)to di Mons(ignor) R(everendissi)mo Gover
(nato)re che sarà pro t(em)p(o)re delli 250 scudi che oltre
alli loro salarij restano alli mastri di strada per spendere
in reparatione di detti edifitij et la magca communità di
Perugia sia obligata gratis et senza pagamento di pegione darli
per d(etto) tempo l'uso della fonderia che oggi serve per
scorticatoro a pie l'orto de R(everendi) preti del Giesù
et riconoscerlo per uffitiale pub(li)co come si fa con
l'officiale della piazza et della fonte tanto nel portar
dell'arme quanto negl'altri emolumenti straordinarij che dà
il palazzo.

Published by O. Scalvanti in L'Umbria, Rivista d'arte

e lettaratura, January, 1898, p. 10. Transcription
above checked against the original. The document is also
transcribed, apparently from another copy, by A. Mariotti,
PBA, Mss. 1712, Miscellanea di A. Mariotti, f. 40v to
42r.

APPENDIX V

THE HISTORY OF THE TRATTATO
AND OTHER OF DANTI'S WRITINGS

Il Primo libro del trattato delle perfette pro-
porzioni di tutte le cose che imitare e ritrarre si possano
con l'arte del disegno. Di Vincenzo Danti. All'illustrissimo
et Eccellentissimo Signor Cosimo de'Medici, Duca di Fiorenza
e di Siena was published in Florence in 1567, the dedication
dated April 21 of that year. This first edition is extremely
rare. A resumé of the treatise was published by L. Cicognara
in his Storia della scultura in 1824 (vol. V, p. 241-244
see also Catalogo ragionato dei libri d'arte e d'antichità,
Pisa, 1821, I, p. 155. He gives the press as Giunti) and
his avid praise for the "utili riflessioni e sani insegna-
menti" contained in it impelled the Perugian scholar G. B.
Vermiglioli to undertake a new edition (Il Primo libro del
trattato delle perfette proporzioni di tutte le cose che imi-
tare, e ritrarre si possono con l'arte del disegno. . .,
Perugia, Tip. Francesco Baduel, 1830) There is no certain
evidence that the first edition of the treatise was published
by Giunti and Vermiglioli probably followed Cicognara. In
the catalogue of the Biblioteca Augusta Comunale in Perugia
there is another edition of 1840 listed with a slightly
varied title (Il primo libro del trattato delle perfette
proporzioni di tutte le cose che imitare e ritrarre si possono
con l'arte del disegno. Edizione seconda dopo la ratissima de'

Giunti del 1567, Perugia, Vincenzo Bartelli (nella tip. di
Francesco Baduel), 1840, with slightly different pagination.
Both of these editions are also extremely rare, and I know
of no other copy of the 1840 edition than that in Perugia.
The fourth edition of the Trattato appeared in 1960 in
Trattati d'Arte del Cinquecento fra Manierismo e Contro-
riforma, Bari, I , p. 207-269 with critical and philo-
logical commentary by Paola Barocchi.

As its present title implies, Danti's treatise was to
have been much longer. The immediate circumstances of its
writing are uncertain, but it may have had to do with Danti's
membership in the Accademia Fiorentina. A book of similar
intention was written by Alessandro Allori to gain acceptance
to the Accademia (L. Berti, Il Principe, p. 279). Allori
and Danti were admitted at the same time, in September, 1565,
and if Danti's Primo Libro was written for a similar purpose,
then its composition would date at least two years before
its publication. At the end of the first book Danti outlined
the encyclopedic undertaking which was to follow. The first
book considered in what way proportion is found in all things
that can be imitated or represented (that is, all visible
things); the second--the first of those which was never
published--was to treat in general of the bones of the human
body and antomy; the third was to treat interior anatomy;
the fourth, the muscles of the head; the fifth the muscles
that move the shoulder, arm, and hand; the sixth, the muscles
that move the back, thorax and abdomen; in the seventh thighs,

legs and feet, and discuss the number, position, and
function of all the muscles. Each of these chapters was
to be illustrated at the beginning with drawings. In the
eighth book was then to have followed a consideration of
the uses of all the parts of the body; in the ninth the
reason for the shape of all the superficial parts of the
body; in the tenth of the attitudes and movements; in the
eleventh, of the emotions; in the twelfth of the composition
of histories, draperies, and other habiliments; in the
thirteenth, of animals and landscape; in the fourteenth
of the proportions of architecture derived from the human
figure; and in the fifteenth "of the practice of this art
in general".

It is difficult to say how far Danti got with this
project. In the dedication (1960 ed., p. 209) he wrote
that he had made many years the opportunity for the study
of the works of Michelangelo, and he adds a few lines later
that he had singlehandedly dissected no fewer than eighty
corpses in order to qualify as the author of such an am-
bitious project. This boast might make us dismiss the
whole enterprise as a pipe dream, if it were not that the
treatise is mentioned as if it were completed by R. Borghini
(Il Riposo, 1584, p. 522: "Scrisse un'opera sopra il
disegno divisa in 15 libri, de' quali sene è veduto uno
in istampa, e tosto si spera di vedere in luce gli altri per
mezo di Frate Ignatio suo fratello matematico, e cosmografo
eccellentissimo, oltre à molte altre sue virtù, che potrebbono

un giorno maggiormente far noto al mondo il valor suo"). Borghini
speaks often of Ignazio Danti, and seems to have been on
familiar terms with him. Ignazio Danti himself mentioned
his brother's writings (I. Danti, Prospettiva del Vignola,
1682 ed., p. 94, "Se bene nella stessa proposta a figura
digradata si potrà dalle misure delle parti del corpo
humano cavare le misure de gl'ornamenti dell'Architettura,
sì come fanno i periti, & come da Vincentio Danti è scritto
ne'suoi libri dell'arte del Disegno. . . .se divideremo una
delle teste nelle sue quattro parti, si potranno parimente
digradare, come si vede nel quadro della testa. . .diviso. "
and p. 3, "Et questo è la descrittione dell'occhio, tratta
da' libri dell'Annotomia di Vincentio Danti: dove perchè si
vede il centro dell'humor Christallino fuor del centro della
sfera dell' occhio per la quinta parte in circa del suo dia-
metro; non lascerò in questo proposito di avvertire, che il
Vesalio, & altri, che posero l'humor Christallino concentrico
all'occhio, hanno errato; non pure per quello che ho osser-
vato nel Valverde, & in Vincentio Danti, ma anco per la
prova, che ne ha da me stesso fatta in molte Annotomie, che
feci altre volte in Firenze, & in Bologna. . ." From these
notices it can be concluded that Danti was serious about
his anatomical pursuits, that he could have carried them on
in Florence as he implied in his introduction, and that the
parts of the treatise which he described at the end of his
first book were at least partially written. Ignazio Danti
had the unhappy fate of being heir of the literary efforts

of his ill-starred family, and hemmanged to prepare few of
them for publication during his own brief lifetime. Ignazio
Danti followed his brother to the grave in 1586, and when
next his library is of interest for Danti's papers, it was
being offered for sale to Ferrante Gonzaga, prince of Guastalla
(V. Marchese, Memorie dei più insigni pittori, scultori e
architetti Domenicani, II, p. 376n). Ignazio Danti was the
bishop of Alatri at the time of his death. There is no
trace of his library there, and I was informed by the Curia
that his papers had been taken some years ago to Rome. Since
there are no drawings from Danti's treatise known (although
certain of the many "school of Michelangelo" anatomical
studies will probably prove to be his) it would seen that
either the remainder of the treatise has been destroyed, or
else that, as Cicognara darkly conjectured, it lies rotting
in some "archivio polveroso". There is sufficient evidence
of its existence to warrant careful search for it.

Some of Ignazio Danti's papers existed in Perugia,
as can be seen from an examination of Ripa's Iconologia (see
the edition, Perugia, 1765, enlarged by C. Orlandi, II, p.
344, where the invention of Equità is said to have been
found among the writings of Ignazio Danti; see also sub
voce "Pellegrino") Ripa was a Perugian and it is reasonáble
to suppose that he was speaking of the papers in Perugia
and not in Alatri and Rome. There is once again no trace
of these papers.

Danti is also credited, along with his poetry, (Appendix, VII) with a book of the lives of the eminent sculptors; see A. Oldoini, <u>Atheneum</u> <u>Augustum</u>, Perugia, 1678, p. 329; followed by P. Bayle, <u>Dictionaire</u> <u>Historique</u> <u>et</u> <u>Critique</u>, Amsterdam, 1734, II note to the life of Ignazio Danti "Monumenta plura reliquit, inter quae connumerantur Vitae Italico idiomate coelatorum staturarum illustrium", followed in turn by L. Pascoli, <u>Vite</u> <u>Perugini</u>, p. 143. Pascoli mentions Oldoini as does Bayle, and there is no indication that the manuscript was known after 1678.

Pascoli also lists an autobiography in <u>terza</u> <u>rima</u> (<u>Vite</u> <u>Moderni</u>, p. 293). He did not seem to know the un-published parts of the treatise saying only that Danti "lasciò diversi manoscritti".

APPENDIX VI

DANTI'S DESIGN FOR THE ESCORIAL

The primary source for the Escorial design competition
is Ignazio Danti, Le due Regole, 1583, p. 3 (unnumbered).
According to his account, Philip II showed plans for the
Escorial to Baron Bernardino Martirano who after criticizing
them suggested the king submit them to the best architects
in Italy. This was done. Vignola, Alessi, Tibaldi and
Palladio are mentioned along with "undisegno publico dall'
Accademia dell'Arte del Disegno (in Florence), & un par-
ticolare di forma ovale fatto da Vincenzo Danti per comanda-
mento del Gran Duca Cosimo; la copia del quale sua Altezza
Serenissima mandò in Spagna nelle proprise mani del Rè, tanto
le parve bello, e capriccioso." In all twenty two designs
were drawn up, out of which, according to Danti, Vignola
made one surpassingly beautiful plan, after the manner of
Zeuxis. This version does not mention that Danti was
invited to Spain. Raffaello Borghini who was undoubtedly
close to Ignazio Danti describes Danti's role as follows
(Il Riposo, Florence, 1584, p. 522): "Fece un disegno
di forma ovale accomdandosi al sito per lo Tempio della
Scuriale, che all'hora disegnava di fare il Re Filippo, il
quale fu mandato dal Gran Duca Cosimo à S. Maestà insieme
con un'altro fatto dall'Accademia Fiorentina sopra il disegno

e se non che si era ritirato Vincentio a Perugia, & avea
preso Donna, farebbe facilmente andato (si come ne hebbe aviso
di fare) à mettere detto disegno in opera. Molti altri
disegni e fabbriche fece. . ."

The notion gradually solidified that Danti was
invited to Spain, Pascoli, Vite Moderni, Rome, 1730, p.
292. ". . . fu richiesto per mezzo del Granduca medèsimo
dal Re Filippo d'ùn disegno della fabbrica, che far voleva
all'Escuriale, che fatto da lui in forma ovata, fu subito a
S. M. trasmesso: e le piacque tanto, che gli ordinò altri
disegni per altre fabbriche, che meditave far nel suo regno,
e lo chiamò alla corte; e se ne sarebbero alcuni messi in
opera, se avesse voluto trasferirvisi ,e non fosse stato im-
pedito da'molti lavori, a cui era in patria positivamente
impegnato."

The records of the Accademia del Disegno yield little
information in addition to Ignazio Danti's version more than
a date. ASF. Arti. Accademia del Disegno, Libro del
Proveditore "F", f. 20v. The last date entered is April
20, 1572. "Ricordo come p(er) ordini dei s(itgnor)i Consolj
& Consiglierj si vinsa. . .6. uominj p(er) vedere certe piante
e djsegni i quali erano duna fabricha del re filippo e quali
sej uominj giudicasino le dette piante e disegnj se (stiano?)
bene se none le djse (gnasino) e cosi fu vjnto

 M. Bartolomeo amanatj

 M agniolo bronzinj

M. Vincenzo derossi

M. Francesco da Sangallo

M. Vincenzo danti

 Zanobj Lastricatj

They seem to have met to discuss the plans "detono libero
parere sopra dette piante di fabrica reale allj. . .di
giugno 1572. No mention is made of Danti's plan. Earlier
plans for the Escorial had been submitted to the Accademia
in 1563, but there is no record that Danti had anything
to do with the episode, although it is often erroneously
stated that his plan was sent to Philip II in 1563. On the
jury of 1563 see V. Daddi-Giovannozzi, "L'Accademia fior-
entina e l'Escuriale", Rivista d'Arte, XVII, 1935, p. 423-
427. The 1572 revision of the plans for which Danti's
oval plan was proposed concerned of course only the church
of San Lorenzo, not the entire building.

 Recently a sketch in the Codex Biringucci has been
linked with Danti's proposal. See W. Lotz, "Die ovalen
Kircheräume des Cinquecento," Römisches Jahrbuch für
Kunstgeschichte, VII, 1955, p. 50-54; and J. Ackerman
and W. Lotz, "Vignoliana," Essays in Memory of Karl
Lehmann, New York, 1964, I, 1-24.
The same plane is discussed by M. J. Lewine, "Vignola's
Church of Sant'Anna de'Palafrenieri in Rome," Art Bulletin,
XLVII, 1965, p. 199-229.

APPENDIX VII

DANTI'S POETRY

Raffaello Borghini (Il Riposo, p. 522) and Lione
Pascoli (Vite Moderni, p. 293) speak admiringly of Danti's
prowess as a poet. Borghini described him as skilled in
writing Tuscan verse and added that he was especially adept
in the composition of centoni on Petrarch and other writers.
Pascoli repeated what Borghini had written and in addition
listed an autobiography in terza rima among Danti's poetic
accomplishments. Perusal of the many contemporary collect-
ions of poems published in small editions in Florence in
the years between 1560 and 1575 would undoubtedly multiply
the numbers of Danti's poems given below. Only one of
Danti's poems has been turned up by a modern scholar, a
sonnet found by Julius von Schlosser and published in his
study of Danti in 1913 ("Aus der Bildnerwerkstatt", p. 73;
from T. Bottonio, Poesie Sacre, I, p. 29. For the intro-
duction to the sonnet and the sonnet to which Danti's poem
is a reply see Catalogue VI and Chapter III, note 11.) The
first poem given below is that discovered by von Schlosser.
The additional poems are here presented for the first time.

Risposta di Vincenzio Danti al Padre Fr. Timoteo
Bottonio:

Ahi ch'errai nel sentier con false scorte
dell'oprar mio, dove 'l desio mi spinse,

Mentr' ei leve, e sublime a far m'astrinse

Opra, ch'ognor pena, e dolor m'apporte

 Voi per la via, che'alle celesti Porti

 Guida ogn'Uom, che quaggiù se stessi vinse

 Veggio sicuro andar, oichè vi cinse

 L'abito sacro, e fè del Ciel consorte

Sopra la pianta d'un si bel disegno

Doveva alzar della mia vita il fianco

Contra il furor di tante aspre procelle.

Ma l'opre mie non van conformi al segno

Dell'alte vostre; e in van m'affanno , e stanco,

Non godendo queste io parti, ne quelle.

There are also two sonnets to Benvenuto Cellini
published by A. Mabellini, <u>Delle</u> <u>Rime</u> <u>di</u> <u>Benvenuto</u> <u>Cellini</u>,
Florence, 1892, p. 326-327 and p. 329-330. Mabellini re-
cognized the signature as "Vincentio scultore da perugia"
in both cases, but did not know who this might have been.
The poem commemorates the completion of Cellini's marble
Christ now in the Escorial, and so must have been written
around 1562.

 Voi ben dal ciel, voi ben venuto sete

Con l'imagin di Dio ne l'alta mente

Per formar qui tra la Cristiana gente

La vera effigie sua che scutto avete

 Quando sì nobile opra scoprirete

A ciaschedun parrà Cristo presente

Veder nel di che fur l'ame redente

Si ben l'arte e'l suggetto aggiunti arete,

 Lo certo veggio uscir l'ultimo fiato

Dai santi labbri; et s'egli è carne o sasso

Chiaro non scorgo, intento a sì bell'opra

 Per cui l'alma si desta e 'l suo peccato

Lascia, mentre il contempla afflitto et lasso,

Si par ch'appunto il ver l'arte discopra.

 A Benvenuto Cellini Scultore

Non vogliate, Signor, prendere a sdegno

Mio troppo ardir che ben l'alma s'accorge

De l'umil verso incolto, on d'ella porge

Quanto più, lode al chiaro vostro ingegno

 Ma se ben il dir mio lunge è dal segno

Frenar non posso il gran desio che sorge

Pur leve in alto, mentre attento scorge

In breve sasso un così gran disegno

 Ben dentro al cor mi sento et quanto et come

Di voi cantar dovrebbe un nuovo Homero;

Ma l'ingegno non basta a esprimer poi

 Dunque sol per mostrarvi il cor sincero,

Con basso stil mossi a cantar di voi,

Non già per giunger fama al vostro nome

 Vincentio scultore da Perugia

See also <u>Sonnetti Spirituali di M. Benedetto Varchi</u>

con alcune <u>risposte</u>, & <u>proposte</u> di <u>diversi</u> <u>eccellentissimi</u>
<u>ingegni</u> <u>nuovamente</u> <u>stampati</u>. In <u>Fiorenza</u> <u>nella</u> <u>Stamperia</u>
<u>di</u> <u>Giunti</u>, 1573, no. 47, in whtch Danti replied to a
sonnet by Benedetto Varchi.

A'Messer Vincenzio Danti

Ben mi credea dopo mie tali,e tante

Colpe da lungo, desto, e mortal sonno

Ringraziar Dio lodando: hor piu m'assonno

Che prima: e meno ardisco andar gli innante.

Perch'è grande il Signore, e sopra quante

Lode mai furo, ò sono, ed esser puonno:

Formidabile ancor, perch'egliè su innante.

Voi dunque DANTI e sì chiaro, e si pio

col dolce vostro à me sì caro Frate;

Per me lodate, e ringraziate Dio:

A Lui potenza, à Lui fortezza date,

Qual non è poco, anzi pur nella fio

À chi nacque per Noi, visse, e morio?

R. di M. Vincenzio Danti

BEATE colpe, che di tali, e tante

Lodi, e grazie cagion fur sì, che'l sonno

(Bench'io son quel, ch'ancor vegliando assonno)

Han desto Voi, che veglianate innante.

Mostrando altera prece sopra quante

Furon gia mai piu grate, e ch'ognor puonno

Render placato Dio d'ogni ira; e Donno

Altrui far sopra à chi di Noi fu innante.

Col vostro altero stile hor sacro, e pio

 Seguite l'alta impresa, e'l mio buon Frate

 Meco di tanto ben ringrazia Dio.

Ma Voi, mentre tal lodi, e grazie date;

 Prego ch'insieme ogni mio graue fio

 Ponghiate auanti à chi per Noi morio.

The major surviving example of Danti's poetry
is the "Capitolo contra l'alchimia" in the Biblioteca
Nazionale in Florence (Palat. 264. 35. E, 5, 2, 39, no.
XXIII f. 76r-78r. See F. Palermo, I Manoscritti
Palatini di Firenze, Florence, 1853, I, p. 459; and
L. Gentile, I Codici Palatine, Rome, 1889, I, p. 438.
It is stated by Gentile that every third verse is from Petrach.
Only the third verse is from Petrarch. The manuscript is
seventeenth century. The poem itself has not been previously
published.

Capitolo di messer Vincenzo Danti Scultore
Perugino contro l'Alchimia del qle ogni terzo verso è del
Petrarca

 Il falso inganno, e la bugiarda froda

 all'Arte, in che s'aggira l'Alchimista

 qual'io mi sia p(er) la mia linga s'oda

Ne dirò sol' di vista né di visto

 Ma di.andato mal p(er) qsta via

qlch' in molt'anni a gran' pena s'accquista

E che sia il ver' guardate in qsta mia
 mal'condotta presenza, che vi dice
 povera, e nuda vai Filosofia.

Cascato in Povertà, che si disdice
 algrado mio, e vivo in molti affani
 miser, 'ond'io sperava esser' felice

Cagion' di tal sofisti iniqui inganni
 che p(er) tal', qual'io son', ognun' m'addita
 all'andar' alla Voce, al Viso, a Panni.

Ch' Avarizia ingorda, et infinita
 ch'altrui conduce, ov'infra quei son messo
 ch'anno se in odio, e la soverchia vista

Ma pur' di me mi maraviglio spesso
 pensando a ql ch'io son, 'e che son stato
 ch'appena riconosco omai me stesso

Ora resti ciascun' maravigliato,
 mentre che la mia lingua sarà tale
 che stringer' possa il mio infelice stato

Voi che filosofando il naturale
 fra Golfi (?), e tra metalli ve' n' andate
 deli restate a'veder' qual' è 'l mio male

E se punto vi cale, e punto a mate

uscir' d'errore, il mio perpetua Danno
tal'or'vi muova, e con pietà guardate

E da me il credan', come a quei che sanno
che dal tempo, che tal laccio mi prese,
rimane 'ndietro il sesto decim'anno

Tutte l'altre mie buone, e sante imprese
Lascia p(er) questa, che sciopra il pensiero,
Or' con voglie gelate, or con accese

E pensa d'arricchir', ma non fu vero,
ch'io con' qual' mi vedete, e messi poi
ugualmete in non cale ogni pensiero,

L'Alchimia pur'facdento i gesti suoi
m'à fatto vostro esempio, Deh (?) guardate
che similmente non avvenga a voi

Nacque ub principio dl mio mal da un frate,
ch'era in qst'arte p(er) sin all gola,
e parve mirabil 'vanitate.

Dietro al convento una Stanzotta sola
aveva, et ivi me. . .ommi il buon padre
dicendomi di ciò non far' parola.

Com'io fui dentro disse: Ecco la madre
dell'Arte, or' guarda ben'qsta Fornace
di triangoli tondi, e forme quadre

Non posso di qst'altra darmi pace

 che vedi in terra, al mondo era qst'una,

 cadde tre volte; et alla terza giace

Or vien' più innanzi, e guarda qlla Luna,

 con tante bocche, e vengoti a mostrare

 tutte le mie fatiche aduna aduna

Wui si puote ogni cosa lambiccare

 qst'e quanto di torre (?), e di Fucina,

 Arte, ingegno, Natura e 'l Ciel' puon' fare

E qsto è glo Fornel, ove s'affina

 L'Argento, e l'Or'ch'io faccio in somma sono

 grazie, ch' a pochi il Ciel' larghe destina

Ma qsto poco curo, che non ponno

 riccheze in me, ma ben'sprezzate d'una

 qund'ero in parte altro Uom, da qlche io sono

Or povertate è la profession' mia

 Sol' p(er) piacer' di qst'Arte lavoro

 Poco prezzando ql che ogn"Uom' desia

In somma il Padre m'insegno il lavoro

 e mi, trovai da ql poi trasformato

 come l'Avaro, ch'è 'n cercar tesoro

Che quando pensa averlo ritrovato

piu ne desia: Così l'Alchimia ogn'ora

 è p(er) lasciar' piro l'Animo invischiato

E p(er) arcifallir' chi non lavora,

 com' or' con'io, che i Creditori mi fanno

 la sera desiar, 'e odiar' l'Aurora

Sei volte son' p(er) Debito qsto Annon

 stato fra Birri; O qual' sorte , o cagione,

 qual'mio Destin, qual Forza, o qual Inganno.

Non altro, che la mia ostinzaione

 che chiarir' non mi volsi, et ora veggio

 come sono 'ngannate le persone.

Pur' come disperato ogn' or' vaneggio

 e poi concludo di viltade il calle

 la mia Fortuna, che mi puo far' peggio.

Ma voi, ch' amate qsto, e ql metallo

 mutar' in Oro, levate ogni speme

 mentre emendar' potete il vostro fallo

L'Argento, e l'Or', ciascum' dalle sue Vene

 si cavi, ne imitar' poss'io gia mai,

 che natura non vuol', ne si conviene.

Tal' mantener' vogl'io, et tu che n'ai

 discritto Alberto, viemmi contro, etanzi

 venghin' quanti Filosofi fur' mai.

E di qsti mi mostrino gl'avanzi

 le lapate Città, Castella, e Ville,

 Sogni d'Infermi, e Fole di Romanzi.

Non bisogna, ch' alcun' piu si distille

 il suo cervello, che ben' sa qlla mano,

 che'io n'ò cercate gia vie piu di mille.

Piu Legne, e piu Carbon' io arsi in vano,

 che'in Etna non ne tien' cotanti accesi

 l'antichissima Fabro Siciliano.

Ancora gl Anni, non che giorni e mesi,

p(er) dimandar; segreti a chi distilla,

 cercar' m'an'fatto diversi Paesi,

Piu volte l'erbe al Lume di Favilla

 salsi di Notcia, i monti ove sta in cima

 l'antichissimo albergo di sibilla

Del fugga ognun' qst' Arte, e faccia p. ma.

 che vi s'invecchi, come dianzi disse,

 com' Uomo, ch'erra, e poi piu 'l dritto stima

Non crediate ad alcun', che chi ne scrisse

 non l'intese quant'io se fusse bene

 Nestor' che tanto seppe, e tanto visse

A poco a poco tal' sete ne viene

 consumando la vita; Ond'io son'veglio

Del tretto (?) e cieco ch' in te pòn' sua spene:

Ma or' chè da tal' conno mi riseglio
 concludo, e dicoi sopr' ogn' altra cosa
 obbedir' a Natura in tutto è meglio

Alcun' vuol'dire, che tal' Arte è nascosa,
 e ch' un' di troverassi; et io le dico;
 Prima sarà ogni impossibil cosa.

Certo non vi vorrei un' mio Nemico
 in qst' errore; ch'a me non riesce,
 che m'è nascosta, ond'io con' si mendico

Ma piu di me, che d'altro al din' mi neresce
 che pria che sia sarà state; et Inverno,
 e col che rassi il Sol' la orbe, ond'esce.

L'Alchimia dal Demonio del'Inferno
 Fu ritrovata, e le miniere sole
 usciron' buon' di man' del mastro eterno.

E voi,ch'avete il tempo e le parole
 indarno spesse in un' tal'Letargo,
 or' vi riconfortate (si. . .) in vostre sole

Vorreti Lungh' esser' piu parlando, e Largo
 ma tra me dico a qsti tali umori
 forse ch'indarno mie parole spargo

Da poi ch'io veggio in corsi in tali errori

Con la Pente idiota gente Magna,

Pontefici, Regnanti, e Imperatori

Onde tal'fame, qual rabbiosa cagna

va p(er) il mondo qsto, e ql mordendo,

da India, dal Cataio, Marocco e Spagna.

E son' uno di quei, se ben' comprendo,

il pessimo veleno, ch'il mal' crebbe (erebbe)

onde n' ò molt'amaro, e piu n'attendo

che piu saggio di me 'ngannato avrebbe.

--FINE--

BIBLIOGRAPHY

BIBLIOGRAPHY

General History:

I. del Badia
"Egnazio Danti Cosmografo, Astronomo e Matematico e le sue opere in Firenze," Rassegna Nazionale, VI, p. 621-631; VII, p. 434-474, 1881. Published separately under the same title, Florence, 1882

P. Bayle
Dictionaire Historique et Critique, Amsterdam, 1734

L. Bonazzi
Storia di Perugia dalle origini al 1860, Perugia, 1875

B. Giliano
Compendium iuris municipalis civitatis Perusiae, Perugia, 1635

C. Guasti
Bibliografia pratese, Prato, 1844

W. Heywood
A History of Perugia, Cambridge, 1910

A. Oldoïni
Atheneum Augustum, Perugia, 1678

V. Palmesi
"Ignazio Danti", Bolletino di Storia Patria per l'Umbria, V, 1899, p. 81-125

G. Panciroli
De Claris Legum Interpretibus Libri Quatuor, Lipsiae, 1721

L. von Pastor
The History of the Popes from the close of the Middle Ages, London, 1891-1924, 35 vols.

G. B. Vermiglioli
Biografia degli Scrittori Perugini, Perugia, 1829

Vocabulario dell'Accademia della Crusca

Sources:

A. Allori
Dialogo sopra l'arte di disegnare le figure, Mss. BNF, Codex Palatina E.B. 16, 4a, carte 39a

G. Beccini "Un'opera inedita del P. Ignatio Danti
 da Perugia," Archivio Storico per le
 Marche e per l'Umbria, IV, 1898, p. 82-
 112

G. Baglione Le Vite de'Pittori, Rome, 1635

P. Barocchi, ed. Trattati d'Arte del Cinquecento fra
 Manierismo e Controriforma, Bari, 1960,
 3 vols.

C. Baroncelli Cronica della Famiglia Baroncelli,
 Florence, Biblioteca Moreniana, Mss.
 Moreni, vo. 96, no. 1

A. Bertolotti Artisti Lombardi a Roma nei Secoli XV,
 XVI, e XVII, Ricerche e Studi negli
 archivi romani, Mantua, 1884

R. Borghini Il Riposo, Florence, 1584

G. Bottari,
S. Ticozzi Raccolta di Lettere sulla pittura,
 Scultura ed architettura scritti da più
 celebri personaggi dei secoli XV, XVI
 e XVII, Milan, 1822-25, 8 vols

T. Bottonio Poesie Sacre, ed. C. Orlandi, Perugia,
 1779, 2 vols

G. Campori Raccolta di Cataloghi ed Inventarii in-
 editi, Modena, 1870

B. Cellini I Trattati dell'oreficieria e della
 scultura, ed. L de Mauri, Milan, 1927

A. Condivi Vita di Michelangelo Buonarroti,
 Florence, 1746

_____ Vita di Michelangelo Buonarroti, ed.
 C. Frey, Berlin, 1887

Ignazio Danti Le Due Regole della Prospettiva Practica
 di Jacopo Barozzi da Vignola, Rome, 1583

V. Danti Il Primo libro del Trattato delle perfette
 proporzione di tutte le cose che imitare
 e ritrarre si possano con l'arte del
 disegno. Di Vincenzo Danti all'illustrissimo
 et Eccellentissimo Signor Cosimo de'Medici
 Duca di Firenze e di Siena, Florence, 1567

V. Danti Il Primo Libro del Trattato delle perfette proporzione di tutte le cose che imitare, e ritrarre si possano con l'arte del disegno, Perugia, 1830

V. Danti Il Primo libro del Trattato delle perfette proporzioni di tutte le cose che imitare e ritrarre si possono con l'arte del disegno. Edizione seconda dopo la rarissima de' Giunti del 1567, Perugia, 1840

S. Fanti Triompho di Fortuna, Venice, 1527

K. and H. W. Frey Der Literarische Nachlass Giorgio Vasaris, Herausgegeben und mit kritischem Apparate versehen von K. Frey (3rd vol H. W. Frey) Munich, 1923-40, 3 vols.

M. Guardabassi "Documenti intorno alla statua di Giulio III gettata da Vincenzo Danti," Giornale di Erudizione Artistica, I, 1872, p. 16-24

O. Lancellotti Scorta Sagra, Mss, PBA

A. Lapini Diario Fiorentino, ed. Corazzini, Florence, 1900

C. Lenzoni In Difesa della lingua fiorentina, Florence, 1557

G. P. Lomazzo Trattato della Pittura, Scultura ed Architettura, Rome, 1844, 3 vols.

A. Lorenzoni Carteggio inedito artistico di D. Vincenzo Borghini, Florence, 1912

M. A. Maltempi Trattato. . .diviso in quattro Libri, Orvieto, 1585

L. Pascoli Le Vite de' Pittori, Scultori ed Architetti Perugini, Perugia, 1730

I. P. Rosello Il Ritratto del vero governo del principe dall'esempio vivo del Gran Cosimo de'Medici, Venice, 1552

G. Ruscelli Le Imprese Illustri, Venice, 1580

F. Santi "Statuto e matricola dell'arte degli orefici di Perugia", Bolletino della Deputazione di Storia Patria per L'Umbria, L, 1953, p. 162-185

B. Varchi Sonnetti spirituali di M. Benedetto Varchi con alcune risposte, e proposte di diversi eccellentissimi ingegni nuovamente stampati, Florence, 1573

_____ Opere, Trieste, 1859, 2 vols.

A. del Vita Lo Zibaldone di Giorgio Vasari, Arezzo, 1938

G. Vasari Die Lebensbeschreibungen der berühmtesten Architekten, Bildhauer und Maler, Deutsch herausgegeben von A. Gottschewski und G. Gronau, Strassbourg, 1904-1927, 7 vols.

_____ Le Vite de' più eccellenti pittori, scultori, ed architettori scritte da Giorgio Vasari pittore aretino, con nuove annotazioni e commenti di G. Milanesi, Florence, 1878-1885, 9 vols.

_____ Vita di Michelangelo Buonarroti, ed. Paola Barocchi, Florence, 1964, 5 vols.

Architecture, Sculpture and Painting:

J. Ackerman The Architecture of Michelangelo, New York, 1961, 2 vols.

_____ Il Cortile del Belvedere, Vatican City, 1954

F. Antal "Observations on Girolamo da Carpi," Art Bulletin, XXX, 1948, p. 94-102

F. Arnau Three Thousand Years of Deception in Art and Antiques, London, 1961

K. Badt "Raphael's 'Incendio del Borgo'", Journal of the Warburg and Courtauld Institutes, XXI, 1959, p. 35-59

E. F. Bange "Spuren von Michelangelos Brügger Madonna in Deutschland, Frankreich und

den Nederlanden", Mitteilungen des
Kunsthistorischen Institutes in Florenz,
VI, 1940-41, p. 109-114

P. Barocchi Vasari Pittore, Milan, 1964

A. Bartsch Le Peintre graveur, Vienna, 1803-1821,
 22 vols.

E. Battisti "Disegni inediti del Montorsoli," Arte
 Lombarda, Studi in Onore di Giusta
 Nicco Fasola, X, 1965, p. 143-8

D. Barbaro I Dieci Libri dell'Architettura, Venice,
 1629

S. Beguin "A Lost fresco of Niccolo dell'Abbate
 at Bologna in Honor of Julius III",
 Journal of the Warburg and Courtauld
 Institutes, XVIII, 1955, p. 114-122

P. Bellori Le Vite de' Pittori Scultori ed
 Architetti moderni, Rome, 1728

L. Berti Il Principe dello Studiolo: Francesco
 I dei Medici e la fine del Rinascimento,
 Florence, 1967

L. Biadi Notizie sulle Antiche Fabbriche di non
 terminate, Florence, 1824

L. Biagi L'Accademia di belle arti di Firenze,
 Florence, 1941

J. Bialostocki "The Renaissance Concept of Nature and
 Antiquity", Studies in Western Art,
 Acts of the twentieth International
 Congress of the History of Art, Princeton,
 1963, II, p. 19-30

A. Blunt Artistic Theory in Italy, 1450-1600,
 Oxford, 1940

W. Bode The Italian Bronze statuettes of the
 Renaissance, London-Berlin, 1907-12,
 3 vols.

──── "Leonardo als Bildhauer", Jahrbuch der
 Preuszischen Kunstsammlungen, XXV, 1904,
 p. 125-141

_____		Die Sammlung Oscar Hainauer, Berlin, 1897
W.	Bombe	"Vincenzo Danti", Thieme-Becker, Künstler-Lexikon, Leipzig, 1913, VIII, p. 380-387
_____		"I Marmi di Firenze e i gessi di Perugia," Il Marzocco, Florence, 1909, no. 50
_____		Urkunden zur Geschichte der Peruginer Malerei, Leipzig, 1929
_____		"Federico Barocci a Perugia," Rassegna d'Arte, XII, 1912, p. 189-196
E.	Borea	"Grazia e furia in Marco Pino," Paragone, CLI, 1962, p. 24-52
A. E.	Brinckmann	Barockskulptur Entwicklungs-geschichte der Skulptur in den romanischen und germanischen Ländern seit Michelangelo bis zum 18 Jahrhundert, Berlin, 1919, 2 vols.
_____		Barock-Bozzetti, Frankfurt-am-Main, 1923-5, 4 vols.
G.	Briganti	Il Manierismo e Pellegrino Tibaldi, Rome, 1945
R.	Brilliant	Gesture and Rank in Roman Art, Memoires of the Connecticut Academy of Arts and Sciences, XIV, New Haven, 1963
M.	Buccio	Lo Studiolo di Francesco I, Forma e Colore, Florence, Sadea/Sansoni, 1965
C.	Bulgari	Argentieri Gemmari e Orafi d'Italia, Parte Prima, Roma, Rome, 1966, 2 vols.
N. W.	Canady	"The Decoration of the Stanza della Cleopatra", Essays in the History of Art Presented to Rudolf Wittkower, London, 1967, p. 110-118
V.	Cartari	Imagini delle dei de gl'Antichi, 1647 ed., fasc., Graz, 1963
C. I.	Cavallucci	Notizie Storiche intorno alla R. Accademia delle Arti del Disegno, Florence, 1873

G. Cecchini L'Accademia di Belle Arti di Perugia, Florence, 1955

E. M. Casalini "Due Opere del Giambologna all'Annunziata di Firenze," Studi Storici dell'ordine dei Servi di Maria, XIV, 1965, p. 261-276

A. Chastel The Crisis of the Renaissance, 1520-1600, Geneva, 1968

S. Chew The Pilgrimage of Life, New Haven, 1962

M. G. Ciardi Dupré
 "Alcuni aspetti della tarda attività grafica del Bandinelli," Antichità Viva, 1966, p. 22-31

———— "per la cronologia dei disegni di Baccio Bandinelli fino al 1540", Commentari, XVII, 1966, p. 15-38

L. Cicognara Storia della Scultura dal suo risorgimento in Italia fino al secolo di Canova, Prato, 1825, 7 vols and Atlas.

K. Clark The Nude, A Study in Ideal Form, Garden City, 1956

D. E. Colnaghi A Dictionary of Florentine Painters from the 13th to the 17th Centuries, London, 1928

R. Colombo De Re Anatomica, Libri XV, Venice, 1559

U. da Como Girolamo Muziano,1528-1592, Bergamo, 1930

 The Complete Works of Michelangelo, London, 1966

J. Coolidge "The Villa Giulia", Art Bulletin, XXV, 1943, p. 177-225

A. Coomaraswamy "Ornament",Art Bulletin, XXI, 1939, p. 375-382

N. Dacos "Il Trastullo di Rafaello," Paragone, 219, 1968, p. 2-29

V. Daddi-Giovannozzi "L'Accademia fiorentina e l'Escuriale," Rivista d'Arte, XVII, 1935, p. 423-27

B. Davidson — "Daniele da Volterra and the Orsini Chapel, II", _Burlington Magazine_, CIX, 1967, p. 553-561

E. Dhanens — _Jean Boulogne: Giovanni Bologna Fiammingo_, Brussels, 1956

A. N. Didron — _Christian Iconography_, London, 1886

U. Diehl, R. Mattaes — "Ehrne Schlange," _Reallexikon zur Deutschen Kunstgeschichte_, IV, p. 818-837

C. Dodgson — "Holbein's Early Illustrations to the Old Testament," _Burlington Magazine_, LV, 1929, p. 176-181

T. Dohm — "L'Arringatore, capolavoro del museo archaeologico di Firenze," _Bolletino d'Arte_, XLIX, 1954, p. 97-117

U. Dorini — "Come sorse la fabbrica degli Uffizi," _Rivista Storica degli Archivi Toscani_, V, 1933, p. 1-40

P. Dreyer — "Giulio Mazzoni as a Draughtsman," _Master Drawings_, VI, 1968, p. 21-14

A. Duchesne — _Essai sur les Nielles, Gravures des Orfèvres florentins du XVI e. Siècle_, Paris, 1826

L. Dussler — _Die Zeichnungen des Michelangelo_, Berlin, 1959

D. L. Ehresmann — "The Brazen Serpent, a Reformation Motif in the works of Lucas Cranach the Elder and his Workshop," _Marsyas_, XIII, 1966-67, p. 32-47

C. Eisler — "The Madonna of the Steps, Problems of Date and Style," _Stil und Überlieferung in der Kunst des Abendlandes, Akten des 21 Internationalen Kongresses für Kunstgeschichte_, Berlin, 1967, II, 115-121

L. D. Ettlinger — "Pollaiulo's Tomb of Sixtus IV," _Journal of the Warburg and Courtuald Institutes_, XVI, 1953, p. 239-274

P. Fabrici — Delle Allusione, Imprese et Emblemi sopra la vita, opere, et attioni di Gregorio XIII Pontefice massimo Libri VI. . . , Rome, 1588

P. Fanfani — Spigolatura Michelangiolesca, Pistoia, 1876

M. Ficino — Concordia Mosis et Platonis Marsili Ficini, Opera, Basel, 1561, 2 vols.

S. J. Freedberg — "Observations on the Painting of the Maniera," Art Bulletin, XLVII, 1965, p. 187-197

——— — Parmagianino, his Works in Painting, Cambridge, 1950

W. Friedlander — Das Kasino Pius des Vierten, Leipzig, 1912

G. Fratini — Storia della basilica e del convento di S. Francesco in Assisi, Prato, 1882

L. Fumi — Il Duomo di Orvieto e i suoi restauri, Rome, 1891

P. Galletti — "I Quadri del Poggio Imperiale nel secolo XVII (da un Manoscritto esistente alla Torre del Gallo)," Arte e Storia, 1883, p. 318, 229-230

C. Gamba — "Nuove Attribuzioni di Ritratti," Bolletino d'Arte, IV, 1924/5, p. 193-217

H. Geisenheimer — "Di Alcune pitture fiorentine eseguité intorno al 1570. II. Gli affreschi nella Cappella dei Pittori (Vasari, Santi di Tito, Al. Allori)" Arte e Storia, 1907, no. 3-4, p. 19-21

J. A. Gere — "The Decoration of the Villa Giulia," Burlington Magazine, CVII, 1965, p. 199-206

M. Gibellino-Krascenninikowa — Guglielmo della Porta, scultore del Papa III Farnese, Rome, 1944

P. Ginori Conti — L'Apparato, per le nozze di Francesco de' Medici e di Giovanna d'Austria, Florence, 1936

P. Giordano "Ricerche intorno alla villa di Papa Giulio", *L'Arte*, X, 1907, p. 133-138

M. di Giovanni "Il Serpente di bronzo della Basilica di S. Ambrogio", *Arte Lombarda*, XI, 1966, p. 3-5

F. Goldschmidt *Die Italienischen Bronzen der Renaissance und des Barock, Erster Teil, Busten, Statuetten, und Gebrauchsgegenstande*, Berlin, 1914

L. Goldscheider *Michelangelo. Painting, Sculpture, Architecture*, London, 1963

L. Goldscheider *Michelangelo's Bozzetti for Statues in the Medici Chapel*, London, 1957

E. H. Gombrich *Norm and Form*, London, 1956

A. Gottschewski "Ein Original Tonmodell Michelangelos" *Münchner Jahrbuch der bildenden Kunst*, I, 1906, p. 42-64

P. Gozzola *Michele Sanmichele*, Venice, 1960

W. Gramberg "Beiträge zum Werk und Leben Pierino da Vincis", *Jahrbuch der Preuszischen Kunstsammlungen*, LIII, 1931, p. 223-228

———— *Die Düsseldorfer Skizzenbucher des Guglielmo della Porta*, Berlin, 1964

———— *Giovanni Bologna: eine Untersuchung über die Werke seiner Wanderjahre (bis 1567)*, Libau, 1936

———— "Guglielmo della Porta, Coppe Fiammingo und Antonio Gentili da Faenza", *Jahrbuch der Hamburger Kunstsammlungen*, V, 1960, p. 31-52

———— "Die Hamburger Bronzebüste Paul III Farnese von Guglielmo della Porta", *Festschrift für Erich Meyer*, p. 160-172

A. Grunwald "Über einige unechte Werke Michelangelos", *Münchner Jahrbuch der Bildenden Kunst*, V, 1910, p. 10-70

C. Guglielmi "Intorno al'opera pittorica di Giovanni Baglione", _Bolletino d'Arte_, XXXIX, 1954, p. 311-326

W. Hager _Die Ehrenstatuen der Päpste_, Leipzig, 1929

N. Hawthorne _The Marble Faun_, Boston and New York, 1889

W. S. Heckscher "The Anadyomene in the Medieval Tradition (Pelagia-Cleopatra-Aphrodite). A Prelude to Botticelli's 'Birth of Venus'", _Nederlands Kunsthistorisch Jahrboek_, VII, 1956, p. 1-39

D. Heikamp "Agnolo Bronzinos Kinderbildnisse aus dem Jahre 1551", _Mitteilungen des Kunsthistorischen Instituts in Florenz_, VII, 1953-56, p. 133-138.

——— "Baccio Bandinelli nel Duomo di Firenze", _Paragone_, 175, 1964, p. 32-42

——— "In Margine alla vita di Baccio Bandinelli del Vasari", _Paragone_, 191, 1966, p. 51-62

——— "Nuovi documenti celliniani, _Rivista d' Arte_, XL, 1958, p. 35-38

——— "Rapporti fra accademici ed artisti nella Firenze del '500", _Il Vasari_, 1957, p. 135-145

A. Hekler "Michelangelo und die Antike", _Wiener Jahrbuch für Kunstgeschichte_, VII, 1930, p. 201-223

J. Hess "Some Notes on paintings in the Vatican Library", in _Kunstgeschichtliche Studien_, Rome, 1967, p. 163-179

N. Huse "Eine Bilddokument zu Michelangelos 'Julius II' in Bologna", _Mitteilungen des Kunsthistorischen Instituts in Florenz_, XII, 1966, p. 355-358.

G. F. Hill _Portrait Medals of Italian Artists of the Renaissance_, London, 1912

G. F. Hill and
G. Pollard _Complete Catalogue of the Samuel H. Kress_

Collection: Renaissance Medals, London, 1967

M. Hirst "Daniele da Volterra and the Orsini Chapel: I. The Chronology and the Altarpiece", Burlington Magazine, CIX, 1967, p. 533-561

_____ "Salviati's two apostles in the Oratorio of San Giovanni Decollato", Studies in Renaissance and Baroque Art presented to Anthony Blunt, New York, 1967, p. 34-36

J. Holderbaum "A Bronze by Giovanni Bologna and a Painting by Bronzino", Burlington Magazine, XCVIII, 1956, p. 439-445

P. Hoffmann "Scultori e stuccatori a villa Giulia. Inediti di Federico Brandani", Commentari, XVI, 1967, 48-66

H. W. Janson "Nanni di Banco's Assumption of the Virgin on the Porta della Mandorla", Studies in Western Art. Acts of the Twentieth International Congress of the History of Art, Princeton, 1963, II, p. 98-107

A. Katzenellenbogen

Allegories of the Virtues and Vices in Medieval Art, New York, 1964

_____ The Sculptural Program of Chartres Cathedral, Baltimore, 1961

H. Keutner "Die bronze Venus des Bartolommeo Ammannati: ein Beitrag zum Problem des Torso im Cinquecento", Münchner Jahrbuch der Bildenden Kunst, XIV, 1963, p. 79-92

_____ "Italienischen Kleinbronzen. Zu den Ausstellungen in London (27. Juli 1961- 1 Oktober 1961) in Amsterdam (29. Oktober 1961-14. Januar 1962) und in Florenz (10. Februar 1962-25. Marz 1962)", Kunstchronik, XV, 1962, p. 169-177

_____ "The Palazzo Pitti 'Venus' and other Works by Vincenzo Danti", Burlington Magazine, C, 1958, p. 427-431

_____ "Uber die Enstehung des Standbildes im

Cinquecento", Münchner Jahrbuch der bildenden Kunst, VII, 1956, p. 138-168

F. Kieslinger — "Ein unbekanntes Werk des Michelangelo", Jahrbuch der Preuszischen Kunstsammlungen, XLIX, 1928, p. 50-54

T. Kitao — "Prejudice in Perspective: A Study of Vignola's perspective treatise", Art Bulletin, XLIV, 1962, p. 173-194

R. Klein — "Giudizio et Gusto dans la Theorie de l'art an Cinquecento", Rinascimento, XII, p.

R. Klein and H. Zerner — Sources and Documents: Italian Art, 1500-1600, Englewood Cliffs, 1966.

W. Körte — Der Palazzo Zuccari in Rom, sein Freskenschmuck und seine Geschichte, Leipzig, 1935

R. Krautheimer — Lorenzo Ghiberti, Princeton, 1956

F. Kriegbaum — "Zum 'Cupido' des Michelangelo in London," Jahrbuch der Kunsthistorischen Sammlungen in Wien, n.F., III, 1929, p 247-257

——— "Der Meister des 'Centauro' am Ponte Vecchio," Jahrbuch der Preuszichen Kunstsammlungen, XLIX, 1928, p. 145-40

——— "Ein verschollenes Brunnenwerk des Bartolommeo Ammannati," Mitteilungen des Kunsthistorischen Instituts in Florenz, III, 1919-32, p. 71-103

E. Kris — "Zum Werk des Pierino da Vinci," Pantheon, III, 1929, p. 94-98

——— "Materialen zur Biographie des Annibale Fontana und zur Kunsttopographie der Kirche S. Maria presso S. Celso in Mailand," Mitteilungen des Kunsthistorischen Instituts in Florenz, III, 1919-32, p. 201-53

K. Langedijk — De Portretten van de Medici tot omstreeks 1600, Diss. Amsterdam, 1968

K. Lankheit <u>Florentinische Barockplastik 1670-1743</u>, Munich, 1962

I. Lavin "Bozzetti and Modelli: Notes on Sculptural procedure from the Early Renaissance through Bernini," <u>Stil und Uberlieferung in der Kunst des Abendlandes. Akten des 21. International Kongresses für Kunstgeschichte</u>, Berlin 1967, III, p. 93-103

———— "Observations on Medievalism in Early Cinquecento Style," <u>Gazette des Beaux Arts</u> L, 1957, p. 113-118

S. H. Levie <u>Der Maler Daniele da Volterra</u>, Cologne, 1962

M. J. Lewine "Vignola's Church of Sant'Anna de' Palafrenieri in Rome," <u>Art Bulletin</u>, XLVII, 1965, p. 199-229

R. Lightbrown "Michelangelo's Great Tondo, its Origins and Setting," <u>Apollo</u>, LXXXIX, 1969, p. 22-31

C. Lloyd "Drawings attributable to Niccolò Tribolo," <u>Master Drawings</u>, VI, 1968, p. 243-245

W. Lotz
J. Ackerman "Vignoliana," <u>Essays in Memory of Karl Lehmann</u>, New York, 1964, I, p. 1-24

W. Lotz "Die ovalen Kirchenräume des Cinquecento," <u>Römisches Jahrbuch für Kunstgeschichte</u>, VII, 1955, p. 7-99

A. Mabellini <u>Delle Rime di Benvenuto Cellini</u> Florence, 1892

E. Maclagan "Notes on Some sixteenth and seventeenth century Italian Sculpture", <u>Burlington Magazine</u>, XXXVI, 1920. p. 234-245

———— "The wax models by Michelangelo in the Victoria and Albert Museum," <u>Burlington Magazine</u>, XLIV, 1924, P. 8-15

———— <u>Italian Sculpture of the Renaissance</u>, Cambridge, 1935

L. S. Maclehose Vasari on Technique, New York, 1960

C. Manara Montorsoli e la sua opera genovese, Genoa, 1959

V. Marchese Memorie dei più insegni Pittori, Scultori e Architetti Domenicani; con aggiunta di alcuni scritti intorno de belle arti, Florence, 1845, 2 vols.

G. Mariacher Argenti Italiani, Milan, 1965

A. Mariotti Lettere Pittorische Perugine, Perugia, 1788

L. Marucci "Disegni del Bandinelli per la Strage degli Innocenti," Rivista d'Arte, XXIX, 1954, p. 97-114

A. L. Mayer "Giuliano Fiorentino," Bolletino d'Arte, VII, 1922-3, p. 337-346

M. Meiss Painting in Florence and Siena after the Black Death, New York, 1964

P. Meller "Physiognomical Theory in Renaissance Heroic Portraits," Studies in Western Art, Acts of the Twentieth International Congress of the History of Art, Princeton, 1963, II, p. 67-69

D. Mellini Descrizione dell'entrata della Serenissima Reina Giovanna d'Austria e dell'apparato fatto in Firenze. . ., Florence, 1566

H. S. Merritt "The Legend of St. Achatius: Bacchiacca, Perino, Pontormo," Art Bulletin, XLV, 1963, p. 258-263

A. Mezzanotte La Deposizione dalla croce quadro di Federigo Barocci di Urbino nella Cattedrale di Perugia. . .con una lettera storico-critica di B. Battista Vermiglioli, Perugia, 1881

U. Middeldorf "A Bandinelli Relief," Burlington Magazine, LVII, 1930, p. 65-71

——— "Giovanni Bandini, detto Giovanni dell'Opera", Rivista d'Arte, XI, 1929, p. 481-518

U. Middeldorf "An erroneous Donatello Attribution",
 Burlington Magazine, LIV, 1929, p. 184-
 188

U. Middeldorf and
F. Kriegbaum "Forgotten Sculpture by Domenico Poggini",
 Burlington Magazine, LI, 1928, p. 9-17

U. Middeldorf "Additions to the work of Pierino da Vinci",
 Burlington Magazine, LIII, 1928, p. 299-
 306

U. Middeldorf "Two Wax Reliefs by Guglielmo della Porta",
 Art Bulletin, XVII, 1935, p. 90-97

G. Milanesi "Documenti riguardanti le statue di marmo
 e di bronzo fatte per le porte di San Gio-
 vanni di Firenze da Andrea del Monte San
 Savino e da Giovanni Francesco Rustici",
 Giornale storico degli archivi toscani,
 IV, 1860, p. 63-75

G. Nagler Theatre Festivals of the Medici, New Haven,
 1964

M. Neusser "Die Antiken ergänzungen der Florentiner
 Manieristen", Wiener Jahrbuch für Kunst-
 geschichte, VI, 1929, p. 27-42.

G. Nicco Fasola "Di nuova dei gessi Perugini: nota michel-
 angiolesca", Commentari, VI, 1955, p. 164-
 172

H. Olsen Federigo Barocci, Copenhagen, 1962

W. and E. Paatz Die Kirchen von Florenz, Frankfurt am Main,
 1940, 5 vols.

W. Paatz "Seit wann gehört zu Sansovinos Taufgruppe
 eine Engelfigur?", Mitteilungen des Kunst-
 historischen Instituts in Florenz, IV,
 1933, p. 141

G. Palagi Di Zanobi Lastricati, scultore e fondi-
 tore fiorentino del secolo XVI, Florence,
 1871

E. Panofsky Meaning in the Visual Arts, Garden City,
 1955

G. Papini Vita di Michelangelo nella vita del suo
 tempo, Milan, 1949

A. Parronchi "Resti del presepe di Santa Maria Novella", *Antichità viva*, May-June, 1965, p. 9-28

M. L. Perer "L'ambiente attorno a Michelangelo", *Acme*, III, 1950, p. 106-114.

N. Pevsner *Academies of Art Past and Present*, Cambridge, 1940

A. Pigler *Barockthemen*, Budapest, 1956, 2vols.

A. Pigler "Neid und Unwissenheit als Widersacher der Kunst. Ikonographische Beitrage zur Geschichte der Kunstakademien", *Acta Historiae Artium*, I, 1954, p. 216-235.

E. Pillsbury "Drawings by Vasari and Vincenzo Borghini for the 'Apparato' in Florence in 1565", *Master Drawings*, III, 1967, p. 281-283

P. Pirri *Giovanni Tristano e i primordi della architettura gesuitica*, Biblioteca Instituti Historici Societatis Iesu, VI, Rome, 1955

P. Pizzoni "Il volo attribuito a Gio. Battista Danti", *Bolletino della Deputazione di Storia patria per l'Umbria*, XLII, 1945, p. 209-225

L. Planiscig *Piccoli bronzi italiani del Rinascimento*, Milan, 1930

E. Plon *Benvenuto Cellini, Orfèvre, Médailleur, Sculpteur*, Paris, 1883

G. Poggi "Lo Studiolo di Francesco I in Palazzo Vecchio", *Il Marzocco*, December, 1910

J. Pope-Hennessy *Italian High Renaissance and Baroque Sculpture*, London, 1963, 3 vols.

——— "Italian Bronze Statuettes, II", *Burlington Magazine*, CV, 1963, p. 58-71

——— "Michelangelo's Cupid: the end of a Chapter", *Burlington Magazine*, XCVIII, 1956, p. 403-411

E. H. Ramsden *The Letters of Michelangelo*, Stanford, 1963, 2 vols.

W. R. Rearick "Battista Franco and the Grimani Chapel",

Saggi e Memorie di storia dell'arte, II, Venice, 1959, p. 105-139.

M. Reymond — La Sculpture Florentine. Le XVIe siecle et les Successeurs de l'Ecole Florentine, Florence, 1900

C. Ricci — L'Architettura del Cinquecento in Italia, Turin, 1923

C. Ripa — Iconologia, accresciuta dall'Abate C. Orlandi, Perugia, 1764-67, 5 vols.

G. B. Ristori — "Di una casa in Via dei Servi, e di alcuni avvenimenti che vi se riferiscono (il Palazzo Almeni)", Arte e Storia, January 1906, no. 1-2, p. 38-40

M. Rosci — "Manierismo e accademismo nel pensiero del Cinquecento", Acme, IX, 1956, p. 78-93.

E. Rosenthal — "Michelangelo's Moses dal sotto in sù", Art Bulletin, XLVI, 1964, p. 544-550

J. Rouchette — La Renaissance que nous a léguée Vasari, Paris, 1959

N. Rubenstein — "Vasari's painting of the 'Foundation of Florence' in the Palazzo Vecchio", Essays in the History of Architecture presented to Rudolf Wittkower, London, 1967

Giovanni da Sacrobosco

La Sfera di Messer G. Sacrobosco tradotta emendata & distinta in capitoli da P. V. Dante de Rinaldi con molte. . .annotazione del medesimo rivista da Frate E. Danti, Florence, 1571

A. M. Salvini — Discorsi Accademici, Bologna, 1821, 8vóls.

F. Saxl — "Veritas Filia Temporis", Philosophy and History, Essays presented to Ernst Cassirer, Oxford, 1936

O Scalvanti — "La Cittadinanza conferita a Vincenzo Danti", L'Umbria, rivista d'arte e letteratura, Perugia, 15 April, 1889, II, no. 7-8, p. 59-60

O. Scalvanti "Un filosofo dell'arte in Perugia", L'Umbria, rivista d'arte e letteratura, Perugia, 25 January, 1898, I

J. von Schlosser "Aus der Bildnerwerkstatt der Renaissance. II. Eine Bronze des Vincenzo Danti", Jahrbuch der Kunsthistorischen Sammlungen in Wien, XXXI, 1913-14, p. 73-86

J. Seznec "La Mascarade des Dieux á Florence en 1565", Melanges d'Archéologie et d'Histoire, LII, 1935, p. 224-237

J. Seznec The Survival of the Pagan Gods, New York, 1961

C. Seymour Jr. Sculpture in Italy 1400-1500, Harmondsworth, 1966

J. T. Shawcross The Complete Poetry of John Donne, Garden City, 1967

J. Shearman "Maniera as an aesthetic ideal", Studies in Western Art, Acts of the Twentieth International Congress of the History of Art, Princeton, 1963, II, p. 200-221

 Mannerism, Baltimore, 1967

G. Smith Elizabethan Critical Essays, London, 1964, 2 vols.

W. Smith "Giulio Clovio and the 'maniera di figure piccole'", Art Bulletin, XLVI, 1964, p. 395-401

C. H. Smyth "The Earliest Works of Bronzino", Art Bulletin, XXXI, 1949, p. 184-209

C. H. Smyth "Mannerism and Maniera," Studies in Western Art. Acts of the twentieth International Congress of the History of Art, Princeton, 1963, II, 174-199

G. Soós "Antichi modelli delle statue equestri, di Leonardo da Vinci," Acta Historiae Artium, IV, 1956-7, p. 129-35

J. Sparrow "Pontormo's Cosimo il Vecchio", Journal of the Warburg and Courtauld Institutes, XXXVII, 1967, p. 163-175

F. Sricchia Santoro "Daniele da Volterra," <u>Paragone</u>, CXIII, 1967. p. 3-34

W. Stechow "Daniele da Volterra als Bildhauer," <u>Jahrbuch der Preuszischen Kunstsammlungen</u>, XLIX, 1928, p. 82-92

E. Steinmann <u>Das Grabmal Pauls III in St. Peter in Rome</u>, Rome, 1912

——— <u>Michelangelo im Spiegel seiner Zeit</u>, Leipzig, 1930

J. C. Rolfe <u>Suetonius: Lives of the Ceasars</u>, (Loeb Library ed), London-New York, 1914-35

M. Tafuri <u>L'Architettura del manierismo nel Cinquecento Europeo</u>, Rome, 1966

U. Tarchi <u>L'Arte del Rinascimento nell'Umbria e nella Sabina</u>, n. p., 1954

G. and C. Thiem <u>Toskanische Fasaden Dekoration in Sgraffito und Fresko, 14 bis 17 Jahrhundert</u>, Munich, 1964

H. Thode <u>Michelangelo und das Ende der Renaissance, (Michelangelo. Kritische Untersuchungen über seine Werk)</u>, Berlin, 1902-13, 6 vols

G. Ticciati <u>Storia dell'Accademia del Disegno in P. Fanfani, Spigolatura Michelangelesca</u>, Pistoia, 1876, p. 193-307

H. Tietze <u>Titan, the Paintings and Drawings</u>, London, 1950

M. Tinti <u>Il Mobilio Fiorentino</u>, Rome-Milan, 1928

K. Tolnai "Die Handzeichnungen Michelangelos im Codex Vaticanus," <u>Repertorium für Kunstwissenschaft</u>, LVIII, 1929, p. 157-205

C. de Tolnay "La Venere con due Amorini già a Pitti ora in Casa Buonarroti," <u>Commentari</u>, XV, 1966, p. 324-332

——— <u>Michelangelo</u>, Princeton, 1943-1960, 5 vols

534

C. de Tolnay "Sur des vénus desinées par Michel-
Ange à propros d'un dessin oublié du
Musée du Louvre," Gazette des Beaux
Arts, LXIX, 1967, p. 193-100

W. Trachsler "Zwei Renaissance Klein-Bronzen im
Schweizerischen Landesmuseum," Zeit-
schrift fur Schweizertsche Archäologie
und Kunstgeschichte, XX, 1960, p. 139-
143

A. L. Tuckerman A Selection of Works of Architecture
and Sculpture belonging chiefly to the
Period of the Renaissance in Italy,
New York, 1891

G. Urbini "I gessi di Vincenzo Danti nell'
Accademia di Belle Arti di Perugia", Il
Marzocco, Florence, 1909, no. 50

H. Utz "Vincenzo de'Rossi," Paragone, 197,
1966, p. 29-36

———— "Pierino da Vinci e Stoldo Lorenzi,"
Paragone, 211, 1967, p. 47-69

A. Venturi "Un bronzo del Verrocchio," L'Arte,
V, 1902, p. 43-4

———— Storia dell'arte italiana, Milan,
1901-40, 11 vols in 25

L. Verani Apparato per le nozze di Francesco I
de'Medici con Giovanni d'Austria, Livorno,
1870

G. B. Vermiglioli Dell'Acquedotto e della Fontana
Maggiore di Perugia, Perugia, 1827

M. Viale Ferrero Arazzi Italiani, Milan, 1961

H. Voss Die Malerei der Spätrenaissance in Rom
und Florenz, Berlin, 1920, 2 vols

M. Walcher Casotti Il Vignola, Trieste, 1960, 2 vols

D. P. Walker "Orpheus the Theologian and Renais-
sance Platonists," Journal of the
Warburg and Courtauld Institutes, XVI,
1953, p. 100-121

J. Wasserman "Palazzo Spada," Art Bulletin, XLIII, 1961, p. 58-63

H. Weihrauch Europäische Bronzestatuetten, Braunsch-weig, 1967

M. Weinberger Michelangelo the Sculptor, New York, 1967, 2 vols

A. S. Weller Francesco di Giorgio, Chicago, 1943

H. Werner-Schmidt "Vasari's Fassade-malerei am Palazzo Almeni", Miscellanea Biblioteca Hertzianae zu Ehren von Leo Bruhns, Fraz Graf Wolff Metternich, Ludwig Schudt, Munich, 1961, p. 271-74

J. Wilde "Cartonetti by Michelangelo," Burlington Magazine, CI, 1959, p. 370-81

_____ "An Illustration of the Ugolino Episode by Pierino da Vinci," Journal of the Warburg and Courtauld Institutes, XIII, 1951, p. 125-7

_____ "Eine Studie Michelangelos nach der Antike", Mitteilungen des Kunsthistorischen Instituts in Florenz, IV-V, 1932-40, p. 41-64

B. Wiles The Fountains of the Florentine Sculptors, Cambridge, 1933

E. Wind "The Four elements in Raphael's Stanza della Segnatura," Journal of the Warburg and Courtauld Insitutes, II, 1938-9, p. 75-79

R. Wittkower Architectural Principles in the Age of Humanism, New York, 1965

_____ "Nanni di Baccio Bigio and Michelangelo," Festschrift Ulrich Middeldorf, Berlin, 1968, p. 355-8

_____ and M. Wittkower The Divine Michelangelo, the Florentine Academy's Homage on his Death in 1564, London, 1964

R. Wittkower	Review of L. Goldscheider, The Sculptures of Michelangelo, Burlington Magazine, LXXVIII, 1941, p. 133
——————	"The Vicissitudes of a Dynastic Monument: Bernini's Equestrian Statue of Louis XIV", De Artibus Opuscula XL: Essays in Honor of Erwin Panofsky, New York, 1961, p. 497-531
P. Zani	Enciclopedia Metodica critico-ragionato delle Belle Arti, Parma, 1819-22, 36vols.
F. Zeri	Pittura e Controriforma: l'arte senza tempo di Scipione da Gaeta, n. p., 1957

Catalogues:

J. Ainaud de Lasarte A. Casanovas	"Catalogo de la Biblioteca de el Escorial," Anales y Boletín de los Museos de Arte de Barcelona, XVI, 1963-1964, I
P. Barocchi	Michelangelo e la sua scuola, i disegni di Casa Buonarroti e degli Uffizi, Florence, 1962, 2 vols
P. Barocchi, A. Bianchini, A. Forlani, M. Fossi	Mostra di disegni dei Fondatori dell' Accademia delle Arti del Disegno, Florence, 1963
J. Bean, F. Stampfle	The Italian Renaissance, Catalogue, Greenwich, Conn., 1965 (New York Metropolitan Museum)
L. Berti	Il Museo di Arezzo, Rome, 1961
A. Bertini	I Disegni italiani della Biblioteca reale di Torino, Rome, 1950
G. Bianchi	Ragguaglio di Antichità e Rarità che si trovano nelle Gallerie, Florence, 1759

Bronzetti Italiani del Rinascimento,
Catalogo della mostra in Palazzo Strozzi,
Feb.-March, 1962, Florence, 1962

Catalogo della Mostra d'antica arte
Umbra, Perugia, 1907

G. Cecchini La Galleria Nazionale dell'Umbria in
 Perugia, Rome, 1932

L. Cicognara Catalogo ragionato dei Libri d'Arte,
 e d'Antichità, Pisa, 1821, 2 vols

B. Davidson Gabinetto disegni e stampe degli Uffizi,
 Mostra di Disegni di Pierino del Vaga e
 la sua cerchia, Florence, 1966

 Duveen Sculptures in Public Collections
 of America , New York, 1944

V. Golzio La Galleria e le Collezione della R.
 Accademia di San Luca in Roma, Rome,
 1939

────── "Le terrecotte della R. Accademia di
 S. Luca," Atti e Memorie della R.
 Accademia di S. Luca, X, 1933

 Indicazione degli oggetti nella
 Università di Perugia, Perugia, 1882

L. Lanzi La Real Galleria di Firenze, Florence,
 1782

E. R. D. Maclagan
M. H. Longhurst London, Victoria and Albert Museum,
 Catalogue of Italian Sculpture,London,
 1932, 2 vols

G. A. Mansuelli Gallerie degli Uffizi,Le Scultore, Rome,
 1958

 Mostra del Cinquecento Toscano, Catalogo,
 Florence, 1940

 Musée Jacquemart-André, Catalogue Itin-
 eraire, 2nd, ed., Paris, n. d.

A. Nocentini Mostra Documentaria e Iconografica
 dell'Accademia del Disegno, Florence,
 Archivio di Stato, Feb-March, 1963

K. T. Parker	Catalogue of the Collection of Drawings in the Ashmolean Museum, the Italian Schools, Oxford, 1956
J. Pope-Hennessy	Catalogue of the Italian Sculpture in the Victoria and Albert Museum, London, 1964, 3 vols
_____	Renaissance Bronzes from the Samuel H. Kress Collection, London, 1965
A. E. Popham	Catalogue of the Drawings in the collection formed by Sir Thomas Philipps now in the Possession of his grandson T. Fitzroy Philipps Fenwick, London,1935
_____, J. Wilde	Italian Drawings at Windsor Castle, London, 1949
P. Pouncey, J. A. Gere	Raphael and his Circle, London, 1962
	Renaissance Bronzes in American Collections, Smith College, Northampton, Mass, 1964
J. C. Robinson	London, South Kensington Museum. Italian Sculpture of the Middle Ages and the Period of the Revival of Art. A descriptive catalogue, London, 1862
F. Rossi, ed.	Il Museo Horne a Firenze, Milan, 1967
F. Schottmüller	Bildwerke des Kaiser-Friedrich-Museums Die Italienischen und Spanischen Bildwerke der Renaissance und des Barock, Berlin, Leipzig, 1933
C. Seymour jr.	Masterpieces of Sculpture from the Nationale Gallery of Art, New York, 1949
J. Wilde	Italian Drawings in the Department of Prints and Drawings in the British Museum, Michelangelo and his Studio, London, 1953
E. Zocca	Catalogo delle cose d'arte e di antichità, Rome, n.d.

Guides and Descriptions:

F. Ansano Visso e le sue Valle, Visso (?), 1964

V. Ansidei La Chiesa di S. Francesco al Prato in Perugia, Città di Castello, 1925

A. Baldanzi Descrizione della Cattedrale di Prato, Prato, 1846

F. Bocchi Le Bellezze di Firenze, Florence, 1591

G. Carocci I Dintorni di Firenze, Florence, 1881

E. Casalini La Basilica Santuario della SS.. Annunziata, Florence, 1957

G. Cinelli Bozze per le Bellezze di Firenze, FBN., Magl. XIII, 34, f. 90r

C. Crispolti Perugia Augusta, Perugia, 1648

V. Fineschi Il Forestiero Istruito in S. Maria Novella di Firenze, Florence, 1790

V. Follini,
M. Rastrelli Firenze antica e moderna, Florence, 1791

O. Gurrieri La Basilica di San Pietro in Perugia, Perugia, 1954

———— Il Tempio di S. Francesco al Prato e l'Oratorio di San Bernardino in Perugia, Perugia, n. d.

———— La Chiesa di San Domenico in Perugia, Perugia, 1960

B. Kleinschmidt Die Basilika S. Francesco in Assisi, Berlin, 1915

A. Lensi Il Palazzo Vecchio, Milan-Rome, 1929

C. C. Lensi-Orlandi Le Ville di Firenze, Florence, 1965 2 vols

G. Marchini Il Duomo di Prato, n. p., 1957

F. L. del Migliore Firenze Città Nobilissima Illustrata, Florence, 1684

F. Moisè	Santa Croce di Firenze illustrazione storico artistica con note e copiosi documenti inediti, Florence, 1845
G. Pelli	Saggio Istorico della Real Galleria di Firenze, Florence, 1779
C. da Prato	Firenze ai Demidoff e S. Donato, Florence, 1886
G. Richa	Notizie istoriche delle chiese fiorentine, divise ne' suoi quartieri, Florence, 1754-1762, 10 vols
A. Rossi	Il Palazzo del Popolo in Perugia, Perugia, 1864
G. B. Rossi-Scotti	Descrizione del Santuario di S. Francesco d'Assisi, Perugia, 1928
L. P. Saraceni	Descrizione della Chiesa di San Domenico, Perugia, 1778
S. Siepi	Descrizione topologico-istorica della città di Perugia, Perugia, 1822, 2 vols
F. M. Soldini	Descrizione del Giardino Reale detto di Boboli, Florence, 1789
I. Supino	La Basilica di San Francesco d' Assisi, Bolobgna, 1924
P. Tonini	Il Santuario della Santissima Annunziata, Florence, 1876

ILLUSTRATIONS

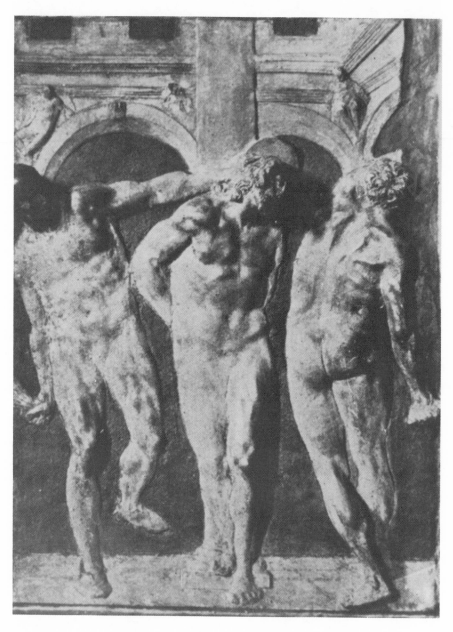

Figure 1.　Vincenzo Danti, <u>Flagellation</u>, Paris, Musée
Jacquemart-André, c.　1550 (Venturi)

Figure 2.　Vincenzo Danti, Christ Driving the Money Changers from the Temple, Galleria Nazionale dell'Umbria, Perugia, c. 1552 (Alinari)

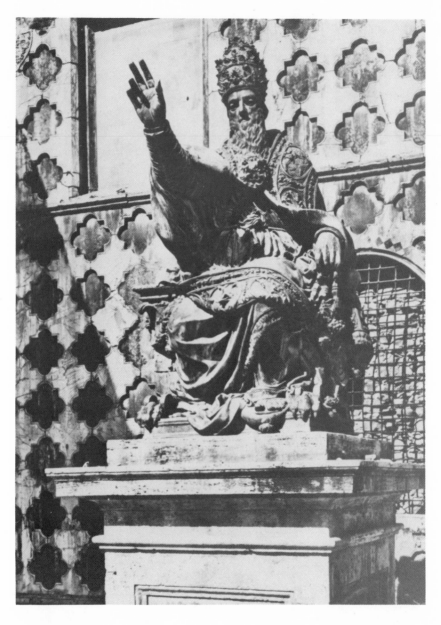

Figure 3. Vincenzo Danti, Monument to Pope Julius III, Perugia, 1553-5 (Anderson)

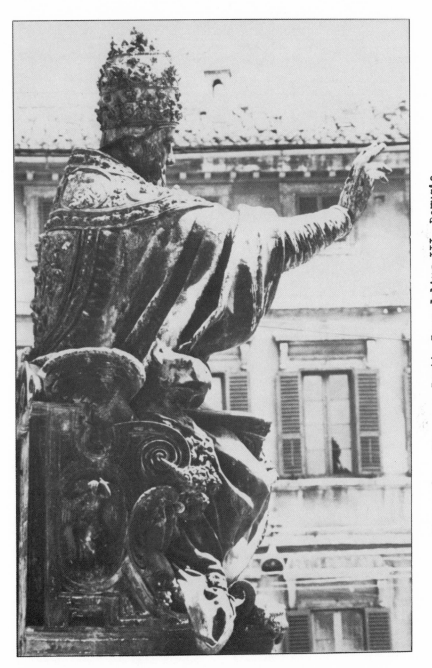

Figure 4. Vincenzo Danti, Pope Julius III, Perugia, 1553-5 (author)

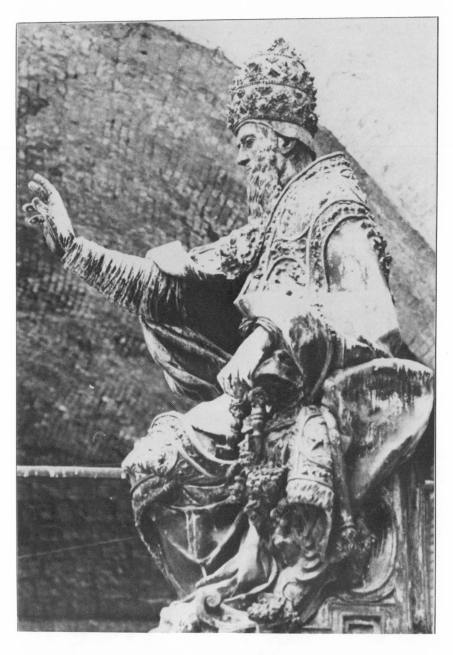

Figure 5. Vincenzo Danti, <u>Pope Julius III</u>, Perugia, 1553
(author)

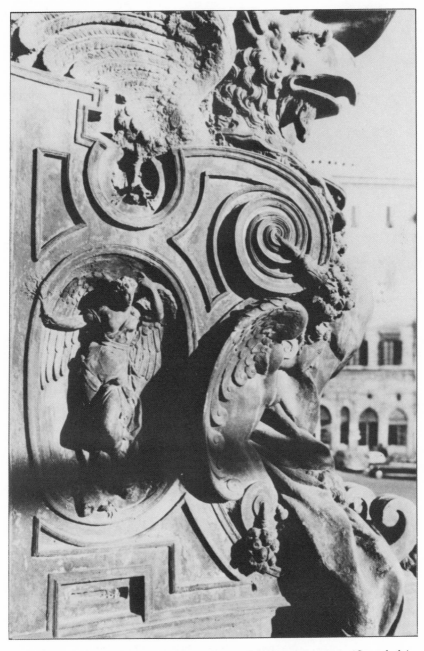

Figure 6. Vincenzo Danti, Pope Julius III, detail: right
side of throne (Bonazzi)

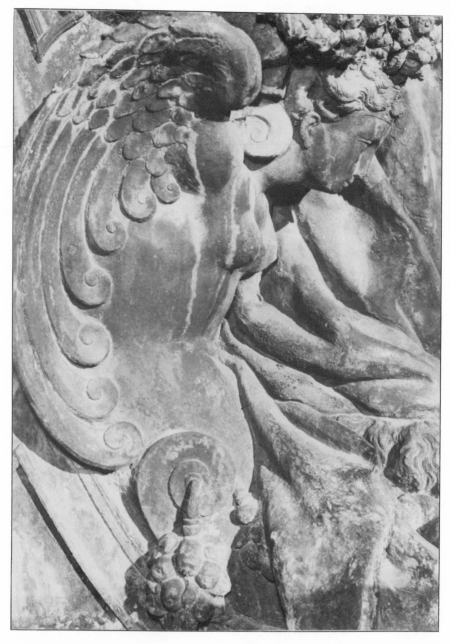

Figure 7. Vincenzo Danti, _Pope Julius III_, detail: right
side of throne (Bonazzi)

Figure 8. Vincenzo Danti, Pope Julius III detail: left
side of throne (Bonazzi)

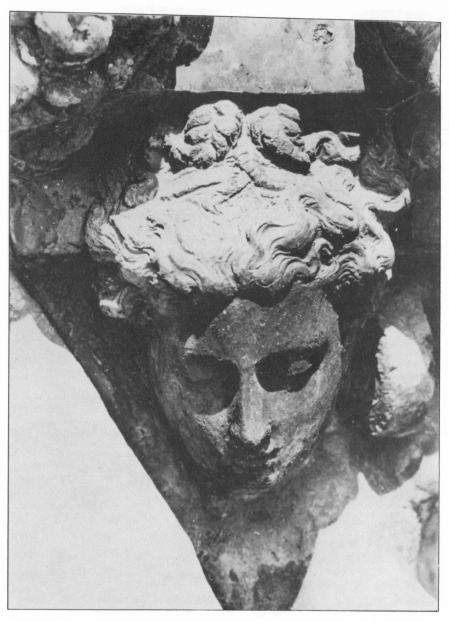

Figure 9. Vincenzo Danti, Pope Julius III, detail: left
side of throne (Bonazzi)

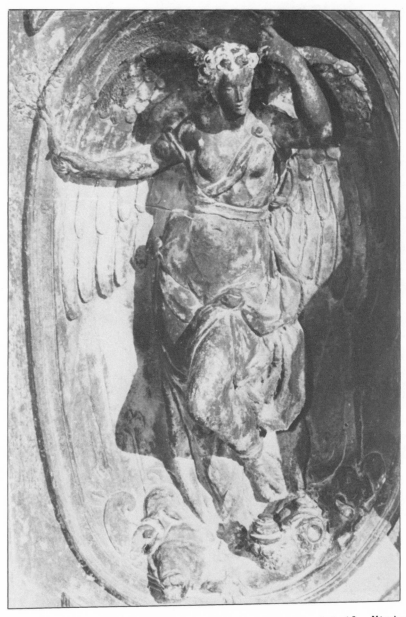

Figure 10. Vincenzo Danti, <u>Pope</u> <u>Julius</u> <u>III</u>, detail: <u>Victory</u>
right side of throne (Bonazzi)

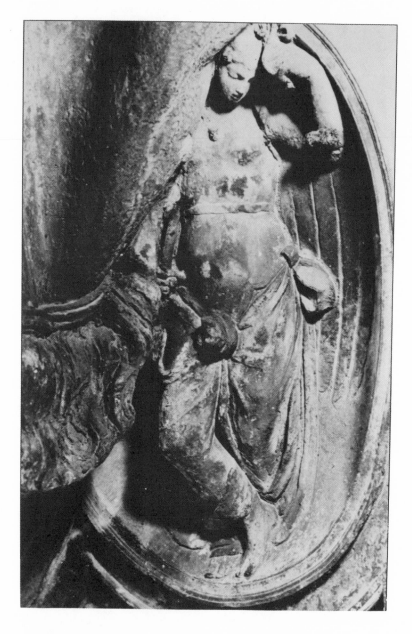

Figure 11. Vincenzo Danti, Pope Julius III, detail: Victory
left side of throne (Bonazzi)

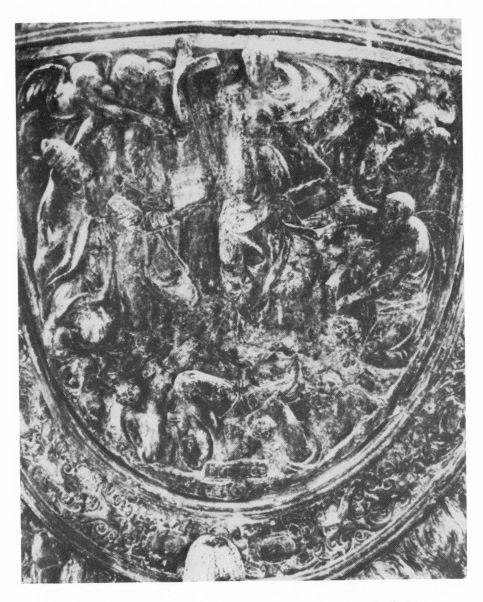

Figure 12. Vincenzo Danti, Pope Julius III, detail: Faith Triumphant over Heresy, and Fathers of the Church relief from the Pope's cope (Sopritendenza)

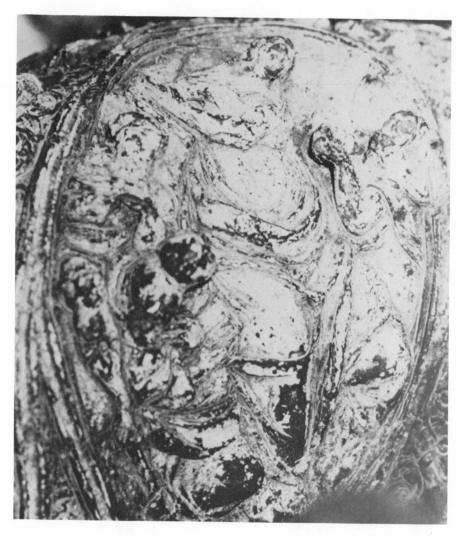

Figure 13. Vincenzo Danti, Pope Julius III, detail: relief on the Pope's pluvial (Soprintendenza)

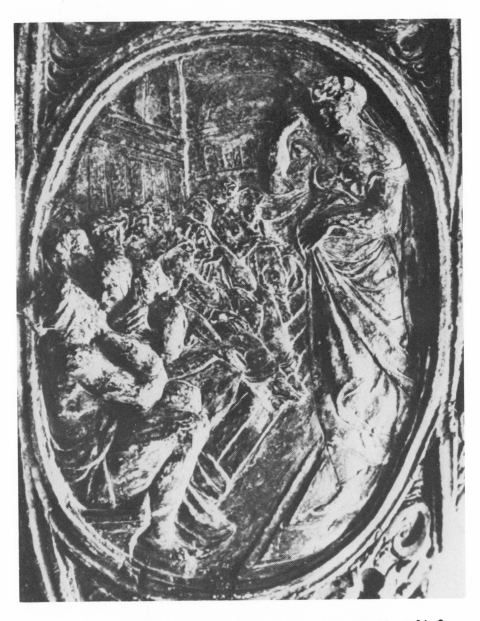

Figure 14. Vincenzo Danti, <u>Pope Julius III</u>, detail: relief
on the Pope's pluvial (Soprintendenza)

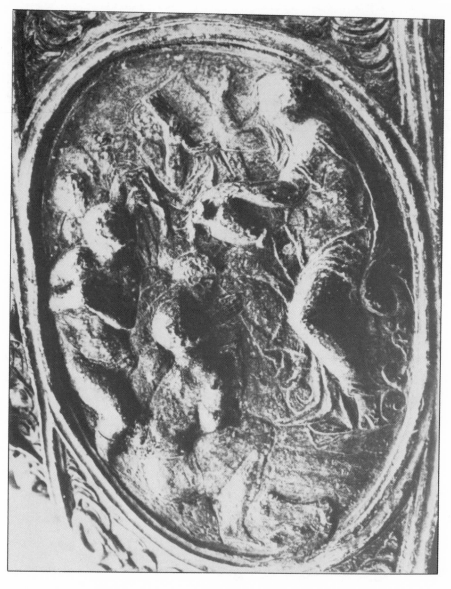

Figure 15. Vincenzo Danti, <u>Pope Julius III</u>, detail: relief
on the Pope's pluvial (Soprintendenza)

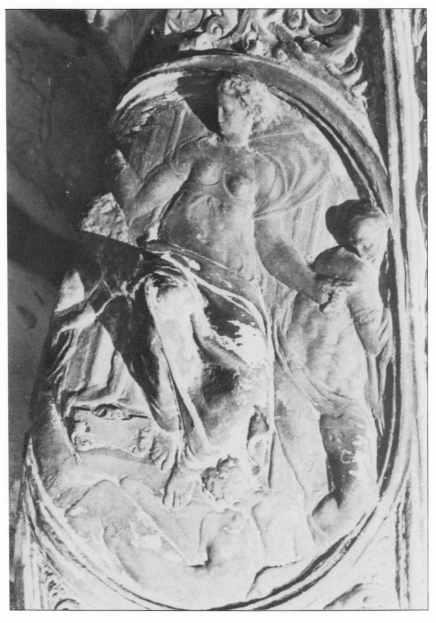

Figure 16. Vincenzo Danti, Pope Julius III, detail: relief on the Pope's pluvial (Bonazzi)

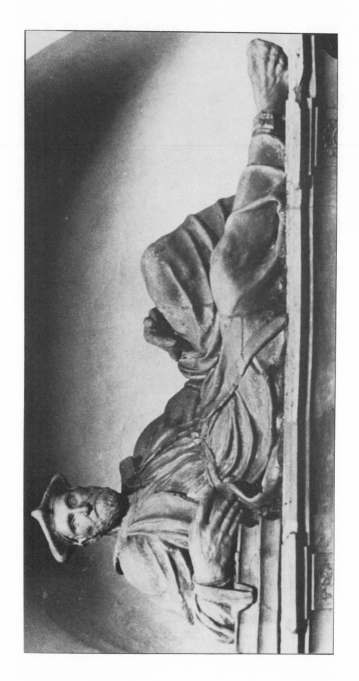

Figure 17. Vincenzo Danti, Monument to Guglielmo Pontano, Perugia, San Domenico, c. 1555 (author)

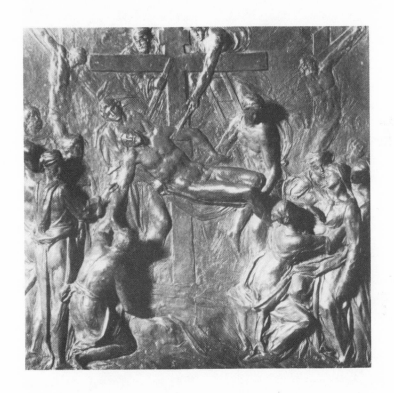

Figure 18. Vincenzo Danti, Deposition, National Gallery,
Washington, D. C., c. 1558 (Seymour)

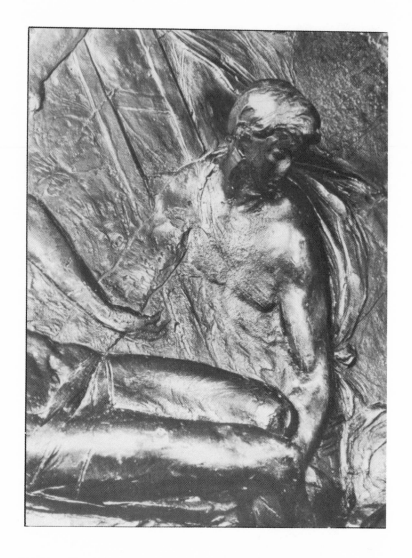

Figure 19. Vincenzo Danti, Deposition, National Gallery, Washington, D. C., c. 1558, detail

Figure 20. Vincenzo Danti, Moses and the Brazen Serpent, Florence, Museo Nazionale, 1359 (Alinari)

Figure 21. Vincenzo Danti, _Moses and the Brazen Serpent,_ detail (author)

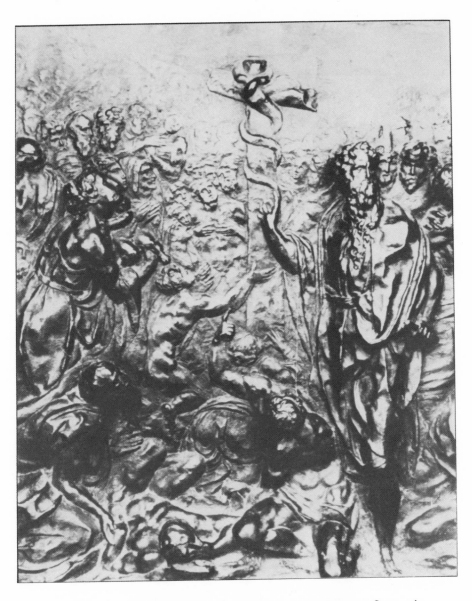

Figure 22. Vincenzo Danti, Moses and the Brazen Serpent, detail (Kunsthistorisches Institut, Florence)

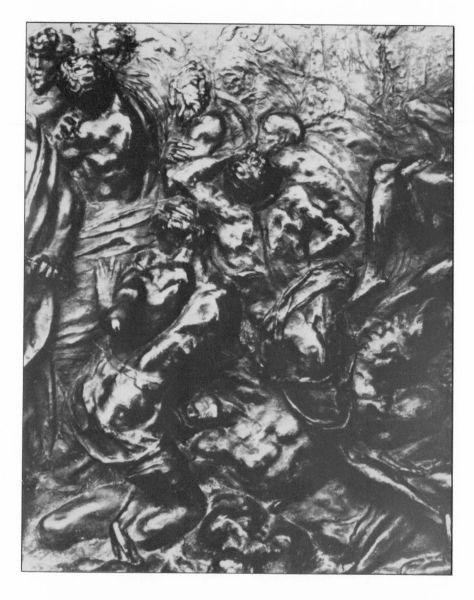

Figure 23. Vincenzo Danti, *Moses and the Brazen Serpent*,
detail (Kunsthistorisehes Institut, Florence)

Figure 24. Vincenzo Danti, Moses and the Brazen Serpent, detail: Expulsion (author)

Figure 25. Vincenzo Danti, Moses and the Brazen Serpent,
 detail (Kunsthistorisches Institut, Florence)

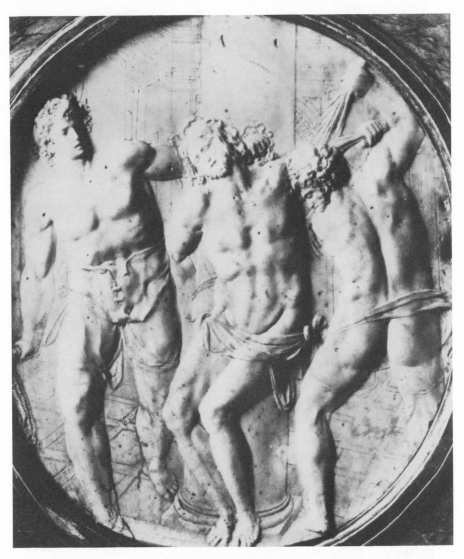

Figure 26. Vincenzo Danti, Flagellation, Kansas City,
Rockhill Nelson Gallery, 1559 (Rockhill Nelson
Gallery)

Figure 27. Vincenzo Danti, Sportello, Florence, Museo
Nazionale, 1561 (Alinari)

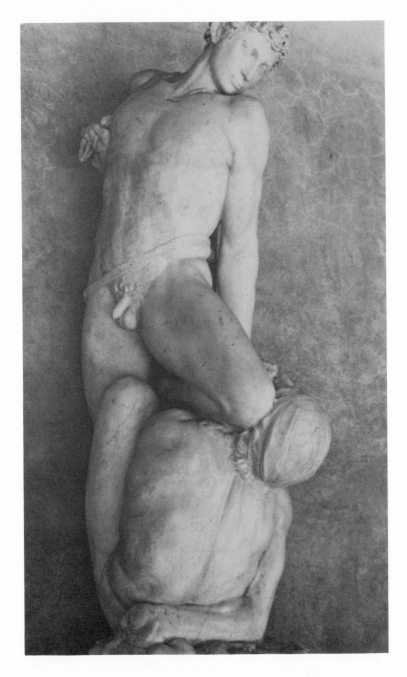

Figure 28. Vincenzo Danti, L'Onore che vince l'Inganno, Florence, Museo Nazionale, c. 1561 (author)

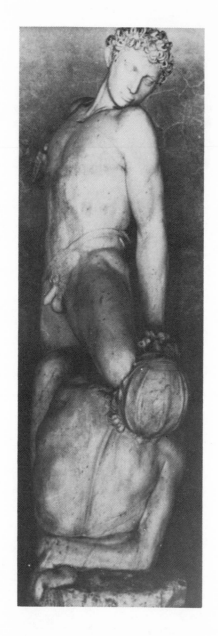

Figure 29.　Vincenzo Danti, L'Onore che vince l'Inganno,
Florence, Museo Nazionale, c.　1561 (author)

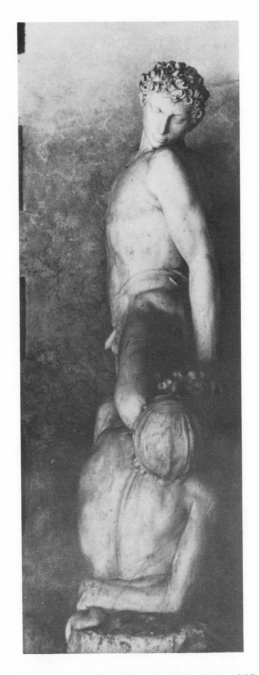

Figure 30. Vincenzo Danti, L'Onore che vince l'Inganno, Florence, Museo Nazionale, c. 1561 (author)

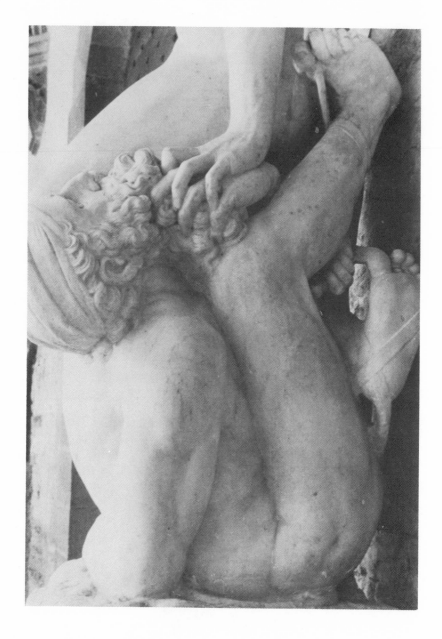

Figure 31. Vincenzo Danti, L'Onore che vince Inganno,
detail: Deceit (author)

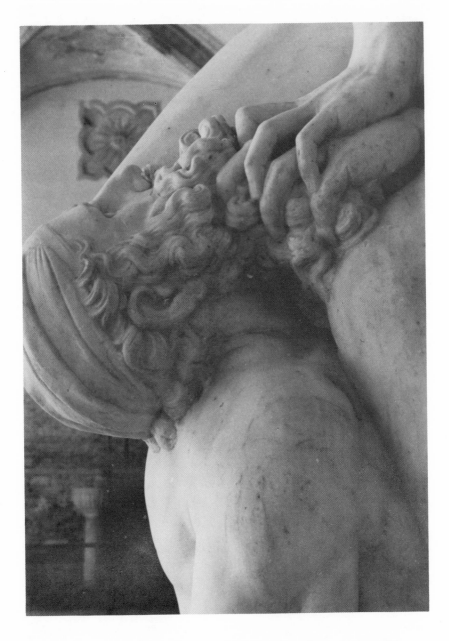

Figure 32. Vincenzo Danti, L'Onore che vince l'Inganno, detail: head of Deceit, (author)

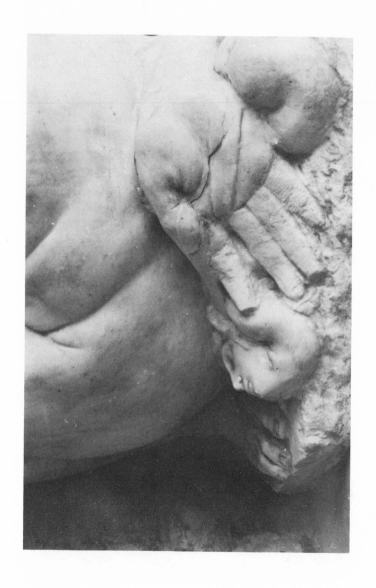

Figure 33. Vincenzo Danti, L'Onore che vince l'Inganno,
detail: base (author)

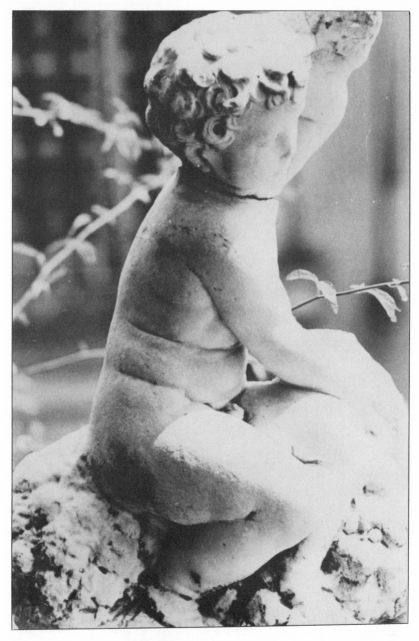

Figure 34. Vincenzo Danti, Putto, Fiesolo, Villa Rondinelli,
c. 1562 (author)

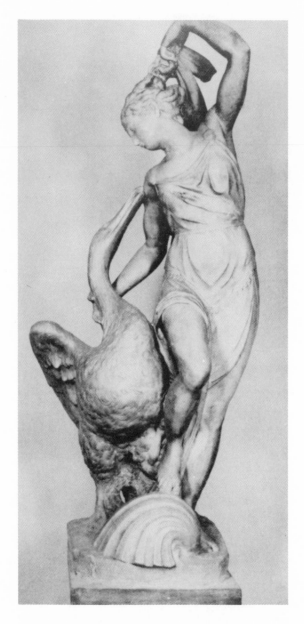

Figure 35. Vincenzo Danti, Leda and the Swan, Victoria
and Albert Museum, London, c. 1563 (J. Pope-
Hennessy)

Figure 36. Vincenzo Danti, Monument to Carlo de'Medici,
 Prato, Duomo, 1564-1566 (Ranfagni)

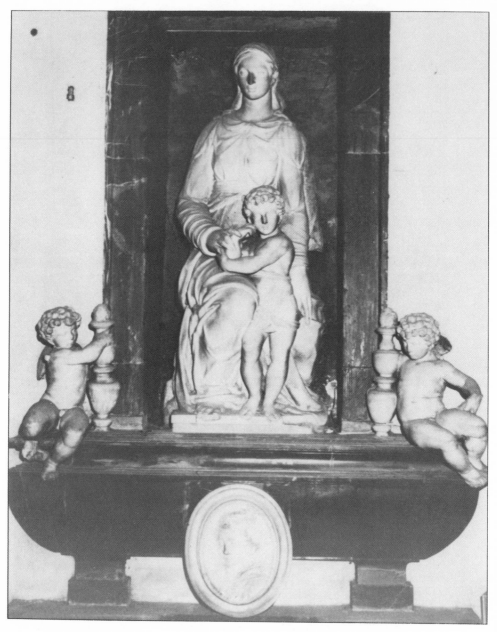

Figure 37. Vincenzo Danti, Monument to Carlo de'Medici, Prato, Duomo, 1564-1566 (Ranfagni)

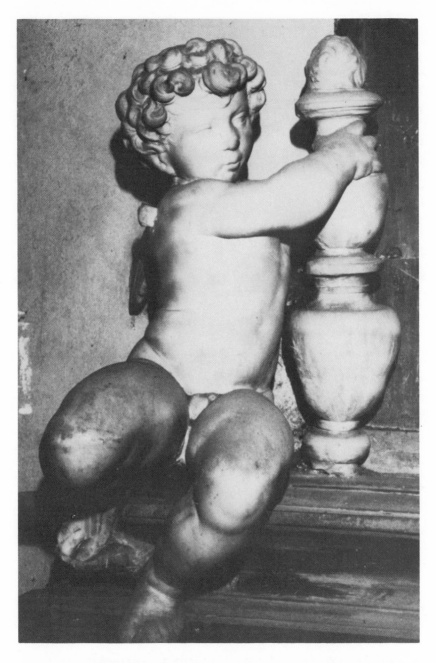

Figure 38. Vincenzo Danti, Monument to Carlo de'Medici, detail (Ranfagni)

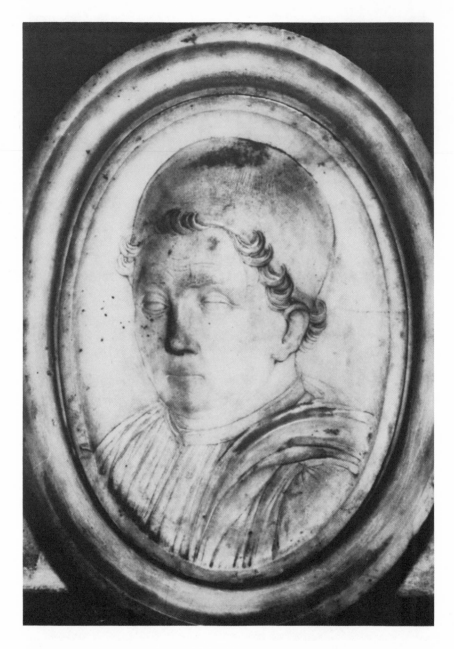

Figure 39. Vincenzo Danti, <u>Monument to Carlo de'Medici</u>,
detail: Portrait of Carlo de'Medici (Ranfagni)

Figure 40. Venus with two Amorini, Florence. Casa Buonarroti, c. 1564, partially carved by Vincenzo Danti (Sopritendenza, Florence)

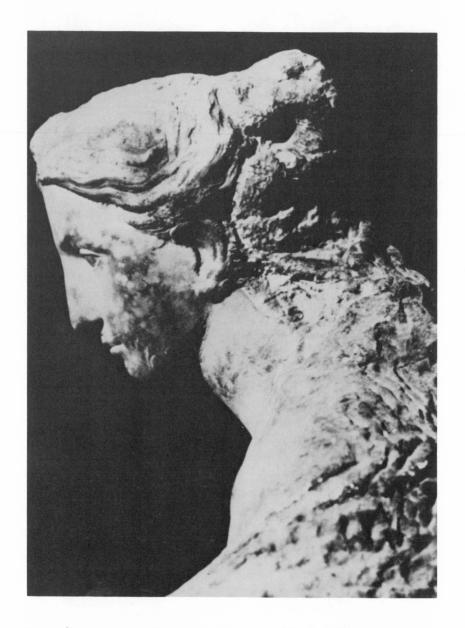

Figure 41. <u>Venus</u> <u>with</u> <u>two</u> <u>Amorini</u>, detail: head(Sopritendenza)

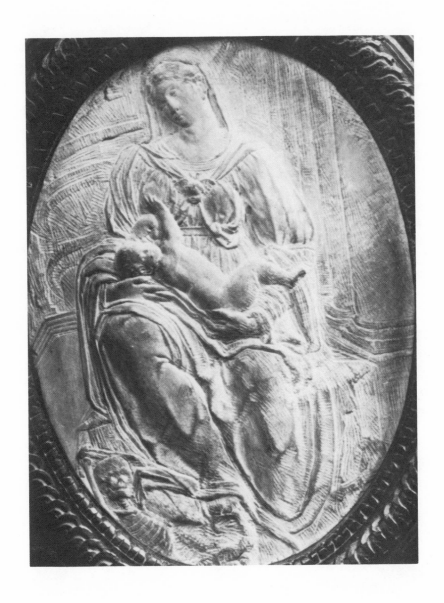

Figure 42. Madonna and Child, Milan, Museo Archeologico,
c. 1564 (Brogi)

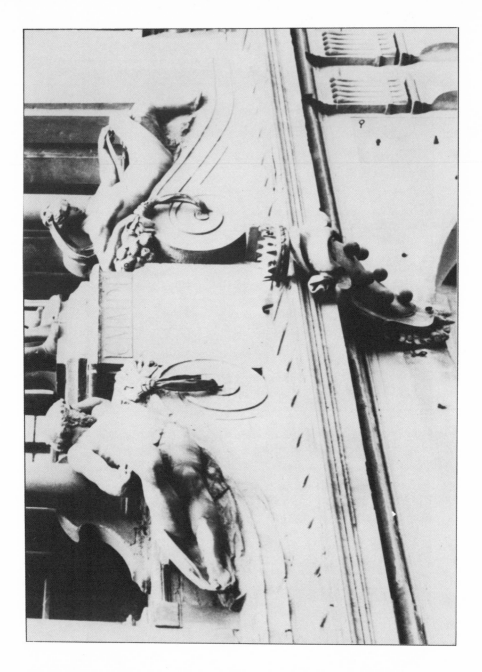

Figure 43. Equity and Rigor, Florence, Uffizi, 1564-1566,
(author)

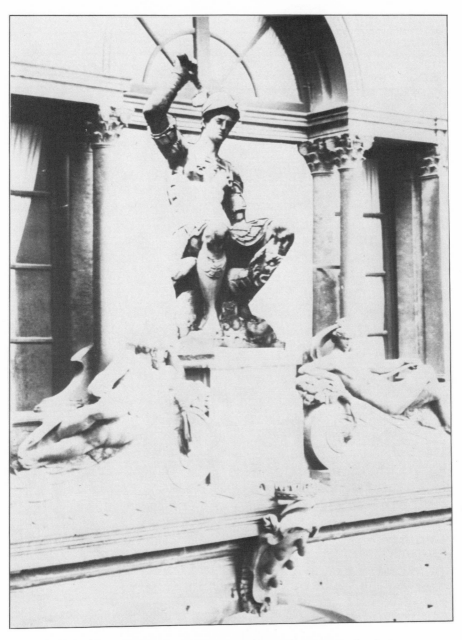

Figure 44. Author's reconstruction of Danti's Testata
group as planned in 1568

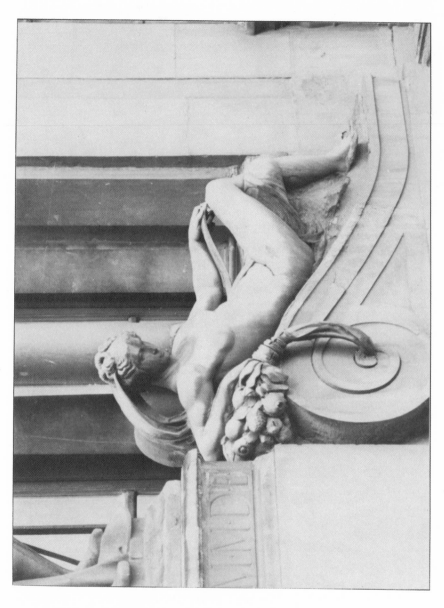

Figure 45. Vincenzo Danti, Equity and Rigor, detail: Equity (Foster)

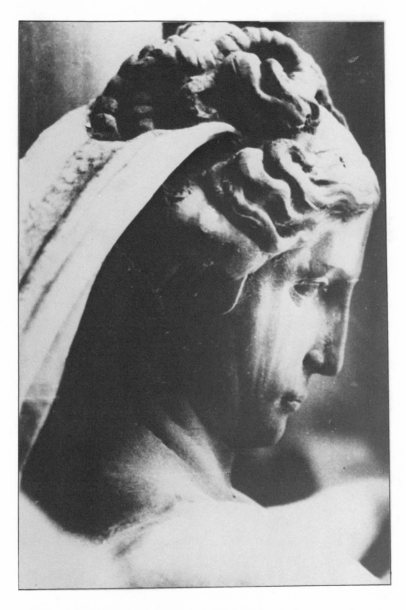

Figure 46. Vincenzo Danti, Equity and Rigor, detail:
head of Equity (author)

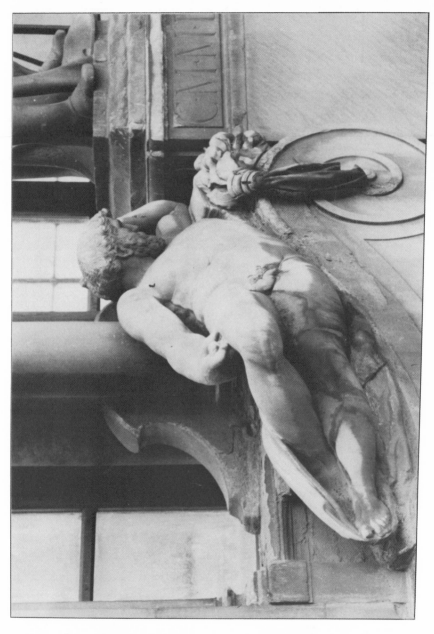

Figure 47. Vincenzo Danti, Equity and Rigor, detail:
Rigor (Foster)

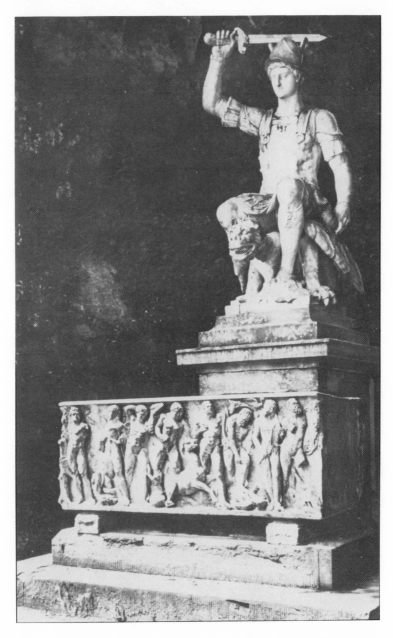

Figure 48. Vincenzo Danti, so-called <u>Perseus and the Dragon</u>,
Florence, Boboli Gardens, <u>1568</u> (Alinari)

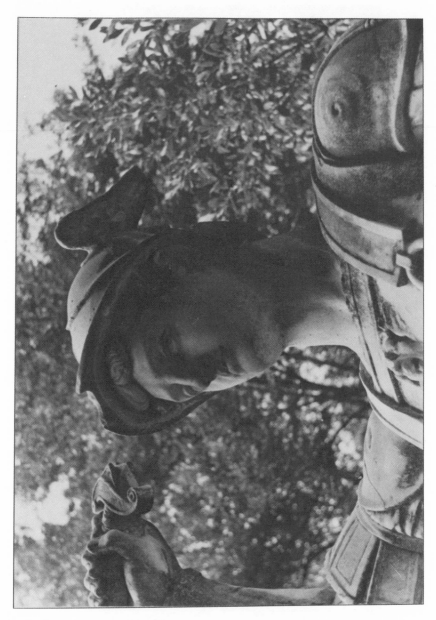

Figure 49. Vincenzo Danti, Perseus, detail: head (author)

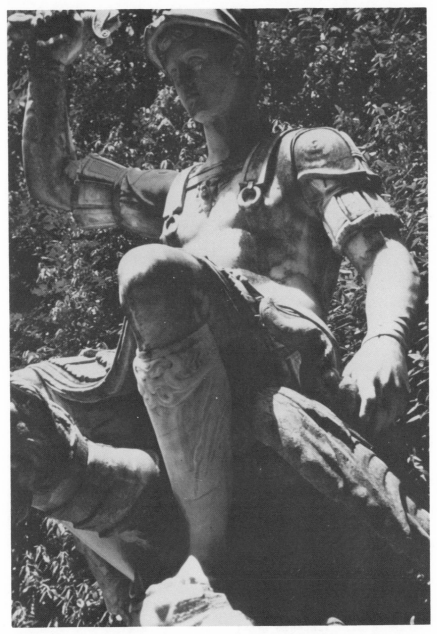

Figure 50. Vincenzo Danti, _Perseus and the Dragon_, viewed
from below, Florence, Boboli Gardens, 1568
(author)

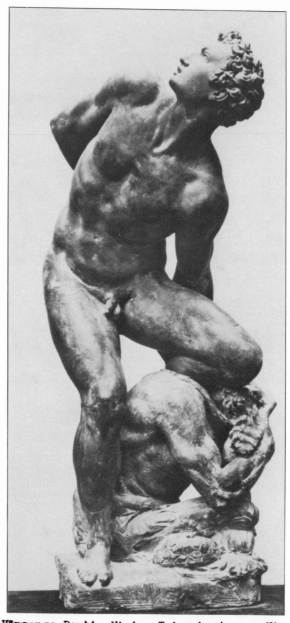

Figure 51. Vincenzo Danti, Virtue Triumphant over Vice,
Florence, Museo Nazionale, c. 1564
(Sopritendenza, Florence)

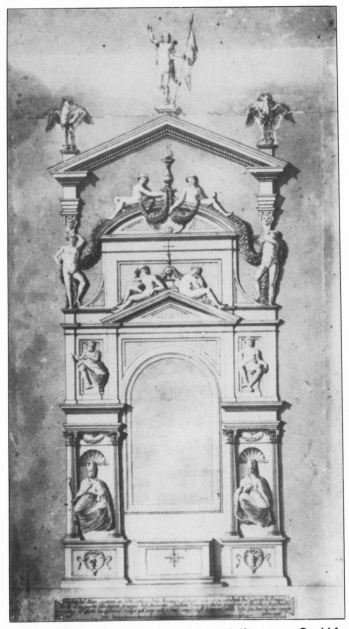

Figure 52. Vincenzo Ciofi, Drawing of Vincenzo Danti's
Altar of San Bernardino, Duomo, Perugia,
finished 1567 (destroyed) (Mercanzia)

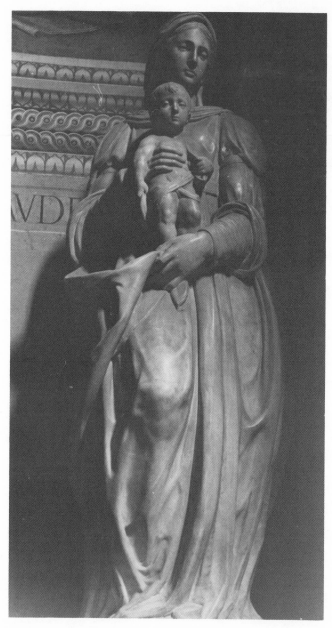

Figure 53. Vincenzo Danti, _Madonna and Child_, Florence,
Santa Croce, Baroncelli Chapel, finished c.
1568 (author)

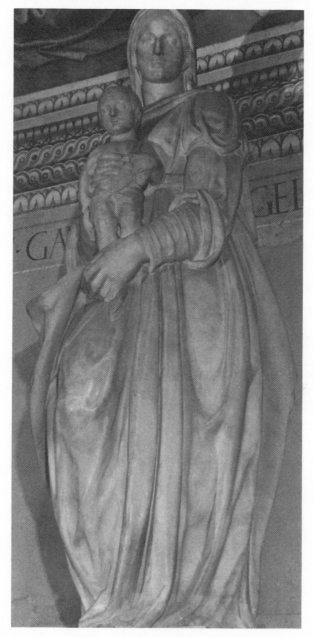

Figure 54. Vincenzo Danti, <u>Madonna and Child</u>, Florence,
Santa Croce, Baroncelli Chapel, finished c.
1568 (author)

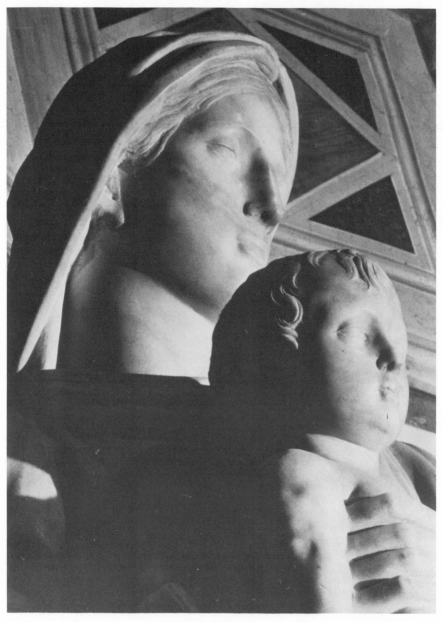

Figure 55. Vincenzo Danti, <u>Madonna and Child</u>, detail: head
of the <u>Virgin</u> (author)

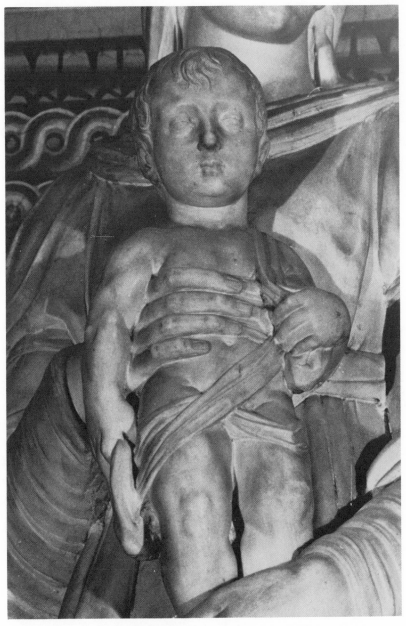

Figure 56. Vincenzo Danti, <u>Madonna</u> <u>and</u> <u>Child</u>, detail: Christ Child (author)

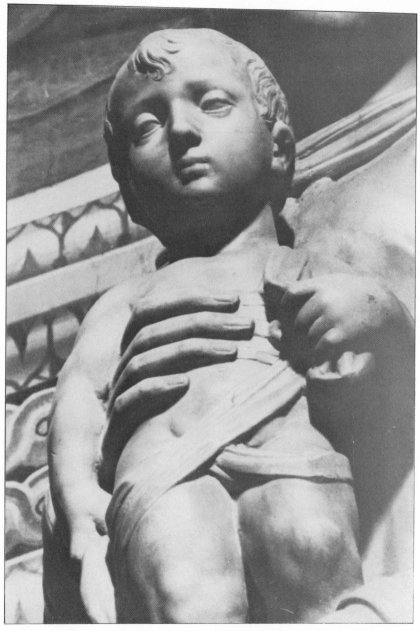

Figure 57. Vincenzo Danti, Madonna and Child, detail:
Christ Child (author)

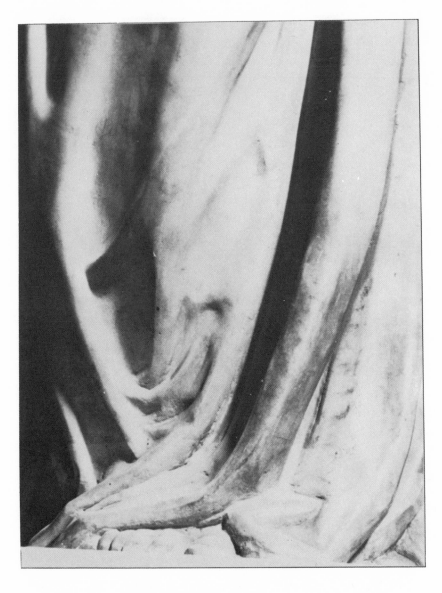

Figure 58. Vincenzo Danti, Madonna and Child, detail:
drapery (author)

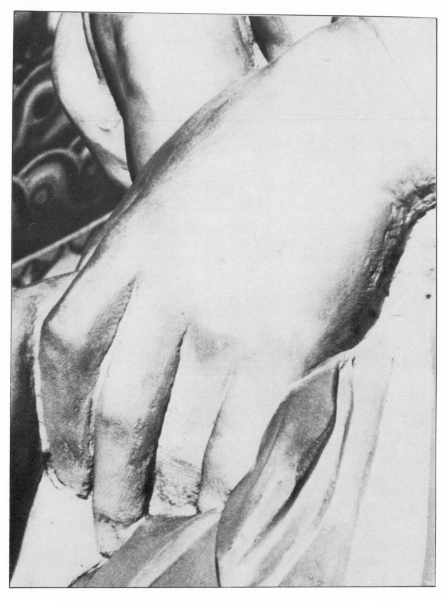

Figure 59. Vincenzo Danti, Madonna and Child, detail:
hand of the Virgin (author)

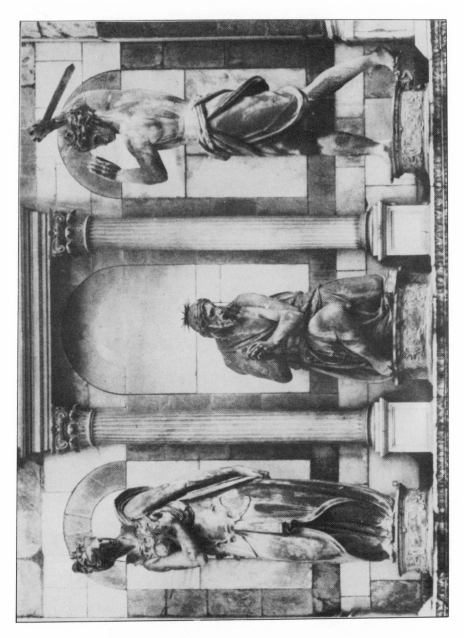

Figure 60. Vincenzo Danti, <u>Decollation of the Baptist</u>,
Florence, Baptistry, 1559-1571 (Alinari)

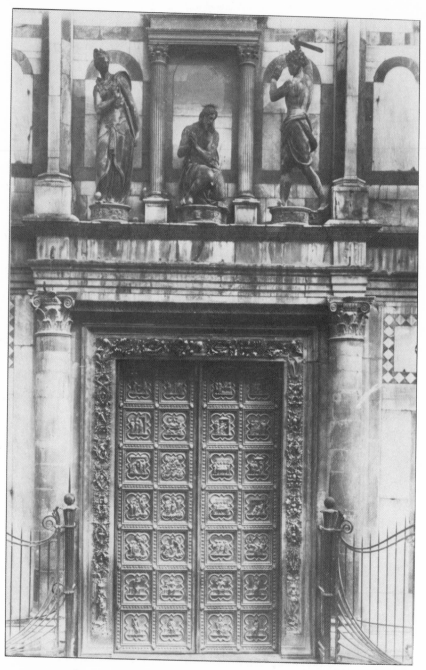

Figure 61. South portal, Baptistry, Florence (Brogi)

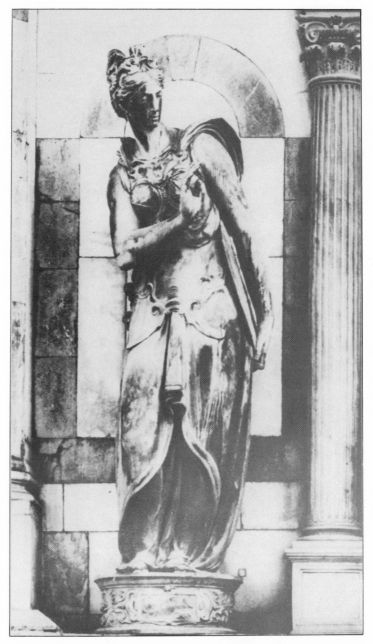

Figure 62. Vincenzo Danti, <u>Decollation of the Baptist</u>, detail: <u>Herodias</u> (Sopritendenza, Florence)

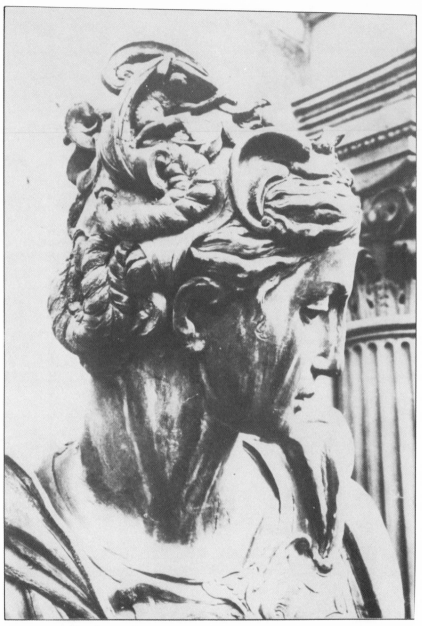

Figure 63. Vincenzo Danti, <u>Decollation of the Baptist</u>,
detail: head of <u>Herodias</u> (Sopritendenza,
Florence)

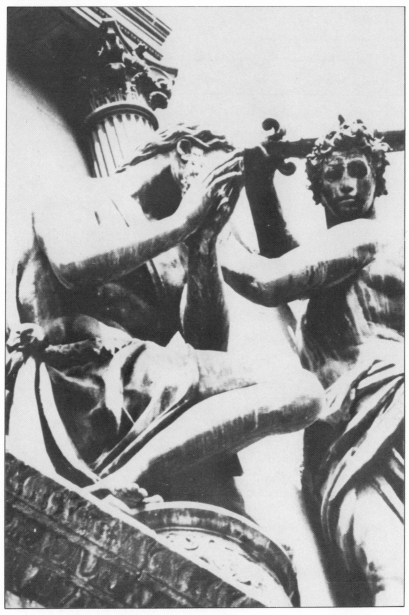

Figure 64. Vincenzo Danti, <u>Decollation of the Baptist</u>,
detail: <u>St. John the Baptist</u> and <u>Executioner</u>
(author)

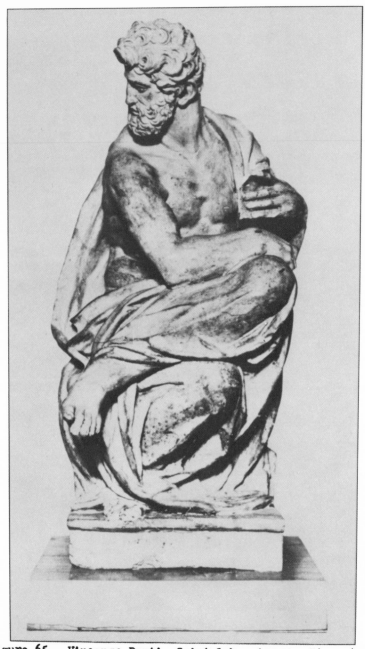

Figure 65. Vincenzo Danti, Saint Luke, Arezzo, Pinacoteca,
c. 1570 (Soprintendenza, Florence)

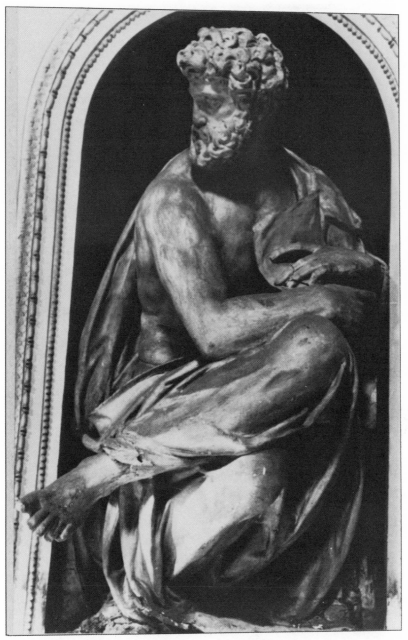

Figure 66. Vincenzo Danti, <u>Saint Luke</u>, Florence, Santissima <u>Annunziata</u>, Cappella di San Luca, 1570-71 (author)

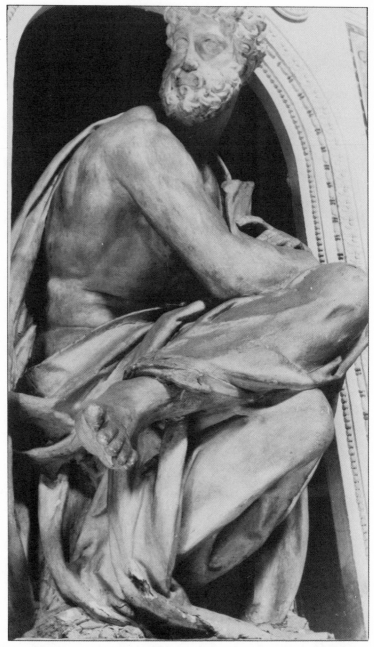

Figure 67. Vincenzo Danti, Saint Luke, Florence, Santissima
Annunziata, Cappella di San Luca, 1570-1571
(author)

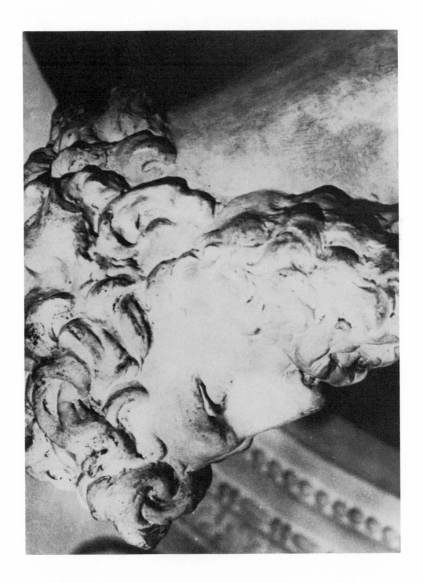

Figure 68. Vincenzo Danti, <u>Saint Luke</u>, detail: head
(author)

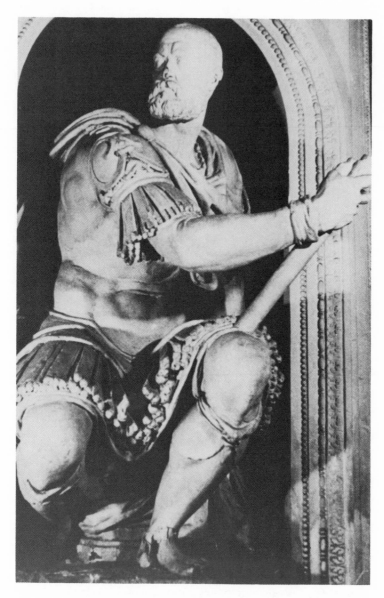

Figure 69. Vincenzo Danti and Zanobi Lastricati, <u>Cosimo I</u>
<u>de'Medici</u> as Joshua, Florence, Santissima
Annunziata, Cappella di San Luca, 1570-1571
(author)

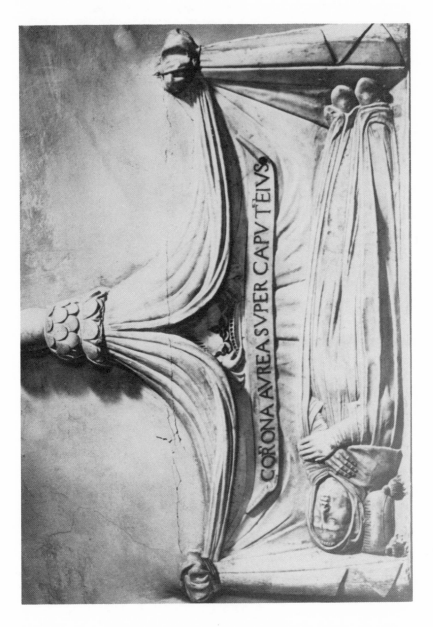

Figure 70. Vincenzo Danti, Monument to the Beato Giovanni
 da Salerno, Florence, Santa Maria Novella,
 1571 (Alinari)

Figure 71. Vincenzo Danti, <u>Venus Anadyomene</u>, Florence,
Studiolo of Francesco I, Palazzo Vecchio,
c. 1572 (Brogi)

Figure 72. Vincenzo Danti, <u>Venus Anadyomene</u>, detail: head
(Alinari)

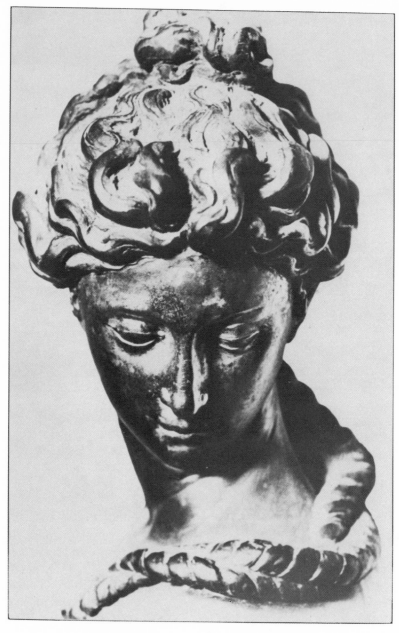

Figure 73. Vincenzo Danti, <u>Venus Anadyomene</u>, detail: head
(Alinari)

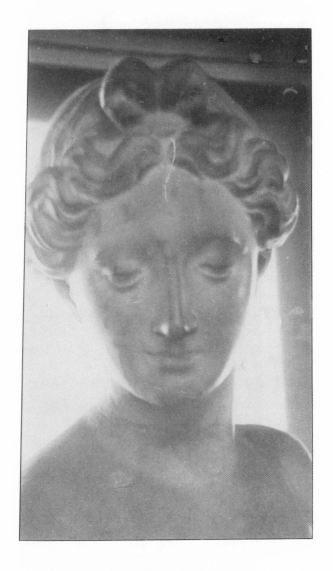

Figure 74. Vincenzo Danti, head of <u>Dancer</u>, Florence, Uffizi,
c. 1572 (author)

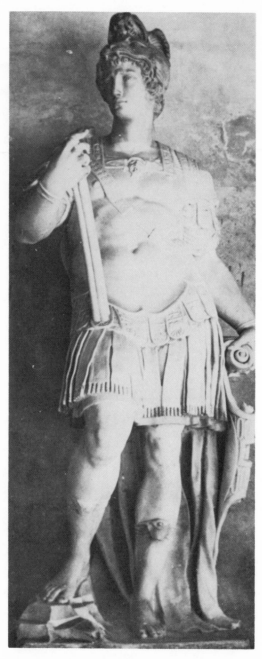

Figure 75. Vincenzo Danti, Cosimo I de'Medici, Florence,
Museo Nazionale, 1572-1573 (author)

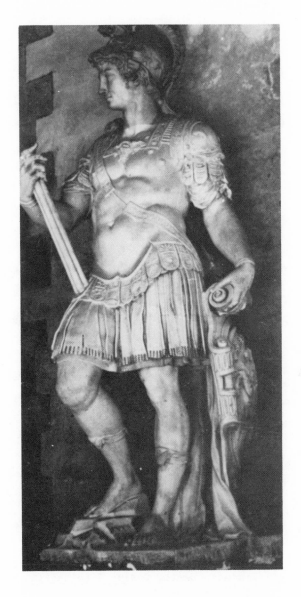

Figure 76. Vincenzo Danti, Cosimo I de'Medici, Florence,
Museo Nazionale, 1572-1573 (author)

Figure 77. Vincenzo Danti, <u>Cosimo I de'Medici</u>, detail
(author)

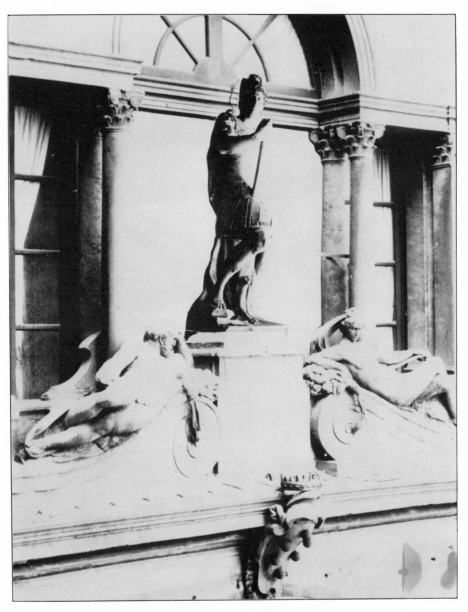

Figure 78. Author's reconstruction of Vincenzo Danti's
second project for the Testata group of the
Uffizi in 1572-1573

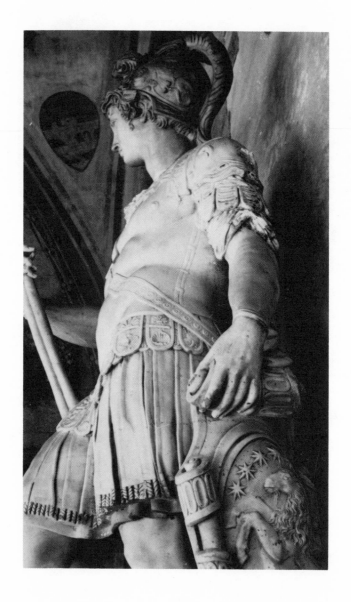

Figure 79. Vincenzo Danti, <u>Cosimo I de'Medici</u>, detail:
profile

Figure 80. Giulio Clovio, Crucifixion and Brazen Serpent
from the Farnese Hours, New York, Pierpont
Morgan Library (W. Smith)

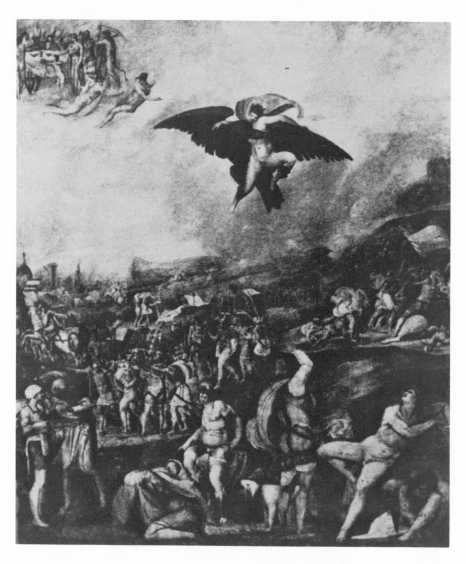

Figure 81. Battista Franco, Allegory of the Battle of
Montemurlo, Florence, Pitti (Venturi)

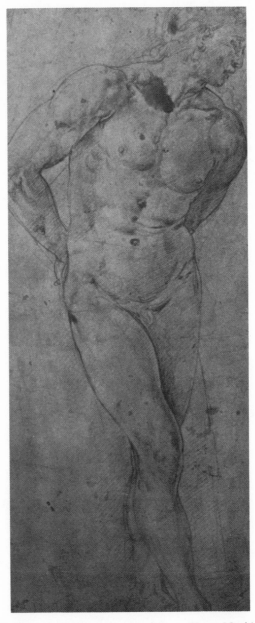

Figure 82. Battista Franco, Study for a Flagellation,
New York, Metropolitan Museum (Bean and
Sampfle)

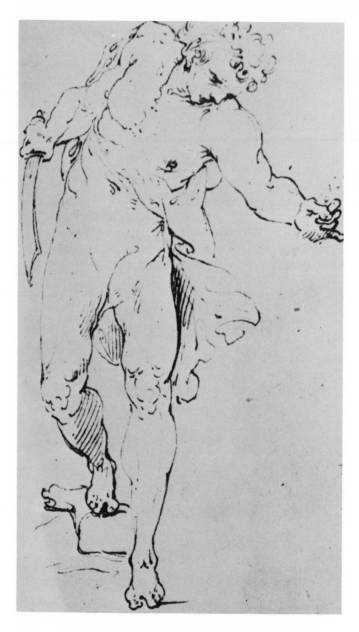

Figure 83. Marco Pino, Study for a <u>Decollation of the</u> <u>Baptist</u>, Florence, Uffizi (E. Borea)

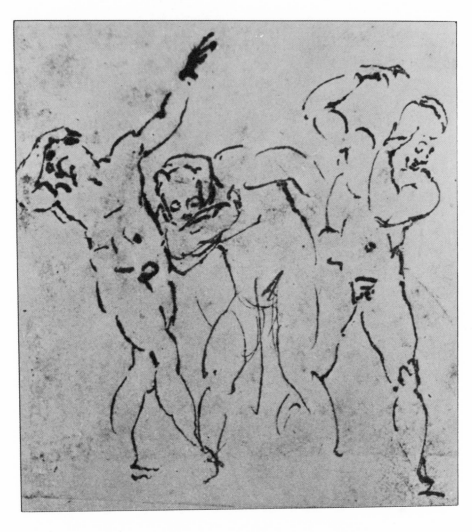

Figure 84. Michelangelo, Study of three figures in
motion, Florence, Casa Buonarroti (Barocchi)

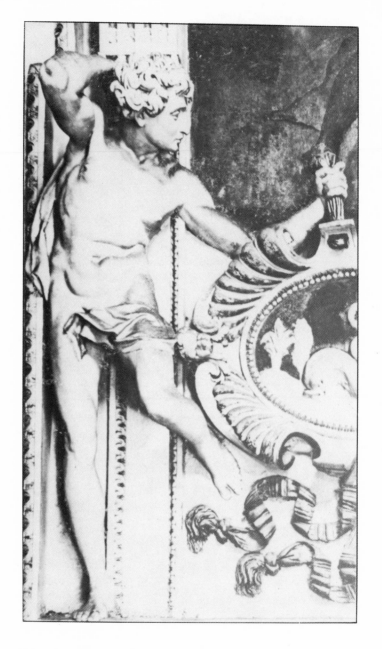

Figure 85. Giulio Mazzoni, Stucchi, Rome, Palazzo Spada,
 detail (Alinari)

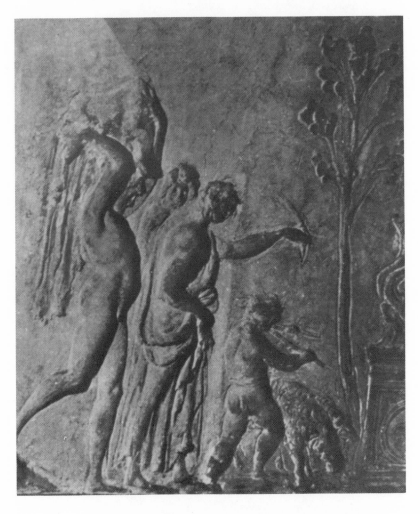

Figure 86. Giovanni da Udine, Stucchi, Loggia di Rafâ ello,
 Rome, Vatican (N. Dacos)

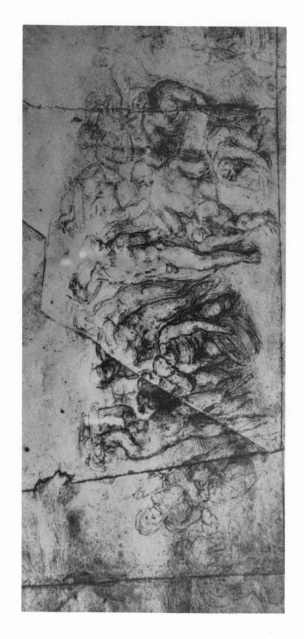

Figure 87. Michelangelo, Study for a Cleansing of the Temple, London, British Museum (J. Wilde)

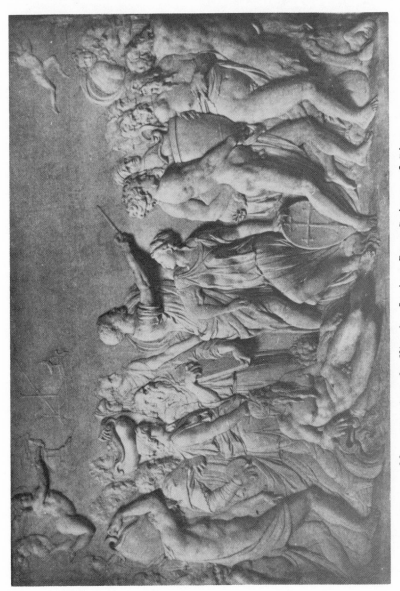

Figure 88. Pierino da Vinci, Cosimo I as Patron of Pisa, Rome, Vatican (Pope-Hennessy)

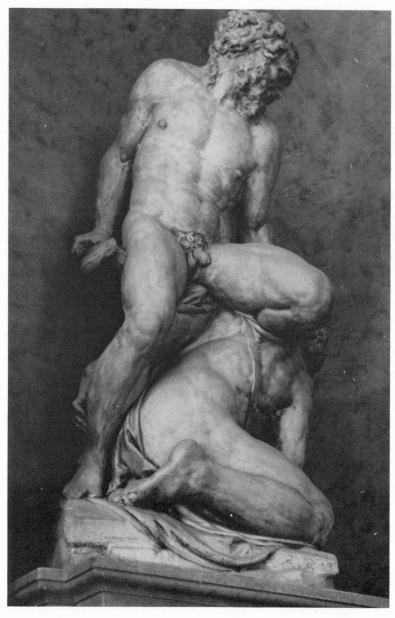

Figure 89. Pierino da Vinci, Samson and the Philistine, Florence, Palazzo Vecchio (Author)

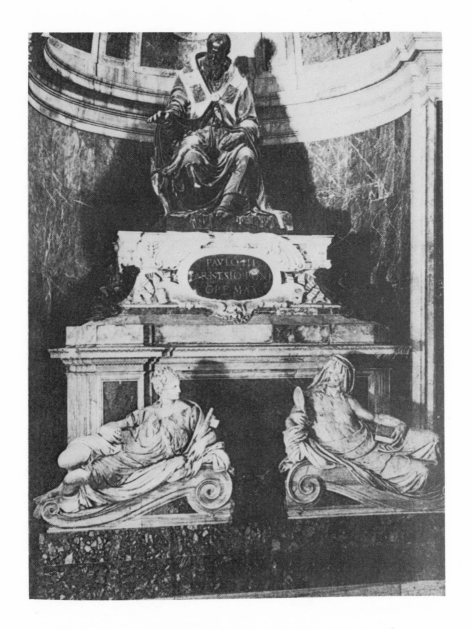

Figure 90. Guglielmo della Porta, Tomb of Paul III,
Rome, Saint Peter's (Steinmann)

Figure 91. Baccio Bandinelli (?), Study for the Tomb of
Clement VII, Paris, Louvre (Louvre)

Figure 92. Giulio Romano, Sala di Costantino, Pope
Gregory VII, Rome, Vatican, detail (Hartt)

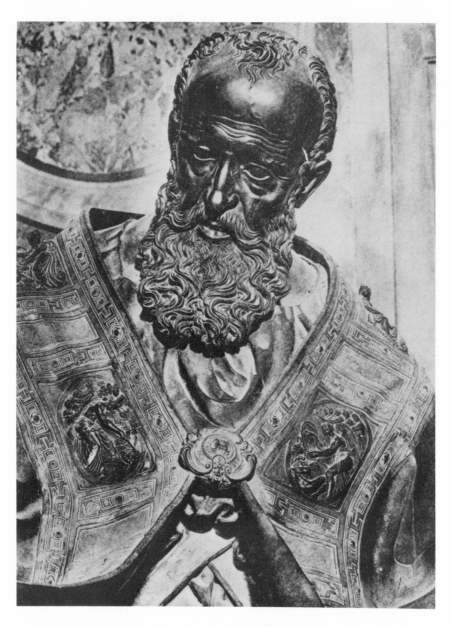

Figure 93. Guglielmo della Porta, Tomb of Paul III, Rome, Saint Peter's, detail (Steinmann)

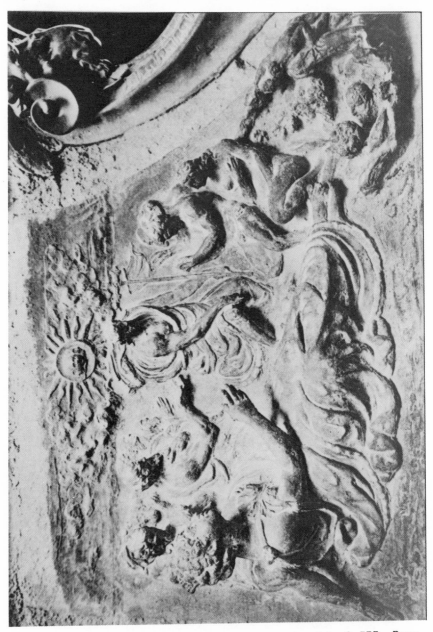

Figure 94. Guglielmo della Porta, Tomb of Paul III, Rome, Saint Peter's, detail (Steinmann)

Figure 95. Perino del Vaga, Study for a pluvial for Pope
Paul III, Windsor Castle (Popham)

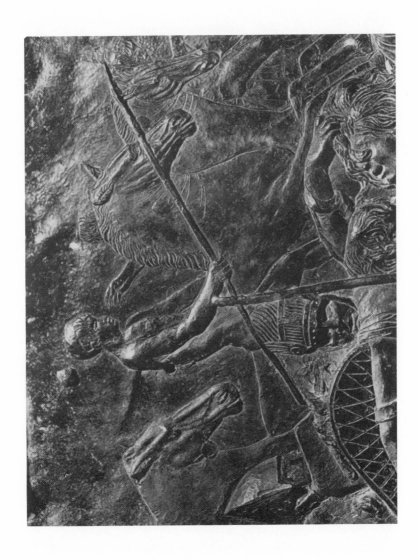

Figure 96. Donatello, Pulpit, Florence, San Lorenzo,
 detail (Janson)

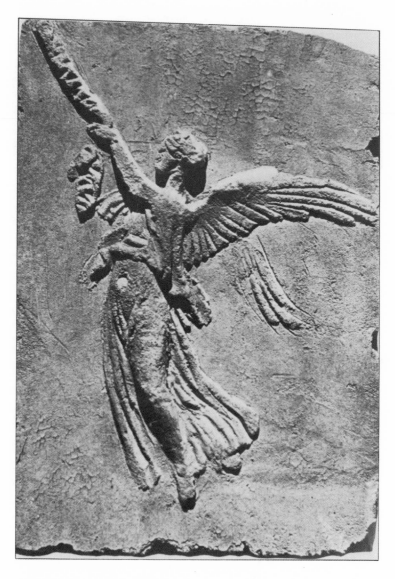

Figure 97. Roman stucco fragment (Dir. Gen. B. A.)

Figure 98. Michelangelo, Brazen Serpent, Rome, Vatican,
Sistine Ceiling (de Tolnay)

Figure 99. Daniele da Volterra, <u>David and Goliath</u>, Paris, Louvre (Venturi)

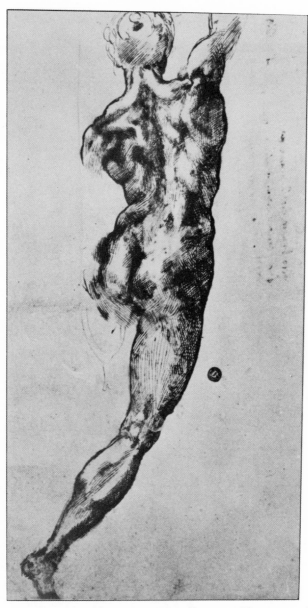

Figure 100. Michelangelo, Male figure, Florence, Casa
Buonarroti (Barocchi)

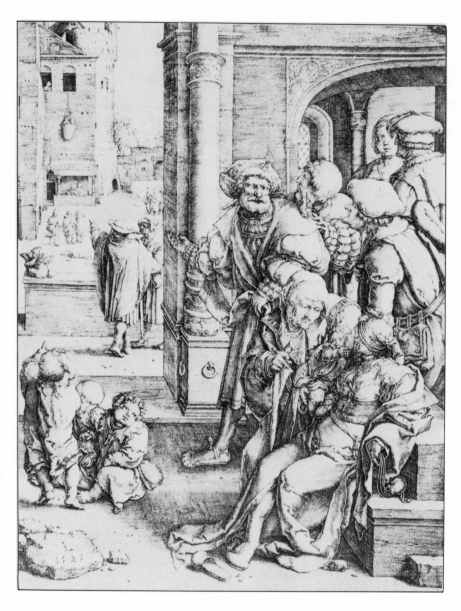

Figure 101. Lucas Van Leyden, *Virgil in the Basket*
(Friedlander)

Desiderium Patri
in Limbo V E N I
D O M I N E Cla-
mantium , ab illo
qui per serpentem
Aeneum figuramus
fuit, num .11 .10,1
cum descendisti
ad inferos imple
cum est. vt sup.al-
lus.præced.

Figure 102. P. Fabricio, <u>Christ</u> <u>in</u> <u>Limbo</u>

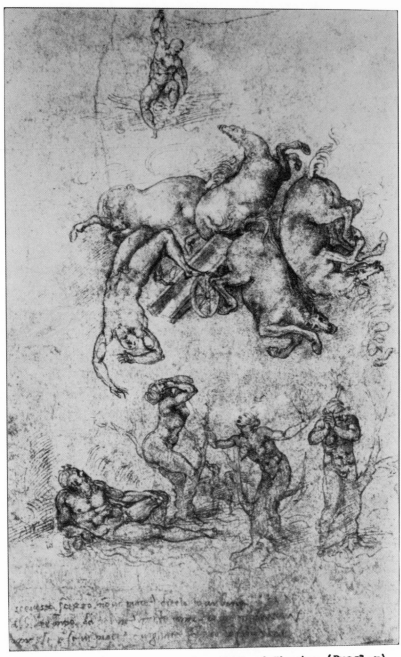

Figure 103. Michelangelo, Fall of Phaeton (Dussler)

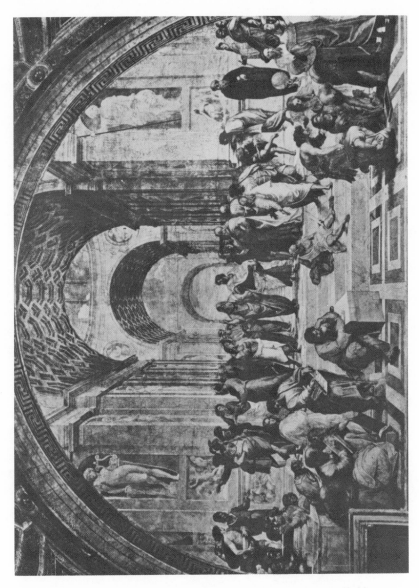

Figure 104. Raphael, School of Athens, Rome, Vatican, Stanza della Segnatura (Alinari)

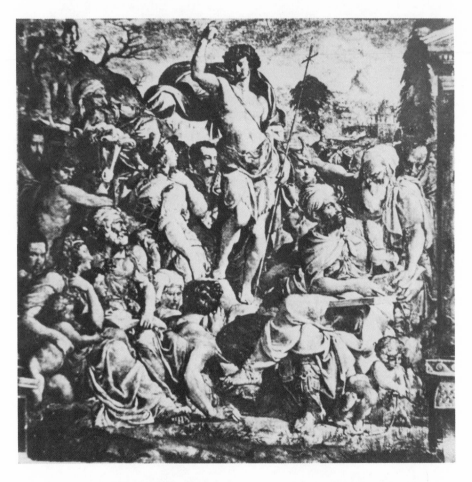

Figure 105. Jacopino del Conte, *Preaching of Saint John* the Baptist, Rome, Oratorio di S. Giovanni Decollato (Venturi)

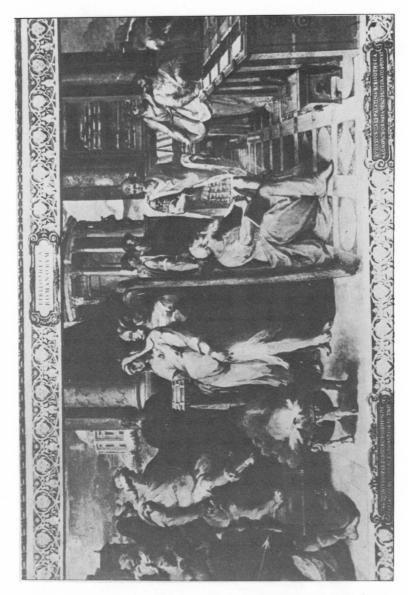

Figure 106. G. Baglione (?), <u>Tarquinius Superbus buying</u>
<u>the three Sibylline Books</u>, Rome, Biblioteca
Vaticana (Hess)

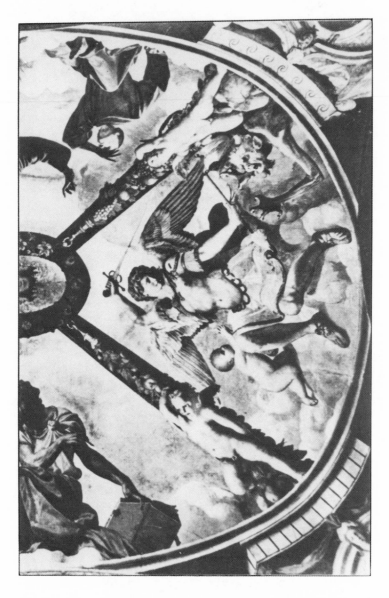

Figure 107. Agnolo Bronzino, <u>Saint Michael</u>, Florence,
Palazzo Vecchio, Chapel of Eleonora of
Toledo (Smyth)

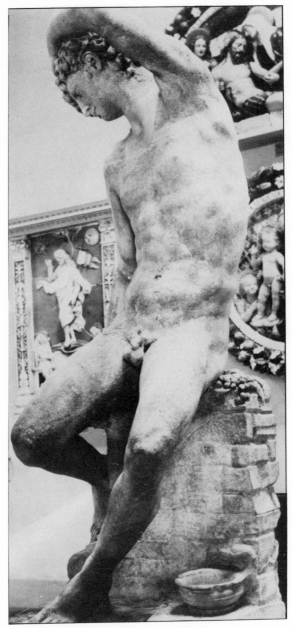

Figure 108. Benvenuto Cellini, <u>Narcissus</u>, Florence, Museo
Nazionale (author)

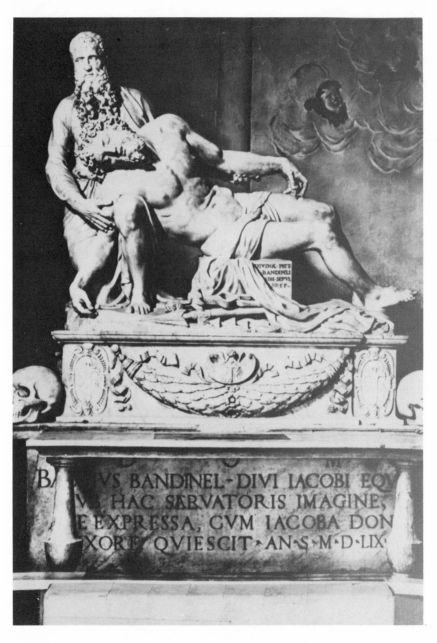

Figure 109. Baccio Bandinelli, Pietà, Florence, Santissima
Annunziata (Alinari)

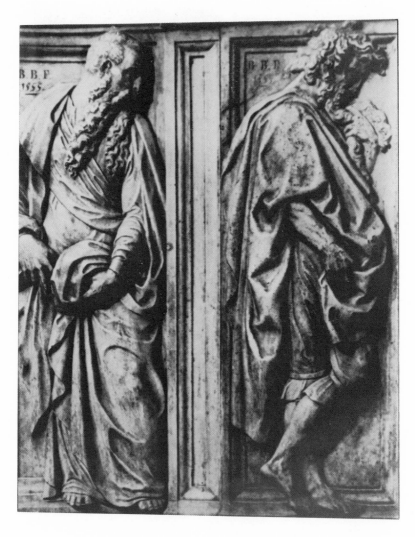

Figure 110. Baccio Bandinelli, choir reliefs, Florence, Duomo (Pope-Hennessy)

Figure 111. Baccio Bandinelli, Monument to Giovanni delle
Bande Nere, Florence, Piazza San Lorenzo,
detail (author)

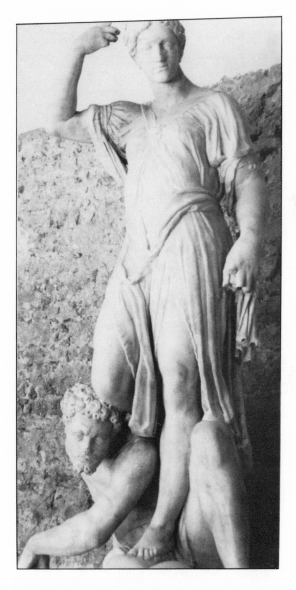

Figure 112. Bartolommeo Ammanati, <u>Victory</u>, Florence,
Museo Nazionale (author)

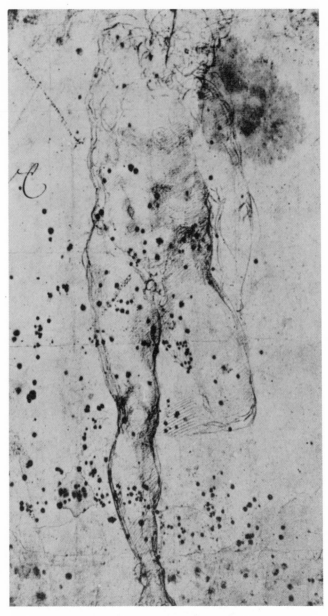

Figure 113. Michelangelo (?), Male figure, Louvre, Paris (Alinari)

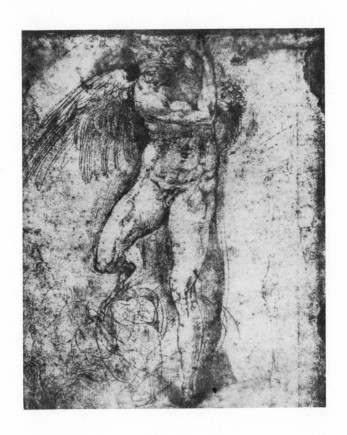

Figure 114. Battista Franco (?), <u>Victory</u>, Casa Buonarroti, Florence (Barocchi)

Figure 115. Francesco Salviati, Allegory of Peace, Florence
Palazzo Vecchio, detail (Shearman)

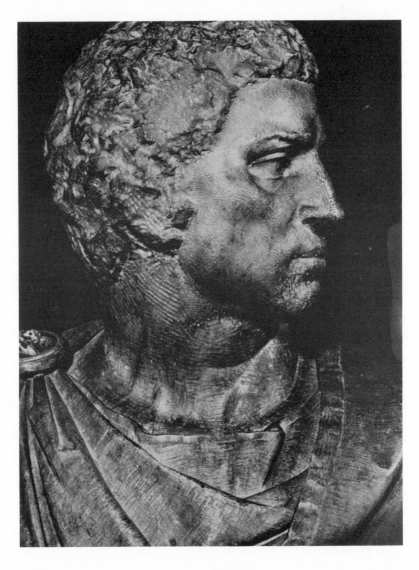

Figure 116. Michelangelo, <u>Brutus</u>, Florence, Museo Nazionale, (de Tolnay)

Figure 117. Baccio Bandinelli, Monument to Giovanni delle
Bande Nere, Florence, Piazza San Lorenzo, detail
(author)

Figure 118. Michelangelo, <u>Bruges Madonna</u>, Bruges, Notre Dame

Figure 119. Parmagianino, Vision of Saint Jerome, London,
National Gallery (Freedberg)

Figure 121. Mino da Fiesole, <u>Alfonso of Aragon</u>, Paris,
Louvre (Girandon)

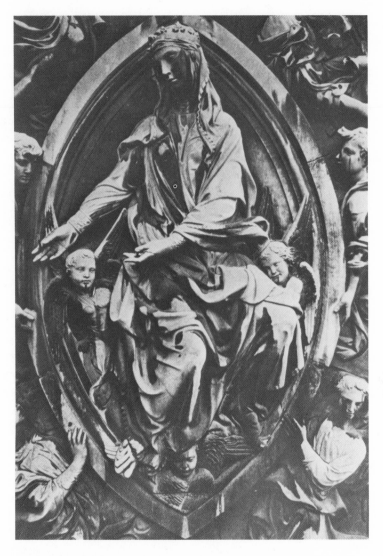

Figure 120. Nanni di Banco, <u>Assumption of the Virgin</u>,
Florence, Duomo, Porta della Mandorla
(P. Vaccarino)

Figure 122. S. Fanti, _Triompho della Fortuna_, Venice, 1527. Michelangelo at work (de Tolnay)

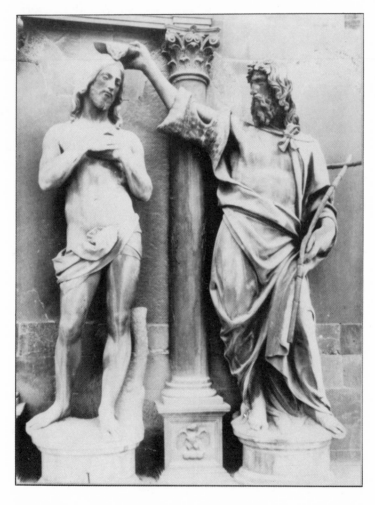

Figure 123. Andrea Sansovino and Vincenzo Danti, Baptism of
Christ, Florence, Baptistry

Figure 124. Domenico Poggini, Foundation Medal for the
Uffizi (Hill and Pollard)

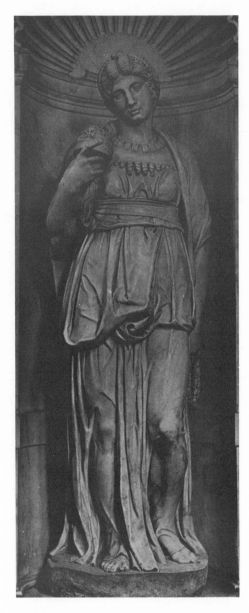

Figure 125. **Michelangelo, Leah**, Rome, San Pietro in
Vincoli (de Tolnay)

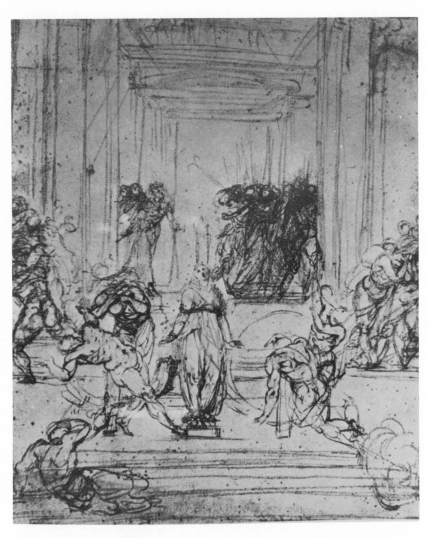

Figure 126. Follower of Michelangelo, *Martyrdom of Saint Catherine of Alexandria*, Rome, Palazzo Corsini, (Dusster)

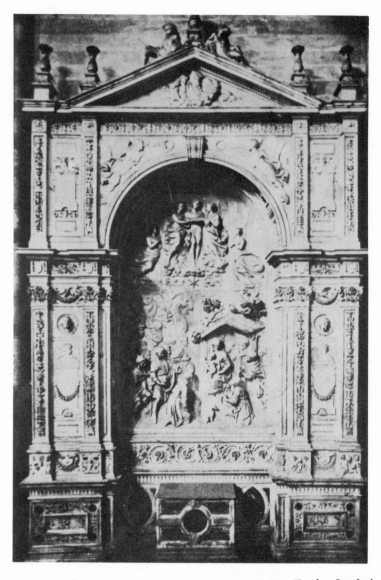

Figure 127. Michele Sanmichele, <u>Altar of the Magi</u>, Orvieto,
Duomo (Fumi)

Figure 128. Antonio da Sangallo the Younger, Study for
the Altar of the Magi, Florence, Uffizi (Pumi)

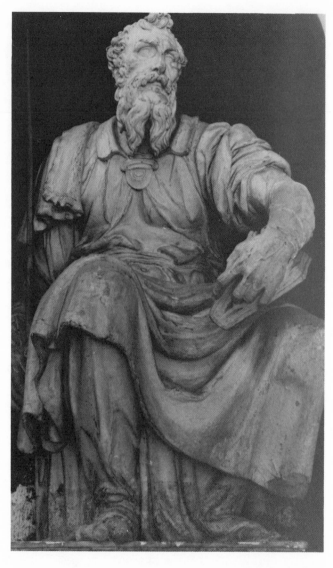

Figure 129. Giovanni Agnolo Montorsoli, Saint Paul,
Florence, Santissima Annunziata, Cappella di
San Luca (author)

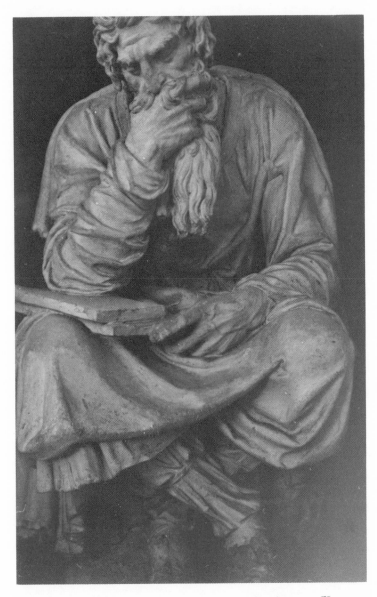

Figure 130. Giovanni Agnolo Montorsoli, <u>Moses</u>, Florence,
Santissima Annunziata, Cappella di San Luca
(author)

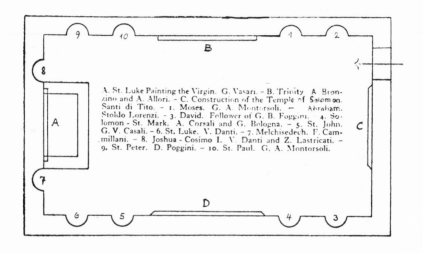

A. St. Luke Painting the Virgin. G. Vasari. - B. Trinity. A. Bronzino and A. Allori. - C. Construction of the Temple of Solomon. Santi di Tito. - 1. Moses. G. A. Montorsoli. - Abraham. Stoldo Lorenzi. - 3. David. Follower of G. B. Foggini. - 4. Solomon - St. Mark. A. Corsali and G. Bologna. - 5. St. John. G. V. Casali. - 6. St. Luke. V. Danti. - 7. Melchisedech. F. Cammillani. - 8. Joshua - Cosimo I. V. Danti and Z. Lastricati. - 9. St. Peter. D. Poggini. - 10. St. Paul. G. A. Montorsoli.

Figure 131. Cappella di San Luca, Florence, Santissima
 Annunziata, present state (not to scale)

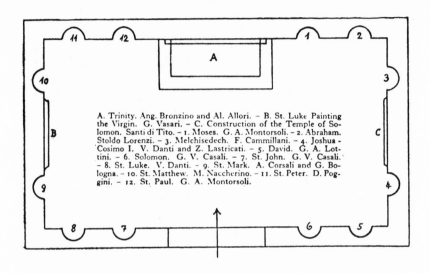

A. Trinity. Ang. Bronzino and Al. Allori. – B. St. Luke Painting the Virgin. G. Vasari. – C. Construction of the Temple of Solomon. Santi di Tito. – 1. Moses. G. A. Montorsoli. – 2. Abraham. Stoldo Lorenzi. – 3. Melchisedech. F. Cammillani. – 4. Joshua - Cosimo I. V. Danti and Z. Lastricati. – 5. David. G. A. Lottini. – 6. Solomon. G. V. Casali. – 7. St. John. G. V. Casali. – 8. St. Luke. V. Danti. – 9. St. Mark. A. Corsali and G. Bologna. – 10. St. Matthew. M. Naccherino. – 11. St. Peter. D. Poggini. – 12. St. Paul. G. A. Montorsoli.

Figure 132. Cappella di San Luca, Florence, Santissima Annunziata, original scheme (not to scale)

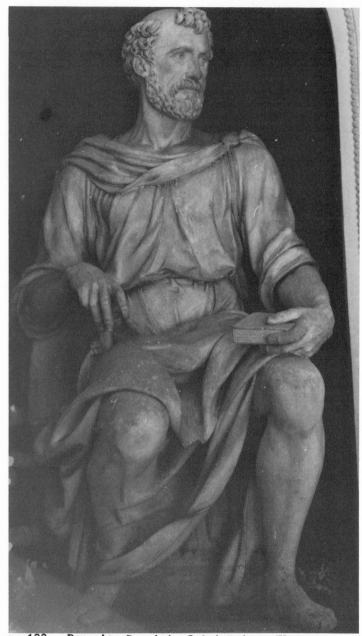

Figure 133. Domenico Poggini, Saint Peter, Florence,
Santissima Annunziata, Cappella di San Luca
(author)

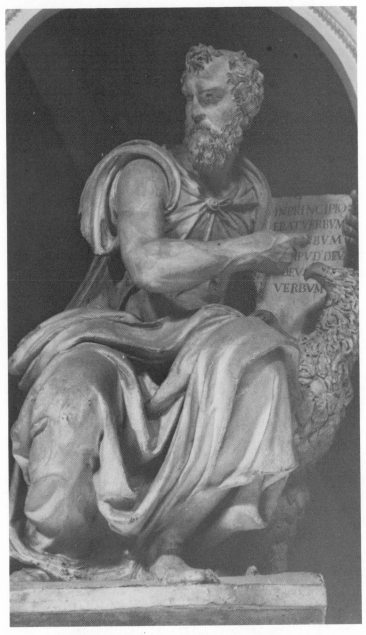

Figure 134. Giovanni Vincenzo Casali, <u>Saint John</u>, Florence, Santissima Annunziata, Cappella di San Luca (author)

Figure 135. Francesco Cammillani, <u>Melchisedech</u>, Florence,
Santissima Annunziata, Cappella di San Luca,
(author)

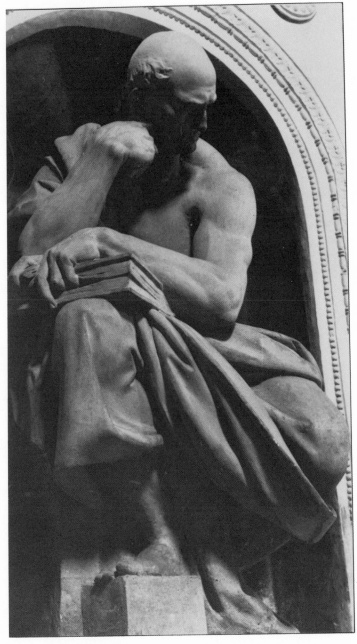

Figure 136. Andrea Corsali after Giovanni Bologna, Saint Mark-Solomon, Florence, Santissima Annunziata, Cappella di San Luca (author)

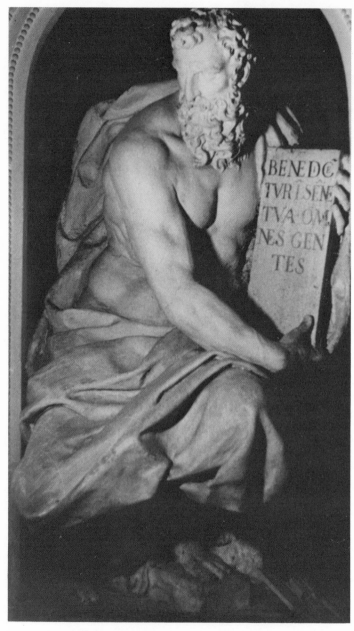

Figure 137. Stoldo Lorenzi, Abraham, Florence, Santissima
Annunziata, Cappella di San Luca (author)

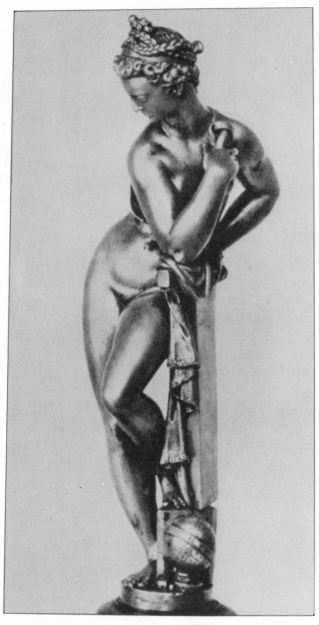

Figure 138. Giovanni Bologna, Astronomy, Vienna, Kunst-
historisches Museum (Weihrach)

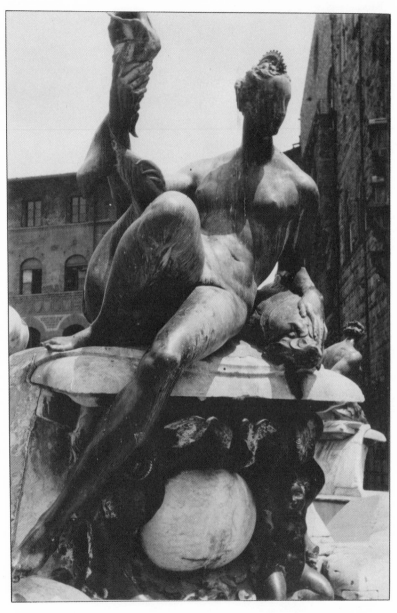

Figure 139. Bartolommeo Ammannati, Sea God, Florence,
Piazza della Signoria (author)

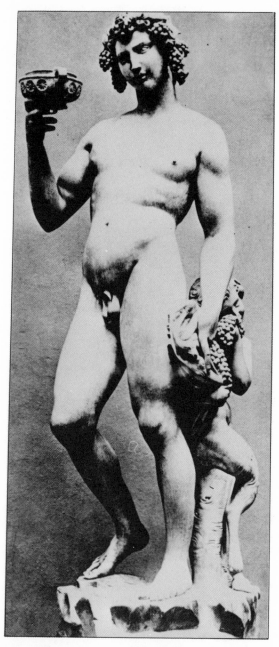

Figure 140. Michelangelo, Bacchus, Florence, Museo
Nazionale (de Tolnay)

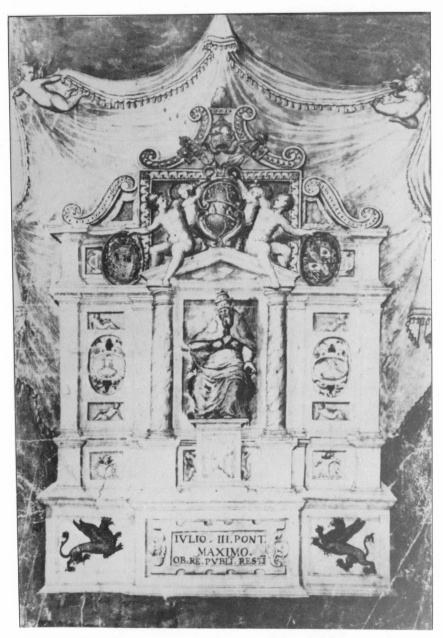

Figure 141. Giovanni Battista Caporali, _Julius III_,
(Archivio di Stato, Perugia)

Figure 142. Vincenzo Danti, Fragments of cast for <u>Sportello</u>
relief, London, Victoria and Albert Museum.
(J. Pope-Hennessy)

Figure 143. Drawing after engraving in Arohwio di Stato,
Perugia, Carte Pucoi 2. 27 (author)

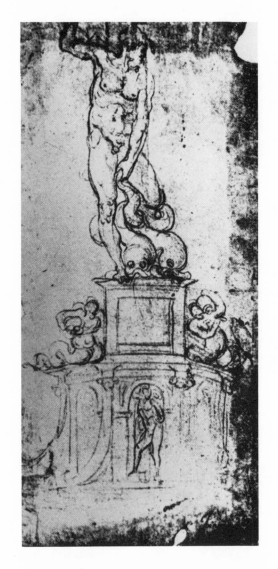

Figure 144. Vincenzo Danti (?) Study for the Fountain of
Neptune, Dubini Collection (Dhanens)

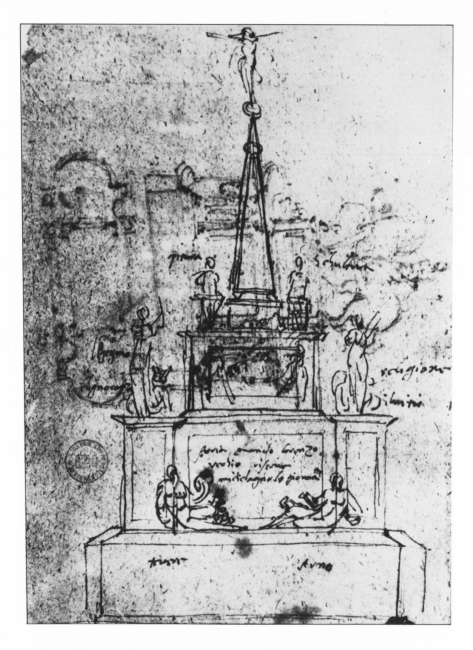

Figure 145. Vincenzo Danti, Drawing for the catafalque of
Michelangelo, Munich, Graphische Sammlung
(Wittkower)

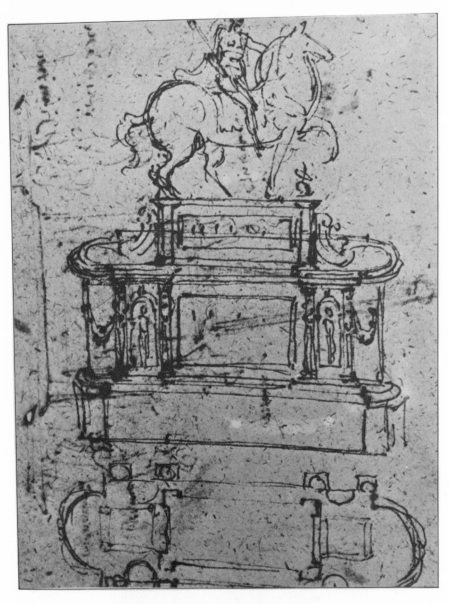

Figure 146. Vincenzo Danti, Study for an Equestrian Monument,
Munich, Graphische Sammlung (Wittkower)

Figure 147. Tabernacle of the Sacrament, Assisi, San Francesco
(Alinari)

Figure 148. Cast after Michelangelo's <u>Four</u> <u>Times</u> <u>of</u> <u>Day</u>:
<u>Day</u> (author)

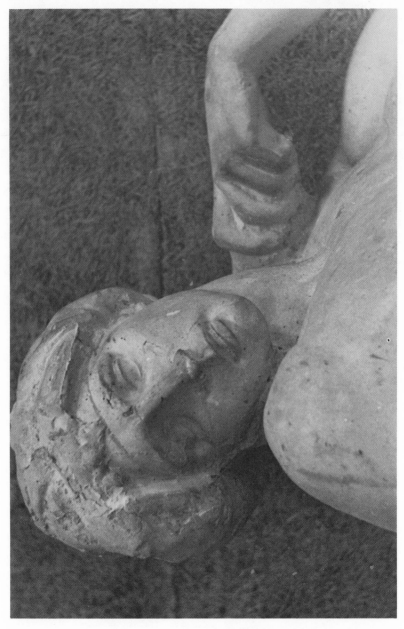

Figure 149. Cast after Michelangelo's <u>Four Times of Day</u>:
<u>Dawn</u> (author)

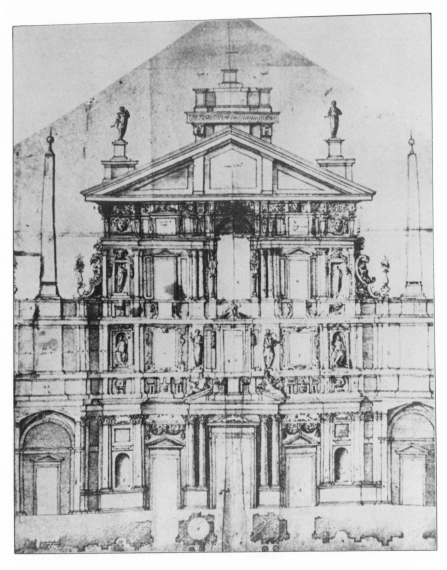

Figure 150. Galeazzo Alessi, Drawing for the facade of
Santa Maria presso San Celso in Milan (Brown)

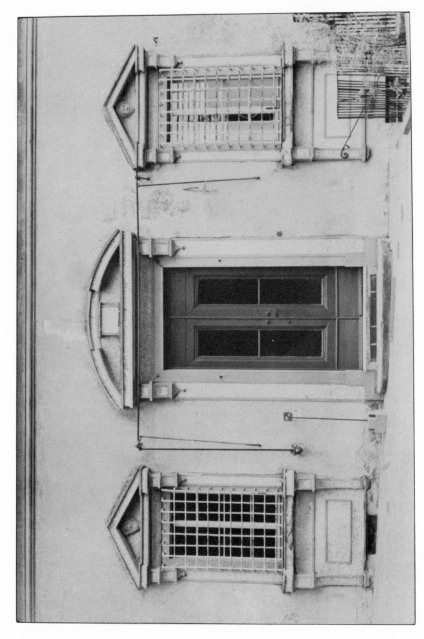

Figure 151. Vincenzo Danti (?), Door and window frames,
Villa Rondinelli, Fiesole (author)

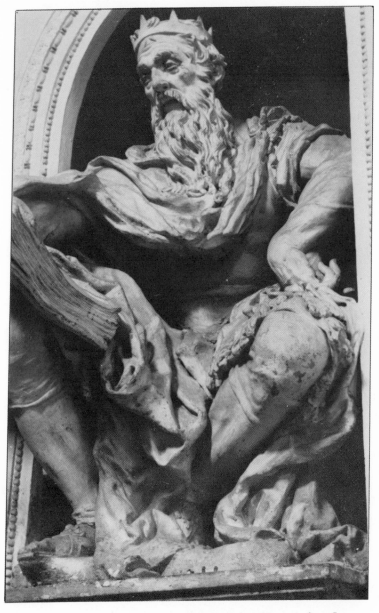

Figure 152. G. A. Lottini, <u>David</u>, Cappella si San Luca,
Santissima Annunziata, Florence (author)

VBI • MORS • IBI • VITA •

Et q in ligno vincebat.

Per
Lignum,
Mulierem,
Serpentem,
i. per
Pomum,
Euam,
Dæmonem,
Homo perierat.
Idem per
Lignum,
Mulierem,
Serpentem,
i. per
Crucem,
Mariam,
Chriftum,
Redemptus eft.
Auguft.

Figure 153. P. Fabrici, The Fall (Delle Imprese. . .)